MANCHESTER
UNIVERSITY PRESS

THE BARBER INSTITUTE'S
CRITICAL PERSPECTIVES
IN ART HISTORY SERIES

SERIES EDITORS
Tim Barringer, Nicola Bown
and Shearer West

EDITORIAL CONSULTANTS
John House, John Onians,
Marcia Pointon and Alan Wallach

Critical Kitaj

Essays on the work of R. B. Kitaj

EDITED BY
JAMES AULICH AND JOHN LYNCH

Manchester University Press

Published by Manchester University Press
Oxford Road, Manchester M13 9NR, UK
http://www.manchesteruniversitypress.co.uk

British Library Cataloguing-in-Publication Data
A catalogue record for this book is available from the British Library

ISBN 0 7190 5525 3 *hardback*
 0 7190 5526 1 *paperback*

First published 2000

07 06 05 04 03 02 01 00 10 9 8 7 6 5 4 3 2 1

Typeset by
D R Bungay Associates, Burghfield, Berks

Printed in Great Britain
by The Alden Press, Oxford

To my uncle William James Sheppard
J.A.

To my father Edward Lynch
J.L.

Contents

Illustrations

Plates

Figures

Contributors

Terry Atkinson is an artist and has forthcoming shows in Silkeborg, Denmark, and Dusseldorf. He teaches at the University of Leeds.

James Aulich is a Lecturer in the Department of History of Art and Design at Manchester Metropolitan University and co-author of *Political Posters in Central and Eastern Europe 1945–95* (1999).

David Peters Corbett teaches at the University of York and is co-editor of *English Art, 1860–1914: Modern artists and identity* (2000) and *The Modernity of English Art, 1914–1930* (1997).

Martin Roman Deppner is a lecturer in the Department of Jewish Studies at Carl von Ossietzky University, Oldenburg, Lecturer in the Department of Art History at the University of Hamburg, Lecturer in the Department of Art and Design at the University of Applied Sciences, Bielefeld, and author of a number of books and articles on Kitaj.

Simon Faulkner is a Lecturer in History of Art at Manchester Metropolitan University. He has just finished a Ph.D. on the London art world, 1958–66 and is currently working on a book on British art in the 1960s.

Pat Gilmour was founding Curator of Prints at the Tate Gallery London and at the National Gallery of Australia in Canberra. She is a Visiting Professor at the University of East London and on the Editorial Board of *Print Quarterly*.

John Lynch is a Lecturer in the School of Cultural Studies at Leeds Metropolitan University.

Giles Peaker is a Lecturer in History of Art and Design at the University of Derby.

Janet Wolff is Professor of Visual and Cultural Studies at the University of Rochester, New York. Her most recent book is *Resident Alien: Feminist Cultural Criticism* (1995*)*.

Alan Woods lectured in art history at Duncan Jordanstone College of Art and Design, a faculty of the University of Dundee. The founding editor of *Transcript*, he was the author of *Being Naked Playing Dead: The Art of Peter Greenaway* (1996).

Acknowledgements

Our thanks must go to R. B. Kitaj who gave encouragement and was generous with his permission to reproduce his work; Geoffrey Parton and Claire Mason who ferreted out the majority of the photographs and transparencies for reproduction at Marlborough Fine Art (London) Ltd., and without whose help the volume would be much the poorer; Pat Gilmour who kindly acquired permission for her article, 'R. B. Kitaj and Chris Prater of Kelpra Studio', to be re-printed from *Print Quarterly*; Andrew Crowley and David Mansell who gave of their photography; the Research Group in the Department of History of Art and Design at Manchester Metropolitan University and the Research Fund of the School of Cultural Studies at Leeds Metropolitan University for their financial assistance; Andrea Rehberg and David Dickinson for their help in adapting from the German; Jane Bedford for putting the manuscript in order; and Vanessa Graham, our editor at Manchester University Press, for her support and patience. Many of James Aulich's thoughts began more than fifteen years ago with a thesis submitted in the Department of History of Art at Manchester University, much as John Lynch's began with a thesis submitted in the Social History of Art at Leeds University. We would also particularly like to thank the contributors for giving of their time and resources.

The editors would like to note with great regret the early death of Alan Woods at the age of 43 during the production of this volume. His contributions to cultural and intellectual life will be sorely missed.

Introduction

James Aulich and John Lynch

Kitaj is a strikingly original artist. He is also one of very few painters in Britain since the 1960s to have inspired a generation of followers, and evidence of his practice lingers in artists as diverse as Tom Phillips and Peter Greenaway on the one hand, to Andrzej Jackowski and Alexander Moffat on the other. This collection of essays reveals Kitaj to be an artist who is not easily defined within the existing discourses of art-historical analysis. His art is positioned on the shifting sands of competing critical approaches, not least those provided by the privileged readings of the numerous notes, texts, commentaries and 'Prefaces' to the paintings written by the artist himself. These interpretations are further nuanced by the artist's continual re-evaluation of the work in exhibition and published sources. This has entailed, for example, the attempt to devalue the screenprints and much of the early work of the 1960s as too literary and dependent on Surrealist precedent. The desire to control belies a particular kind of anxiety[1] that can be found in the different ways he signs his name. There is the 'R. B. Kitaj' of the paintings, the 'R. K.' of the print series 'In Our Time: Covers for a Small Library After the Life for the Most Part', 1969; the 'Kitaj' of the pastel drawings of the 1970s and 1980s; the 'Ronald' of the 'Bad' paintings from the early 1990s; the 'Ron and Sandra' of the 1996 Royal Academy exhibit; the mischievous 'Stanley Hayter' and 'M. Rothenstein' in letters to the printmaker Chris Prater during the 1960s;[2] and the 'K.' from Franz Kafka of more general correspondence.[3]

The authors in this book variously place Kitaj's work between the visual and the verbal, sometimes in conflict, sometimes in harmony. They situate it in that gap which exists between different systems of signification and effectively structure the work and its interpretations in fabrics of concealment and ambiguity of meaning. The art exists in the spaces between memory and history, the private and the public, the abstract and the figurative, the painted and the drawn, the surface and its subject, symbol and allegory, allegory and its picture, tradition and radical avant-garde individualism, between Western liberal democratic and Jewish Talmudic traditions. In the end, it defies ultimate explanation, and here lies its strength as art.

The pictures have powerful resonances of contemporary urban life, but unlike other figurative artists to whom he might be compared such as David Hockney

or Edward Hopper, he does not make pictures of things, so much as ideas. His practice is late modernist in so far as it is sure of its own artifice: simultaneously, it is engaged with postmodern issues of historical memory, individual liberty and identity. As the chapters by John Lynch and Simon Faulkner demonstrate, his art has gone over the traces of histories obscured by the cultures of cold war and consumerism to recall the heroic role of individuals in the collective tragedy of the twentieth century. The work is devoted to an exploration of the ways in which the past haunts the present. He rediscovers in the streets of our contemporary urban lives a Baudelairean subject matter variously culled from individual lives, the brothel, the second-hand book shop, the library, the museum and the gallery. In portraits of friends and the historical *personae* he has discovered in the books of his library and imagination, he records the intellectual geography of his cultural milieu. In many ways, the oeuvre is a portrait gallery of individuals who are *marginal*, yet whose existence is *essential* to the mainstream, as if they were part of a repressed cultural subconscious. Kitaj gives these obscured figures new life: not Sigmund Freud but Aby Warburg; not Herbert Marcuse but Walter Benjamin, not Clement Greenberg but Edgar Wind, not Jacques Derrida but R. P. Blackmur, not Jean-Luc Godard but John Ford. Complex in their references, the pictures bear comparison to the work of Benjamin West, Larry Rivers and even the contemporary state history painters of the communist bloc such as Willi Sitte and Werner Tubke of the former German Democratic Republic. The subjects of his work and life have taken him on a journey via Vienna, New York, Paris, London, Frankfurt and Los Angeles from youthful bohemianism to studied anarchism and the discovery of his Jewishness. And, after the controversial retrospective exhibition at the Tate Gallery in 1994 and the subsequent death of his second wife Sandra Fisher, the final break with English domicile in 1997.[4]

For the most part, Kitaj has worked in a traditional manner, representing for artist–teachers such as Terry Atkinson an uncritical acceptance of the 'structural category of painting'. Kitaj shuns even the use of plastic paint in pictures, which are a return to, and secularisation of, history painting. Once considered the noblest of art forms, history painting involves the representation of human passions, intellect and history as symbolised in the iconographies of classical history, mythology and Christianity. Modernists maligned the genre as too literary, a vessel too impure to carry the value and quality of the pure in art. This has been a criticism levelled at Kitaj by many commentators throughout his career. However, recognition came at the beginning of the 1960s when he was identified with 'Pop art' and a generation emerging from the Royal College of Art.[5] Tony Reichardt who was shortly to take up a post at Marlborough Fine Art noticed his work at the seminal Young Contemporaries exhibition in 1960. He introduced Kitaj's work to the gallery's co-founder Harry Fischer who was attracted to the central European themes and the expressionist textures of paintings such as *Austro-Hungarian Footsoldier*, 1958.[6] Two major one-man exhibitions followed

at the Marlborough New London Gallery in 1963 and the Marlborough-Gerson in New York in 1965. His reputation was assured with the purchase by the Tate Gallery of the painting *Isaac Babel Riding with Budyonny*, 1962.

The early exhibitions, pictures and catalogues were heavily larded with literary allusion. Kitaj has often spoken of his 'lifetime' with Ezra Pound who, as fascist apologist and broadcaster for Mussolini in the Second World War, was no lover of Jews. In the light of his rediscovery of his own secular Jewishness discussed below by Janet Wolff and Martin Deppner, his fascination with Pound is revealed as part of a search for identity previously found in modernist American exile.[7] As one of Kitaj's prime obsessions in his pictures and writings, the 'outsider' is an analogue for the expatriate and dispossessed kernel of modernism: Pablo Picasso and James Joyce as Spaniard and Irishman in Paris, T. S. Eliot and Ezra Pound as Americans in London. That the pictures share a great deal in common with Pound's poetry is certain: the quotation, the arcane learning, the montage-like construction, the free-form association, are all to be found in the painting as much as they are in the poetry. But there is much reading and erudition which is not referred to, and the observer must be wary of the sources and the written commentaries or prefaces to the paintings provided by the artist.

Since the early 1960s the oeuvre has bodied forth a sense of narrative continuity self-consciously pursued in later pictures through invented characters such as Joe Singer in the picture *The Listener (Joe Singer in Hiding)*, 1980.[8] Joe Singer is representative of one of the most consistent tropes to emerge from the work of the 1960s, where the individual in pictures such *Aby Warburg as Maenad*, 1962, is depicted as a twisted, crippled, afflicted and rejected individual. As the events of World War One drove the German art historian into madness, he is visually aligned to the subject of his study into the impact of Dionysiac pagan culture on Christian Renaissance forms. Similarly, as in *The Ohio Gang*, 1964 (Figure 1),[9] the poet, Robert Creeley, appears as a distorted and grotesque transvestite.[10] Another painting, *Randolph Bourne in Irving Place*, 1963 (Figure 2), depicts the literary bohemian and anarchist from the heyday of Greenwich Village. Pictured as a Wandering Jew as a hunchback with a stick from a fairy tale by the late German Romantic, Moritz von Schwind, the figure of Randolph Bourne epitomises the opposite of what Bourne had configured as the 'herd intellect'. In Kitaj's hands, Bourne the anarchist outsider who was rejected even by his own family for his pacifism becomes prophetic of the first steps along the road to the Second World War. As Giles Peaker quoting Juliet Steyn has shown, the figure becomes for Kitaj emblematic of Jewishness in the later part of his career as a 'single unequivocal character, a common and unchanging identity – as outsider'.[11]

Until the early to mid-1970s Kitaj nostalgically associates himself and his work with an anti-bourgeois and late bohemian, bibliophiliac, leftist and anarchic pedigree drawn principally from American art and letters, remote from the later interest in Walter Benjamin and specifically allegorical forms. It is a tradition identified

with figures such as Theodore Dreiser and Edward Dahlberg and includes others
he does not mention such as John Dos Passos, whose novel, *U.S.A.*, has a passage
dedicated to Randolph Bourne:

> If any man has a ghost
> Bourne had a ghost,
> a tiny twisted unscared ghost in a black cloak
> hopping along the grimy old brick and brownstone streets
> still left in downtown New York,
> crying out in a shrill soundless giggle:
> *War is the health of the State.*[12]

1 *The Ohio Gang*, 1964, oil on canvas, 182.9 x 182.9.

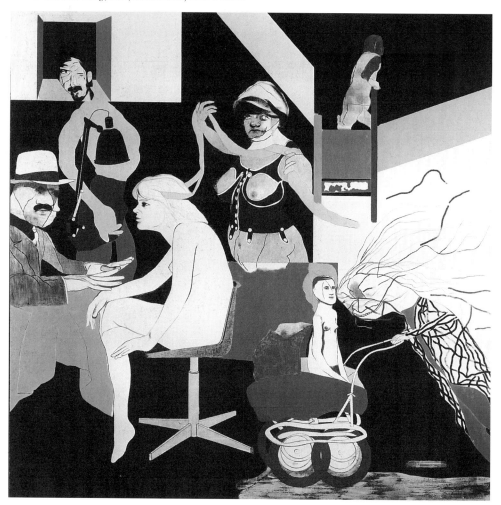

Dos Passos's poem also refers to the 'purplish normalcy of the Ohio Gang', as if Kitaj was using *U.S.A.* as a compendium from which to extract his gallery of protagonists, which he was not.[13] But there are formal analogies to be made between Dos Passos's literary modernism and Kitaj's pictures. The use of verbatim quotations of press headlines in 'newsreels' in oblique support of Dos Passos's gallery of characters in the novel is parallelled by the artist in the paintings in general and *Randolph Bourne in Irving Place*, in particular. The newsreel construction of Passos's literary montage also points to another of Kitaj's sources

2 *Randolph Bourne in Irving Place*, 1963, oil and collage on canvas, 152.5 x 152.5.

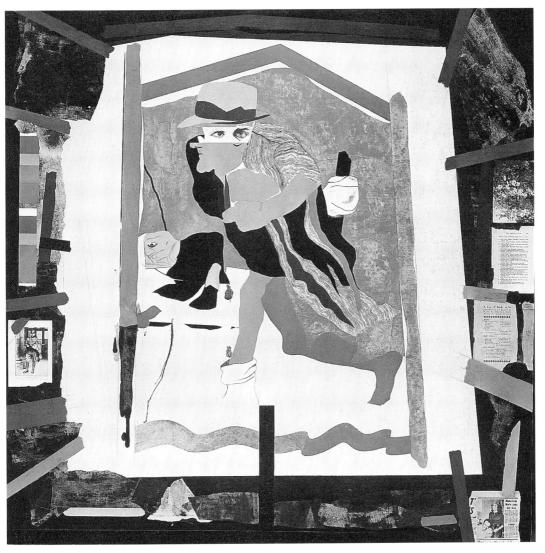

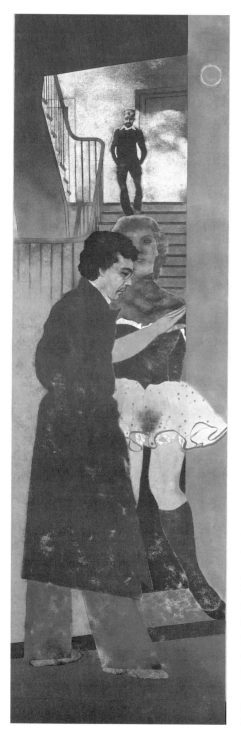

of inspiration in film, discussed by Alan Woods below: the pictorial sources discovered in film stills, the allusions to film and even the portraits of actors in pictures such as *Walter Lippmann*, 1966 (Plate 16).[14]

Even during the 1970s, when he developed a more decorative and pictorially coherent style, the layers of literary parallels remain. The painting *Smyrna Greek (Nikos)*, 1976–77 (Figure 3), for example, with its complex weave of geographical, literary and biographical associations offers a clear comparison with *Randolph Bourne in Irving Place*. According to the artist it was: 'posed by my friend Nikos Stangos and it will be a kind of Smyrna Greek, suggested by a recent life of Cavafy, the episodes when he lived above a brothel in Alexandria. The background here will be a brothel.'[15] The point is that Kitaj's chains of associations are neither accidental nor abitrary.

Many commentators and the artist himself have pointed out that the texts and notes to the pictures function rather as T. S. Eliot's notes to *The Waste Land*. They are part revelatory and part red herring, and they serve to enrich and prolong the life of the pictures, and to enable work to continue on the image even after it has left the studio.[16] In this volume David Peters Corbett establishes that they contain the potential to detract from the 'visual'. But for Martin Deppner they place the work in the tradition of Talmudic interpretation, and deprive the pictures of stable meanings. He discusses the Jewish Other of the Western tradition in the memory traces revealed in the proliferation of secondary material which, he argues, dispossesses the singular speaking subject from the pictures. In different ways, Simon Faulkner also argues that the references to the iconographical traditions of West European art, the

3 *Smyrna Greek (Nikos)*, 1976–77, oil on canvas, 243.5 x 76.2.

notes and texts, point to a world beyond the subjective. The allusions are intended to make the work remote from contingent emotion, and to make it generate feeling and interest in its own right. Experience and memory are plotted with reference to objective conditions through reference to the cultural environment of the subject of the picture. To pursue the analogy with modernist poetry, Eliot had written of Ezra Pound: 'Invention is wrong only because it is impossible ... The poem which is absolutely original is absolutely bad: it is, in the bad sense, "subjective" with no relation to the world to which it appeals.'[17] Originality consists in the development of what already exists, objectively, in the tradition and in the material contexts of life as it is lived.

As David Peters Corbett points out, Kitaj sometimes deliberately set out to emulate the look of poetry on the page. To do so is to suggest a visual connection with literature beyond questions of process, and to engage with text as a material object, physically existing in the world as print: as significatory system to be understood *and* a distribution of words on the page to be seen. Allusions to literary modernism and its jackdaw-like raids into the tradition for quotations were further supported by the tradition of humanist art history and its investigations into the classical tradition. Aby Warburg had described the process of the coining of iconographies and their cultural fate in the history of images as a function of the social memory. His approach was comparable in some respects to C. G. Jung and his notions of the collective unconscious, but articulated on a cultural level. It was based on an intuitive understanding of the processes of collective memory, defined by Jay Winter and others, as an exchange of information, memories and values negotiated between the individuals of elite groups in society. These would include artists and the functionaries of public institutions and the media industry, all of whom are capable of contributing to the determination of the frameworks of public memory.

Warburg had described the route back from Isadora Duncan to the maenad, the frenzied dancer of classical mythology, for example, in terms of the re-emergence of ancient formulations transformed and disguised in the clash of pagan and Christian traditions. Kitaj pillaged the illustrations to the articles he found in the *Journal of the Warburg and Courtauld Institutes*. Art-historical scholarship provided a readymade lexicon of visual archetypes and a visual vocabulary with an authority beyond the arbitrary. As such, it was endowed with the potential for bearing meaning in a manner comparable to the way poetic language had worked for Eliot, where every word carries with it the history of its own previous usages and contexts.

By the mid-1960s, Kitaj had a highly developed awareness of certain aspects of contemporary American poetry which had a direct impact on his work. Poundian aesthetics had been developed among a group of poets centred on Charles Olson at Black Mountain College during the 1950s. Among them were the poets and friends of the artist, Jonathan Williams and Robert Creeley.[18] Particularly important was Olson's notion of composition by field, not least because it is directly comparable to Robert Rauschenberg's development of what became known as 'bulletin

board' composition, particularly in the ways the imagery is spread as points of visu-
al interest over the surface of the picture.[19] Similarly, the poets at Black Mountain
regarded the page as a field of points of poetic energy, considered as imagistic or
ideogrammatic. The poets made use of language to construct striking images,
sometimes finding them in the available tradition, or in fragments of unadorned
material in the manner of William Carlos Williams's verbatim menus in his long
poem *Paterson*.[20] The poetry is built from the literal material of experience and the
learned vocabulary of the tradition, 'no ideas but in things', as Williams had so
famously expressed it. It shares with Eliot's notion of the objective correlative the
hope that the conjunction of certain objects configured in language might have the
power to express or to conjure human emotion aside from the contingent.

Another aspect of this post-Poundian aesthetic is equally important, and resides
in the value placed in the measure of the poem through breath. Its equivalent in
painting is the gesture, familiar from Abstract Expressionism and the influential
writings of Harold Rosenberg.[21] When read, the poetry is comprised of verbal
sounds issuing from the body as intervals of breath, they are also seen (as words
on the page and as images in the mind), heard (in the music of the poem) and intel-
lectually grasped through their elaborate weave of associations. The poetry has a
sense of measure defined in the spatial distribution of the words on the page, in
turn defined by the intervals of breath the language demands. This literary aes-
thetic offers parallels to the structures of the pictures where images coalesce to cre-
ate a single, but literally tangible work of art. The heterogeneous elements of the
picture are distributed as points of interest over the area of the canvas. They find
their measure in the body of the artist through the gesture as it functions as the
measure of the dynamic between the intellect and the body. That is, between the
eye and the hand, in the physical experience of the materiality of the pictures, and
in the comparisons and acts of interpretation they present to the viewer.

In the pictures, one image suggests the next to make sketches unnecessary as
they develop under their own free-associative impetus: 'The entire composition is
rarely clear in my mind to begin with.'[22] The composition is determined by the
transformational possibilities of the imagery through its capacity for reference and
allusion on figurative and abstract levels.[23] The aesthetic is one of inclusion rather
than exclusion. The abstract co-exists with the figurative, the pictorial with the
textual, the highbrow with the demotic, the contemporary with the historical, the
private with the public. Characteristic of many postmodern cultural developments
in its pursuit of a semiological understanding of imagery, it would seem to make
anything available. To give the work a system is to deny its intuitive nature, but it
did find still further support in the artist's knowledge of some aspects of European
and American Surrealism available to him in the magazine *View*.[24] Among its pages
were explorations into ethnography, cosmology, anthropology, psychology and
philosophy, its concerns are more Jungian than Freudian, and it is representative
of a search for meaning in remote corners of a public culture, rather than an indi-
vidual subconscious.

Kitaj is a bibliophile and collector of books; his methods are haphazard, unrestricted by the strictures of scholarly inquiry. The attitude has much in common with a rummaging among cultural artefacts which is peculiarly American, and it found contemporary expression in the work of Joseph Cornell and Robert Rauschenberg. According to the poet and writer Guy Davenport, Americans are 'Foragers by destiny, we like to go into familiar places and make a new report on the contents – Henry Adams to Chartres, Pound to China, Olson to Yucatan. All too characteristically we have no notion of what we're looking for; we are simply looking.'[25] In the painting *The Education of Henry Adams*, 1991–92, the artist would seem to confirm this reading as he depicts Adams striding away from the viewer across a peopled landscape. Potential discoveries are determined by the contents of his 'own backyard' as Jonathan Williams put it. John Lynch in his analysis of the painting *The Murder of Rosa Luxemburg*, 1960 (Plate 8), shows how the literal quotations in the early work are objects which can as easily be drawn from the worlds of books and pictures as the physical environment. In these contexts they invariably take on the aspect of a biographical experience mediated through the agency of his cast of actual or fictional characters. E. R. Curtius, a German scholar indebted to Aby Warburg and whom Kitaj cites, asserted the value of the complex traditions found in the history of civilisation in preference to the naive, and subconscious dreams of the individual, 'where tales are today is not in stories but in things'.[26]

The materiality of the book, the page, the word, the photograph, the canvas fragment, the marbled and lined paper fragments, and the paint, in fact, place Kitaj's work firmly in the tradition of the history of American art. The sometimes painted, sometimes literal imagery combined with the constructed 'bulletin board' composition recapitulates the illusionism and objectivity of nineteenth-century precedent found in pictures such as William Michael Harnett's *The Artist's Letter Rack*, 1879, John Frederick Peto's *Reminiscences of 1865*, 1897, and John Haberle's *A Bachelor's Drawer*, 1890–94. Like Kitaj's art they are a romance for what is about to disappear, as Robert Hughes commented: 'They all bear the mark of recent social use. But the implication is that the society that used them is vanishing or gone.'[27] These pictures have the painted appearance of assemblage or collage and are the direct forerunners of a tradition of surrogate portraiture in American modernism seen in Marsden Hartley's *Portrait of a German Officer*, 1914; Demuth's poster portraits begun in 1924, such as *I Saw the Figure Five in Gold*, 1928; Charles Sheeler's *Self-Portrait*, 1923; Arthur Dove's *Portrait of Ralph Dusenberry*, 1924, and Gerald Murphy's *Portrait*, 1928, for example. None of these manifests a recognisable likeness; rather they submit the components of the design to modernist arrangements to evoke the presence of an individual through cryptic allusion. As Walt Whitman had once said, the objects with which a person surrounds himself are more revealing than the literal description of an individual likeness. In the quotation from William Carlos Williams on the title page to the second one-man exhibition catalogue Kitaj specifically aligns himself

with this tradition in American art and letters: 'A local pride: spring, summer, fall and the sea; a confession; a basket; a column; a reply to the Greek and the Latin with the bare hands.'[28]

The point is that American feelings of cultural provincialism and of 'separation' from Europe contrast with an idea of European sensibility, and construct a self-image of Americans as pioneers. They become, therefore, explorers in the tradition rather than its native inhabitants. They bring back trophies from the history of the tradition, but are unable to distinguish them from any other cultural artefacts. It is the cultural landscape of the exile and the autodidact, where cultural value is learned rather than lived. The sense of being an American in London combined with an intuition that the continuity of the Judaeo-Christian and classical traditions had been in some senses compromised, as James Aulich argues below, means that they are only really accessible through study and scholarship. He had discovered in the theoretical writings and the poetry of his friend, Robert Duncan, for example, a marriage of the 'lordly and the humble' and of 'mythology and folktale'. This was combined with a strong sense of the survival of the past in the present through processes of rediscovery, rather than any interaction with a 'natural environment'. Thinking of Duncan, Kitaj wrote, 'I devour his sense of past, of heroism, his syntax, his wasp-talmudic take in an arcane myth-dredging tradition, the way his life and lines burn on in his own townism … its late sunlight and westernamericaness, the expectation and surprise as so much value is given out of the mouths of libraries.'[29] The attempt is made by the artist to give what Aby Warburg called the engrams of the past new life, through the employment of self-conscious parallelisms in the pictures and the texts to which they are so painstakingly related.

Stories in the pictures are seen to connect. *Juan de la Cruz*, 1967 (Figure 4), for example, depicts a negro in an interior 'meant to evoke transport to Vietnam'.[30] There is a Negro Tragedy, a Black unhappiness I have felt deeply all my life which I've also begun to treat, haltingly.'[31] The figure in the picture has Cross on his name tag, and he is depicted in the *persona* of Juan de la Cruz, the Spanish mystical poet. Kitaj commented at the time, 'I had been reading Juan de la Cruz in Roy Campbell's wonderful translations, at the same time I wanted to make a composition about the activist political situation in America and it seemed just right to have a negro, an American negro soldier stand in for Juan de la Cruz in this context.'[32] The layers of association reach back from Los Angeles in 1967 to the Spanish Inquisition through the Spanish Civil War. Roy Campbell wrote of 'the miserable cell so small that he could hardly turn round, and where he was all through the burning summer of 1567 and where as he said, through suffering came to him experience which he could express through poetry'.[33] And Roy Campbell, translator of the poem, hispanophile, Catholic and poet, was himself caught in the crossfire in the battle for the Alcazar outside Toledo during the Spanish Civil War.[34] As Simon Faulkner suggests, a romance of the past ambitions of the European Left resounds through the oeuvre from *Kennst du das Land?*, 1962 (Figure 34), to *Go and*

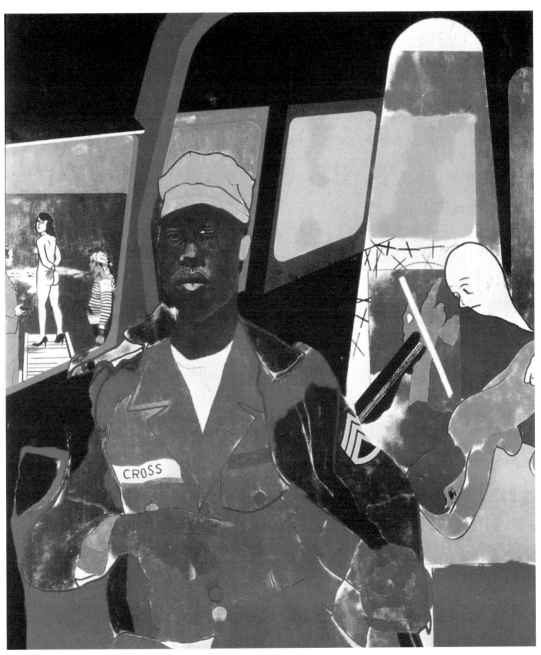

4 *Juan de la Cruz,* 1967, oil on canvas, 183 x 152.4.

Get Killed Comrade – We Need a Byron in the Movement, 1966.[35] Three distinct characters emerge from the literary and visual fabric of the picture. Firstly, there is St John of the Cross who suffered for his devotion to his faith. Secondly, there is Roy Campbell, a supporter of the Nationalist cause during the Spanish Civil War, Catholic convert, fierce defender of 'genius', and arrogant bibliophile with a romantic passion for adventure. And thirdly, there is Cross, the invented man in the picture who is trapped by the history of his race in his 'most familiar guise ... in the United States Army ... he's usually a tough specialist and he finds in the army a brand of socialism, a brand of democracy he never knew in civilian life, and all the dignified trappings that go along with that'.[36]

It was at about this time that Kitaj discovered the writings of Walter Benjamin. Giles Peaker in this volume shows how Walter Benjamin provided Kitaj with one of the most important encounters of his career. The collection of essays *Illuminations* with its introduction by Hannah Arendt was a vital way into the complex thought of this idiosyncratic critic and essayist. Arendt begins her essay with a reference to 'The Hunchback' and Benjamin's essay, 'Franz Kafka. On the Tenth Anniversary of His Death', and defines a territory which in the context of his own oeuvre the artist would find impossible to resist.[37] First published in English in 1968, the essays can be seen to provide intellectual justification for Kitaj's bibliophilia. The essay 'Unpacking My Library' might be said to provide inspiration for the print series of book-covers *In Our Time*, 1969. 'The Task of the Translator' might have provided a buttress for the transformation of secondary material such as poetry, literature, films, photographs and other art. In 'The Story Teller' the artist might have found critical justification for the construction of the artist as a liberal humanist, endowed with the power to tell stories.

Significantly, the collection contained Benjamin's most famous of essays, 'The Work of Art in the Age of Mechanical Reproduction'. Kitaj could not have helped but draw succour from it for his screenprints. This most Marxist of all Benjamin's well-known works, placed great faith in the socially transformative capacities of the new reproductive technologies of the industrial age. But most important of all are the 'Theses on the Philosophy of History', which give theoretical credence for Kitaj's working practice as a whole.

Benjamin's thought shared many characteristics with Aby Warburg,[38] and the artist could not have failed to notice the correspondences between Warburg's theory of the social memory, and Benjamin's concept of history. Warburg had written of the survival of images crucial for the history of the race:

> It is in the zone of orgiastic mass-seizures that we must look for the mint which stamps upon the memory the expressive movements of the extreme transports of emotion, as far as they can be translated into gesture language, with such intensity that these engrams of the experience of suffering passion survive as a heritage stored in the memory. They become exemplars, determining the outline traced by the artist's hand as soon as maximal values of expressive movement desire to come to light in the artist's creative handiwork.[39]

And Benjamin, abandoning the orthodox Marxist position equating progress in history with technological advance, posited a theologically derived sense of history:

> To articulate the past historically does not mean to recognise it 'the way it really was' (Ranke). It means to seize hold of a memory as it flashes up at a moment of danger. Historical materialism wishes to retain that image of the past which unexpectedly appears to a man singled out by history at a moment of danger. The danger affects both the content of the tradition and its receivers. The same threat hangs over both: that of becoming a tool of the ruling classes. In every era the attempt must be made anew to wrest tradition away from a conformism that is about to overpower it. The Messiah comes not only as the Redeemer, he comes as the subduer of the Antichrist. Only that historian will have the gift of fanning the spark of hope in the past who is firmly convinced that even the dead will not be safe from the enemy if he wins. And that enemy has not ceased to be victorious.'[40]

The kind of 'homeomorphic' construction where unrelated events share a common theme, seen in *Juan de la Cruz*, and described by Robert Duncan as essential to his poetry, is mirrored in the montage construction of the pictures. They are visually analagous to Benjamin's constellations of ideas which refract the object to represent it as a rebus to be deciphered by the discerning eye in dialectical images. They are not narratives, nor are they historicist, but serve to demonstrate the life of history in the present on public and private levels. John Lynch describes how the historical figure of Rosa Luxemburg is martyred socialist, murdered Jew on the altar of German nationalism *and* Kitaj's grandmother. The constellation resists traditional aesthetics where every detail is subordinated to the organising totality, and instead gives detail specificity, and allows the object to be presented with all of its contradictions intact. Terry Eagleton described the 'act of constellating' as 'an idiosyncratic free-wheeling of the imagination which recalls the devious opportunism of the allegorist. Indeed at its worst the constellation would appear an unholy mixture of positivism … and whimsicality; … montages … to involve a fetishism of immediacy yoked to an arbitrary, undialectical subjectivism.'[41] The process is deliberately recapitulated by Kitaj in *The Autumn of Central Paris (after Walter Benjamin)*, 1972–73 (Plate 9). Dedicated to the writer, when it was first shown the picture was accompanied by a text clearly indebted to *Charles Baudelaire. A Lyric Poet in the Age of High Capitalism*.[42]

The influence of Benjamin was to persist and surfaced most clearly in the introduction to the catalogue *The Human Clay* where Kitaj makes extensive reference to Hannah Arendt's introduction to *Illuminations*:

> In Hannah Arendt's beautiful introduction to Benjamin, she likens that wonderful man to a pearl-diver who wrests what he can from the deep past, not to resuscitate the way it was and to contribute to the renewal of extinct ages, but because the rich and strange things he found in the deep 'suffer a sea-change' and survive in new form and shape. That is how I want to take human images to survive – as Arendt put it, 'as though they waited only for the pearl-diver who one day will come down to them and bring them up into the world of the living'.[43]

The position is complex, remaining open to at least some aspects of the avant-garde while salvaging the traditional. It is anti-historicist conjoining the contemporary with the archaic. In their different ways Peters Corbett and Peaker demonstrate how the work refuses autonomy and the primacy of the visual, and in so doing place the work at the centre of debates concerning the boundaries of the visual and the literary, the allegoric and the symbolic.

Warburg had attempted to measure distance from the classical tradition by the forms an image takes. Whether it might be a major work of art or a minor medallion would help determine the relationship of that particular present to the classical past. So it might be said that the revival of the iconographical scheme of the Pietà in paintings such as *The Murder of Rosa Luxemburg* rescues the image from devotional Catholic popular art. The image reasserts its status in the collective memory as a secularised image of sacrifice for a political cause. Just as, historically, it had been filtered through the lens of Enlightenment modernity by Benjamin West's *Death of Wolfe*, 1771, and Jacques-Louis David's *Death of Marat*, 1793. Armed with this renewed weight, and in combination with the biographical literature to which the artist refers, it is perhaps capable of placing Rosa Luxemburg's martyrdom back into a public realm from which it had been excluded by the cold war paranoia of the late 1950s and early 1960s.

The switch towards equally complex and allusive, but more compositionally coherent pictures, is exemplified in the transition from *Reflections on Violence*, 1962 to *Walter Lippmann*, 1966 (Plate 16). The latter was one of the first pictures to have an extensive text written by the artist, rather than a quotation acting as a parallel to the picture. Here the open debt to modernist abstraction conceiving of the canvas as a pictorial field is superceded by a treatment of space which is no less pictorial, successfully integrating photograph, film still and arcane Renaissance iconography. The picture abandons the modernist critical doctrine of the flatness of the picture plane, and instead manipulates spatial and stylistic conventions, playing *de sotto in su* off against passages of hard-edge abstraction and drawing, without attempting to present the viewer with an illusion or a coherent narrative. In this respect the treatment of the space has more in common with Picasso's late synthetic experiments and pictures such as *Minotauromachia*, 1936, or even *Guernica* of the following year. It is also comparable to early American modernist experiment, and one might look as easily to Patrick Henry Bruce or Stuart Davis. In different respects, the approach to the quotation of style had been anticipated by Marcel Duchamp and Richard Hamilton, but Kitaj is more resolutely tied to a cultural domain rather than the demotic ones of the readymade, advertising and the media.

Introduced by Eduardo Paolozzi to Chris Prater and the technique of screen-printing in 1963, he became one of the most prolific and experimental of the many artists associated with Prater's Kelpra Studio. Kitaj became deeply engaged with the medium despite its commercial origins and the highly technical nature of some aspects of its production. Eventually, as Pat Gilmour describes here, Kitaj gave the

elements of the print to Prater and his assistants with only written instructions for its execution. Technologically progressive, potentially democratising and relatively cheap, it had a number of advantages for the artist. He could work easily and effectively in series, developing and exploiting a theme by means of collage, a technique which does not require the effort of the sustained facture of the artist. Furthermore, the medium through its photo-lithographic processes has the facility to portray a literalism which is both traditional, in so far as it looks back to Harnett, Peto and Haberle, and avant-gardist in the modernist sense of being able to accommodate the found object and the readymade. In this the prints are more Duchamp than Picasso: they are literary, distanced, playful and ironic.

Often criticised for his literary tendencies, as James Aulich discusses, by the middle 1970s he had become the focus for a figurative revival in mainstream contemporary art in reaction to minimal, conceptual and performance forms. The compositions often appear at first glance to be whole and coherent, while still ascribing to an understanding of pictorial space within modernist convention in pictures instilled with a *bricollage* of associations. He also begins to focus more precisely on the creation of what the artist called characters in paint, visual analogues for fictional presences which he hoped would be as memorable as those from Charles Dickens or even Fyodor Dostoevsky. The attempt was embodied in a series of single-figure paintings beginning with *Batman*, 1972, and *Superman*, 1972, finding fullest immediate expression in *The Orientalist*, 1975–76, and *The Arabist (formerly Moresque)*, 1975–76. However, within contemporary structures of taste their authority is undermined by a pervasive decorative decadence reminiscent of Whistler and Klimt.

1975 saw a return to drawing, inspired by the contemporary example of Sandra Fisher and the historical one of Edgar Degas. He shared the return with Jim Dine. The association began with 'Dine/Kitaj: A Two Man Exhibition' at the Cincinnati Art Museum in 1973. Writing of Dine in the catalogue, Kitaj spoke of the 'art we grew up with', 'regional dialects', 'left-wing depression era dialects', 'forties dialect', 'the popular art published in *Life* and *Time*', 'Whitney Annual dialects' and 'the dialect of the big-city cafeteria life which still existed only twenty years ago'.[44] Both artists' 'Americanness' might be defined in relation to their attitudes to the facticity of the objects of their paintings – Dine with his tools, Kitaj with his books. By the end of the decade they had a substantial body of work made up of large-scale pastel drawings bearing a superficial resemblance to Degas's explorations into the medium.[45] In the context of postwar aesthetics the move was certainly a revisionist one, and the example of Degas was the most overt demonstration of self-conscious reference and quotation of the art of the past. His presence is continually asserted in *The Human Clay*[46] and was reinforced by another polemical exhibition, *The Artist's Eye*, organised by the artist in 1980 at the National Gallery.

Kitaj was looking for a way to reinvigorate the tradition of figurative art, and as he had done before he looked to pornography, an area which lies outside the

discourse of high cultural expression and, unrestricted by its boundaries, has the potential for experiment and innovation. These explorations led to a kind of coded elaboration of subject matter in sexually explicit pictures such as *Communist and Socialist*, 1976. As an image, the erect penis is an anarchic challenge to convention and a transgression of sexual taboos in the public sphere. Yet, it is also an appeal to a wider audience in an allegorical picture with a subject matter which has to do less with personal human desire than the pursuit of a romantic political utopianism. The pornographic might seem wilfully capricious, but is in character as it responds to a secretive, conspiratorial pictorial tradition. It has the attraction of an exclusive body of knowledge, and represents a shift from the recondite and the scholarly to the raw, prohibited and populist in the most anti-bourgeois of senses. Pornography has always attracted the unwanted attentions of the authorities, and in the case of art in England the hostility of the establishment. Pictures such as *His Hour*, 1975, *The Yellow Hat*, 1980, and *The Red Brassiere*, 1983, for example, address auto-eroticism from a voyeuristic point of view. This was offensive to a public rehearsed in the ideology of the family and was condemned as 'decadent' expressions of the experience of modern city life. But they are also illustrations of Duchamp's allegory for the modern condition found in *The Bride Stripped Bare by Her Bachelors, Even*, 1915–23.[47]

In the mid-1970s Kitaj was on record as perceiving the attempt to make art more accessible as a political act.[48] It was a comment perhaps more pertinent than the artist realised. Taking the representation of the body as a starting point for significant art, his investigations had taken him into the areas of human sexual activity, and particularly that of the prostitute. For Benjamin, the prostitute was the political allegory of modernity, of the relationship between human relationships and commodity exchange: 'The prostitute is the ur-form of the wage labourer, selling herself in order to survive. An objective emblem of capitalism, a hieroglyph of the true nature of social reality, exposing the true synthesis of the form of the commodity and its content.'[49] As a figure it was also an allegory for the artist as a purveyor of dreams and seller and commodity in one. The theme was treated most explicitly in the painting *Self-Portrait as Woman*, 1984 (Plate 12).

As part-time merchant seaman his first sexual experiences had been with prostitutes in encounters he has revisited in the paintings *The First Time (Havana, 1949)*, 1990, and *The Second Time (Vera Cruz, 1949), A Tale of Maritime Boulevards*, 1990. *Frankfurt Brothel*, 1976, was also born of autobiographical experience. Watching surreptitiously in the Frankfurt bar, La Sphinx, until noticed, Kitaj would go back to his hotel room and sketch from memory. As confessionals they are the memory of fleeting sexual encounters, not the life-long relationships found in his portraits. Frankfurt is a city famous for its legalised prostitution, proffering a sanitised world of sex as transaction, but inextricably linked to a darker world of drugs, crime and disease. The pictures run counter to feminism in art, and are in advance of feminist art-historical interpretations of Degas's *Laundresses* which describe their sexual undertow and

implicit betrayals of wider and gendered power relations in society. They also assert an anti-bourgeois sensibility comparable with Henry Miller, Ernest Hemingway and, latterly, Charles Bukowski.[50]

Frankfurt Brothel leads to *Sighs from Hell*, 1979. Benjamin had described modernity as the time of Hell, a configuration of repetition, novelty and death. In his critical analysis of William Burroughs, Eric Mottram wrote of the 'desires of private fantasy [which] have been able to seize power and realise themselves in public action as rarely before in history and have been rendered legitimate by a model of human nature and government as monstrous in its extreme versions as the concentration camp and the brothel'.[51] Hitler had identified the pimps in Frankfurt as Jews and condemned them as the perpetrators of a moral cancer in German society. What Hitler had failed to realise was that Jewish pimps were exploiting Jewish girls, and in doing so they had unwittingly aided the fascist cause: 'Brothel life … its hellish sighs at the heart of decaying cities, whose very streets would offer up victims to the death transports!'[52] The work would seem to place the Holocaust at the core of modernity; it is not presented as a peripheral aberration but is of its essence.

Janet Wolff (chapter 1) analyses Kitaj's growing engagement with Jewish identity during the decade 1975-85, and at this time there is a retrospective assertion of Jewishness in relation to pictures such as *The Murder of Rosa Luxemburg*, 1960 (Plate 8), *Isaac Babel Riding with Budyonny*, 1962, *Walter Lippmann*, 1966 (Plate 16), and *The Autumn of Central Paris (after Walter Benjamin)*,1972–73 (Plate 9), for example. Explicitly Jewish themes had first emerged in *If Not, Not*, 1975–76 (Plate 3), and *The Jewish School (Drawing a Golem)* (Figure 6), 1980, before reaching their most intense expression in the *Germania* and *Passion* series in and around 1985. In an interview with Timothy Hyman he spoke of memory, the fate of the European Jews, and the symbol of the Wandering Jew:

> Out of that maelstrom I've begun a meditation on historical *Remembrance* and its attendant senses of exile and survival. And now the agony of the Palestinian Diaspora confounds historical Jewish agonies and those two battered peoples embrace in deathly lock step. I intend to confront these impossible things in art some day, when I'm chased limping down a road looking at a burning city, I want the slight satisfaction that I couldn't make an art that didn't confess human frailty, fear, mediocrity, and the banality of evil as clear presence in art-life.[53]

The identification with modernism in exile, alienation and loneliness, combined with the portrayal of the artist as a kind of Jew, makes a nostalgic construction of the liberal democratic individual as someone who is sceptical of received opinion, and who protects their perceived freedoms from the intrusions of state and corporate orders. These are all found in the 1989 publication, *First Diasporist Manifesto*:

> And so I've come to make myself a tradition in the Diaspora, until I can think of a better place, where the terms of my own life have been staged. It is real American

rootless Jew, riddled with assimilationist secularism and Anglophiliac-Europist art mania, besieged by modernisms and their skeptical overflow, fearful at the prospect and state of Wandering, un-at-homeness, yet unable to give myself to Ohio or God or Israel or London or California. Like Kafka, I've never made a frank deposit into the Bank of Belief; not yet.[54]

Hilton Kramer described the manifesto as a 'quintessentially American document' belonging 'to the tradition of expatriate complaint and self-exculpation. In spirit, … it reminds one of Pound's *Cantos*. There is a similar, though smaller-scale, attempt to turn the accidents of autobiography, the fragments of eccentric learning, and the loneliness of the exile into a myth for the modern world.'[55]

Kitaj becomes preoccupied in the task of inventing an iconography of the Holocaust during this period. *The Jewish Rider*, 1984–85 (Plate 1), is generally held to be the most successful in this respect. It is a portrait of the art historian Michael Podro, it shows a man with a book – and therefore intellectual – alone in a railway carriage passing through a landscape with a chimney.[56] The chimney became the focus for most discussion, and it features in a large number of pictures from this period, most notably *The Painter (Cross and Chimney)*, 1984–85 (Plate 2), the series *Passion (1940–45)*, 1985,[57] and *Germania (The Tunnel)*, 1985 (Plate 4). The latter is a painting that Kitaj regards as one of his most difficult and it features the artist as a cripple with his family. The picture of the artist is none other than the outcast from the early part of the oeuvre. He embodies the 'myth of the modern world' of which Kramer speaks, but contained within that myth from the perspective of the second half of the century is the fate of European Jewry. As Deppner indicates below the perpetual encounters with the 'outsider' in innumerable guises is part of Kitaj's negotiation with the modern romantic myth of the artist. As such, it is a reassertion of one of the essential defining characteristics of modern art within the liberal humanist discourse of high art, to which Terry Atkinson (chapter 7) lays down a challenge. Kitaj's practice is a conscious act, it seeks to preserve the capacity of art to coin images capable of taking on a social function through the collective memory. The tunnel, or funnel, or corridor, becomes an image for a journey no longer able to support thoughts of exploration and adventure, rather they have become journeys of displacement to darkness and an uncertain fate. Kitaj notes in relation to *Germania (The Tunnel)*, 'The "way" to the gas has been given several names. I believe I saw "Tunnel" recorded somewhere. But subsequently, in Lanzmann's great film, *Shoah*, he presses an SS officer from Treblinka: "Can you describe this 'funnel' precisely? What was it like? How wide? How was it for the people in this 'funnel'?"[58] It is probably worth remarking on the relatively large number of pictures from this period which have a funnel-like composition, articulated in representations of alleys, corridors and passages: they all appear in *Sighs from Hell*, 1979; *Cecil Court, London WC2 (The Refugees)*, 1983–84 (Plate 13); *Drancy*, 1984–86 (Figure 10); *Bad Foot*, 1990–93; and *Bad Thoughts*, 1990–93. Kitaj mentions that the original idea for the image had come from literature or possibly documentary film. It has a life of its own as a functioning iconography and has

been very successfully adapted to architecture in Daniel Libeskind's Jewish Museum in Berlin.

The paintings in the 1980s take on a more expressionist and spontaneous look. They have a deliberate awkwardness to stave off the mawkish and the sentimental. A rounding on traditional themes such as the bather, revisited through the western, *Western Bathers*, 1993–94 (Plate 15), as easily as Titian's *Tempesta*, *Tempesta (River Thames)*, 1992–93, characterises the work. They have a painterliness reminiscent of what some have identified as a Jewishness in art found in Chaim Soutine and Oskar Kokoschka, for example. These references are complemented by those to Marc Chagall, particularly in the background of some of the later pictures. But in the end, the pictures of the 1990s seem to look more to American precedent. The artist even refers to George Bellows, for example, in *Whistler vs. Ruskin (Novella in Terre Verte, Yellow and Red)*, 1992, and indirectly in the painting *London, England, Bathers*, 1982, which in its gauche, demotic utopia is closer to Bellows's *42 Kids*, 1907, than it ever was to Cézanne.

In June 1994 Kitaj's long-awaited retrospective opened at the Tate Gallery, organised by Richard Morphet. The number of new paintings and their patina of expressivity in line, gesture and composition, which was unfamiliar to the critical establishment, attracted a great deal of adverse, and sometimes personal, criticism. Janet Wolff interprets the reaction within the context of a peculiar kind of British anti-semitism, and the exhibition was much better received in the United States.[59] In June 1995 Kitaj received the painting prize at the Venice Biennale amidst false accusations of nepotism.[60] While the artist wished that 'all the old stories might whisper once more', for a section of the viewing public many of the old favourites were absent from the exhibition. Nevertheless, in the paintings the emphasis on biography, interpreted through portraiture, history, literature and the history of art, was as sustained as it had ever been. The written texts for the catalogue followed the pattern clearly established in Marco Livingstone's 1985 monograph, and showed a tendency towards narrative explication, rather than the ostentatiously modernistic and allusive nature of the texts produced for *The Autumn of Central Paris (Walter Benjamin)*, for example. Many of the texts were retrospective and modified earlier, perhaps more poetic or even scholarly commentaries familiar from the first two one-man exhibitions.

Among the pictures on show and not seen in public before were two, in particular, which proved to be prophetic in the circumstances of the adverse critical reception. *Whistler vs. Ruskin (Novella in Terre Verte, Yellow and Red)*, 1992, re-enacts the bitter legal conflict between Whistler and Ruskin. They are depicted as two boxers in a version of 'Bellows, Dempsey and Firpo, at the Whitney'. Whistler, the eventual winner of the trial, is seen to be knocked from the ring as Dempsey, the eventual winner of the fight, was knocked from the ring.[61] In *Against Slander*, 1990–91 (Plate 7) the subject of the painting is not directly inspired by art, but by a book authored by 'a Jewish saint', Hafetz Hayim. Its title is translated as *Hold Your Tongue* and it was published 'At the very moment Cézanne was showing in the first

Impressionist exhibition'. It is associated by the artist with 'the slander (*lashon hara*), evil speech and defamation – all of which Cézanne was suffering'.[62] At the end of the century, Kitaj aligns himself as strongly as he ever did with the essential critical debates of modernism. Terry Atkinson maintains that modernist critical orthodoxies have lost their potency, in so far as so much art has shifted the terms of its engagements away from the specifically aesthetic, to identity politics and the nature of the art institution as a discursive practice on wider social and political levels. The point for Kitaj is that once torn from a liberal humanist practice art loses its currency in the collective memory, and with it, its capacity for coining memorable, meaningful images.

But the debate, as Janet Wolff articulates, was to take an altogether more personal and vitriolic turn with his exhibit *Sandra One / The Critic Kills*, 1996 (Plate 6) which occupied a wall at the Royal Academy Summer Exhibition in 1997. In 1994 his wife, Sandra Fisher, had died of an aneurysm at the height of what the artist called the 'Tate-War'. In conversation with Lucinda Bredin he said, 'Never ever believe an artist if he says he doesn't care what the critics write about him. Every artist cares. Those reviews of my show were by pathetic, sick, meagre hacks. They were about small lives and lousy marriages. They were after me, but they got Sandra instead.'[63] The work included a portrait of Sandra Fisher juxtaposed with stark and fragmentary, largely abstract panels, emblazoned with the words 'The Critic kills by Ron and Sandra'. The following year at the Royal Academy he exhibited another large polyptych, titled *Sandra Three – The Killer Critic* (Plate 5): sensitive portaits of Sandra Fisher and their son, Max, are linked to the most controversial panel, *The Killer-Critic Assassinated By His Widower, Even* which makes visual reference to *Against Slander*. The title is a play on Marcel Duchamp's *The Bride Stripped Bare by Her Bachelors, Even*. The painting is an act of catharsis and brings to bear all of his devices of compositional transformation within the snake-tongue curl of the words 'yellow press, yellow press, kill, kill, kill', and is based on Édouard Manet's *The Execution of the Emperor Maximillian of Mexico*, 1867. Literary reference and false trails are seen in the modified book-covers plastered to the surface of the canvas: 'In Praise of Folly', 'Dialogue with Death' and 'Men without Women'. American modernist masculinity is acted out and mediated rather than authentically experienced, an observation witnessed in the pointless ejaculations of the erect penises belonging to the portraits of Manet and Kitaj. Simultaneously, the vivid contrasts between expressive passion and careful drawing are inscribed in the (mis)quotation from T. S. Eliot, 'art is the escape ~~from~~* to* personality'.

The one most fundamental iconography for Kitaj is portraits of cultural and political figures, which as surrogate self-portraits simultaneously celebrate and challenge the stereotype of romantic individualism as one of the cornerstones of subjectivity in Western city life. This is combined with the celebration of the arcane and the marginal, the lost and the obscured, and it carries with it the determination to assert an anarchist, Left–liberal and humanist tradition. The oeuvre

has echoes of the socialist realist practice of dedicating pictures to authors in a celebration of their work in order to assert revolutionary and socialist histories.[64] So it is with Kitaj and his own kind of histories. The references to Spain discussed below by Simon Faulkner, at once redolent of heroic modernism and the American expatriate tradition of Ernest Hemingway, also speak of nostalgia for the possibilities of utopian socialism which were lost with the defeat of the Spanish Republic. By recalling the memories of the 'premature anti-fascism' of those Americans who fought in Spain, and by reasserting the cultural value of Soviet writers such as Isaac Babel, or political theorists such as Rosa Luxemburg, Kitaj struggles to reconstitute a particular kind of history which reclaims figures from the past and places them in antagonistic relationship to the icons of Western commercial popular culture. He tells us not so much of the heroism of individuals as their tragedy in the face of a wider European historical experience.

The books and histories extraneous to the pictures consistently prevent closure and refuse fixed meanings. Complex layers of support reveal deep anxieties. In the emulation of the modernist poets and certain aspects of late Surrealist practice, Kitaj engages with a repetition, a doing over again, which speaks for a relationship to the tradition and the world which is secondary and mediated, distanced and troubled. These buttresses of support secured from American art and letters, and central European scholarship of the interwar period, position Kitaj's work within a cultural field which owes a clear debt to traditions more thorough-going in many respects than the dominant formalism which he would wish to oppose. Nevertheless, the first two one-man exhibitions showed that his art was a gallery-based activity. In emulation of a museum installation the paintings were augmented by written notes, and displays of supplementary material in museum cases. Ironically, for this artist foremost amongst traditional figurative artists, the practice shares with conceptualism a mistrust of the purely optical.[65] Paradoxically, as Kitaj follows the trace of the pain and loss his artisitic commitment to history entails, he is caught in the situation of producing unique luxury objects for sale, legitimated by postmodern orthodoxies promulgating an undifferentiated continuum far from his own concerns.

It is hoped that the essays that follow in this volume will encourage the reader to consider, and even reconsider, the work of R. B. Kitaj in the light of the various readings offered. It is not part of the project of this collection to identify or narrate an 'authentic' Kitaj. Rather than presenting a unitary reading of 'Kitaj' there are multiple readings, some of which are, perhaps, incompatible with each other. The 'Kitaj' they are organised around is not Kitaj the 'individual' but Kitaj 'the producer of the works'; Kitaj names the space opened up within. This volume represents an attempt to address the work of R. B. Kitaj dialogically, that is we want to stimulate and engage in argument about the work and how it can be read and understood and to acknowledge its multiple-voiced nature.[66] In this sense the book's frame of reference is not one of an assertion of a singular originary impulse

that can be traced back and identified to anchor subsequent interpretations; rather, the motive is, as recent historians have asserted, to make such arguments as informed and open to counter-argument as possible.[67]

Art history has over recent years been subject to many theoretical and method-ological challenges, from the objects it studies to its very coherence as a discipline.[68] This volume reflects the impact of such challenges; and, we would argue, is stronger for it. What motivated us to begin the process of collecting the contribu-tions for the book was a desire to see Kitaj's work subject to a rigorous reading that went beyond the boundaries of biography and proclaimed artistic intention; these are made elsewhere.[69] Even with this in mind it is still effectively impossible to transcend the *desire* for biography as it seems impossible to write of the work pro-duced by Kitaj without recourse to biography as the key to interpretation. For the sake of analysis it is possible to identify three biographical contexts for the work that define most accounts of artistic production: authorial intention, author's life and social history. If each of these is considered in turn it is possible to see what presumptions and ideologies underpin their conceptual framework as they describe the work of Kitaj.

As part of his by now established practice, Kitaj produces a growing number of 'prefaces' to individual pictures. In the catalogue to his retrospective at the Tate Gallery in 1994, Kitaj produced a large number of these and they serve to provide for the viewer a map of influences, intentions and revealed meanings of individual pictures. Although Kitaj maintains that they are not in themselves explanations they have a privileged status on the scale of interpretative discourse given that they are made by the artist himself, who has also in this way become an author. But what can we say about such writings? They can provide clues as to individual icono-graphical detail – the figure here is based upon a friend, relation, historical char-acter – but the picture is much more than this. As the chapter by John Lynch explains, there may be private meanings to individual pictures but fundamentally they have a public life and the two realms are not necessarily compatible, which is not to imply that they should be. It is evident that Kitaj is motivated by a genuine desire to explain, to dispel the modernist myth of self-contained and self-present meaning. However, as already pointed out, given the status of the artist as the priv-ileged figure within the discourse of art it can be said that the consequence of this is an impression of a coherent and unified relationship between producer and cul-tural product that belies the actuality of the process. Not only may the public read-ing be contested but it is also the case, perhaps, that the private readings of the artist himself are actually self-contested. It is not necessarily the case that 'Kitaj' the person is known even to himself, as the discipline of psychoanalysis has shown, or a Marxist notion of ideology explores. What also has to be taken into consider-ation is the fact that, as the very name of the event suggests, such intentional accounts are produced retrospectively, long after the pictures themselves have entered the public discourse. One aspect, therefore, of such statements is the appearance of a fixing of meaning and a limiting of potential interpretation. Again,

it must be said that this is not something that can be, or should be avoided. But the cultural resonance of art objects is that they work seemingly to generate potentially infinite readings, and this volume is testament to the desire to rework once more the terrain mapped out by the work of the artist. Nevertheless, the notion of intention as it is generally presented, that is as cause, is clearly not sufficient to offer an open inquiry into the determinations of art in a wider social sense.[70]

The mainstay of the intentional account of the work of art is biography. The role of biography as the master-narrative in accounts of an author's cultural production is still predominant, if suffering the ravages of various theoretical challenges.[71] Biography is what is usually offered as the structure to the intentional act and it is from this that the picture gets its meaning. With Kitaj the centrality of biography is more obvious given his figurative style and overt historical references. It is used to help pin down the meaning of the painting. It is the key to 'unlocking' the intention behind the work and is usually offered as the connection which traverses the space between art object and spectator to allow for effective interpretation. But such narratives, for this is what they are, are not so straightforward as they are presented as being. Any biography is by necessity a process of selection, and that process is manifested in a written account within which events are ascribed significance on the basis of the end point of that narrative, its *telos*. Kitaj as a painter is unusual in that he has seemingly always relied upon writing to act as a supplement to the painting to the extent, as we shall see, that it is sometimes even included on the canvas.[72] In this way Kitaj has taken an active role in working to intervene into what is in many cases a passive relationship between spectator and art work. Faced with the sensation of vertigo from the unsecured and free-floating meanings generated by an art work we grasp at the biography of the artist to determine intention from which we postulate a 'truth'. In the case of some artists, such as Van Gogh and Jackson Pollock, the role of biography has come to play such a discernible role in popular readings of the work that what is visibly apparent is a mythology, an ideological process of mystification underpinned by the demands of the art market.[73] In this way all biographies are myths used to underpin a particular version of history.

The catalogue to the Kitaj retrospective at the Tate Gallery in London in 1994 is an example of a multifaceted presentation of biographical writing attempting to define an expressive and artistic presence, indicated by the title of the first essay by Richard Morphet: 'The Art of R. B. Kitaj: "To thine own self be true".'[74] Further in the catalogue is a 'Chronology'.[75] As a distillation of biographical detail it establishes the preferred reading of Kitaj and his work. Out of the incomprehensible and unarticulable range of possible events occurring since 1932, the year of Kitaj's birth, particular events are identified that are deemed to have affected Kitaj's development (for it is clearly presented as a singular process of becoming) up until the moment of the retrospective. For instance, in the entry for the first date, '1932', the significant event described is: 'Hitler attains power and "casts his shadow on parts of my life and art from year one".'[76] This entry is then followed

by a long series of accounts of other events, experiences and influences across the period of Kitaj's life. Such accounts do provide an interpretative framework of what can be seen to be important in relation to Kitaj's work as it is expressed by the artist. But it is also a procedure of selection and construction that, rather than declaring itself as such, does not acknowledge its processes. The problem is not that it relies upon biographical detail as elements of a historical narrative but that it presents these as singular, originary and unconsciously driven. It is not the case that art history can jettison biography, but it must be acknowledged that there is, in fact, a plurality of biographies and that the uses of a monographical narrative are limited.[77]

Once again it should be clear that what we are seeking to do is to open up the discussion to a wider scope of possibilities that exist in relation to Kitaj's work rather than attempting to confine it to a limited range. If the chronology mentioned above had been produced ten years previously perhaps the 'significant events' would be different from those selected for the 1994 retrospective; similarly if in ten years another chronology is produced it could again be very different. What this points to, then, is not a rejection of such accounts but the necessity for an awareness of their constructed and selective nature; it is the apparent naturalness and unproblematical presentation of such accounts that is mythologising and ideological.

An interview with Kitaj and his supporting 'prefaces' to individual pictures within the retrospective catalogue reinforce the primary role of biography in his accounts of his work. At the back of the catalogue there is a bibliography of writings by, and on, Kitaj but again this is given a further twist by the fact that what is available is a 'selective' version compiled in 'consultation with the artist', and the reader has to visit the Tate Gallery Library for the complete version.[78] The retrospective is once more writing the life of the artist.[79]

What we set out to do was to make the discourse of Kitaj far less fixed and secure than it had, arguably, become. This is not an attempt to replace what has gone before with another account but, on the contrary, to force open the space occupied by the work and to make it a realm of critical talk. In the same way that Paul de Man talks of the relationship between autobiography and fiction as one that does not resolve to either/or but is in fact an 'undecidable', so too do we see the work of Kitaj as occupying an undecidable space between private and public meaning.[80] We would seek to avoid the dangers of privileging either the authorial intention as the exclusive determinant of meaning or a sort of excessively semiotic celebration of the free-floating signifier.[81] But we are not arguing for a form of postmodern anti-foundationalism that perceives the art work as merely 'performative' in opposition to claims of meta-narrative theory. Agency is actually located historically, both in terms of production and in terms of the discursive context of its reception. The dialectical relationship between authors as agents working within the specificities of histories, meanings and social locations is what gives rise to the various accounts of Kitaj that follow. What we are seeking to do is to demystify those forms

of explication that smooth out and elide traces of time, history and difference by an appeal to the psycho-biographical motivation of the author, where the implicit assumption is a complete identity and unity between life and texts, as if they can be plotted out in parallel. It is our assertion that understanding the complexities of the particular works of Kitaj is not deepened by any putative link between psycho-biography and content unless it is as part of a wider and self-declared process of reading. What we urge, then, is a growing awareness in the reader of the resistances within the work of R. B. Kitaj to a kind of aesthetic idealisation that is presented as a transcending of history and politics in the name of a mystified organicism, whatever form that might take.

The essays that follow, in different ways, begin the process of tracing the interrelationships between the work and the histories under discussion. Simon Faulkner explores the relationships between Kitaj's art practice, as located within the changing strategies of painting in the early 1960s, and his attempts to engage with a tradition of political and historical subject matter, specifically the Spanish Civil War. Kitaj, like other artists of that moment, rejected a pure form of abstraction in favour of a declared flatness within which the motifs and figures were distributed across the canvas. What is significant in this process is that Kitaj chooses as the substance of his pictures elements copied from found material or the literal unmodified matter, that is, signs already in circulation, that become reworked and repositioned via the sensibility of Kitaj and his artistic subjectivity. Kitaj's keen sense of historical imagery and cultural memory is framed by his negotiation of the art practices of that moment. An interest in Left and anarchist romantic heroes feeds directly into a form of bohemian artistic identity that ultimately celebrates liberal individualism in the face of the postwar technological estrangement. What becomes evident throughout this engagement is a working on the space between the subject of the representation and its re-presentation as framed by the context of the painting; that which is remembered and the act of remembering itself generate a productive tension.

James Aulich considers the work of Kitaj in relation to the context of figurative painting in Britain as articulated in what became known as the School of London. Located firmly within a liberal humanist discourse the impulse behind the polemic was an attempt to salvage something from the perceived empty strategies of avant-garde practices with their denial of history and narrative, and the rejection of the traditional art object. Through the expressive struggle to reclaim, once more, an aesthetic of imagination and existential inter-subjectivity the return to painting and the human form was part of a wider 'revision' of the social role of art, most clearly articulated by the critic Peter Fuller. As Aulich makes clear, this is predicated upon is a notion of the work of art as repository of universal values and meaning, that is as part of the Tradition, accessible to an audience familiar with the artists' sensitivities and themes to which they can have unmediated access. Whilst clearly problematising such notions, Aulich argues that the relationship between the painters of the School of London and history and tradition is more complex

than it would appear at first glance, given that the material at hand is actually itself already mediated through a failed project.

Terry Atkinson, a practising artist himself, sees Kitaj's practice much more as a repetition of painting within the Tradition which is predicated upon a fetishised view of the very category of painting itself. Defining Kitaj as the 'paradigmatic modernist painter' with an attendant concern for the defining opposition of inner and outer meaning, Atkinson sees Kitaj's self-proclaimed position as premised upon an 'ancestor worship', in this sense a call for continuity directed at individuals and at painting itself. Atkinson goes on to contrast the practice of the Art & Language collective of around the same time, the second half of the 1960s, which shifted the centre of production from the studio (with its concomitant ideologies of private and solitary expression) to a collective and public space contingently located. Atkinson argues that Kitaj and most of those involved in Art & Language actually emerged into the same cultural milieu – 1960s London – having gone through similar institutions – art schools – but rapidly adopted quite opposite views on the potentials of a modernist conception of art and the artist. Art & Language, and Atkinson, had and have problems with precisely such notions as inner self, authenticity and the unconscious as repository of all this. In this way the question of Kitaj's practice is subject to quite critical scrutiny.

David Peters Corbett is interested in the relationship between word and image in Kitaj's work. As has been described above, Kitaj has always been an artist who has supplemented his paintings with textual accounts and readings. This raises the question of quite what role the visual actually plays. Does it, for instance, remain the space of the finally unknowable in the way that the very experience of history for its subjects is unknowable prior to its narrativisation? The distinction between the visual and the verbal is that the former reflects the relative chaos and uncertainty of lived experience as opposed to the latter which is inherently organising, ordered and coherent. Art history is therefore one attempt to reduce the visual to a coherent system of meaning that positions it as the precursor to textual explication. Kitaj's written supplementation is evidence of an attempt, worked through in the 1960s, to overcome the loss of faith in modernist art practice to deliver on its promise to provide the connection between image and experience. By the 1970s Kitaj has shifted significantly to the visual order as the bearer of historical knowledge, fundamentally that of the Holocaust. Nevertheless, even in 1994 Kitaj continues to rework the visual through the verbal in his series of prefaces, as though wanting to order the visual, when the resonance of the pictures is their continuous resistance to rational discourse.

In a similar way John Lynch is concerned to explore the relationship between visual and verbal in Kitaj's painting *The Murder of Rosa Luxemburg*, 1960 (Plate 8), where Kitaj has actually collaged onto the canvas a written account of Luxemburg's murder. By digging over the sedimented layers of discourse around Kitaj's painting Lynch considers what readings we can make of this image of the corpse of the Marxist Luxemburg and the relationship between the visual and written when

attempting a 'history painting'. Once again it is the space of the 'undecidable' as described above that refuses to allow for any easy location of meaning.

Walter Benjamin is someone who is continuously called upon in many of the essays in this volume and Giles Peaker has recourse to his work on allegory in his contribution. By mobilising allegory as a strategy for deciphering examples of Kitaj's painting it is possible to recognise the ways in which what is presented in the picture consists of different orders of presence and meaning, orders that can never be reconciled. The gap that exists between the materiality of the emblem and its articulation as sign is a space into which reading is drawn. Presented as a series of fragments, pulled together by an organising figure, the disjunctures produced become themselves further signs in a continuous cycle of interpretation. Through close analysis of two pictures, *Desk Murder* (formerly *The Third Department (A Teste Study)*), 1970–84 (Figure 12), and *The Autumn of Central Paris (after Walter Benjamin)*, 1972–73 (Plate 9), Peaker draws out what he sees as the implications of Kitaj's mobilising the allegorical as the dominant mode of representation for attempts to create an opening into a co-existent realm of history and present.

Janet Wolff's starting point is Kitaj's engagement with his Jewish identity from the 1970s onwards and the, by now, infamous critical reception of Kitaj's retrospective at the London Tate Gallery in 1994. Wolff sees Kitaj's engaging with signs of Jewish identity in a more complex and sophisticated way than just the negative sense of Holocaust imagery. One element of this engagement is Kitaj's use of extensive written texts to accompany paintings, one of the most problematic elements of Kitaj's practice for art critics. All this comes together in the sharply critical response to the retrospective. Wolff argues that there were three elements in the critical response in Britain to the show which come to light when it is contrasted to the response in America when it travelled there: an anti-literary sentiment in art criticism, a hangover of anti-American feeling, and a qualified but latent anti-semitism. It was precisely the combination of these three elements that produced the generally negative response to the retrospective. Issues around Kitaj's affirmation of a Jewish identity lead on to a discussion of the representations of women within his work and the relationship between this identity and the assertion of an excessive masculinity. For Wolff, Kitaj's use of exegetical supplementation to his paintings when understood as part of his expression of Jewish identity points not to a 'fixed' meaning, but to a reflective and contingent mobility of meaning.

Martin Roman Deppner also explores Kitaj's self-discovery of contemporary Jewish identity. Deppner argues that the discovery and artistic negotiation of Jewish identity for Kitaj results in a productive tension in his work as he engages in dialogue with the 'Other' culture of the Jewish Talmudic tradition. In a painting such as *If Not, Not*, 1975–76 (Plate 3), Deppner identifies a reflection on Jewish identity mediated through the cultural matrix of European art. The multidimensional references of the painting can be compared to Derrida's deconstructive project of tracing origins without resolution and of the irresolvable ambiguity of the

sign. In this way Deppner reads Kitaj's work through an engagement with a Talmudic practice of commentaries and responses.

Kitaj has sourced his imagery from a wide range of cultural locations and Alan Woods examines the relationship between Kitaj and cinema. Kitaj has always had a strong interest in film (he is now resident in Los Angeles where his son is a screenwriter) and the ways in which figures and spaces within the medium have become mythologised to the extent that they begin to create rather than reflect social consciousness. The differences between the modes of painting and film – one static, one continuously moving – make a direct translation untenable. But cinema is not just film but the whole range of Hollywood paraphernalia and imagery, from film stills to stars to posters, that provide the cultural reservoir of meaning for an audience's comprehension of what is happening on the screen in the darkened theatre.

Pat Gilmour discusses Kitaj's output of screenprints from the 1960s and 1970s. Kitaj has since this time come to be very dissatisfied with his screenprints and generally dismisses them as part of a 'Duchampian' phase, given their reliance on collage and a mechanical process of production that displaced the trace of the artist's gesture into the realm of technology. As Gilmour details, however, the prints are an incredibly rich and sophisticated product of the collaboration with the printer Chris Prater of Kelpra Studio.

All the essays in this anthology contribute to a more sophisticated understanding and analysis of the work of the artist and the links between its making and its cultural reception. In this way it is part of a continuous process of reading and re-reading the work of R. B. Kitaj.

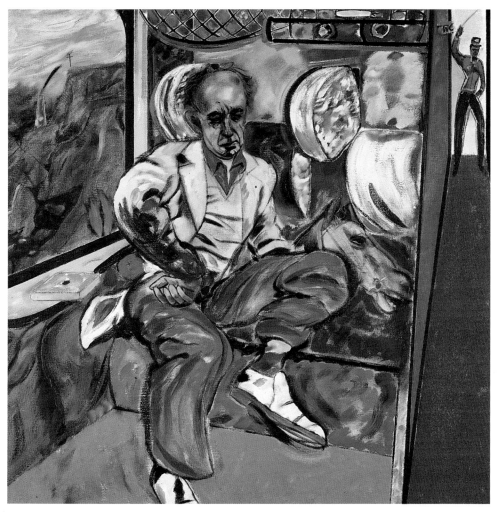

1 *The Jewish Rider*, 1984–85, oil on canvas, 152.4 x 152.4.

2 *The Painter* (*Cross and Chimney*), 1984–85, charcoal and pastel on paper, 78.1 x 111.1.

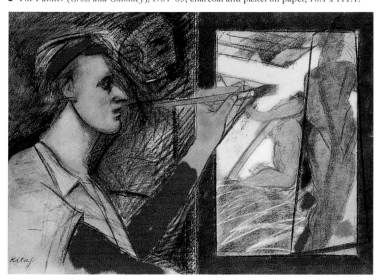

3 *If Not, Not*, 1975–76, oil on canvas, 152.4 x 152.4.

The impolite boarder:
'Diasporist' art and its critical response

Janet Wolff

R. B. Kitaj describes his portrait *The Jewish Rider*, 1984–85 (Plate 1) as a 'Diasporist painting'.[1] How are we to understand this notion of a Diasporist image? The artist himself is Jewish – an American Jewish artist who lived and worked in England for over thirty years.[2] The subject of his portrait is, as the title tells us, also Jewish. (In fact, it is the English art historian, Michael Podro.) But Kitaj has something else in mind, which is not just a matter of artist and subject. In his book, *First Diasporist Manifesto*, published a few years after he painted *The Jewish Rider*, he explains: 'A Diasporist picture is marked by Exile and its discontents as subtly and unclearly as pictures painted by women or homosexuals are marked by their inner exilic discontents.'[3] Elsewhere in the text he describes Diasporist work as 'instinctive paint-dramas of incertitude', mani-festing irreconcilable positions, difficulty, and indeterminacy of meaning.[4] He makes it clear that Jews are not the only Diasporists, but that he is interested himself in specifically Jewish Diasporism.

One obvious clue to the theme of Jewish Diasporism in *The Jewish Rider* is the chimney included in the top left of the picture, seen out of the train window. Kitaj, who became interested in Jewish identity in mid-career, in the 1970s,[5] has often included images related to the Holocaust in his work. The Auschwitz gatehouse appears in *If Not, Not*, 1975–76 (Plate 3).[6] The train, with its inevitable (contex-tual) reference to transport to the camps, appears not only in *The Jewish Rider* but also in *The Jew Etc. (First State)*, 1976 (Figure 5). The tunnel, passageway to the gas chambers, is represented in *Germania (The Tunnel)*, 1985 (Plate 4). The chim-ney is present in other works, too (the *Passion* series of 1985, for example, and also in *Germania (The Tunnel)*). Sometimes, as in *The Jewish Rider*, Kitaj juxtaposes the chimney with a crucifix, to register the equivalence (and, perhaps, the tragic his-torical opposition) between the two symbols. He has said that in his view it is the Holocaust which has destroyed Jewish assimilationism,[7] and speaks about the need for a post-Auschwitz art.[8] But does this mean that the definition of Jewish art is produced only in relation to the Holocaust? The more general question is whether

Jewish identity is constructed negatively, in terms of the oppression of the Jews (what Andrew Benjamin has called 'the logic of the synagogue'[9]), or whether there is not another, affirmative, basis for such an identity. Where Kitaj's use of the symbols of the chimney and the cross suggest the negative definition which has been the product of the representation of the Jew in Christian thought (the 'Other' of Christianity), further elements in his work allow a different reading, at the same time avoiding the artificial imposition of new symbols. Discussing another work,

5 *The Jew Etc. (First State)*, 1976, oil and charcoal on canvas, 152.4 x 131.9.

The Jew Etc. (First State), Benjamin explores the dual meaning of the train – as transport to the death camps (the negative definition of Jewish identity), and also as mobility (the Jew as wanderer). Of course, the wandering of the Jews has been, much of the time, the enforced response to persecution, and hence a characteristic produced in the negative. But the lack of fixity contained in the image of travel, which returns us to Kitaj's notion of Diaspora, exilic identity, and uncertainty, is the core of a different, affirmative conception of Jewishness. Andrew Benjamin, quoting Edmond Jabès, puts it like this: '"This absence of place, as it were, I claim. It confirms that the book is my only habitat, the first and also the final. Place of a vaster non-place where I live."' The wandering Jew, alluded to in these lines by Jabès, takes place within a process which in philosophical terms privileges becoming over being. It is this privilege that is captured, presented, by the train. It is thus that the train cannot be reduced to a simple image of the Holocaust'.[10]

The signs of Jewish identity in Kitaj's painting are more complex and more subtle than the Holocaust imagery which he self-consciously employs from time to time. They consist in the detail of physiognomy; the references to 'Joe Singer' (his archetypal Jew, modelled on a remembered figure from his childhood[11]); thematic references (the Jewish school, Yiddish theatre); and, of course, in the textual clues given in his titles and his unusually extensive written texts which accompany many of his paintings. It is these written texts which have proved highly problematic with regard to the response to Kitaj's work in England.

The astonishingly hostile reception by London critics to Kitaj's 1994 retrospective at the Tate Gallery has been widely commented on.[12] For the critic of the *Daily Telegraph*, 'by the 1980s Kitaj had lost all sense of direction'.[13] The *Independent Sunday Review* stated that 'at the Tate, canvas after canvas tells us one simple fact: no amount of exegesis will improve paintings that fail for pictorial reasons'.[14] Brian Sewell in the *Evening Standard* concluded a damning review with this sentence: 'A pox on fawning critics and curators for foisting on us as heroic master a vain painter puffed with amour propre, unworthy of a footnote in the history of figurative art.'[15] In the weekly edition of *The Independent*, Andrew Graham-Dixon wrote: 'Kitaj has finally allowed the myth of himself to be seen through. The Wandering Jew, the T. S. Eliot of painting? Kitaj turns out, instead, to be the Wizard of Oz: a small man with a megaphone held to his lips.'[16] As some of these comments indicate, a recurring objection to Kitaj's work was his dependence on literary sources, and his inclusion in the exhibition of wall texts ('Prefaces') referring to those sources. But Kitaj is surely not the only artist to work in this way. Moreover, a long-standing commitment to connecting the visual image with literary and philosophical figures and moments of inspiration did not prevent Kitaj from being elected to the Royal Academy in London in 1985 (the first American to be elected since Benjamin West in the eighteenth century and John Singer Sargent in the nineteenth), and from being granted an honorary doctorate at the Royal College of Art in London a few years later.[17] The reviews of the same exhibition in museums in Los Angeles and New York, to which it travelled after the

Tate Gallery, were quite different in tone (though not without some reservations), treating his work seriously and with respect, and in many cases finding a new maturity and development.[18] Kitaj himself has speculated on the anti-American and anti-Jewish sentiment behind the critical response in England, and it seems very likely that something other than objections to textual references explains the extraordinary viciousness of the attacks. One commentator reports the belief that 'the reviews reveal a culture clash between the reserved, self-deprecatory English and the open, Jewish-American sensibility'.[19] It may be not so much Kitaj's dependence on *words* which alienated the critics, but what he speaks *about*. Kitaj himself is on the right track when he refers to 'a form of low-octane English anti-Semitism'[20] (though his own more immoderate accusations since that 1994 statement increasingly abandoned the qualifier 'low-octane'). My own suggestion is that the critical response to the Tate retrospective makes sense in relation to the confluence of three separate, and normally unemphatic, English sentiments: a certain anti-literary prejudice in art criticism, a lingering anti-Americanism, and a persistent (though by no means pervasive) anti-semitism.[21]

Indeed, Kitaj's career in England up to the point of the 1994 retrospective had been indisputably successful. He settled in London in 1959, having studied for two years before that at the Ruskin School in Oxford. He had his first exhibition in 1963 at the Marlborough Gallery in London (and his first New York exhibition in 1965, at the Marlborough-Gerson Gallery); organised the important Hayward Gallery exhibition, *The Human Clay*, in 1976 (coining, for the occasion, the lasting term 'The School of London'); curated a National Gallery exhibition – *The Artist's Eye* – in 1980; and was awarded an honorary doctorate at the University of London in 1982. His election to the Royal Academy followed in 1985, and an honorary doctorate at the Royal College of Art, London, in 1991.[22] The critical response to his work was not, of course, always uniformly positive; a 1977 exhibition at the Marlborough Gallery in London met with a 'lukewarm' reception.[23] But he was invariably taken seriously, and accorded thoughtful, often highly positive, critical attention. This was so even though his preoccupation with literary and philosophical texts was manifest in his work well before the 1980s, for example in his major print edition, 'In Our Time: Covers for a Small Library After the Life for the Most Part', 1969, which consisted of fifty screenprints of book jackets, and the 1966–69 print series, 'First Series: Some Poets'.[24] There was, to be sure, some resistance in those earlier years to the incorporation of the literary into the work. For example, in 1981 John Ashbery wrote that Kitaj's tendency to 'introduce raw "literature" into his work … still shocks otherwise open-minded critics';[25] and a 1978 exhibition was criticised as 'bookish' and 'literary' by some.[26] Kitaj was well aware of this before the 1994 exhibition, as certain defensive comments in the catalogue interview make clear.[27] But this was all in the context of a fundamental respect for the work.

It is also worth noting Kitaj's continuing successes after the 1994 debacle. His international achievements since then include the Golden Lion award at the Venice

Biennale of 1995; an honorary doctorate at the College of Arts and Crafts, Oakland, California; a commission from the State Opera in Vienna for a portrait of Mahler.[28] He has also continued to be honoured in Britain (including, of course, by his inclusion as British representative in the Venice Biennale) – a doctorate of letters at the University of Durham; a commission of a portrait of President Bill Clinton for University College, Oxford; a major tapestry based on his painting *If Not, Not* for the British Library; and the choice in 1997 by the new Labour Heritage Minister, Chris Smith, of a Kitaj print for his office.[29] Perhaps most surprisingly, he also received the Charles Wollaston Award for his work, *Sandra Three – The Killer Critic* (Plate 5), shown at the Royal Academy in June 1997.[30] The fact that this piece, which served as ammunition in his post-1994 battle with the English art critics, was recognised in this way suggests a possible split between the critics and the art world itself, which continues to promote and display Kitaj's work (and, of course, to benefit financially from doing so), despite the ongoing escalation of rhetoric and abuse between Kitaj and his critics.

As is well known, Kitaj's reaction to the overwhelmingly hostile response to the London retrospective has been passionate and enraged. He has blamed the death of his wife, Sandra Fisher, on his critics – saying 'They tried to kill me and they got her instead.'[31] In *Sandra / Two*, a brochure published on the occasion of an exhibition of his work in Paris in 1996, he refers several times to 'Sandra's death under fire'.[32] *Sandra Three*, a multi-part work shown at the Royal Academy in 1997, followed his 1996 work (also shown at the Royal Academy), *Sandra One*, which included a painting entitled *The Critic Kills* (Plate 6). The central painting in *Sandra Three* is *The Killer-Critic Assassinated by his Widower, Even*, an image based on Manet's *Execution of Maximilian* and showing Kitaj and other artists firing at a monstrous 'critic'.[33] After this display of pain and anger, and several intemperate interviews, Kitaj left England permanently in September 1997, to settle in Los Angeles.[34] (Kitaj once said 'if I don't come to a rotten end, I think I'll live and die here, under English skies, where, like Jimmy Whistler at the end of his life, I hope, "I don't have a close enemy left in London"'.[35]) But his accusations of anti-semitism and anti-Americanism among his critics,[36] not surprisingly, provoked angry replies. The *Times* critic, A. A. Gill, referred to Kitaj's 'obscene and ludicrous accusation of anti-semitism'; Richard Cork to his 'overheated tactics'; William Packer to his 'increasingly absurd and self-destructive campaign against the critics'.[37] Waldemar Januszczak called *Sandra One* 'a piece of emotional blackmail'.[38] (He is also quoted as saying 'if Kitaj could not take criticism, he should live in Italy where he could pay critics to write "nice things"'.[39]) Richard Dorment, critic for the *Daily Telegraph*, even wondered whether to fear for his life, recalling that years earlier, when he had criticised Kitaj's work, Kitaj had sent him hate mail 'so frightening and threatening that my wife wondered whether we should turn the letters over to the police'.[40] Some critics remained calm, merely registering perplexity,[41] or making the sensible point that Kitaj's accusations of anti-semitism 'are as hard to refute as they are to prove'.[42] Although it is certainly true that there is no 'proof'

of anti-semitism, I want to suggest that the critical discourses in this mid-1990s episode in British art history can be situated and interpreted in the social and historical context of an anti-semitism which *has* been well documented.

I return to my claim that these events should be seen as the product of the convergence of three particular resistances in English art criticism. The first is the objection to literary tendencies in art. In an earlier context, critics in 1912 'were suspicious of the seemingly literary basis of Futurism'.[43] Similar points of view were part of the explanation of the difficulty many critics had with the radically new work of Pop artists and the Independent Group in the 1950s.[44] So Brian Sewell's comment (in the context of one of the more dismissive reviews of Kitaj's 1994 exhibition), that Kitaj is 'imprisoned by his library', could stand without elaboration in a context in which over-literariness is assumed to be a weakness.[45] Kitaj knew enough about this to adopt a position of bravado in this regard: 'I'm not afraid of the word "literary"', he stated in an interview in 1965.[46] And it is worth noting that a major commission in recent years has been the translation of his highly literary work, *If Not, Not*, into a tapestry to hang in the British Library – a work whose later accompanying text cites Eliot, Conrad, and Goethe.[47] But his earlier experience of critical dislike of the textual annotations did nothing to prepare him for the savage nature of the new attacks on them. Nor can these be explained by the undoubted xenophobic (and particularly anti-American) tendencies among some British intellectuals. Kitaj puts himself in the company of fellow sufferers from such anti-foreign sentiment – Whistler, Wilde, and Pound[48] – but what sounds like grandiosity and perhaps paranoia in his own often repeated charge is confirmed by other commentators with more distance from the matter. A British art historian, reflecting on the Kitaj case, says, 'I think there is some America-baiting here. It's the irritation of a little country that used to be a big country attacking an American upstart who seems to have it all: a big exhibition at the Tate where his work hangs next to Turner'; and historians and cultural critics have identified and analysed this political outlook.[49] Its manifestation in art criticism is not always indirect or disguised. Peter Fuller's editorial statement for the first (1988) issue of *Modern Painters* is quite explicit about the 'bankruptcy' of American art and the general worthlessness of contemporary European modernist and post modern work.[50]

And yet Kitaj had been working, and exhibiting, in England for over thirty years before the 1994 debacle. Perhaps the particular socio-cultural formation of the 1990s provided new reasons, and new licence, for a more hysterical and less guarded reaction to the vocal expression of difference.[51] That aside, though, what *was* different by the time of the 1994 retrospective was that this American, too literary artist had become increasingly vocal about his Jewishness. Only a minority of the works in the exhibition dealt with Jewish themes, but they are unavoidable – and emphasised in the Prefaces, which were written for the Tate show. Thus, the 1960 work, *The Murder of Rosa Luxemburg* (Plate 8), becomes inseparable from issues of Jewish history; *Desk Murder*, 1970-84 (Figure 12), an unpeopled display of

furniture and other objects, seen as if through the black frame of a window, is about an SS officer; the concentration camps are foregrounded as 'the second main theme' of *If Not, Not,* 1975–76 (Plate 3); *Self-Portrait as a Woman,* 1984 (Plate 12), is accompanied by a narrative in the voice of an Austrian woman who was Kitaj's lover in Vienna in 1951, and who had been in trouble with the Nazi regime earlier for having sex with another Jewish man. The works whose content was already explicit are sometimes elaborated in a text – for example, in the case of *The Jewish School (Drawing a Golem),* 1980, (Figure 6).[52] When asked in a 1994 interview when he became a 'Jewish artist', Kitaj replied, 'There's no straight answer to your question because I seem to have been tempted by Jewish themes as early as the late Fifties and early Sixties with pictures "about" Warburg, Babel, Rosa Luxemburg and so on, years before this obsession took hold in part of my consciousness.'[53] But it was with the publication of *First Diasporist Manifesto* in 1989 that the subtle allusions to Jewish themes, figures, and autobiographical moments gave way to a more

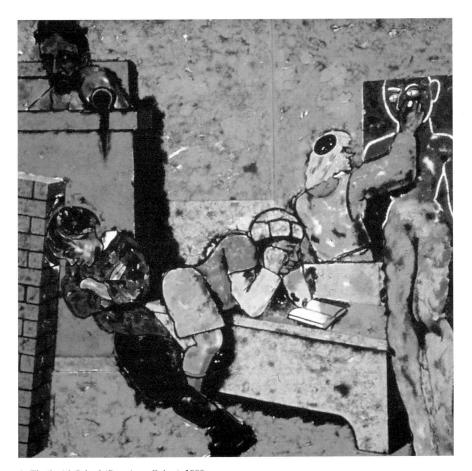

6 *The Jewish School (Drawing a Golem),* 1980.

vocal expression of interest and identity. To understand why this might provoke such a negative reaction, we need to consider the situation of Jews in Britain in the twentieth century.

The history of anti-semitism in Britain has been well documented, and its particular manifestation in the twentieth century, especially in response to the immigration of large numbers of Jews from Eastern Europe at the turn of the century, has been explored by many historians.[54] George Orwell reported, in 1945, that '[t]here is more anti-Semitism in England than we care to admit', quoting many anti-semitic remarks made to him by all types of people.[55] In this context, Jews in England have been accustomed to keeping a much lower profile than Jews in the United States. In the early twentieth century, Jewish identity was acceptable if Jews were committed to assimilation – to not being too 'loud' about their Jewishness. Jews already living in Britain colluded in this, particularly in relation to newly arrived Jews from Eastern Europe whose difference was, of course, highly visible. As is well known, the 1905 Aliens Act, designed to restrict immigration into the country, was directed primarily at Jews from Eastern Europe, at that time arriving in large numbers. More assimilated English Jews were keen to distance themselves from the newcomers, and were even involved in plans for their repatriation.[56] Anglo-Jewish artists in the early twentieth century were affected by this expectation of assimilation, which was problematic for those (like Mark Gertler and Jacob Kramer) whose work included Jewish themes.[57] A similar attitude prevailed among British Jews during the Second World War, in relation to refugees from Nazism, as Richard Bolchover has shown. At the extreme, '[T]he desire to be in keeping with the national spirit and to affirm their integration into British society led British Jews not only to frequent expressions of loyalty, but also to take what in retrospect appears to be an almost detached view of European Jewish life under Hitler.'[58]

The expectation in England that Jews will keep quiet about their Jewishness persists today. As A. Alvarez has said, 'Being Jewish in England is not quite polite. It's rather like dropping your 'h's when you speak.'[59] A controversy in London a few years ago, about whether or not a group of Orthodox Jews should be granted planning permission to erect posts around a six-and-a-half-square-mile *eruv* (a bounded geographical area within which Sabbath restrictions on carrying do not apply) has to be understood in the context of the unusual, and unwelcome, visibility of issues of Jewish identity in a culture in which the perfect guest blends politely into the landscape. As Calvin Trillin pointed out, reporting on this event for *The New Yorker*, 'English Jews ... have traditionally had to grapple with a problem that can be difficult for an American Jew to grasp: they are not English'. He repeats the observation of the South African Jewish novelist, Dan Jacobson, who lives in England, that 'English Jews felt that they had been given a room in the house but were not part of the family. They felt more like boarders.'[60] In the dispute about the *eruv*, perhaps unsurprisingly its opponents included many Jews, whose invisibility was threatened by the public discussion of the issue (though

there were also many secular and non-Orthodox Jews who opposed it for other reasons). Philip Roth has a devastating version of this imperative to hide in his novel, *The Counterlife*, in which the anti-semitic Sarah accosts her new (Jewish, American) brother-in-law – Roth's alter ego, Nathan Zuckerman:

> You laugh very quietly, I notice. You don't want to show too much. Is that because you're in England and not in New York? Is that because you don't want to be confused with the amusing Jews you depict in fiction? Why don't you just go ahead and show some teeth? Your books do – they're all teeth. You, however, keep very well hidden the Jewish paranoia which produces vituperation and the need to strike out – if only, of course, with all the Jewish 'jokes'. Why so refined in England and so coarse in *Carnovsky*? ... Don't worry about what the English will think, the English are too polite for pogroms.[61]

This cultural difference has been understood by some of the journalists reporting the Kitaj affair. The *Forward* (a New York based progressive Jewish newspaper) quotes the English critic David Cohen as saying of Kitaj, 'He's never acquired the English art of understatement ... They don't like the fact that he is a brash American Jewish name-dropper. But that doesn't mean they don't like Americans or Jews.'[62] The incitement to 'Englishness' and to assimilation and conformity need not be based specifically on anti-semitism, but the effect is the same – the necessity to hide difference. My suggestion is that the response to Kitaj's exhibition makes sense in this context. The hostility was not due simply to anti-semitism or anti-Americanism. Nor was the excess of literary reference and written text the real objection. Rather, it was a combination of all these elements. Kitaj articulated in an explicit (American?) way his deliberations about Jewish identity, compounding the lack of politeness by reinforcing the visual image with *words*. A complex and subtle visual text on this theme, like *If Not, Not*, may have been acceptable; the same work, accompanied by a wall panel directing such a reading, was not.

Lesley Hazelton, an English Jewish writer who lives in the United States, has also written about the English imperative to discretion about Jewishness (how it is important not to 'go on so about it').[63] She also cites Roth's portrayal in *The Counterlife*, and adds that her own unthinking immersion in the British silence meant that, 'It never occurred to me that there was no English Malamud, no Roth, no Bellow or Potok, no Jews who wrote about Jewish life', adding that if there had been, 'I wouldn't have wanted to know. Being Jewish was something to be played down, not written about.'[64] Hazelton's list of names renders unavoidable a consideration of a problematic characteristic of much of this writing, namely its tendency to misogyny (or at least androcentrism and/or the unsympathetic portrayal of women). Feminist literary critics have taken issue with Roth, Bellow, and other writers on this count, and since it has been an issue, too, in relation to Kitaj's work, I want to consider for a moment the possibility of a complex connection between the struggle for the assertion of Jewish identity in gentile culture and the aggressive

denigration of women in the process.[65] Kitaj himself has claimed to be a 'strong feminist',[66] but there is no doubt that many of his images – of prostitutes, of women 'naked for the men' (his own phrase, in the Preface to *The Ohio Gang* of 1964, Figure 1),[67] of views from the perspective of the male voyeur *(The Rise of Fascism* of 1979–80, Figure 7), of nude women with clothed men (*Where the Railroad Leaves the Sea* of 1964, Figure 8) – produce an uncomfortable viewing position for the woman spectator. In *Erie Shore,* 1966 (Figure 9), the bound and naked torso of a woman can be seen in a dinghy in which a man and woman enact some kind of encounter (both dressed, though the woman's pubic hair shows beneath her short skirt). *The Murder of Rosa Luxemburg,* 1960 (Plate 8), is graphic in its violence, and in this somewhat reminiscent of the *Lustmord* (sex murder) tradition in Weimar Germany. I don't want to overstate the misogynist tendencies of these images, and Kitaj has certainly made many beautiful and sympathetic portraits of women, including nudes (*Waiting*, 1975; *Marynka Smoking*, 1980; *The Hispanist (Nissa Torrents)*, 1977–78, and portraits of his daughter, Dominie, and his wife, Sandra Fisher). Nor is my objection to his interest in eroticism which, inevitably, is portrayed from the point of view of a heterosexual man. Nevertheless, I am suggesting that his images too often collude with the visual discourses of misogyny. Most striking, and also amusing in its literal disempowering of the female, is a 1967 print entitled *Vernissage-Cocktail,* a collage whose centrepiece is the famous 1951 photograph of the New York School painters, which Kitaj has cropped so that Hedda Sterne's head is cut off, leaving only her fourteen male colleagues. In his 1994 'Afterword', written on the publication of a book devoted to his prints, Kitaj does not even mention Sterne's radical elimination, and its evident insignificance to him increases its significance for the critical reader/viewer.[68]

7 *The Rise of Fascism,* 1979–80, pastel and oil on paper, 84.5 x 157.5.

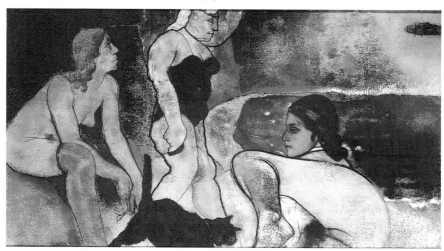

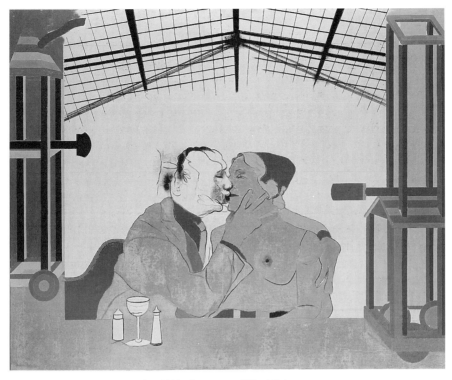

8 *Where the Railroad Leaves the Sea*, 1964, oil on canvas, 122 x 152.4.

9 *Erie Shore,* 1966, oil on canvas, 182.9 x 152.4.

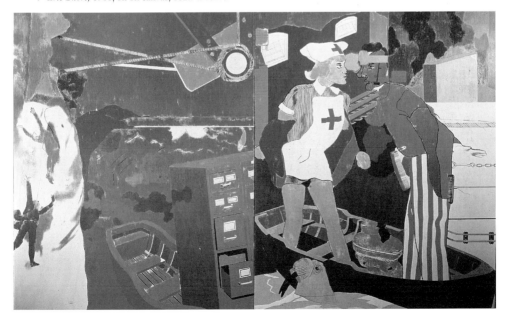

Like the 'Oriental', the Jewish male has been feminised in the discourses of the West.[69] As a number of writers have shown, the periodic crises in masculinity in Western culture have manifested themselves both in exaggerated homophobia and in the feminisation of non-European males.[70] For the feminised male, the struggle for masculinity (and heterosexuality) becomes imperative. Daniel Boyarin has explored this discursive production and its consequences for Jewish men in detail, through a discussion of the Talmud, Zionism, Freud, and many examples of contemporary Jewish culture.[71] His argument is that modernity, and the rise of masculinist heterosexuality in the late nineteenth century, required the invention of 'the modern Jewish man as an undoing of the tradition of the effeminate Jewish male', adding that '[t]he extent to which the heterosexualization of Jewish culture implied a loss for Jewish women has not been fully realized'.[72] Although little has been written about the implications of the modern imperative for Jewish men of the assertion of masculinity (and disavowal of homosexuality) for attitudes to women, it seems to me that the consequent energetic distantiation from the feminine which is involved cannot avoid a denigration of women. So cultural expressions of Jewish identity by male writers and artists in the twentieth century are likely to be assertively 'masculine' and implicitly (and sometimes explicitly) misogynistic. Such an account of Kitaj's imagery of gender deserves a more careful and subtle analysis, and here I can only suggest the possibility of such an approach. The critical issue in this context is whether it is somehow *in the nature* of the representation of contemporary Jewish identity by men to demean women, as a byproduct of the anxious assertion of heterosexual adequacy. It would be quite wrong to accuse Kitaj of a generalised masculinism and misogyny in his work, even in his 'diasporist' work; for example, the figure of Joe Singer, his archetypal Jew, is far more like the traditional 'feminine' scholarly Jew discussed by Boyarin than his conflicted twentieth-century counterpart (the typical Roth protagonist). The figure in *The Jewish Rider* (Plate 1) is equally legible as this non-macho type. But any discussion of diasporist, or Jewish, art must take account of the tendencies born of its own cultural construction. To put it simply: can the male 'Diasporist' artist in the late twentieth century confront and resolve his own gender anxieties and produce work which is not also a record of this particular struggle? The answer to this question is clearly affirmative, in the case of some of Kitaj's own work too. But here I will have to leave the issue of gender and diasporism, and conclude by returning to the more general question of what 'diasporist art' might be, and by suggesting that an alternative view, quite overlooked in the confrontation between Kitaj and his critics, can be derived from several of Kitaj's paintings and their relationship to Jewish identity.

I have argued that the critical response to Kitaj's 1994 Tate exhibition was a reaction to his vocal, and literary-verbal, expression of Jewish identity. Earlier, I discussed the question of 'Diasporist painting' in terms of the particular Jewish symbols, features, and themes visible in Kitaj's work. But, as several of his more reflective commentators have pointed out, the didactic, polemical aspects of his

work are more than matched by a central quality of provisionality. The meaning of Jewishness thus emerges more subtly, in the juxtapositions, absences, and contradictions of the images. Ken Johnson emphasises Kitaj's attempt to register 'the incoherence and instability of modern life', by both narrative and associative means, insisting even that the texts and wall labels (so condemned for their supposed fixing of meaning) 'do not fully decode the often-enigmatic iconography of the pictures; rather, they tend to add more layers of reference and poetic expression'.[73] In Norbert Lynton's view, Kitaj has always operated with the split inclinations to tell and to withhold, to be both polemical and obscure – a contradiction Lynton calls 'Kitaj's fork'. Despite the insistent presence of the wall texts, particularly in the 1994 Tate exhibition, Lynton finds that the paintings themselves consistently evade singular or simple meaning.[74] This perception of complexity, fragmentation, contradiction, obliqueness, and provisionality in the works is shared by other critics.[75] Kitaj himself approves this reading of his work, and relates it directly to his conception of Diasporist art:

> People are always saying the meanings in my pictures refuse to be fixed, to be settled, to be stable: *that's* Diasporism, which welcomes interesting, creative misreading … There is a traditional notion that the divine presence itself is in the Diaspora, and, over one shoulder, *Sefirot* (divine emanations and 'intelligences' according to Kabbalah) flash and ignite the canvas towards which I lean in my orthopedic backchair, while from my subconscious, from what can be summoned up from mind and nerve, and even after nature, other voices speak more loudly than the divines, in tongues learned in our wide Diaspora. These are the voices I mostly cleave to. Listen to them. They will tell you what a Diasporist has on his mind (Michelangelo said you paint with your mind) as he strokes his canvas.[76]

I think it is clear that we cannot talk about 'Diasporist art', or 'Jewish art', in terms of intrinsic content or particular style.[77] Rather, the features of a work which make it 'Jewish' will be a matter of the trace of experience in the text, a trace which is never immediate, but multiply mediated (by cultural meaning, aesthetic conventions, and other signifying practices). The focus on the Diasporist nature of Jewish life in Western society leads us to understand its expression in the very mobility and provisionality of specific representations. The dual meaning of the train, which I referred to at the beginning of this essay, is only a simple example of this. If we return to the painting *If Not, Not* (Plate 3) – a painting whose 1994 Preface is one of Kitaj's most elaborate – we can now see that not only does the text fail to 'fix' the image, or to provide a unified reading of the work; the painting itself, in the complexity of its imagery and the mysteriousness of its juxtapositions and allusions, resists summary. Its Diasporist nature cannot be equated with the Auschwitz gatehouse in the top left corner, since this is put in question by the inclusion, lower on the canvas, of the figure of Joe Singer, which imports a very different set of connotations of the Jew in Western culture.[78] In the case of the drawing entitled *Drancy*, 1984–86 (Figure 10), one of Kitaj's most compelling images, and also one

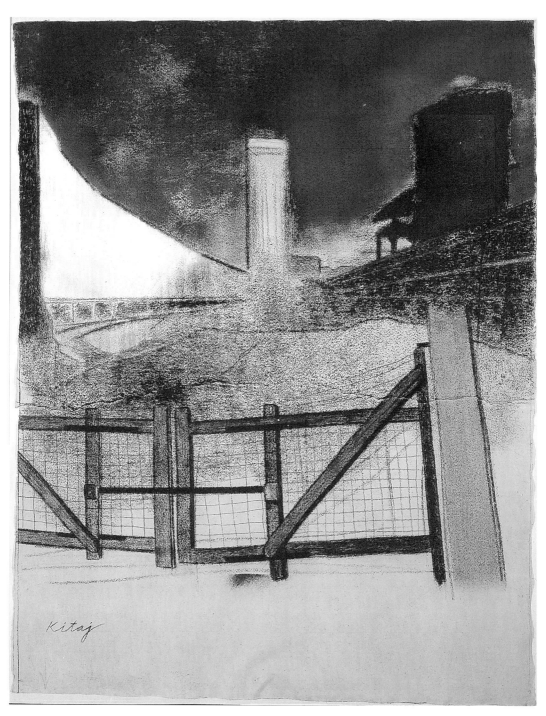

10 *Drancy*, 1984–86, pastel and charcoal on paper, 100.4 x 78.1.

of the less complex ones, it is only the title which insists on the work as a repre-
sentation of the Diasporist experience.[79] There is no polemic, no text, no question
of any visual or verbal bombardment of meaning. It is ironic, then, in the light of
the critical hysteria about Kitaj's 'megaphone' and his excessive 'exegesis', a reac-
tion which I have suggested has everything to do with Kitaj's expressed interest in
Jewish identity, that in fact the signs of Diasporism emerge in silence, mobilised
not by rhetoric or polemic, but by the play of images and their open-ended, and
often contradictory, connotations.

2

Authority and visual experience: word and image in R. B. Kitaj

David Peters Corbett

This is part of the ekphrastic Preface which R. B. Kitaj has written to his 1975–76 painting, *If Not, Not* (Plate 3):

> Two main strands come together in this picture. One is a certain allegiance to Eliot's *Waste Land* and its (largely unexplained) family of loose assemblage. Eliot used, in his turn, Conrad's *Heart of Darkness*, and the dying figures among the trees to the right of my canvas make similar use of Conrad's bodies strewn along the riverbank. Eliot said of his poem, 'To me it was only the relief of a personal and wholly insignificant grouse against life; it is just a piece of rhythmical grumbling'. So is my picture … but the grouse here has to do with what Winston Churchill called 'the greatest and most horrible crime ever committed in the whole history of the world' … the murder of the European Jews. That is the second main theme, presided over by the Auschwitz gatehouse. This theme coincides with that view of the Waste Land as an antechamber to hell … The general look of the picture was inspired by my first look at Giorgione's 'Tempesta' on a visit to Venice … My journal for this painting reports a train journey someone took from Budapest to Auschwitz to get a sense of what the doomed could see through the slats of their cattle cars ('beautiful, simply beautiful countryside') … I don't know who said it. Since then, I've read that Buchenwald was constructed on the very hill where Goethe often walked with Eckermann.[1]

Kitaj is a painter whose work from the first has been closely connected to verbal authority, that is to reference outside and beyond the visual object to principles of intellectual order embodied in the verbal structures of politics, history and literature. In the passage above Kitaj moves from Eliot and Conrad, through politics and one of the major, tragic, themes of twentieth-century history, via anecdote ('beautiful, simply beautiful') and a brief gesture towards the visual, and back to literature again. Kitaj calls this desire 'to write a preface, or … better term, epilogue, for many of my pictures', 'one of my animated manias'.[2]

But if Kitaj's ceaseless explication of, and commentary on, his own work sometimes seems as fundamental a part of it as the object itself, his art also seems aware of the complexities of signification which the word promises. *Secret Page* (c. 1963),

an early work, proposes that words conceal meanings which are there to be excavated if we wish, but also that the apparent clarity of words and images is misleading and that representation is not the same as truth.[3] This essay proposes to examine the relationship between word and image in Kitaj's work. It argues that the problem, for Kitaj, is finally how visual art can speak about the world of experience, about living through and within history, and that the solution he has arrived at in his work has been to stress the tension between the need for authority, understanding, all the mechanisms of the verbal as intellectual practice, and the resistance to that need which lived experience and the brutal facts of twentieth-century history propose. Kitaj's weaving together of textual and visual elements within his work allows him to articulate a balance between understanding and experience, to attempt to grant the lived moment of history its due without the necessity of betraying it into an ordering and rationalizing structure it does not possess. In pursuit of this aim Kitaj has struggled throughout his career to realize history and experience within the visual order of his art. The hard-won espousal of the capacity of visual art to achieve and communicate this apprehension of the world is an important element in Kitaj's career and in its interest for us.

I want to begin by defining the terms in which I am thinking about the relative capacity to apprehend the world of verbal and visual orders of knowledge. To do so I shall introduce a contrast Norman Bryson draws in an essay on Baron Gros's realism published in 1988. There, Bryson distinguishes between the ordering of the world as it is embodied in the verbal (for instance, in historiographical knowledge projects like that of art history), and the experience of events as they happen. In the first case, says Bryson, 'those who come later, as they look back' construct a 'global' account of the events they wish to record in which all traces, archival, material, or consequential, are reviewed and disciplined into a verbal order.[4] Characteristic of this activity is the reapprehension of the complexities of experience in the logic and coherence which organisation in language allows.[5] Verbal knowledge, of which historiography is only an example, orders and organizes the chaos of experience into a logical and progressive model of events. It appears to know its subject, but does so only by reinventing it in a form which it can understand. In contrast, 'for those inhabiting the social formation, as they inhabit it, such a panorama is exactly inaccessible' (78). When we are 'within the perspective of history as it is experienced, rather than as it might be posthumously reassembled' (79) we cannot see the neat and logical connections and apprehensions offered by subsequent forms of verbal knowledge: 'for those who live *in* history ... abstraction is clearly not possible. In the *durée* of history, all that is known directly is a local situation, one position only in the field of interactions, a point of knowledge hedged about by ignorance. Because this situation is actual and not recollected, because it is experienced in its passing and not experienced as the already-passed, this is necessarily a position of ignorance. Exactly because the experience is real, it is apprehended as a field in which some things are understood and others not' (78).

Once this distinction has been established, Bryson in the remainder of his essay sets out to identify and analyse an example of 'the mode of ignorance embodied in actual representations' (79). In looking at Gros's *The Plague-House at Jaffa* and *The Battlefield of Eylau* Bryson wishes to see competing iconographies within the paintings. *The Plague-House* promotes both a rationalistic heroism in Napoleon (touching the open tumours of his troops in order to allay the panic which the plague had sparked off) and an irrational narrative in which Napoleon appears as a supernatural, sacred, figure, Christ or Saint Roch. Such alternatives are not simply options. In the *Eylau*, the polarisation of the 'iconography of sacredness' and that of 'material death' (98) 'almost pulls the image apart' (99). The result is a painting of a 'dialectical openness ... so great as to produce a radically disjunctive text, an open text in which the synthesis of contradictory frames or voices seems impossible' (101). If we look at these paintings with the aim of explaining them, that is seeing past these disruptions and 'iconographic disturbances' (100) to some imagined unity of meaning, then we will erase the images' capacity to represent the unknowability of lived experience. The verbal construct of Art History will want 'to credit the image with a power, which it desires for itself, to reduce reality to a prospect that can be mastered ... a world which is constructed, elaborated, self-sufficient, reduced to significant contours and outlines – in a word, narrated' (100).

The distinction between word and image, the verbal and the visual, which Bryson proposes is the distinction between a form of knowledge which aspires to a smoothly comprehended world, ordered and organized, narrated through words as a logical and completed account of the events it describes, and a form of knowledge which is, in its dialectical capacity to hold disparate versions of the same material simultaneously in tension, able to represent the unknowableness of the world. These are paintings which 'come from a history lived out as a present riven with contradiction' (101). These two forms of understanding are not, and can never be, exclusive. We need in the end to acknowledge that both are implicated in our relationship to the visual. We will always, in accounting to ourselves for the power of visuality, translate it into the alien medium of words. But in order to confront it successfully, we need to acknowledge as well that the capacities and strategies of the visual are different from those of the verbal order. If verbal explanation is just that, the explanation of events, an ordered, hierarchised, and coherent imposition of meanings onto events, then visual representation may be able to reproduce for us the uncertainty, unknowableness and confusion of the lived experience of history.

R. B. Kitaj's ambitions as a painter were from an early stage to enter painting on the stage of history and make it meaningful as a register of experience and understanding.[6]

> I'm always keen to confound the very widespread idea among our art people that *nothing* matters but the damned *thing* itself and that this thing has to 'work', as if there could be any real agreement about what 'works' and what does not. Even artists I most admire, dear friends, really shy away from making connections between art and what may be called *the life*, one's life ... Not me.[7]

Kitaj's intention is to extend art into the world, to breach the boundaries which separate art and history and to allow the work of art to express or apprehend on our behalf the realities of experience.[8] Not only does this place him squarely within the tension between language and visuality which Bryson describes in his essay on Gros, but it also defines one of the central problems that Kitaj has taken on, how history, as well as the history of art – experience, that is, as well as fictionality – can take place in the painting. Certainly the history of painting provides plenty of examples of conscious connections between visual art and the circumstances of its time, but as James Aulich has suggested, for Kitaj the difficulty of making them is of particular intensity because he is confronted with a situation in which the understanding of those connections has broken down.

Aulich argues that for Kitaj, struggling to define a career as an artist in the late 1950s and early 1960s, this ambition to connect up the painting with the world, to express the experience of life in the picture, was threatened by the decline of belief in the power of art, and the lack of conviction in its universality, which came to dominate the intellectual climate of the postwar period.[9] There seemed, as Aulich implies, no clear way in which the visual object could mean and could assert its connection with the world. Located as he is in this 'postmodern' condition, Kitaj is 'only able to give expression to experience through mediatory procedures' such as those which the fragments of culture and tradition assembled by modernists like Pound and T. S. Eliot might offer, and he thus attempts 'to understand the present ... through its cultural representations'. Aulich sees the diversity and variety of the visual sources Kitaj draws upon, as well as the overt sources of his early catalogues and his comments and interviews throughout his career, as evidence of this.

In the conversations recorded by Julián Ríos in *Kitaj: Pictures and Conversations*, there is a discussion of Joe Singer and his appearances in the paintings in which, while Kitaj appears generally uncomfortable and unforthcoming, he does seem willing to espouse the well-established modernist position whereby art's fictionality is the precondition for its deeper truthfulness and its capacity to access and reveal the nature of history and the world. It is the transformation of history and its signs in the art work which paradoxically allows depiction to function effectively as a means of entry to that reality. For this reason Ríos sees that 'apart from History, with a capital H for horror, the history of art also intervenes in [Kitaj's] painting', and he instances the contorted figure of the protagonist in *Bad Faith (Riga), Joe Singer Taking Leave of his Fiancée*, 1980, where Singer's figure is modelled on Rodin's *L'Amour ou l'idole éternelle*.[10] This is established in the context of a discussion of *Riga* as part of 'an endless and sinister ... dance of death – the one of History'. Kitaj's reply conflates both: 'I paint in a library in which the history of art and other histories intervene every day in my painting.'[11]

Kitaj from the first had both visuality – 'the history of art', the repertoire of technical and executive possibilities which painting and drawing can offer, and which Jim Aulich sees as peculiarly apposite for an artist working self-consciously

at the end of modernism – and the persistent claims of history, the world and experience within it. Kitaj's self-imposed task, one ideally suited to the problems defined by Bryson, was to link both together, so that visual art could become the representation of history, of the experiences of the self and of others. The 'zone of silence', which Virginia Woolf identified at the heart of painting, accordingly needed for Kitaj to speak with its own, other, language of the events of the world and of history.[12] I want to suggest that it is possible to read Kitaj's subsequent career as a prolonged, engaged, struggle with how this might be brought about.

Iconography is one of the principle art-historical means of explaining the visual away and replacing it with a verbal simulacrum which stands in for its meanings. It substitutes the ordered and cogent explanation of the verbal for the visuality of the work and thus reduces the painting to a series of visual clues to verbal explanation. It provides for us, in fact, a means of ceasing to see the picture by replacing it with a complex of verbal signs and explications. In Bryson's terms it allows the verbal ordering of experience to take precedence over the visual rendering of its uncertainties and disjunctions. Iconography was an early enthusiasm of Kitaj's, and iconographical strategies and references abound in his first exhibited works. Kitaj had already begun to read Panofsky before he arrived at the Ruskin School in Oxford in 1958. He attended Edgar Wind's lectures there, and subsequently immersed himself in the *Journal of the Warburg and Courtauld Institutes*, the volumes of which he discovered in the Ashmolean.[13] When he moved on to the Royal College of Art the following year, Kitaj began to produce works which derived their subject matter directly from the *Journal*.[14]

Kitaj's subsequent comments on these early works have tended to stress the fantastic and surreal quality of the visual material discussed in the *Journal*'s iconographical studies, and thus to connect this interest with his involvement with Surrealism, a fascination which was already established when he arrived in Britain. Kitaj told Marco Livingstone that 'it was the *weirdness*, the unfamiliar ring of so much of the "art" they would use to illustrate their theses' that attracted him to the iconographers: 'if you were a young romantic like I was, having been drawn inexorably to modernist Surrealism and arcane Duchampism as a precocious teenager, these studies, with their fabulous visual models and sources in ancient engravings, broadsheets, emblem-books, incunabula, were like buried treasure!' But this connection is not the only one possible. As Kitaj told Livingstone, 'of course, there were, for me, ideological discoveries in those obscure readings ... It dawned on me that here were people who had spent their lives re-connecting pictures to the worlds from which they came.'[15] Although works like *Yamhill* and the related *Notes Towards a Definition of Nobody* (both 1961) take up the idea of the connections which pictures might make to the world by re-using the arcane medieval figure of Nobody – his mouth padlocked, and his body immobile, exhausted or passive – to define contemporary themes of political powerlessness or exile, Kitaj at this early stage of his career, distrusted the capacity of the image

to make that connection adequately by itself. Marco Livingstone has seen this part of his oeuvre as making use of the word 'in a way unparalleled in the work of his contemporaries'.[16] In practice Kitaj surrounds his visual art with a grid of textual matter to which he constantly and overtly refers.[17]

The notes Kitaj appended to the catalogue of his exhibition at the Marlborough-Gerson Gallery in New York in 1965 are typical of his strategies at this period. Kitaj often provides long paragraphs of explication for each image, and goes so far as to include epigraphs which imply a possible linkage or imagined connection between the use of verbal explanations of the iconography of his work and the work itself. These are two of them:

> Pound has always been intent to make a very clear demarcation between a symbol which in effect exhausts its references as opposed to a sign or mark which constantly renews its reference – Robert Creeley.

> It may be asked whether the interpretation of meanings apart from satisfying our intellectual curiosity also contributed to our enjoyment of works of art. I for one am inclined to maintain that it does. Modern psychology has taught us … that the senses have their own kind of reason. It may well be that the intellect has its own kind of joys – Panofsky.[18]

These passages suggest or sketch out a defence of Kitaj's practice of attaching texts or textual meanings to his images. Broadly, this defence seems to be that if art is to offer a rich meaning it must be intellectual – here in the sense of discursive and textual – rather than purely sensual or visual. This enables meaning in art to extend itself beyond the impoverishment of the symbol described in Robert Creeley's version of Pound. By aggregating to itself the materials of the verbal order, art as sensual mark can extend its own meanings towards a fuller reality than the purely visual or haptic can offer. Kitaj said as much in an essay entitled 'On Associating Texts with Paintings' which he published in 1964. 'Texts', he said there, 'may assert themselves in such a way that the work or works which they may have helped give rise to, becomes something splendid.'[19] In the essay Kitaj is very keen to use the possible 'association' of texts with paintings after they have passed from the painter's hands as a means of keeping the painting open, so that it remains unfinished, can potentially be reactivated at any time if the painter chooses to declare the relationship still in progress. 'A work may be given a title or a title may be changed (for better or for worse) long after the painter has given the work up in which case it may be said that he *hasn't* given the work up', so that '*he may be said to still be working on the painting*'.[20]

I believe that this is what Kitaj meant when he allowed Robert Creeley to speak of the extended relationship to meaning of the sign or mark. By associating the image with texts – including the texts generated by the artist, of which a title or a re-titling is one – the image becomes part of an extended network of signification and is thus connected to the worlds beyond itself: 'not after life but about life'.[21]

Like the re-use of the medieval figure of Nobody to define contemporary themes, and like Kitaj's praise of the iconographical scholars of the *Journal of the Warburg and Courtauld Institutes* for 're-connecting pictures to the worlds from which they came', the verbal becomes a means of bringing the visual into a relationship with the world of a sort that Kitaj wants to recognise. For my purposes here, I want to insist that this relationship is one which sees the verbal order of understanding as finally more important than the purely sensual order represented by the visual. The extended meanings of the visual work turn out to be the result of textual accumulations or revisions which take place not only literally outside the work but in fact at potentially huge geographical and physical distances.[22] What fascinates Kitaj about the prospect of retrospective naming is that nothing changes in the painting when it is done, but, nonetheless, some element in our understanding of the painting changes because of it. It is a fundamental observation about the relationship of words to images.

Nevertheless, the changes which are wrought here amount to a reduction of the status of the visual work itself. An alternative response to Kitaj's narrative of renaming would be to say that the titling of a picture is never fundamental to it, and that, give it whatever name you like, since it is certainly the fact that the painting itself is not altered by that act any change of name is otiose. While we spin our net of iconographical and other descriptions around the image we ignore the fundamental facts of its visuality, what Kitaj in these early writings seems to be thinking of as the sensuous aspects of the picture. Kitaj's early interest in iconography and in the association of texts and pictures would appear to be evidence of a position which is suspicious or uncertain about the status of the visual. It is as if the visual would not have a comprehensible or convincing meaning or status if it were not supported by the word, as if the form of knowledge and understanding offered by the visual were itself somehow less than properly visible if not given a colouration by the recognisable meaning which the verbal order of the word carries with it. Kitaj uses the word and its power – recognisable, present, acknowledged – to support and grant an extended meaning to his visual art. It becomes Creeley's 'sign or mark' around which recognisable and accepted meanings can accumulate. Kitaj at the start of his career is more convinced of the verbal as a form of knowledge about the world than he is of the capacity of the visual to understand and acknowledge the world.

I have already indicated that Kitaj's interest in the question of meaning and the relationship of words and images in contributing to it can be assigned to a fundamental concern to extend the range of visual art into the world. Hence his concern to make the iconographical creature conjured out of a scholar's essay on a medieval figure like Nobody resonate with modern themes in his paintings. In pursuing that ambition he was confronted very swiftly with the difficulties which the lapsing of the modernist belief in the power of art to comprehend and render the world brought with it. Kitaj had no immediately appropriate language to hand with

which to tackle the task that he set himself in his painting, and that language, as James Aulich argues, needed to be won out of the materials he did have access to. One consequence of this situation was the tendency in Kitaj's earliest works to reach out to the supporting discourse offered by the verbal order as a way of supporting the claims to analysis and understanding which the medium of paint itself offered to him. Unfortunately, this also meant that the verbal ended up with a more prominent position within his practice than was commensurate with the desire to make painting itself a convincing medium of knowledge. To this extent the visual in early Kitaj is weakened rather than strengthened by the admixture of imported textual authority with which he associates it. In this section I want to nuance this slightly rarefied and theoretical conclusion by looking closely at some of Kitaj's productions of this period. I argue that there is a powerful visuality in Kitaj's art which works in opposition to the verbal order which I have already identified. I then go on to consider the subsequent development of his painting under the impulse of the need to rescue the image from his early espousal of the word.

Kitaj's first powerful interest in the history of art was not in the arcane world of textual iconographic analysis, but in Surrealism. Kitaj is on record as celebrating the Surrealist achievement, and has recorded his love of iconographic interpretation as an outflow from his Surrealist interests. Whether or not one can trace substantial Surrealist influence in Kitaj's work, beyond the juxtaposition of unexpected objects and the montage effect of works like *Specimen Musings of a Democrat*, 1961, *Kennst du das Land?*, 1962 (Figure 34), or *The Ohio Gang*, 1964 (Figure 1), it remains the case that his interest in Surrealism issued mainly from the visual character of his paintings rather than from the textual materials associated with it. The aggregative and montage elements in his early paintings help to mark out a strong visual presence which goes a considerable way to offset the presence of the text. Quite often it is precisely the gap between the apparent explanation provided by the associated texts or references and the experience of looking at the painted or drawn object which is the most pungent and memorable result of encountering one of Kitaj's works. It is our inability to see in the visual surfaces and techniques of the paintings anything resembling the themes and concerns of the texts and claims (often confessional or seeming to proceed from similar verbal authority) which surround them.[23] 'Besotted since teenage years with Eliot and Pound and The Waste Land', Kitaj wrote about *Tarot Variations*, 1958 (Figure 11), 'Eliot inspired me ... to place images abreast (and later annotated), as if they were poetic lines on a page. Some few early modernist poets had arranged words to resemble pictures or designs and I began to think I could do the reverse for art: to lay down pictures as if they were poems to look at.'[24] But he goes on, 'my journal entries for this painting are lost and I can't remember what exactly stands for what, but Eliot claimed that characters and genders melt into each other in his poem, and anyway I have obviously departed to suit my own convenience'.[25] In this last sentence Kitaj quotes Eliot's 'Notes' to the poem, in which he acknowledges that he has 'obviously departed

11 *Tarot Variations*, 1958, oil on canvas, 109.2 x 86.

to suit my own convenience' from the precise details of the Tarot pack.[26] To this
degree there is some identity of theme between the image and its text, but to look
at the marked and worked-over surface of the painting in which very oblique ref-
erences to cards and to the Tarot compete with the immediately visually appre-
hensible articulation of the background and foreground is enough to scotch most
thoughts of Eliot's poem or its 'Notes'. *Tarot Variations* works as visual dialectic
on entirely visual things – the relationship between ground and surface, the dif-
ferences between drawing and painting, the effects of varied marks across a plane
– that Eliot's comments cannot touch. If we are to look at this painting effec-
tively, the textual aspects of its constitution can only occupy a peripheral or sec-
ondary arena for our attention. Its visuality strikes us first.

This is the case, too, with *The Ohio Gang* (Figure 1), described by Kitaj as a
'very late Surrealist picture' in which the 'freely associated depictive abstraction'
is allowed to grow outside the textual or verbal associations of its subject matter.[27]
Marco Livingstone has called this effect 'the organization of the picture in a seem-
ingly random scatter' which 'directs the eye not to any one image' but to the inter-
relationships promoted by the technique, obliging us to attend to what Kitaj called
the 'plural energies' of the composition.[28] It is precisely the interweaving visual
'energies' of *The Ohio Gang* which strike us and hold our attention, and this
authority of the visual is repeated in other works of the period. *Kennst du das Land?*
(Figure 34) assembles a conglomerate of materials in order to signify 'Spain' and
to comment on the persistence of fascism. In *Kennst du* the authoritarian or at least
militaristic images of the soldiers in the lower section of the canvas with its explic-
itly linked reference to political themes, is undercut by the visual montage which
occupies the top quarter. These montaged sections run a visual gamut between the
transcribed drawing after Goya which, particularly within the sexual interests of
Kitaj's work, serves as a sign about looking and its pleasures, via the decorative
realism of the bowl of fruit which doubles as a mask, to the presence of non-ref-
erential brush and pencil work. Under the pressure of this enforced division, this
distinction becomes visible within the painting. The snowy landscape and sky
resolve themselves into increasingly autonomous visual actors in the picture, par-
ticularly when the sky is opened out into active brush marks to the right hand side
of the canvas and is ruptured towards the left centre to reveal a disembodied
marching leg which serves, in a highly visual and cinematic way, to signify
militarism and fascism.

In all these works there is a dialectic in process between the verbal order of
meaning and reference and the visual order of the medium. *Kennst du* especially
raises that dialectic to an organising principle in the construction of the painting
itself. Continually the pictures set up a contrast between word and image. If in
Kennst du das Land? it is the verbal which refers out to the world and to experi-
ence most clearly (to the political aspects of the painting and to Spain), the visual
seems to struggle with that direct relationship and to refuse or counter it. These
early works are sites of the conflict between the visual and verbal fully as much

as they are moments of integration of the two media. The referencing out to the verbal as a mechanism for connecting the painting with the world and experience is called into question and made problematic by the re-emergence of the visual as an independent and non-verbal mode of analysis. This situation is further complicated by an apparent uncertainty about whether this is an adequate mode of analysis. The independence of the visual is ambiguous and it consequently takes up a combative or opposed position, both subservient to the verbal and continually contesting and denying its authority.

The tension in Kitaj's early works between the visual and verbal orders is the result of the recourse to verbal knowledge which Kitaj made under the pressure of the apparent inadequacy of the visual in postmodernity. While the ordering knowledge made available by the character of verbal explication serves as the final touchstone against which his works test themselves and on which they rely for meaning and authority, the visual elements in the paintings are in fact involved in a sort of revolt or repudiation of this situation. At the very moment when the visual seems to lean most heavily on the verbal for its viability, visuality is contesting the verbal mode of authority in the arena provided by the paintings themselves. That situation is discernable already in the early works of Kitaj's first productive period as a painter, and in the art of his mid-period Kitaj worked to achieve some accommodation with the visual as a form of knowledge about the world and experience. By the 1980s Kitaj had already decided that 'the iconographical business hasn't really interested me in the past ten years or so like it used to'.[29] This change of interests was partly provoked by Kitaj's acknowledgement of and prolonged confrontation with his Jewishness which, beginning in the early 1970s, caused him to revise many of his previously held ideas about the themes and techniques of his work.

For my purposes here Kitaj's growing interest in Jewishness and what he has called 'the vexing and … fascinating questions and arguments swirling around the notion of Jewish art' are important principally because Jewishness becomes the central example of experience for him, and the major connection to history (including History 'with a capital H for horror') which Kitaj can claim. Works such as *Drancy*, 1984–86 (Figure 10), *Self-Portrait as a Woman*, 1984 (Plate 12), and the 'Germania' series 1983–86 all make direct reference to the Holocaust and Kitaj has declared himself a 'diasporist artist' as an assertion of identity with the historical state of exile which defines the Jewish experience.[30] *Self-Portrait as a Woman* puts – literally puts – Kitaj in the place, and the body, of a woman he knew in the 1950s. During the Nazi years this woman was forced to parade naked through a suburb of Vienna shouting out that she had slept with a Jew and wearing a placard with the same message. In his textual Preface to the painting, in which he also ventriloquises the voice of the woman, Kitaj says of himself that 'he felt close enough to my humiliation to have put himself in my place as it were, to have put himself into the picture'.[31]

This identification with history and its conditions has led to some of Kitaj's most powerful and authoritative paintings, and these paintings have attempted to

understand the meanings of that experience through the visual itself. Works like *Self-Portrait as a Woman* and *If Not, Not* (Plate 3) expand the visual field which had been present in the earlier work towards an authority of presence which relies on visuality and its power as knowledge. The *Self-Portrait* surrounds the body of the Kitaj/woman with a varied regime of brushmarks and descriptive techniques calculated to define the painting as emphatically a depiction. Visuality in this work is very strong, and the options of representation are made quite explicit in the variety of techniques used to describe the body, from accomplished foreshortening to very loosely brushed description in the legs and feet and the non-naturalistic colour of the face. This is announced not as a direct view of an historical event, the 'damned *thing* itself', but as a reading of it, invested with the warmth of experience. It is an interpretation, a view, even a projection, onto the events, and this is declared and celebrated rather than claimed as the authentic voice of truth. Kitaj's insertion of his own being into the woman's suffering amounts to an interpellation through the visual, both historical and 'art historical', in order to announce a visual apprehension of the experience of history. Although the word is central to *Self-Portrait as a Woman*, paint itself is, literally, also shown to utter and mean. Visuality here has achieved a stronger presence than in Kitaj's earlier works.

Similarly, the varied visual incident of *If Not, Not* both sets itself against the textual narrative, with its connections to Eliot and Conrad on the one hand and to the Holocaust on the other, and works to generate a visual version of these meanings which relies confidently on its own capacity to signify. The painting, which Avram Kampf has perceptively described as 'a pastoral composition polluted by historical memories', works by montage-like combinations which vary paint surface, colour, incident and descriptive technique (as well as the character of what is described), integrating the painting through the compositional articulation of the whole.[32] Montage and the associative meanings which generate the images of sexuality, the legionnaires and the detritus scattered over the 'sea of mud' serve to present a confusion of experience which is visual in its essence.[33] Significantly, it is hard to see *If Not, Not* as a painting powerful enough to meet the demands of its subject matter. It has often been claimed that representation is inadequate to the task of reflecting upon or understanding the Holocaust.[34] But in this case the sense of the painting as a mnemonic, a roster of images and possibilities which might open up access to the horrors to which it refers, rather than as a means of representing directly the nature of what it deals with, might be seen as a strength or at least a consequence of a more robust or confident espousal of the potentials of visuality on Kitaj's part. We are not offered, either in the textual references to Conrad or *The Waste Land* or in the composition of the canvas itself, any sense of an ultimate, completed meaning. The visual character of the painting is allowed to reflect an incomplete experience. The theme of the Holocaust is in a sense Kitaj's repudiation of the promise which the word makes to us: that it will define our lives and experience for us, that it will render down the complexities of lived experience to an ordered and efficient mechanism of comprehension. Once Kitaj abandoned that

promise in relation to the horrors of the murder of the Jews, then he abandoned also the efficacy of language as a principle of authority to which the visual order of his paintings had to defer. This sense of the Holocaust as inexpressible in language is present too in the prolonged gestation and completion of *Desk Murder* (Figure 12) and the continuing incompletion of Kitaj's masterpiece on this theme, *The Jew Etc.*, 1976 (Figure 5), in which Joe Singer, the embodiment of exile, passes anxiously through the landscape of *If Not, Not*, solitary and cut off from the world and his experience except through the medium of sight.[35] Unfinishedness is the necessary condition of any attempt to understand and organize this material, which is by its nature too exorbitant to be appropriately communicated by completion. But there visuality – including the bleached colour and unemphatic surface of *The Jew Etc.* – composes that experience in ways that Bryson's distinction between experience and the verbal order of history can allow us to clarify. The resistance of the major events of twentieth-century history to comprehension through the word allows visuality in these works to strengthen its position as a medium of knowledge. While it is certainly not the case that Kitaj abandons connection to the verbal order, knowledge now is more confidently announced as available through the visuality of the works. Inheriting the Surrealist as well as the 'postmodern' uses of montage, Kitaj builds in the 'disjunctive' 'openness' of the visual which Bryson identifies in Gros as a central device of his paintings.

The colourism and deliberately disjointed compositions of later Kitajs such as *In the Sea*, 1993, or *Greenwich Village*, 1990-93, suggest that this new confidence in the mechanisms of visuality as dominant in the paintings survived this first encounter. In *If Not, Not* the composition is built up in part on the model of Giorgione's *Tempesta*, a painting which has had a continuing presence in Kitaj's work, forming the central compositional reference in the later work *Tempesta (River Thames)* of 1992–93. As a visual reference and influence its great advantage is that the meanings of the original are enigmatic and irretrievable. Giorgione's painting is resistant to verbal explication. No matter how much commentary it might generate, the significance of its visuality will never be exhausted or captured by the word. In *Tempesta (River Thames)* this aspect of the original is reproduced by the enormous plume of smoke pouring from the chimney across the river in Battersea – the scene of course of the highly visual and autonomous paintings of Whistler, who is also a reference here.[36] The smoke becomes the tempest, the storm itself, and captures the eye with the intensity and variation of its colouring and the descriptive lines, drawn with paint, which lie within it to convey the vitality and violence of its movement. This plume of tempest-smoke becomes the index of visuality in the painting, the sign of its own vitality and autonomy which directs it away from the word (it is barely mentioned in Kitaj's own extended ekphrastic commentary on the painting, however central it is to our visual experience).[37] In *If Not, Not*, the compositional patterns which derive from the Giorgione continue to introduce the same uncertainty and undecidablity of the visual order into the painting. Like the *Tempesta*, *If Not, Not* is finally a mystery, a sequence or montage of

imagery which words have a restricted capacity to explicate or to assign to a definite meaning. It becomes a compendium of images, the only sure linkage between which is the visual proximity and organisation which the bounded frame of the composition provides for them.[38]

On the evidence of the paintings and drawings of this mid-period it may not be too much to say that the essential technical question facing Kitaj during these years was how to make visual objects mean for themselves and not just as the outriders of the verbal ordering of past experience. In this project what Norman Bryson posits as the capacity of the visual to express the experience of the event (as opposed to language and history's capacity to order it retrospectively) becomes of central importance. Kitaj's work in these years strives towards the realisation of history within the visual, that is the experience of living through these events, history as experience rather than as retrospective ordering. The espousal of the possibilities of visuality as a form of apprehension of the world independent of verbal knowledge is a crucial moment in this struggle.

But the struggle is not resolved in Kitaj's work, and perhaps, by virtue of the nature of the relationship of words to images, it never can be. However much Kitaj gains in confidence about the visual in the latter part of his career, he nonetheless continues to produce extensive verbal explication as an intellectual crutch or principle of support for the painting. Kitaj's 1994 comment on the Prefaces to his paintings is a telling one.

> These are *not* explanations of the paintings, whose chastity and autonomy remain, if not pure as driven snow, then only somewhat shopworn like people are in real life. I only offer some remarks about some of my paintings because we all talk about real life all the time and I hope my paintings are little imitations of my life. Some paintings have resisted my advances so far and their quietude persists.[39]

A 'shopworn' autonomy is no autonomy at all. Kitaj's remark is helpful in that it allows us to see that his visuality takes on the mantle of reality (of 'real life') in his middle and later career, but that its status is far from absolute. He continues to insert it into a web of discourse the ultimate purpose of which is to ratify the ambitions and capabilities of painting. A context which, although it is intended to shore up the visual, continues at some level to undermine it. The best of Kitaj's works do succeed in broaching the experience of history as disorder for us through the visual. Painting is a form of knowledge and its opposition to the verbal and to the shallow ordering of the world in retrospect is something to be valued about it. Kitaj's work strives to realize these capacities of the visual, but however much the dialectic of his practice opens up space for that to happen, visuality never floats free. It is always, as in *Secret Page*, with which I began, at one with the opaque and problematic meanings of the word.

The Murder of Rosa Luxemburg: monuments, documents, meanings

John Lynch

It is characteristic of the unity of theory and practice in the life work of Rosa Luxemburg that the unity of victory and defeat, individual fate and total process is the main thread running through her theory and her life.

Georg Lukács, *History and Class Consciousness* (London), 1971, p. 43

[H]istory, in its traditional form, undertook to 'memorize' the monuments of the past, transform them into documents, and lend speech to those traces which, in themselves, are often not verbal, or which say in silence something other than what they actually say; in our time, history is that which transforms documents into monuments.

Michel Foucault, *The Archaeology of Knowledge* (London), 1992, p. 7

R. B. Kitaj's work *The Murder of Rosa Luxemburg* (Plate 8) is usually dated to 1960, sometimes to 1960–62, and it has been owned by the Tate Gallery since 1980. It was a work central to his first and widely praised solo exhibition at the Marlborough Gallery in London in 1963.[1] Critically acclaimed works from the beginning of an artist's career are interesting, not because they serve as mere starting points for a simple developmental narrative that identifies an essence evident in the early stage which is developed through to maturity, but because subsequent readings and interpretations develop into a discourse that is actually not quite so coherent. The texts are organised around and seemingly generated by the mythical figure of the artist but they can also be transformed in this process of organisation. When texts are placed in relation to each other the configuration offered becomes more significant than if they were considered separately as, through an ideological effect, they are seen to be part of a 'natural' category of thinking. In this essay I want to consider how this painting has been mobilised at different times in different ways that seem to offer quite disparate, and arguably incompatible, readings. I want to draw attention to the unconscious of this discourse and expose the way in which such conflict is elided. A central question is how far the meanings of a particular work depend upon the artist as

the privileged voice in this discursive process and whether what is offered by critics is actually an index of the changing discourse of the artist 'Kitaj' rather than a 'truer' or 'clearer' understanding of a work.

Described by Kitaj himself in the 1994 retrospective as rather 'graceless', the picture takes as its subject the murder of the revolutionary Marxist Rosa Luxemburg in 1919 in the aftermath of the failed uprising in Berlin by forces of counter-revolution acting in connivance with the Social Democratic government.[2] It is not just the subject of the painting that is interesting but the various strategies, evident in the picture, involved in the attempt to produce a painting of a political subject which opens up the pictorial space to questions of history and meaning. The painting works to draw attention to the ways in which an event can act as a locus around which revolve a series of accounts and historical narratives. Such narratives and accounts, however, do not necessarily co-exist peacefully but are mobilised to justify the interpretation advocated by any one party within the continuous contest of meaning that is the painting's discourse, which is not to argue for a form of cultural relativism but merely a recognition of the struggle that takes place over interpretation.[3] Part of the gracelessness of the picture, perhaps, is the visibility of the processes of construction and containment that for some are meant to remain effaced within an aestheticised realm.

The picture is dark both in visual tone and theme. A series of symbols and figures overlap and intrude on each other to produce a disconcerting feeling in the viewer who is forced to look for clues to establish a meaning. Figures are placed within outlines of other figures with no uniform sense of scale or perspective. A disfigured corpse occupies the central space of the picture, held by a female figure and resting on a bed of sharply pointed striations. An obelisk in a landscape setting also points up to the body and a pyramid monument floats alongside it. A wraith-like figure hovers in the space of the top left hand of the canvas; there is an outline of a vehicle seemingly driven by a male figure; and a statue of a female figure resides within the outline of a helmeted soldier suggested by the khaki and brown hues of clothing and infill. A handwritten note is collaged to the top right hand of the canvas, as is the title of the picture itself on marbled paper at the bottom left-hand, with much of the lower half of the painting left bare. The picture has a rough quality to it, seen in the intemperate brushstrokes and graphic style. Overall the style is suggestive of Abstract Expressionism and even Surrealism. The central figure in the picture is the corpse of Luxemburg. After her murder Luxemburg's body was thrown into the Landwehr Canal in Berlin from where it was not recovered for four months. What is presented, therefore, is not an idealised body, as, perhaps, in a typical homage to a revolutionary martyr, but one that has been distorted by the effects of decomposition and having been abandoned in fetid water. A partly obscured hand holds a phallus/gun with a dotted line tracing a path to the head of Luxemburg which presumably refers to the soldier's execution- shot but can also be read as a comment on aspects of gender and violence.[4] The outline of the figure in a vehicle and that of a helmeted soldier with a brown

shirt relate to the role of the military, the state organisations of legitimated vio-
lence, in this event. The lifeless body of Luxemburg is in stark contrast to the
female figure of German national identity as represented by Johannes Schilling for
the Niederwald monument, commemorating the establishment of the German
Reich in 1871, placed within the outline of the helmeted figure.[5] This opposition
works to highlight the rhetoric of nationalism that operates through its mytholo-
gising and its symbols, and its implication in the events surrounding the death of
Luxemburg, a dedicated internationalist, executed in the aftermath of the defeat
of a revolutionary uprising.

 The two other monuments depicted in the picture relate to Kitaj's quotation
from an illustrated article in *The Journal of the Warburg Institute* from 1938:
'Monuments to "Genius" in German Classicism' by Alfred Neumeyer.[6] The pyra-
mid is based on the proposed *Monument to Kant*, designed by Janus Ginelli, and
the obelisk is derived from the *Monument to Frederick the Great and His Generals*,
dated by Neumeyer to some time during the French Revolution, but also never
built. The use of these more abstracted forms as symbols, designed to be posi-
tioned in a picturesque setting, points to the attempt within one aspect of Romantic
philosophy to transcend the particulars of an individual and gain access to a realm
of pure Nature and Being. Kitaj's use of these second-order representations works
to set up a powerful and disturbing contrast between the abstracted and figurative
monuments to an imaginary concept of nation and greatness and the darker force
of state-organised violence which underpins it, to show how the former degener-
ates into the latter during the course of the twentieth century.

 The montage-like form of the picture with its lack of a single narrative and its
interplay of various signs offers a reading of an historic event which, at this point,
is not an attempt at defining a single moment of origin but rather a making visible
of a point of intersection of multiple discourses both personal and public. The
sense is one of fragmentation and decay, marked literally on the body of
Luxemburg which also functions metonymically as a sign of the ever present
potential for disaster which those symbols of greatness can resolve into. For
Luxemburg 'socialism or barbarism' was the stark choice facing the German and
European working class, and her death was a forewarning of what would befall
them and others. The pessimism inherent in such an account serves as a warning
against a complacent notion of history as natural evolutionary progress, as adhered
to by the social democrats in Germany at that time with their belief in the
inevitability of the decline of capitalism and concomitant, naive faith in parliamen-
tary politics. The problematising of such narratives points to the acknowledgement
of the potential disruption, and indeed irruption, posed by the specifics, positive
and negative, of the contingencies of what Trotsky called the 'inspired frenzy of
history'. What can be seen in the picture, therefore, is a complex array of signs that
give some sense of the contradictory impulses of unity and fragmentation that con-
tinuously operate within the realm of historical meaning. This is referred to in a
review of Kitaj's 1963 show where an enthusiastic critic observed that:

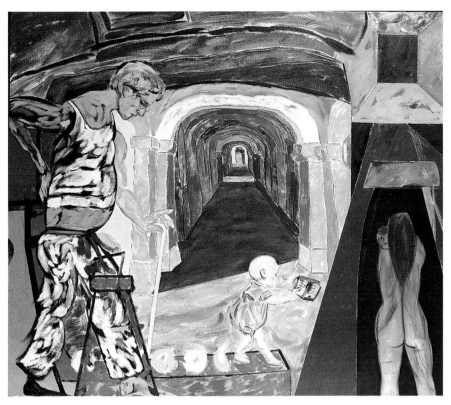

4 *Germania* (*The Tunnel*), 1985, oil on canvas, 183.2 x 214.

5 *Sandra Three – The Killer Critic*, 1997, photograph by Andrew Crowley.

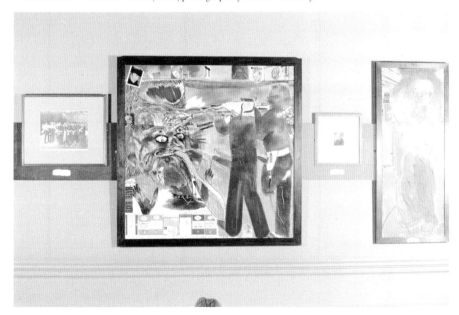

6 *Sandra One/The Critic Kills*, 1996, photograph by David Mansell.

7 *Against Slander*, 1990–91, oil on canvas, 152.4 x 152.4.

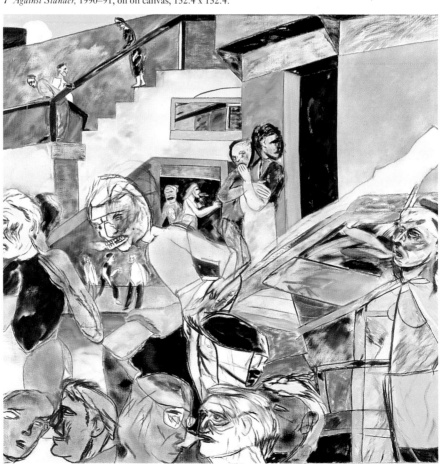

The concept of an immediately graspable formal unity has been abandoned. These [paintings] are the equivalent not of sonnets but of novels or – more nearly – of mediaeval chronicles. Of course there is an underlying unity of theme or inspiration (often deeply suppressed) but the end product has to be pored over, investigated and read like a map with many points of reference.[7]

The setting up in this way of the different monuments which positioned around the body of Luxemburg can be read as a critical commentary on the desire within the, by now dominant, bourgeois order to produce something that can transcend the particular and allow access to the universal, with a corresponding reflection on the terms of such an attempt. As Paul de Man describes it in his essay 'The Rhetoric of Temporality' the symbol is valorised over allegory because it is founded upon 'an intimate unity between the image that raises up before the senses and the supersensory totality that the image suggests'.[8] Within the picture, therefore, there is a rejection of the illusion of a single transcendental moment of unity that the symbol is positioned to offer. As John A. Walker observed in a show that featured the Kitaj painting: 'The painting is emphatically two-dimensional; its space, and therefore its time, are not singular and coherent.'[9]

Monuments to nationhood seek to hold in place an essential truth that speaks of the greatness of the culture and its dominant values. The process of historical commemoration, as Irit Rogoff observes in an essay on postwar German monuments, is driven by the attempt to overcome 'the replacement of an absence with a presence', whether that absence be the dead of war or a moment of defining historical identity.[10] But what this effects is an immediate emptying of the very force that originates within lived existence into a form of cultural reification. The utopian impulse, sensed in the blink of a moment of tantalising unity and experienced as a transitory instant of possible redemption, might be an anticipation of the not-yet-existing but it can only take form through that of the mediating material: at the moment it is fixed it ceases to be.[11]

Kitaj sets up an effective and illuminating tension by the juxtapositioning of the monuments and Luxemburg's body within the picture space. For the socialist tradition the distorting effect of Stalinism can be seen in precisely the discredited practice of erecting hagiographic statues to Marx, Lenin, Dzerzhinsky and others, many of which have since been destroyed by the very people whose being they were meant to express. Monuments in this way offer a particular temporality in that they are an expression of an attempt by the dominant order to suspend history at that moment with attention directed forever back and fixed in a recurring present rather than allowing a sense of a potential future.

To engage further with the question of history and temporality it would be useful at this point to consider the writings of Walter Benjamin. Benjamin, someone whom Kitaj would also later take up as a 'tragic hero', or 'heroic failure' as the artist would call him, addresses many of the questions of culture, memory and meaning that Aby Warburg, whose work was familiar to Kitaj, would seek to

address if in a rather different way with his concern for pictorial rather than literary representations.[12] As Richard Wolin points out, in Benjamin we can see the idea of history not simply as an empty movement from one point of transition to the next but rather as containing those unique moments of 'now-time' charged with emancipatory potential. It is precisely the role of the critic, or the historical materialist as Benjamin would later characterise it, to reclaim such points in history from the homogeneous, 'empty time' of unredeemed historical life.[13] Benjamin wrote in his 'Theses on the Philosophy of History' (1940), 'Thinking involves not only the flow of thoughts, but their arrest as well. Where thinking suddenly stops in a configuration pregnant with tensions, it gives that configuration a shock, by which it crystallizes it into a monad.'[14] This reflects his persistent rejection of the myth of automatic historical progress or, conversely, inevitable catastrophe. Susan Buck-Morss makes clear that, for Benjamin, myth and history are incompatible because myth reduces agency to the level of fate, whereas history implies the possibility of action and with it the responsibility of conscious agents to actually shape their own destiny.[15]

The elevation of symbols such as the monuments to nation and genius is precisely the emptying of history of that quality of significance which is, instead, filled with myth. Myth, in this way, is mobilised to position such symbols as the end point of a predetermined narrative of events and teleological development. The establishment of such mythic symbols is in part a response to the need for meaning in a realm of potential chaos but it actually works to invert the relationship between human actions and change. As Roland Barthes points out, it is part of an ideological act of draining history of the dialectical processes of human significance to leave behind the simplicity of essences, which at heart is actually an absence.[16]

The relationship between representation and experience can be considered in the light of the concept of allegory. Joe Shannon, in the exhibition catalogue for the 1981 retrospective of Kitaj's work at the Hirshhorn Museum in Washington, D. C., refers to the way in which Kitaj can be seen to mobilise imagery in an allegorical way that sets in train a series of readings generated by the culturally significant emblems taken as the subject matter of his pictures.[17] Informed by Craig Owens' essay from the journal *October* in which, via a particular reading of Benjamin, he proposes the allegorical impulse as the defining strategy of postmodern art, Shannon offers an interpretation of a series of works that span the course of Kitaj's career.[18] What allegory offers is a continuous process of reading that on one level is evident in all things but which can also be structurally foregrounded within a text to immediately allow the reader to engage with the semiosis inherent to it; its meaning becomes plural not singular. This manoeuvre brings me to one of the most critically important aspects of the painting, namely, the collaged handwritten text in the top right-hand corner of the canvas.

The full text reads:

... Rosa Luxemburg was led from the Hotel Eden by Lieutenant Vogel. Before the / door a trooper named Runge was waiting with orders from Lieutenant Vogel and Captain Horst von Pflug-Hartung to strike her to the ground with the butt of his / carbine. He smashed her skull with two blows and she was then lifted half-dead / into a waiting car, and accompanied by Lieutenant Vogel and a number of other / officers. One of them struck her on the head with the butt of his revolver, and / Lieutenant Vogel killed her with a shot in the head at point-blank range. The / car stopped at the Liechtenstein bridge over the Landwehr Canal, and her corpse was / then flung from the bridge into the water, from where it was not recovered until / the following May'/ (from Edward Fitzgerald's translation of Paul Frölich's 'Rosa Luxemburg' ... Left Book Club Edition, Victor Gollancz, 1940)/

The bust in the car window bears some resemblance to Field-Marshal Count von Moltke / a figure similar to the image at the left of this sheet surmounts the German national / monument, Niederwald, commemorating the foundation of the new German Empire / in 1871.

The Journal of the Warburg Institute, vol. II number 2, contains a paper by Alfred / Neumeyer called 'Monuments to "Genius" in German Classicism'. The monument at / the bottom left looks like a monument to Frederick the Great and / his Generals are seen in an aquatint used in illustration to Neumeyer's paper.

What this offers is a series of references that give some sense of where Kitaj's influences in the picture come from. His use of quotation brings together both history and art history and, with the appropriated imagery, draws attention to the ways in which our understanding of these events are always mediated through other accounts.[19] Frölich's account itself is based on newspaper reports and details of interviews with the perpetrators of the murder.[20] The collaged sheet seems to be pasted over the figure of the murderer who therefore becomes buried under the layers of historical discourse. Kitaj writes in 1992 that this is one of the last pictures that included collaged text and the general sense he gives of the work as a whole is more as a 'student' work.[21] Nevertheless the text is there and the question is what purpose it serves. On one hand it seems unnecessary as the title of the picture serves to define the event portrayed and is itself actually collaged onto the canvas. This seems to point, therefore, to an anxiety; an anxiety about wanting to pin down the meaning and possible readings of the picture. The account from Frölich serves to further this aim and could be argued to be an attempt to limit the potential semiosis generated by the picture. In terms of the rhetorical organisation of the picture the question is now: what is the relationship between the two elements of image and text? It would seem logical to assume that the image has priority over the textual account given the status of the object as a picture and that therefore the text works merely as a supplement to the images on the canvas. Just such a relationship is, of course, central to a notion of deconstruction, where at some point the attempt to produce a unified and coherent sense actually breaks down under the weight of the very inner logic of the text.[22] As Christopher Norris describes it such an approach seeks to identify some crucial opposition within the text, to establish that there is a hierarchy between the terms with one of them

conceived as supplementary to the other but which, in fact, can actually be invert-
ed with the supplement assuming a kind of 'logical priority', and that this unsta-
ble relationship is evident throughout the work.[23] With respect to the Kitaj picture
and the relationship between the two orders of representation, what is offered by
the Frölich account is an 'optional extra' but one that at the same time is neces-
sary to overcome a perceived lack within the work – the lack being history in a his-
tory painting. This can be seen in the view expressed by Michael Podro in 1979
on Kitaj's attempt in that first show to resist the aestheticisation of his painting:

> Painting is unlike literature because language can be part of political action and at the
> same time saturated with complicated meaning. And the poet or historian can retrace
> the action through the language. But painting and the historical facts never engage
> each other so easily. And for Kitaj there was neither a socially or morally charged
> imagery which he could take for granted and deploy, nor a range of factual reference
> which he could assume his spectator could take for granted and draw upon.[24]

What becomes evident, then, is a compulsive return by Kitaj to the picture to
attempt to overcome this gap between the different systems of signification.

Kitaj maintains that even when a picture is seemingly completed in the studio
it has a life after this and that he wishes to continue to have a 'dialogue' with the
work and to keep the question of 'finishing' a painting open.[25] This relationship,
however, is one that poses a number of difficulties. It immediately raises the
question as to whether it is right to privilege the author's voice over others once
the work has been exhibited and therefore becomes part of a subsequent public
discourse. Given Barthes observation that 'The birth of the reader must be at the
cost of the death of the Author', it could be argued that the flip side of the lib-
eral urge to explain is an (author)itarian impulse to maintain control of what is
fundamentally a public exchange.[26] Kitaj positions himself as the cultural medi-
ator in this process of negotiation that seems to extend beyond the boundaries of
the canvas. His agenda would appear to be that of the liberal humanist, asserting
the values of individualism in the face of late capitalism. This can be seen in the
way in which the textual account from Frölich is handwritten, as is the title of
the picture on the canvas, which points to the central idea of the autographic
trace as revealing the presence of the author.[27] Yet, paradoxically, the writing,
whether account or signature, marks the empirical absence of the signer and
points to the otherness actually within it.[28]

In the catalogue to the 1963 exhibition, *Pictures with Commentary: Pictures with-
out Commentary*, Kitaj includes an essay by A. R. Orage,: 'Sorel, Marx and the
Drama', and a fairly substantial bibliography. Displayed next to the canvas on the
walls of the gallery and in the catalogue are further 'footnotes' to the Luxemburg
picture:

> The prophetic murder of the remarkable woman Harold Laski called one of the
> greatest Socialist thinkers of our time is described in hand-written notes which occur
> in the upper right-hand corner of the painting.

The profile in the car window bears some resemblance to Field-Marshall Count von Moltke.

Rosa Luxemburg. Her Life and Work, P. Frölich. London 1940
Rosa Luxemburg, Tony Cliff. London 1959
Letters From Prison. Rosa Luxemburg, London 1946
Monuments to 'genius' in German Classicism. A. Neumeyer, (*Journal of the Warburg Institute*, 11, 2, 1938)

To display an explanatory bibliography consisting of a biography of Luxemburg, a critical introduction to the politics of Luxemburg by a leading member of the Trotskyist Socialist Review Group, Luxemburg's prison letters and the Neumeyer article points towards the framing of the subject by a fundamentally political reading. This can be considered in the light of other strategies Kitaj employs in the show including exhibiting a large photograph of the Spanish anarchist Durruti in the window of the gallery by way of an advertisement for the exhibition, an exhibition actually located in a fashionable and thoroughly bourgeois part of London. However, it is clear that Kitaj never claimed any commitment to organised Left politics and such staging is rather more illustrative of Kitaj's involvement with the generation of young artists connected with the Royal College of Art and the general sentiment of the early 1960s as a period of social turmoil which Pop art responded to.[29]

By 1982, in a statement provided for the Tate Gallery, Kitaj offers a reading of the picture that is a personal account, one now motivated by a negotiation of his own family history:

The picture arose out of a mediation upon two of my grandmothers ... It is about an historic murder but it is really about murdering Jews, which is what brought my grandmothers to America. One of them, Rose, left Russia because her Ukrainian neighbours regularly liked to kill Jews around the turn of our century. The other grandmother, Helene, left Vienna 40 years later because the Austrians were becoming expert at killing Jews and, in fact, Helene's two sisters (like Kafka's two sisters) were later murdered at Theresienstadt.[30]

This then explains the two other female figures in the picture, the figure holding the corpse of Luxemburg and the wraith in the top left. Clearly any such revelation adds another layer to the painting and is an entirely legitimate explanation which allows for a further iconographical deciphering of the picture on the part of the viewer. What could effectively be set up is an interesting exploration of the negotiation between public and private meanings that shift and slide across the surface of the picture and echoes the structure of the picture itself with the jump from one association to another. But this is not as straightforward as it might seem given the compulsive attempts by Kitaj to actually block off this process. When in 1994 Kitaj states in the Preface to the picture for the retrospective exhibition and catalogue, 'It is about an historic murder, but it is really about murdering Jews',[31] I

would argue that Kitaj is not pointing to the instability inherent in meaning and
reading as it shifts from one register (public) to another (private) but is wanting to
deny one side of this relationship and advance the other; in effect to reverse the
hierarchy he worked so hard to establish in 1963.

This latter account does fit with one narrative of artistic development, as Kitaj
became concerned throughout the 1970s and 1980s with an explicit exploration of
contemporary Jewish identity which Andrew Benjamin, amongst others, has writ-
ten about.[32] However, I want to question whether such an interpretation can be
retrospectively applied to the Luxemburg picture as evidence of some unconscious
engagement with Jewish identity. What has to be considered as an issue is whether
there are limits to this process of reading, which whilst not necessarily singular
does not therefore have to be infinite. On one level anything can mean anything
but in terms of an historicised social discourse interpretation is implicated in an
ideological struggle over meaning and action.[33]

Carol Salus offers an interpretation of the picture from the perspective of
Kitaj's negotiation of Jewishness and anti-semitism. Salus's starting point main-
tains that:

> The following study of his *The Murder of Rosa Luxemburg* will demonstrate how
> Kitaj examined the plight of Rosa Luxemburg (1871–1919) and cast it in a distinct-
> ly anti-Semitic context. The Holocaust, in particular, emerges as a major factor in
> the formulation of this painting.[34]

Salus relies on Kitaj's 1982 statement to the Tate Gallery as the basis for her jus-
tification of this viewpoint. Pointing to Kitaj's reference to how his use of the pyra-
mid form of the proposed monument in the Luxemburg picture echoes certain
'pyramidal monuments' created in some Jewish cemeteries after the war, Salus
states:

> Thus, Rosa's death becomes intertwined with victims of anti-Semitism in all ages.
> Although her death occurred before the rise of Hitler and the erection of the 'grave-
> stone facades' in Eastern Europe, Kitaj's imaged, collaged and written designations
> enabled him to regard Rosa as a universal victim of anti-Semitism, even a Holocaust
> victim, an historical event which occurred after her death.[35]

I want to consider this for a moment. Firstly, Rosa Luxemburg was Jewish and, no
matter how unimportant she might have considered this, for some it would have
been enough to condemn her.[36] To argue that Luxemburg was regarded by Kitaj
as 'a universal victim of anti-Semitism' in the early 1960s, however, seems to me
untenable. There is nothing to point to in the picture that is a specific reference to
anti-semitism other than the two associative references to his grandmothers who
had indeed both escaped the persecution of Jews in Europe. As stated above, Kitaj
clearly drew on a wide range of references including his own personal history when
making the picture. But, as I have shown, Kitaj was very much concerned to put
forward a political reading at this point. Secondly, the description of the picture

as a 'personal metaphor' really only works to elide the complexity of the reading of the picture that can actually allow for a number of metaphoric and metonymic meanings to be developed. What must frame all of these is an attention to history, in the sense of tracking the chains of significations without necessarily closing down those which are no longer convenient. Luxemburg was Jewish; was killed by members of the *Freikorps*, an ultra-nationalist paramilitary organisation from which Hitler would soon recruit his first wave of street thugs; and a degenerate form of German Romanticism was to become increasingly ominous in the 1920s and 1930s. But to argue that the figure of Luxemburg is really a metaphor for the universal suffering of victims of anti-semitism, which transcends the historical co-ordinates of her time, is a denial of the very quality that Kitaj seemed to work so hard to reinforce. It speaks once again of an attempt to fill an absence but this time from the opposite direction to that proffered earlier.[37]

To return to the point made earlier about the relationship between image and text on the canvas, what Kitaj now seeks to do is to actually deny the textual account; to close down on what had previously been central. The textual account of Luxemburg's murder on the canvas and the explanatory bibliography intrinsic to the 1963 show now play no part in Kitaj's discourse on the picture. I would argue, however, that the presence of the account on the canvas undermines the attempt to posit some universal and essential notion of identity as the securer of its truth.

Kitaj probably came across Rosa Luxemburg through her prison letters which had been reproduced in the American journal *Partisan Review*, copies of which he picked up in a New York bookshop.[38] In 1969 Kitaj reproduced a cover of an issue of *Partisan Review* as part of his screenprint series 'In Our Time: Covers for a Small Library After the Life for the Most Part' (1969). This series consisted of fifty screenprints printed by the Kelpra Studio in London.[39] What interests me is the way in which the mythical figure of Rosa Luxemburg emerges once more in a Kitaj work. This series of prints of book jackets, more or less unaltered, points to Kitaj's artistic relationship to European culture, history, and sense of location and temporality. Laid out, these books which have become pictures give a sense of the breadth of cultural influences the artist engages with. Now at a level of icon, the book covers have shifted between orders of meaning; if the monuments described above strive for the status of documents, then, conversely, these documents have been transformed into monuments. Monuments in that they are mute but from which you cannot but hear whispers of memories, and of struggles fought; they become spaces that have to be filled. As a whole the series hints at a conceptual exploration of the relationship between language and aesthetics.

If in the Luxemburg picture Kitaj compulsively tries to fill the absence at the heart of the picture with history in whatever form that may be, in the screen-print the reverse is the case as there has been an emptying out of history. Unable to go beneath the surface of the covers of the books into the realm of deeper meaning, all that can happen is the continuous slide along the series. The series

as a whole gives a structure to what is essentially a collection of fragments devoid of coherence other than that of the space mapped out for the place of the author. The covers have become reified objects that now seem to have a mystical relationship between themselves, produced by a mechanical process that bears no trace of human labour. They are reminiscent of Lukács's description of how, under the dominant relations of capitalist production, 'reality disintegrates into a multitude of irrational facts and over these a network of purely formal laws emptied of content is cast'.[40] Like the experience of the narrator of Umberto Eco's metaphysical novel *The Name of the Rose*, all that is left for the viewer is a sense of the endless raking over of the remains of a once great library that offers only a kind of 'lesser library … a library made up of fragments, quotations, unfinished sentences, amputated stumps of books'.[41] Of course Kitaj never actually adopts such a profoundly anti-humanist position because what is presented to anchor the series, once again, is his own individual sensibility and a series of Afterwords he has since written on the prints. Kitaj has subsequently looked unfavourably upon his screenprints precisely, it seems to me, because the processes of production, both collaborative and mechanical, can be seen to undermine the mythical figure the artist has sought to create.

For Kitaj, Rosa Luxemburg is a figure that reappears to continuously problematise his narrative of the artist. Retrospective attempts to silence the troubling nature of such a spectral presence seek to overwhelm it through the sheer weight of a narrative of identity, but such a process can never be complete and, like the body of Luxemburg herself, the questions will always resurface to disturb the closure imposed.

Natural history:
Kitaj, allegory and memory

Giles Peaker

Allegory has been consistently invoked in relation to Kitaj's work, serving a number of roles from accusations of 'literariness' to claims for its 'postmodern' status.[1] Typically, this has involved casting allegory in opposition to some other mode, perhaps 'symbolic' or modernist. This essay is not, or at least not entirely, concerned with such oppositions and the valuations that they involve. Instead, via some writings of Paul de Man and Walter Benjamin, I want to explore the allegorical in Kitaj's work as a means of operating both in and on history.

As a beginning, I would like to look at a painting, *Desk Murder* (formerly *The Third Department (A Teste Study)*), 1970–84 (Figure 12), that shows a room, empty of occupants; a room which resembles nothing so much as the 'scene of a crime', as Walter Benjamin described Atget's photographs.[2] But for a long time this was a scene without a particular crime. The title *Desk Murder* was given (as 'the last stroke') many years after the painting was 'finished'. Given the rather heavy late nineteenth-century furniture and the trappings of bourgeois paternal authority, one could see this as the scene of many other crimes, resembling anything from Edgar Allan Poe's physiognomies of the interior to Kafka (a parricide perhaps). But in any case, the room, and the painting, is a site of something which either has happened or perhaps will happen, but is not here, now. In order for a room to resemble a scene of a crime, as Poe knew, the possibility of any crime will do. For all that the reconstruction of the possible act might furnish a narrative structure, the room will not stop looking like its scene once we know what happened. The reason a room looks like a scene of a crime is that the detective is always too late. Because the presence of the detective and the presence of the crime never coincide, the scene can never be without its pretext, nor can it become identical with it.

Such, in some accounts, is a condition of allegory. The detective story, at least as it functions in Poe, has allegoresis as the motor of its narrative and allegory as its basis. Each scene, each element has both overt presence and its hidden meaning, a meaning given by its pretext. The assemblage and interpretation of emblems

might eventually enable the detective to decipher the pretext, but it will never unite the two texts, of scene and crime. The scene will always remain separate. Allegory, as Paul de Man has pointed out, involves temporality, a gulf of time between meaning and sign, or rather, between sign and sign.

> [I]n the world of allegory, time is the originary constitutive category. The relationship between the allegorical sign and its meaning (*signifié*) is not decreed by dogma … We have, instead, a relationship between signs in which the reference to their respective meanings has become of secondary importance. But this relationship between signs necessarily contains a constitutive temporal element; it remains necessary, if there is to be allegory, that the allegorical sign refer to another sign that precedes it. The meaning constituted by the allegorical sign can then only consist in the *repetition* (in the Kierkegaardian sense of the term) of a previous sign with which it can never coincide, since it is the essence of this previous sign to be pure anteriority.[3]

In establishing 'its language in the void of this temporal difference',[4] allegory becomes bound up with self-presentation. That which is presented must also be recognised as a sign for something else. For a room to look like a scene of a crime,

12 *Desk Murder* (formerly *The Third Department (A Teste Study)*), 1970–84, oil on canvas, 76.2 x 121.9.

it must emerge through a particular vision, through the eyes of the detective. In order for its materials to stand forth as already signs, allegory must involve a staging of them. *Desk Murder*'s drapery of 'mourning black' is also, in this sense, a proscenium arch. As Walter Benjamin points out in *The Origin of German Tragic Drama*, in the seventeenth century allegory was considered a form inherent in written, not spoken, words. Even when spoken, as in the performance of the 'mourning plays' or *Trauerspiels*, he finds that:

> In the anagrams, the onomatopoeic phrases, and in many other examples of linguistic virtuosity, word, syllable, and sound are emancipated from any context of traditional meaning and are flaunted as objects which can be exploited for allegorical purposes. The language of the baroque is constantly convulsed by rebellion on the part of the elements which make it up.[5]

The materiality of the emblem, separated from 'traditional' or 'natural' meaning, enables its status as sign. Benjamin extends this to note the tendency of allegorical language to congeal, to become rigid, to form an image or emblem. The rebus, as both text and image inextricably intertwined and mutually determining, might stand as the apogee of this direction. Anything human or natural stands capable of becoming an allegorical sign. However, in order to be so, it must simultaneously undergo a reduction to merely material existence. Benjamin perceives a fragmentation of even the human body into parts in baroque allegory; limbs, regions, skin and bones are separable and stand alone as signs. It is in the gulf between the empty material particular and its mobilisation as sign that allegory presents itself and presents itself as to be read or rather deciphered.

In this insistence upon the mute material element as a necessity for the allegorical sign, one can discern a reason for a compositional orientation within the *Trauerspiels*, one which might apply for all extended allegory. An allegorical discourse upon the human body might include all its parts, but such a totality will not constitute a body reassembled. The drawn-out narratives of the *Trauerspiels*, Benjamin suggests, are formed out of a series of material elements which individually constitute emblems or even something close to rebuses; series here should not be taken to imply a narrative or temporal development. The elements rather form an assemblage, described by Benjamin as 'built up in the manner of terraces'.[6] This does not mean that the dramas lack mobility of narrative, but that mobility is constituted by the 'irregular rhythm of the constant pause,'[7] and constellation anew. The composition is organised as a collection of fragments, which is not to say that there is no central or organising figure. The principle of organisation is, however, incapable of fusing the emblems gathered under its rubric. '[A]llegory brings with it its own court; the profusion of emblems is grouped around the figural centre, which is never absent from genuine allegories, as opposed to periphrases of concepts. They seem to be arranged in an arbitrary way'.[8] In part, this is because their relationships – the passage from one to the other, or juxtaposition – also become allegorical signs, and any relationship, likewise, can become a

sign. The organisation of elements in allegory, and the distinctions between elements, can be taken as both formal and significant; such (dis)junctures, as in the rebus, are themselves material elements and signs.[9] *Desk Murder* might seem to enact just such a disjuncture in, for instance, the stuck-on fragment of canvas with its 'contraption of some sort, emitting fume',[10] or perhaps the black framed hills (picture? window?) or indeed the mourning drapes/proscenium, which both claim and distance the spectator. Given their material and formal differences to the rest of the painting, it is hard to encounter these elements in any other way; one meets the stuck-on canvas as a 'rebellion of the elements'.

In allegory, time is 'the constitutive category' not only in its construction but in its reading, which also requires a process of construction of meaning. The process of allegoresis, as the narrative of the detective story makes clear, requires the seeking of meaning. The emblems must be combined and interpreted. For Benjamin, the constructor and reader effectively are one, and both find a person-ification in the figure of the melancholic. The melancholic gaze 'causes life to flow out of [the object] and it remains behind dead, but eternally secure, then it is exposed to the allegorist, it is unconditionally in his power'.[11] The melancholic is, in some ways, a dweller in de Man's 'authentically temporal predicament'.[12] Brooding upon the world, he strips it of all pretence to self-present meaning, but, pursuing its hidden meaning, follows a cycle of the ever failing construction of signs, a process of interpretation which is, in principle, endless, because the melan-cholic can never be satisfied with finding himself as the only guarantor of the linkage of sign and meaning.

Allegory, de Man maintains, renounces 'the nostalgia and the desire to coincide'. Benjamin's account of allegory poses some difficulties for this insistence, even if de Man's specification of secular allegory is taken into account. De Man's own read-ings of Rousseau and Wordsworth establish allegory as a 'negative moment' of renunciation or loss. Allegory is a constituent of a movement from falsity to truth, but de Man can only indicate this truth as a loss, a loss of conciliation or false unity. What a sustained dwelling in the truth might be, he does not suggest. The direction of de Man's argument is to identify the conception of the symbol as a defensive strategy against the unpalatable conception of the self in its 'authentically temporal predicament'. This argument, perhaps against its aim, also results in an eternal positing of the false symbolic because allegory is only figured as the negative moment. Although de Man concentrates on Romanticism – as the presumed 'home' of the symbol – the implication of his argument is that literary history, and I would add perhaps history, consists in this relation of false positive and authentic negative moments. Allegory and symbol necessarily co-exist. The argument of Benjamin's book has a different trajectory. Although Benjamin does spend some time opposing allegory to the symbol and indeed classical tragedy, the bulk of the book is a sustained consideration of allegory with little reference to the symbol. If de Man can only figure allegory as a negative moment, then Benjamin's text is an examination of a dwelling in the negative. This involves mourning rather than loss.

> For the baroque sound is and remains something purely sensuous; meaning has its
> home in written language. And the spoken word is only afflicted by meaning, so to
> speak, as if by an inescapable disease; it breaks off in the middle of resounding and
> the damming up of the feeling, which was ready to pour forth, provokes mourning.
> Here meaning is encountered, and will continue to be encountered as the reason for
> mournfulness.[13]

This mournfulness, which has its counterpart in the mourning by mute nature, is
not the same as the renunciation of false consolation found in de Man. As
suggested before, Benjamin's allegory likewise involves the stripping away of the
pretence of the symbol and its appearance (*Schein*[14]) of beauty, which could also be
cast as the coincidence of human meaning and nature. The mourning, however, is
not for something apparently possessed and then lost, unless one wishes to hold
to a literal account of the Fall (something of a contradiction in terms in this
account); rather the mourning is for the silence of the non-self. Allegory both
provokes and denies this mourning. The objects that it seizes upon are at once
stripped naked, as mere material, and imbued with the most extravagant signifi-
cations. Once in the hands of the allegorist the object is 'incapable of emanating
any meaning or significance of its own; such significance as it has, it acquires from
the allegorist. He places it within it, and stands behind it; not in a psychological
but in an ontological sense'.[15] But in its very muteness, the object becomes a key
to 'the realm of hidden knowledge'. The material, at the same time, stands as the
mute provocation to and residue of the search for such knowledge. The disparity
of material and signification in allegory marks it as at once a desperate claim to
knowledge and a mourning. One could argue that *Desk Murder* stands at such a
point and, given Kitaj's eventual identification of the crime of which this is the
scene, it would be the disparity between material and signification rather than the
necessarily still functional claim to knowledge that is emphasised. For all that this
is a scene to be interpreted, which must be interpreted, it is the failure of the mate-
rial elements to sustain significance which is the strongest sense of the painting.[16]
It would be wrong, though, to take this, and perhaps with it *Desk Murder*, as a
mourning for that which cannot be brought to meaning, that which cannot be
represented. Meaning is the reason for mournfulness, not meaning's failure.

> For the only pleasure the sick man permits himself, and it is a powerful one, is alle-
> gory. It is true that the overbearing ostentation, with which the banal object seems
> to arise from the depths of allegory is soon replaced by its disconsolate everyday
> countenance; it is true that the profound fascination of the sick man for the isolated
> and insignificant is succeeded by that disappointed abandonment of the exhausted
> emblem.[17]

In this is a suggestion of what Benjamin terms the dialectic of allegory. Its antin-
omies are marked. On the one hand, the eternal, on the other, the ruin. Benjamin
argues that 'the baroque work of art wants only to endure, and clings with all its
senses to the eternal'.[18] He cites Alberti's comparison of alphabetic script

unfavourably with Egyptian 'signs' as to their suitability for monuments, because alphabetic script is 'known only to its own age and therefore must inevitably fall into oblivion',[19] whereas the Egyptians represent god by an eye, nature by a vulture, time by a circle and so on. The 'hidden knowledge' that is sought in the accumulation and combination of emblems resembles the object of the alchemist's search. It is the knowledge of the divine and of the human to which, for the baroque, nature had been given as a form of instruction – nature as an emblematics. Yet this involves, as discussed before, the stripping of any significance from the natural, and importantly, the historical world. 'Any person, any object, any relationship can mean absolutely anything else. With this possibility a destructive, but just verdict is passed on the profane world: it is characterised as a world in which the detail is of no great importance'.[20] Indeed, as a world of the material fragment. In this 'saturnine view', history is as nature and nature is eternal transience. As Benjamin describes it in a now famous passage:

> Whereas in the symbol destruction is idealised and the transfigured face of nature is fleetingly revealed in the light of redemption, in allegory the observer is confronted with the *facies hippocratica* of history as a petrified, primordial landscape. Everything about history that, from the very beginning, has been untimely, sorrowful, unsuccessful, is expressed in a face – or rather in a death's head.[21]

At this point, it is worth returning to the 'authentic temporality' of de Man, and with it, what might be at work in *Desk Murder*. The temporality of which de Man writes, it should be clear, is not just a passing of time, but an ontological gulf between sign and meaning (or rather sign and anterior sign and, by implication, so on) which can never coincide. But it is hard to see what distinguishes de Man's allegory from that of Benjamin's in the *Origin of German Tragic Drama*, apart from the word 'secular'. His examples, Wordsworth and Rousseau, both involve a turning from the 'values associated with a cult of the moment', the negative moment of renunciation and loss, but de Man prefers to keep that moment as entirely negative in his writing, rather than face a dialectic of allegory in which the melancholic turns transient nature, and its transience, into signs of the eternal beyond the profane. In the Lucy Gray poem quoted by de Man,[22] it is death, and an impersonal death at that, which effects the transformation of the sense of the word *thing*, from a possibly affectionate gallantry to the all too transient, material thing of the 'retrospective perspective of the eternal "now" of the second part'.[23] That eternal 'now' returns de Man's allegory to Benjamin's baroque, to history as nature, and nature as transience. Yet the poem, and the allegorist, appears capable of writing as if able to hold that eternal 'now' in view. De Man considers Wordsworth to be 'one of the few poets who can write proleptically about their own death and speak, as it were, from beyond their own graves'.[24] Allegory might put forward a conception of the self 'seen in its authentically temporal predicament', but it does so from a place of the eternal. From this place, the world and, in part, the self can be seen as transient, 'ruined' and

empty, but it is still a self which sees. Allegory cannot, it seems, be wholly 'secular', as Benjamin indicates towards the end of the book.

> As those who lose their footing turn somersaults in their fall, so would the allegorical intention fall from emblem to emblem down into the dizziness of its bottomless depths, were it not that, even in the most extreme of them, it had so to turn about that all its darkness, vainglory, and godlessness seems to be nothing but self-delusion.[25]

The melancholic, faced with his own countenance as a death's head, 'leaps forward to the idea of resurrection' and so 'in God's world the allegorist awakens'.[26] This is an encounter not with significance in allegory, but with the significance of allegory. In one last allegorical turn, subjectivity 'grasps what is real in it, and sees it simply as its own reflection in God'.[27] There is, then, a division of the self into a historical, transient, material subjectivity and an eternal or divine spirit which is utterly separate from the condition of human, subjective, knowledge. Benjamin frames this condition of allegory in terms of seventeenth-century theology, with a certain Gnostic strand, the human world is a world from which God is absent. But, stripped of this particular theological construction, one can see something similar at work in de Man's examples and even his own account; allegory as a negative moment, a 'negative self-knowledge', brings with it a place, beyond the death's head, from which the 'authentic temporality' can be seen as such. Within allegory, nothing is what it is, yet allegory, as itself a sign, does promise a coincidence of sign and origin.

It often seems as if Kitaj's deployment of allegory is intended to hold on to or reinstate history. Sometimes clutching at the shards of that which is disappearing, at other times following Warburg on the persistence of visual symbols in 'the social memory',[28] Kitaj's works can appear to lay a claim on the present in the name of the past. The logic of the 'anterior sign' means that the present is never just 'what it is'. It is in something of this way that Juliet Steyn sees Kitaj's later work as a response to 'the need to illuminate and to restore, to re-own, to make sense of history'.[29] She identifies Kitaj's 'chosen strategy' as the attempt to create a symbol, the chimney of Auschwitz, 'through and in which the Jewish experience can be encapsulated'.[30] But this attempt seems as bound to failure as any of the melancholic's attempts to find more than himself behind the mute material. As Steyn rightly observes, the repeated use of a motif does not lead to the creation of a symbol; the chimney rather takes a role as an emblem, as incomplete and therefore unstable as any allegorical sign. The attempt to make a symbol is, however, a key part of the 're-owning' of history. Such a re-owning is, in part, a gathering of the past into the present, but the structure of allegory means that the past and the present cannot be unified. If one is to understand by 'restoring' history a sense that a unity, an identity, can be established in the present, allegory will constantly undermine such a project, leaving the present sign dependent on another with which it can never coincide.

It is this failure of the present to be just itself that Andrew Benjamin considers to be the indicator of an altogether different relation of history and

Jewish identity. His analysis is concerned with 'the co-presence of two different and incompatible fields of interpretation'[31] in a painting, whose interplay and tension will be the source of the painting's interpretation. In the course of a discussion of *The Jew Etc.*, 1976 (Figure 5), the hearing aid emerges as a site of just such a plurality, at once marking vulnerability, the Jew as victim, and over-coming the 'weakened' ear to give an active listening. This, Andrew Benjamin argues, is a space of paradox, a space that 'contains the past but which moves towards the future'.[32] History, here in the specific sense of the definition of Jewish identity by anti-semitism, marks the present, yet there is not an identity of the two, as the present is also inscribed by possibility, by the 'not yet' or becoming of the futural. There are, arguably, marked similarities between Andrew Benjamin's account and what has so far here been sketched of a logic of allegory. Indeed, the sign which is opened towards the future can be envisioned as a rather more positive version of de Man's authentic temporality. It is hard to discern, after all, a theoretical necessity for the 'anterior sign' to be temporally prior to the allegorical sign.[33] It is the temporal difference of the two signs which is significant, such that, as Andrew Benjamin puts it, 'interpretation is always taking place'.[34] For Andrew Benjamin, this 'futural', an endlessly 'not yet', is positive: 'the mirror image of the Jew as transgressor – namely the Jew as trans-gressed against – is mediated by the possibility of an affirmative conception of identity. Even if the latter is the continually always as-yet-to-be-determined conception of the Jew.'[35] This possibility is, in part, identified with the Messianic in Kitaj's work. Andrew Benjamin considers the messianic to be a suggestion of the possibility of completion, but also thereby an indication of the incompletion of the present. He, however, prefers the 'different hope' of the always yet to be that he also finds in Kitaj. This is a tempting prospect; allegory as an 'affirma-tion of human creativity', creation as 'continual renewal'.[36] But on what grounds is the non-coincidence of signs given a positive value?[37] Like de Man's power of the negative, renunciation and loss, allegory gains a value from being opposed to identity – for de Man, that of the symbol, for Andrew Benjamin, that of the 'logic of the synagogue', the identity given by anti-semitism, and, by extension, the Enlightenment demand for universality.[38] For both, allegory invokes a recog-nition of the non-self as such. But, as I argued above, Walter Benjamin's account has allegory as provoking mourning for the silence of the non-self. History appears as the *facies hippocratica*, as a petrified landscape, as nature. All history, including the future, is thus condemned. Such a mourning might appear near to what Andrew Benjamin describes as the 'possibility of the ethical', but in the *Trauerspiel*, the Same and Other will never 'look into each other's face' as he hopes. From this perspective, Andrew Benjamin's 'continual renewal' finds its answer in the sick man's pleasure described by Walter Benjamin.

Kitaj has implied that *Desk Murder* should 'express an historical unhappiness'.[39] If my reading of it through Benjamin's book has any value, then it is not an histor-ical unhappiness, but the unhappiness of history that is expressed here. Allegory,

shorn of its 'liberatory' or 'negative' relation to an identity as found in Andrew Benjamin and de Man where it acts to remove false consciousness, has its own dialectic in which the materials are both stripped naked and 'raised to a higher plane'. Acting through this dialectic, *Desk Murder* presents mute elements for which interpretation is demanded, but for which any meaning is unavoidably contingent. It establishes itself in the 'void of this temporal difference'.[40] In the language of the *Trauerspiel*, it provokes mourning for the muteness of that which it has no choice but to seek and fail to grasp. Allegory itself emerges as a sign for history, or rather historicity. Here Walter Benjamin's 'one last turn' reappears. Allegory as sign involves the projection of a place beyond historicity, an eternal or spirit, from which human historicity can be seen, albeit a space which cannot itself be represented. This might be called messianic, but not in the sense of completion; there is nothing that is necessarily futural about this space. Even in the Christian baroque of the *Trauerspiel*, according to Benjamin, redemption has the quality of an interruption, as expressed in the manner in which scenes of apotheosis are added onto works, rather than emerging from their internal logic. *Desk Murder*, along with many other of Kitaj's works, seem to lay claim to such a space beyond historicity. One might give this space many names when considering Kitaj's works; for instance, one of its names might be 'Art'. Another name might be, as Juliet Steyn indicates, the 'wandering Jew' or the 'people of the book'. 'Kitaj's paintings suggest that, wherever the Jews are, over and beyond the diversity of their concrete situations, they share a single unequivocal character, a common and unchanging identity – as outsider.'[41] Steyn identifies this in the emblems which Kitaj develops, including the later, more expressionist, use of paint. One might take this a step further to suggest that the particular use of allegory situates the Jew as eternally elsewhere. Beyond the use of certain motifs and styles, the allegorical structure of the work becomes a sign for the Jew. With this comes the projection of a place from which the history of the Jews is seen instead as the condition of the Jews in history. History collapses into historicity, which itself takes on the face, or death mask, of nature. The trouble that Steyn has with the construction of Jewishness in Kitaj's works can be related to this. She argues that Kitaj's representation of the Jew continues 'the legacies inherited from the nineteenth century',[42] and remains caught in that past. In Kitaj's 'refusal to contextualise, the tragedy becomes paradoxically the consecration of Jewish otherness in history'. This can be understood as an effect of allegory, which, for all that it is bound to its historical materials, renders history as historicity. In such landscapes, fate can all too easily reappear.

Allegory, in this description, is both the analogue of historicity and itself without history. But does this mean that Kitaj's use of allegory undoes his clear desire to inform or delineate the present? To put it another way, is there a possibility that the very use of allegory marks something of the present? If there is then one might retrieve allegory as historical by discerning within the form of allegory variations or extremes through which history, or at least certain elements, can be

reclaimed from the *facies hippocrates*. Walter Benjamin thought that this was possible, albeit in a complex way. Allegory is something of a constant preoccupation in Benjamin's work, surfacing in varied ways in varied texts and at different times. Benjamin does not treat allegory as a constant, or as a form with its own developmental history. He is interested in the sites of its occurrence, but he does not reduce the form to those sites, simply linking a form to its time. The *Origin of German Tragic Drama*, for instance, makes a specific association between baroque allegory and the Expressionism of Benjamin's own time. Nonetheless, specific forms of allegory are, for Benjamin, indicators of the socio-historical situation in that they emerge as expressions of the experience of that situation. The difference between allegory in the work of Baudelaire and baroque allegory can serve as an example. Crudely, the difference is as follows: baroque allegory arises from the encounter of the melancholic with a world at once mute and mysterious which is made into allegory. Baudelaire encounters a world that is already rendered allegorical. Benjamin considers this in relation to the commodity form. The commodity, which comes to form the 'natural' world for Baudelaire, can be taken as the epitome of allegory, at least in terms of exchange. In exchange value, the commodity is both stubbornly material and a sign whose meaning is always elsewhere, its 'essence' being exchange. The upshot is a world of manic and continual substitution, and a curiously static, spatial scene of equivalence. Baudelaire, unlike the melancholic, does not continually find 'himself' behind each emblem. Instead, according to Benjamin, he empathises with the commodity, which is to say he allegorises the 'self' of the writings. Unlike Wordsworth, say, there is no projection of an 'eternal' from which one's own death can be figured (with the possible exception of the 'eternal' of art). The 'self' of the poem's poet is as transient and contingent as the emblem.[43] Alongside this, the separation of the symbolic and the allegorical is heightened. The famous *correspondances* involve not just the connection or union of self and world, but the fusion of the two to the point of the dissolution of subjectivity, at least for Benjamin. Aspects of Baudelaire's work, although or rather because it is atypical, are associated with historical circumstances which, in a sense, make them possible in a manner which allows this occurrence of allegory to be read as history. However, Benjamin's historical writings also resemble allegorical works. Rather than a construction of a linear history, or even a 'full' account of their objects, the writings are an assemblage of fragments, conjunctions and associations. Benjamin's declared intention was, at one time, to produce a work entirely made up from montaged citations. The resemblance is deliberate, for Benjamin regarded any form of writing of history which involved, implicitly or explicitly, a claim to being beyond history itself as mythic, dangerous and naive, a falling back into symbolic representation. To simply produce a history of allegory as a form would be to accept a symbolic mode, that of a linear developmental history. The equation of word and world that would take place in such a history – making a form of allegory into a symbol for a historical moment and thereby exhausting it – would be to ignore the manner in which allegory troubles that kind

of writing and that idea of history. After all, from where could such a history be written?

Benjamin's response was to argue that his historical work is determined by the (his) present. If it can be compared to allegory, then the present is the pretext for which the assembled historical fragments are to act as an interpretation. But, in comparison with allegory, there is a significant difference. Benjamin was aware of the possibility and the perils of his work being considered as allegory. If it were to be taken so, it would be the undoing of everything that he wished to achieve as philosopher, critic or historian. In place of the subjective assemblage of the allegorist, faced with the landscape of history as ruin, he wished to place the objective motivation of the present. His fragments were, he considered, assembled out of historical need, and their work was to reveal the present. The difficulty of representing history, in Benjamin's view, is that a claim must be made for a motivation for the representation which extends beyond the subjective, or the linguistic, and at the same time that claim must be subverted before it hardens into a symbol. This dichotomy underlies Adorno's concern about Benjamin's 'casual' relation of elements of the superstructure to those of the base. Adorno highlights this in Benjamin's comment that '[i]n the performance of the clown, there is an obvious reference to the economy. With his abrupt movements he imitates both the machines which push the material and the economic boom which pushes the merchandise'.[44] Such a passage combines elements so as to associate the two, to intimate their relation, but at the same time displays the violence of the making of that association, its artifice, in their incongruity. Style effects a presentation which hovers between the allegorical and the symbolic, or moves constantly between the two.[45] It is an attempt to write history which rescues some meaning for fragments without claiming the unity of word and world, and which escapes both the vision of history as linear continuum and the spatialised vision of historicity of allegory. In this way, Benjamin attempts to wrest historical truths from his material through a process of construction which, at the same time, undermines any sense that this is *the* truth.

Kitaj has claimed a certain importance for Benjamin's work in relation to his own. In relation to *The Autumn of Central Paris (after Walter Benjamin)*, 1972–73 (Plate 9), Kitaj wrote: 'the adventure of his addiction to fragment-life, the allusive and incomplete nature of his work (Gestapo at his heels) had slowly formed up into one of heterodox legacies upon which I like to stake my own dubious art claims'.[46] Given this, it is worth asking whether Kitaj's works, to the extent that the allegorical is their dominant mode, might either, like Baudelaire, mark an extreme or particular form of allegory, or whether, like Benjamin's work, they might present an indeterminacy which simultaneously promises and withdraws the possibility of a kind of meaning beyond allegory. I cannot say whether or not the first possibility might be true. Such an answer would require a close consideration of each individual work. However, as my commentary on *Desk Murder* will have indicated, I think that this work remains within the parameters of baroque

allegory as described by Benjamin. I don't think that *Desk Murder* is the only work that can be considered in this way, but the analyses that would be necessary to support this assertion are beyond the scope of this essay. The second possibility would also require a work-by-work analysis in order to be properly assessed, but *The Autumn of Central Paris (after Walter Benjamin)* will serve as an, admittedly convenient, case study, as it is arguable that this work performs a complication or disruption of allegoresis.

The image of Benjamin that is a component of *The Autumn of Central Paris* has a rather different status to the other elements of the painting. The subtitle indicates this status, but the painting confirms it. Formally, the image of Benjamin is situated at the apex of a horizontal triangle and at roughly the mid-point of a diagonal running from bottom right to top left. His eyes are hooded, regarding the scene, but detached from it. The mouth is hidden so that one cannot tell if he speaks or not. The image of Benjamin appears as something of a key to the scene, and, when combined with Kitaj's claim to the fragmentary and allusive as a legacy of Benjamin, it is possible to see the figure as a point where a reading of the work has to move from allegoresis to a consideration of allegory. In this reading, Benjamin stands for the construction of the work, such that his image is the point at which the work enables a reflection upon its own means. But it is not enough to take the figure of Benjamin as the 'master code' for the painting, because that figure is also inseparable from the scene upon which he looks. The borders between his figure and those elements that surround and 'overlap' him are of the same sharpness of tonal and colour contrast as the rest of the painting. There is nothing in the paint handling or drawing that would single this figure or part of the canvas out as distinct from the rest. Despite the distance of his regard, his gesture is expansive, even embracing, and other figures are directed towards him. The figure is in this manner an element of the painting alongside the others and equally engaged in the scene. From this perspective, Benjamin might be the dominant figure in this 'allegorical court', but, as in the *Trauerspiel*, the dominant figure is ultimately indistinguishable from the others. Neither of these readings can stand by itself. One suggests that the painting is not just an allegory, but, through the figure of Benjamin, presents allegory. The other insists upon the figure as an allegorical sign amongst others. The status of the image of Benjamin therefore has a certain duality;[47] it can be taken as both spectator/reader and participant. This offers a tempting potential reading, particularly given Benjamin's own acute awareness of the contradictions of the social situation of the intellectual, but it does not go far enough. It would be more accurate to cast the ambivalence of the image of Benjamin in terms of that between author and participant. The 'after' in the subtitle can be read in any number of different ways, of which two in particular, given the artistic context, seem to me to be at play in the painting: 'after' in the sense of a reworking, a derivation, on a theme of …; and 'after' in the sense of a likeness. Derivation, which seems the more allegorical sense, is however, the weaker of the two and ultimately is overwhelmed. Likeness, which is the more

symbolic sense, extends beyond the figure of Benjamin to the rest of the scene. The scene that surrounds Benjamin is Benjamin's world in that it is a representation of Benjamin's writing, a representation from which the figure of Benjamin is not distinct. The painting, including its allegorical construction, is meaningful as a whole. That the painting does have a central, unifying subject is clearer when Kitaj's association of Benjamin's personality and his manner of working is taken into account: 'His personality began to speak to the painter in me – the adventure of his addiction to fragment-life'.[48] In crucial respects, I would argue, *The Autumn of Central Paris* is a portrait. It is not an allegorical portrait, but a portrait of allegory – a likeness or semblance of 'fragment-life'. The allegorical assemblage of elements is refigured as an integral whole at the level of the reflection upon allegory. Whilst the painting does enable a movement from an allegorical reading to an attention to allegory, it does so by presenting that perverse, if not uncommon, thing, a symbol of allegory, of 'fragment-life'.

Although other works by Kitaj might well work differently, *The Autumn of Central Paris (after Walter Benjamin)* opens up the possibility of a reflection upon allegory only to collapse back into the symbolic as it does so. In that, it involves a claim to representation as presence[49] that has none of the difficult, indeed painful, ambiguities of Benjamin's work. Benjamin's complex engagement with allegory stands as an attempt to find truths in his historical materials, albeit one of questionable success. In doing so, Benjamin hoped to institute a form of memory which involved neither the (false) unity of subject and object in the symbol, nor the equalisation of history into historicity through allegory 'in which the detail is of no importance'.[50] Kitaj, at least in the case of the two works I have discussed, veers from one pole to the other, between historicity and presence. The danger is that, despite his manifest desire, Kitaj's work loses that which he wishes to hold together, both history and the present, and in losing them also loses that which Benjamin sought, an opening onto something else.

R. B. Kitaj and Chris Prater
of Kelpra Studio

Pat Gilmour

Between 1963 and 1964 Chris Prater of Kelpra Studio introduced screenprinting to two dozen artists,[1] each of whom had been invited to produce a print for the now legendary portfolio published by the Institute of Contemporary Arts.[2] In 1970 the portfolio was exhibited by the Arts Council at the Hayward Gallery, as part of the first major exhibition of screenprints in London.[3] In the catalogue foreword, Robin Campbell praised Prater's 'widely acclaimed' interpretative skill, and said the show represented a chapter of 'enormous vitality' in the history of contemporary British art, which might never have been written but for an imaginative and resourceful master-printer and a group of artists able to develop the full potentialities of the medium.[4]

Ronald Alley, then Keeper of the Tate Gallery's Modern Collection, selected 214 exhibits from a total of some 600 prints, and, in the catalogue introduction, said that since 1961 there had been an extraordinary rise in the status of screenprinting, 'a remarkable new development in British Art'. Singling out R. B. Kitaj as one of four artists whose work was particularly suited to the process, Alley remarked that making prints had been a turning point for him, exerting 'a radical effect' on his development. And he noted that Kitaj's suite 'Mahler Becomes Politics, Beisbol' had already been internationally recognised as 'an outstanding feat of modern printmaking'. Observing that the originality of Kitaj's early paintings lay in the way he fused figurative and abstract elements together, Alley continued:

> This is an approach which he has been able to develop yet further in his screenprints, working not from a preliminary collage but from a selection of photographs, patterns, pages from books, drawings and so forth which he arranges and modifies as he goes along. The prints are the result of an extremely close collaboration with the cameraman and other technical assistants on whose skill and patience he makes enormous demands.

Kitaj, an American expatriate, came to England to study in the late 1950s, under the terms of the GI Bill. He went to the Ruskin School in Oxford, then to London's

Royal College of Art, from which he graduated in 1962. By the time the show at the Hayward Gallery opened, Kitaj already had an international reputation for his painting,[5] and critics were equally enthusiastic about his screenprints. Marina Vaizey, who thought Prater's range 'awe-inspiring', felt that the process had extended the artists in unexpected, often highly intellectual directions, their ideas being expressed in 'stunning visual terms', and she mentioned 'the sophisticated, allusive Kitaj who, with his impeccable control, is a visual Joyce'.[6] In *The Times*, Guy Brett noted the screen's ability to combine printed imagery from disparate sources with a variety of the artist's own marks, and felt a screenprint had greater 'visual presence' than the original collage. He wrote:

> R. B. Kitaj has taken these facts and possibilities furthest. The arrangement of his material is never predictable; each print seems to have a separate logic deriving from the quality in the image, with the result that his prints have increased in visual richness … He has undertaken a real voyage of exploration among the debris of books: he has been to strange lands.[7]

Commenting in *Art and Artists* that Prater's dedication had visibly enlarged the vocabulary of graphic art, Robert Thomas described *The Defects of Its Qualities*, 1967 (Figure 13), which won Kitaj a major prize at the Bradford International Print Biennale,[8] as a seminal work and a classic of the genre.[9]

Before the Arts Council show, Kitaj's prints had already been seen in a Berlin retrospective, with a *catalogue raisonné* of the fifty-four images he had already created.[10] In 1971, five Kitajs were included in Richard S. Field's landmark show 'Silk-screen: History of a Medium',[11] where Kelpra's share of the contemporary exhibits caused Field later to say of Prater that he had 'almost single-handedly metamorphosed screenprinting into a fine art'.[12] In 1980 Kelpra was again featured in a major British exhibition, when the Tate Gallery celebrated the gift of Rose and Chris Prater's personal collection,[13] negotiated by the Institute of Contemporary Prints.[14] Among two dozen images by Kitaj was a portrait of Prater (by now an OBE),[15] made for a portfolio published to mark the occasion.

Given the unanimous approval with which Kitaj's prints were (and still are) received, the artist's rejection of his 'collagist' years comes as something of a surprise. Perhaps intimations of his change of heart can be detected in the affectionate double portrait of Prater and his wife, painted by Kitaj in 1974, when his work at Kelpra was nearing its end.[16] Prater believes the tall figure in the foreground of *Malta (for Chris and Rose)*, is the artist Victor Pasmore, who lived in Malta, where the Praters regularly took a vacation. Behind Pasmore, in a room of subtle and intense colours, stands Prater as circus-master, his attribute a bank of knives, indicating his genius as a stencil-cutter.[17] 'Art', as a sculpture, bows her head to accommodate the low ceiling,[18] but the space of the room opens out above the printer, who looks at the stencilled image on the wall, or dreams of possibilities beyond the open window. Meantime Rose, relaxed despite her mortal illness, lies on a precipitous ledge, above a fathomless gulf of Mediterranean blue.[19]

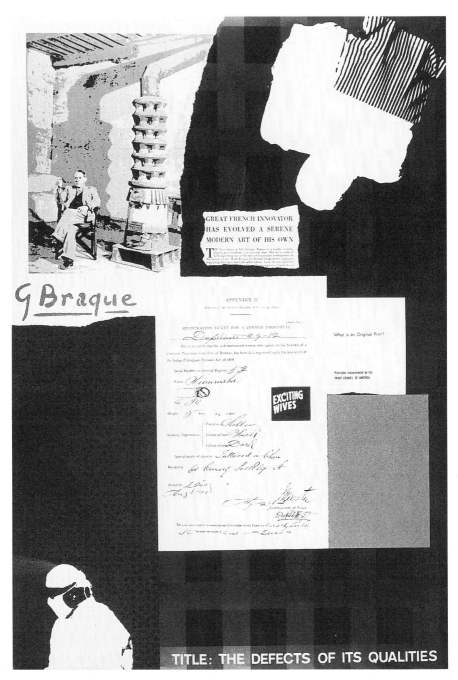

13 *The Defects of Its Qualities*, 1967, colour screenprint, photo screenprint, collage, 90.2 x 60.9.

One can only conjecture the reasons for Kitaj's subsequent dissatisfaction with his early prints. No doubt the tragic death of his first wife in 1969 cast every activity undertaken at the time into a negative light. Then his rejection of collage and photography – associated in his mind with 'Duchampism'- was part of his falling out with modernism and the much-publicised return to figure drawing.[20] In 1967, however, Kitaj told Mark Glazebrook, that, although he was an unreconstructed easel painter, whose most serious ambitions lay with painting, he was also

> an unreconstructed modernist and there's the rub. Printmaking (which is not what it was) is as close to SPONTANEITY as I've managed to come – I can get manifold *ulterior* premises, visualised, on sheets; premises, false starts, supplications, what have you, which would take me many months to commit to oil painting. I've been able to engage at levels of sensibility through this printmaking counterpoint which cut across the dour patch of painting ... and sometimes lodge there ...[21]

Introducing Kitaj's Berlin print exhibition in 1969, Werner Haftmann confessed he was touched by something timeless, even 'archaic' in his work. Identifying Romanticism as one of its guiding principles, he welcomed the reappearance of the *Bildungsbild* or educational picture. This kind of picture, he said, was rare among the easily read, declamatory works of contemporary non-abstract art, but Kitaj, who had studied Aby Warburg, Erwin Panofsky and Fritz Saxl, had learnt that by decoding hidden relationships of content and iconography, he could, with the help of invented imagery and montaged quote, give reality 'the timeless power of legend'.[22]

The same catalogue contained Kitaj's densely worded text, 'Mainly about using photos; re: the prints', in which he said he aspired to the '*arch* pattern that Dürer wanted: "of a kind never seen before"... as he put it'. He also revealed, in discussing 'this great fright, awful dream that the meek won't *ever* inherit the earth', an attractive social consciousness, suggesting that the 'commonplaces' of such people were caught 'just that much nearer their original state in a photo than you might get otherwise'. And seven years before his embroilment in the polemics about human depiction, Kitaj said he meant to deliver 'something like *human character* into picture making ... if inequity, lethal injustice, the suffering of children, get to you; well – if you can *see* it – it's visual. And you *can* see that aside from the flesh in photos.'

Kitaj's later emphasis on the 'hand-made' may have been a delayed response to the debates about 'originality' in the mid-1960s, although at the time he reacted mainly with humour.[23] It became an issue when screenprints – yet to receive the art establishment's cachet – unsettled traditional printmaking. The matter came to the boil in November 1965, when four Kelpra screenprints scandalised the Biennale des Jeunes Artistes in Paris. The Parisians, who had just reprinted the 1937 definition of 'originality' in *Nouvelles de l'Estampe*,[24] first banned, then segregated the British entry. In 1966, the artist Michael Rothenstein paid a handsome tribute to Prater's work in *Frontiers of Printmaking*, saying the printer and the

artists around him were making a remarkable contribution 'that we could ill afford to lose merely upon the strictures of an outdated definition'.[25] But despite his vision and generosity, Rothenstein was clearly disturbed by the absence of human gesture – a position he reiterated the following year in an article called 'Look! No Hands.'[26] When *Frontiers of Printmaking* came out, Paolozzi was planning 'Moonstrips Empire News'. *Formika-Formikel*,[27] one of eight signed prints in this portfolio, shows a Disneyesque elephant of patterned plastic doing a balancing act in a field of coloured baubles. Paolozzi also defended his own and Kelpra's work in response to a *Guardian* article in February 1967. Announcing the imminent show of the engraver S. W. Hayter – who had defined no less than 'Five Degrees of Originality in Prints'[28] – the article called for a code of printmaking practice, declaring that Paolozzi's masterly portfolio 'As is When' was 'barely tolerated' by the Printmakers' Council.[29]

Kitaj, who worked regularly at Kelpra until leaving to teach in California in the autumn of 1967, was alive to all these issues. Earlier than most, he discovered the work of the German-Jewish writer Walter Benjamin, whose essay 'The Work of Art in the Age of Mechanical Reproduction' appeared in an English translation during the decade.[30] And not only did he collage into two of his graphic images[31] pages from the Print Council of America's booklet *What is an Original Print?*,[32] but between autumn 1967 and early 1968, he signed three letters to Prater – with whom he was now making prints by post – 'M. Rothenstein', 'Stanley Hayter' and 'Stanley W. Hayter' (Figure 14).[33]

14 Spoof signatures written by R. B. Kitaj on three letters to Chris Prater.

Kitaj has since explained his equivocal attitude to printmaking as a hatred of technology.[34] Yet technology, a skill acquired and passed on, applies equally to painting a canvas with a brush. 'Photomechanical screenprinting' is invariably invoked as if it were an automated procedure, yet when Prater and his wife Rose (née Kelly, hence Kelpra) began their business, its 'technology' was a kitchen table and home-made screens.[35] For a long time Prater could not afford a vacuum-base to hold his paper in place, and even at the height of Kelpra's fame, techniques remained so basic that he used only two gauges of mesh.[36] No matter how great the volume of work – at one time handled by twenty-seven staff – Prater did not believe in automatic presses, so every Kelpra print was pulled by hand.[37] Indeed, when he took on his first assistant, Christopher Betambeau, straight from school, his '60 x 40 hands' helped him secure the job.[38] But Betambeau – who became shop manager and later founded his own press – learnt not only from Prater's outstanding gift for colour, but the trickier task of finding technical solutions to match artists' intentions.[39] Choosing staff was also an aspect of Prater's sensibility: his other protégé was the brilliant cameraman Dennis Francis. Far from standard commercial procedures, Francis dreamed up strategies for individual artists. Innovatory gradations from the film's grain, and unusual half-tones, made by spinning images on an elderly gramophone, were among his many memorable inventions.

Prater believes Kitaj, and other artists commissioned by the ICA, were told to prepare collages for their first prints. In fact, ready-made images were far from ideal, for Prater did not yet have photography in-house, and the shadows cast by the layers made it difficult to obtain good photo-stencils. By 1967 the printer had devised a more flexible method, and he explained to *Studio International* that the materials for a Kitaj print had 'just arrived from California by mail as a page of instructions, a small pencil sketch, and about 20 photographs from newspapers and magazines. The first proof is the beginning on which we and Kitaj start working.'[40] Five years later, writing an epitaph for the 'original print', John Curtis gave a detailed account of a similar approach to the hauntingly beautiful *Outlying London Districts I*, 1971 (Figure 15). Comparing this image, created in terms of the medium, with those that merely imitated watercolours, Curtis applauded Kitaj for working 'in a genuinely original way'.[41] Even when finished collages were the jumping-off point – as for such early prints as *Errata* and *Acheson Go Home* – one could argue that, as distant relatives of Max Ernst's *Une Semaine de Bonté*,[42] the purpose-made maquettes were not so much 'originals' as means to a screenprinted end.[43] *Errata* was derived from a collaborative work that Kitaj had made with Paolozzi,[44] which featured repeated images of Christ's thorn-crowned head, overlaid with a fragment of Kitaj's painting, *The Murder of Rosa Luxemburg*, 1960 (Plate 8),[45] and a quotation from Isaac Babel, the masterly Russian-Jewish short-story writer, said to have been 'the greatest single casualty of the Stalin Terror'.[46] Part of this image became *Errata*'s background, yet in the print the dark mood of violence and tragedy is dispelled by children. Babel, Luxemburg and Christ all but disappear, under a flight of moths and butterflies, although one divine head survives,

mischievously grafted onto a tweed suit. The lepidopteran invasion stems from the pages of a painting book, signed and dated by several girls in 1907–9. Although a printed legend had instructed its users to dry the pages before closing the book, the insects came from Rorschach blots, which required the pages to be folded while wet.[47] With delicious inconsequentiality, the errata slip that provides the print's title reads: 'The film illustration on p. 16 is incorrectly titled *Three Little Girls in Blue*. This should, of course, read *Margie*, starring Jeanne Crain.'

It is Kitaj, expatriate and Jew, who emerges in *Acheson Go Home* – a print featuring propaganda that Kitaj picked up in the streets of Vienna while studying at the Akademie in 1951. Although Kitaj dates his conscious attempt to make a Jewish art from around 1970, his prints abound with earlier references. As he told David Cohen in 1990: 'Even in my Vienna days, I shuddered to think of my kind in those very streets a few years before.'[48] The propaganda he found, which attacked the Marshall Plan for attempting to buy Austrian blood with dollars, reminded Kitaj of blood already spilt in the city, and he used some of his own to stain his collage.[49] Around a central lexicon of *intaglio* mark-making are sunnier images – photos of Kitaj, the young ex-mariner, about to set sail in a pleasure boat, and Lemuel, the son he later had by Elsi Roessler, whom he courted in Vienna. He also used a marbled paper – a complexity brilliantly interpreted by Prater, with an unheard-of total of twelve colours.[50]

Kitaj's first suite, 'Mahler Becomes Politics, Beisbol' comprises fifteen prints based loosely on the composer. It sprang from meeting the American poet Jonathan

15 *Outlying London Districts 1*, 1971, colour screenprint, photo screenprint, 65.2 x 106.6.

Williams, when he gave a reading in Kitaj's Dulwich pub. Williams had written 'exercises in spontaneous composition', based on all forty-four movements of Mahler's symphonies, and Kitaj, working from the music, rather than the poems, viewed his own enterprise as 'a free-verse game to play in art'.[51]

Kitaj's situation as a displaced person, which he has called 'utterly American, longingly Jewish, School of London',[52] no doubt gave him an empathy for Mahler, who described himself as 'thrice homeless – as a Bohemian among Austrians, as an Austrian among Germans, and as a Jew throughout the world'. Hitler's banning of Mahler's music as 'Jewish trash' must have increased Kitaj's fellow feeling.[53] In the light of Mahler's pantheism (but Kitaj's lack of interest in landscape painting), *The Gay Science*[54] invokes nature by a partly opened window, saturated with the blues and greens of grass and sky, and covered with textual 'panes' of poetic writing about the natural world. Another stylised view of nature occurs in *Hellebore for Georg Trakl*, where the figure of a game-hunter in a forest – made to look to the right while his gun points to the left[55] – is overlaid with *Jugendstil* flower ornaments of the Mahler period. Trakl was an Austrian poet of fabulous illogicality, of whose work Wittgenstein said, 'I don't know what it means, but its tone delights me'.[56] (As Kitaj was to observe later: 'We are all looking for meaning in our lives, as if we'd know what to do with it once we'd found it'.)

While these two sheets obliquely address Mahler's feeling for nature, others, like *Nerves, Massage, Defeat, Heart*, 1967 (Figure 16), beat out a strong rhythm,[57] testifying to Mahler's 'underlying angst, anxiety, and fear',[58] which Kitaj expressed, partly by moving imagery from print to print.[59] The significance that railways had for Jews must lie behind the recurrence of rails, sidings[60] and even station canopies in Kitaj's pictures. In the painting *Where the Railroad Leaves the Sea*, 1964 (Figure 8), the girdered station roof[61] shelters a strangely vulnerable man and woman clasped in a passionate embrace. For Joe Shannon, this is 'a grieving picture', epitomising poignant farewells, and suggesting Jews 'separated forever from family and friends by crimes beyond human understanding'.[62] The canopy, the salt, sugar and wine glass from the couple's table recur in *What is a Comparison?*, 1964 (Figures 17 and 18) – one of the first prints of the suite that Kitaj completed.[63] In *For Fear*, the woman's head takes its place among fragments suggesting a gas mask, a seal, a stain and a Christ-like figure in a garden. The unforgettable print, *The Cultural Value of Fear, Distrust, and Hypochondria*, 1966, pictures an incandescent railroad running parallel to a row of rat's paws mutating into human hands (Figure 19).[64] *Go and Get Killed Comrade – We Need a Byron in the Movement* tells the story of Hans and Sophie Scholl, beheaded for their resistance to the Nazis;[65] their fate is symbolised by a figure – his head obliterated by a train – first seen in a Kitaj painting.[66]

In 1966, Kitaj was commissioned to draw baseball players for *Sports Illustrated*, and gradually the game infiltrated his prints.[67] Echoing Mahler's dislike of programme music, Kitaj told a Tate Gallery compiler that the suite had taken so long that he had become bored with the convention of finishing the series 'in the

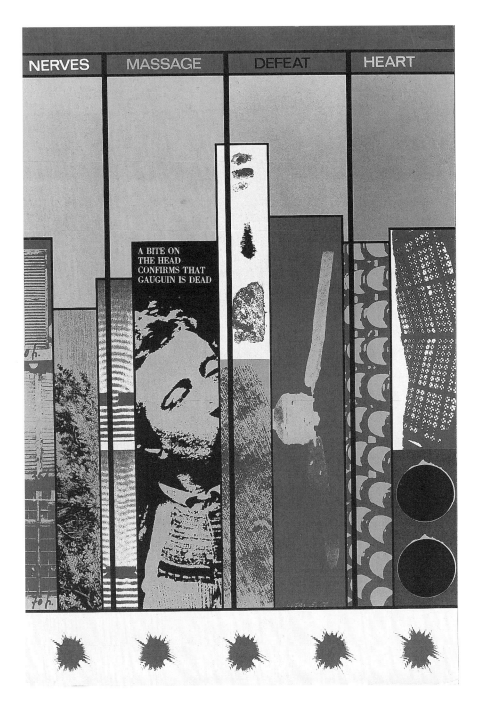

16 *Nerves, Massage, Defeat, Heart,* 1967, from 'Mahler Becomes Politics, Beisbol', colour screenprint, photo screenprint, 84.4 x 57.2.

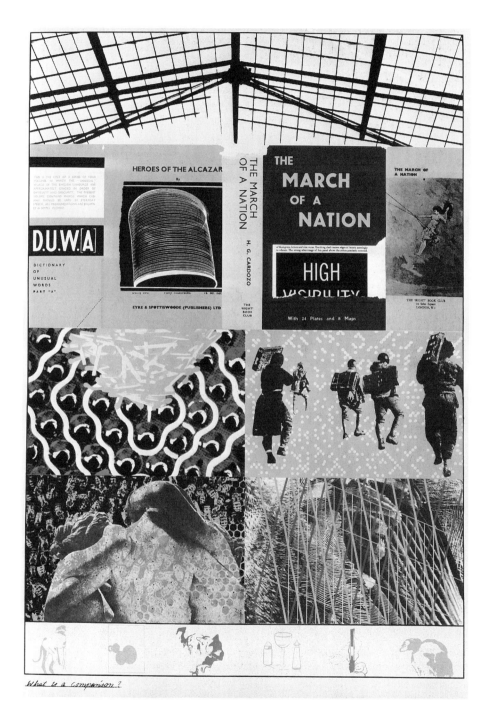

17 *What is a Comparison?*, 1964, from 'Mahler Becomes Politics, Beisbol', colour screenprint, photo screenprint, 71.8 x 50.0.

18 Sketch for *What is a Comparison?*, biro and red crayon on cartridge paper, 17.5 x 25.2.

19 *The Cultural Value of Fear, Distrust and Hypochondria*, 1966, from 'Mahler Becomes Politics, Beisbol', colour screenprint, photo screenprint, 42.6 x 69.0.

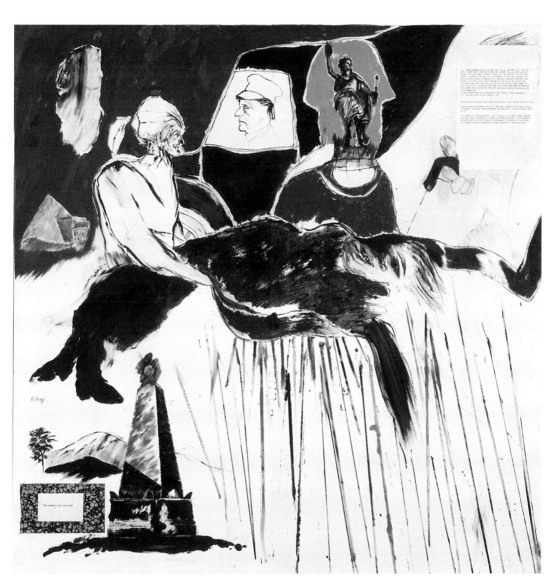

8 *The Murder of Rosa Luxemburg*, 1960, oil on canvas, 152.4 x 152.4.

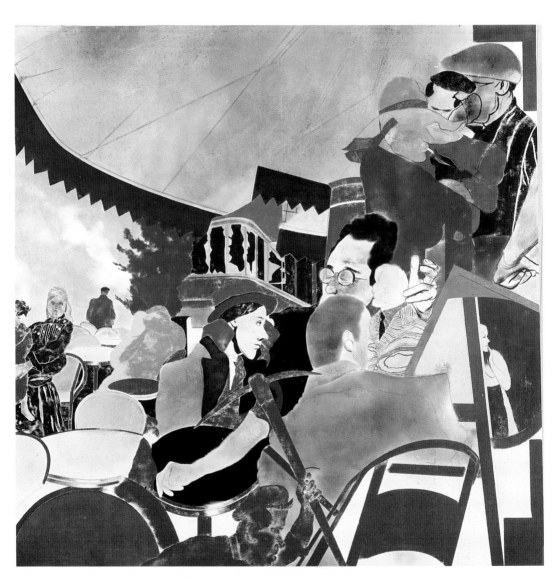

9 *The Autumn of Central Paris (after Walter Benjamin)*, 1972–73, oil on canvas, 152.4 x 152.4.

same spirit in which it had begun'.[68] *His Every Poor, Defeated, Loser's, Hopeless Move, Loser, Buried (Ed Dorn)*, 1966 pitch (Figure 20), suggests an aerial view of a baseball pitch and includes a trichomatic halftone[69] taken from Kitaj's photograph of a player, and a Chaplinesque figure, slinking off, as if dismissed from a game.[70]

Although a substantial catalogue for an exhibition was devoted to the Mahler suite in Hamburg,[71] only a few of the images now meet with Kitaj's approval.[72] He still looks with some satisfaction, however, on the ten sheets of 'First Series: Some Poets' made between 1966 and 1970,[73] most of which feature post-Pound American writers associated with Black Mountain College.[74] Each is based on a portrait drawn in paint on canvas, which Prater interpreted by screen.[75] Some heads are simply presented with metrical or ordering devices – rulers, calibrated in eighths, which frame *For Love (Creeley)*; an index card for *Kenneth Rexroth*; a series of rectilinear intervals for *Deerskin (John Wieners)*; and areas of varied proportions for *His Every Poor, Defeated, Loser's, Hopeless Move, Loser, Buried* (*Ed Dorn*). Charles *Olson* – conversing with whom is said to be 'like talking to a flame-thrower'[76] – enjoys a more exotic treatment. His name is spelt out in bullet holes (Figure 21). His leonine head, placed against a field of royal purple, gazes towards a telephone dial bearing only the alphabet, and no numbers.[77] The only British poet, (apart from Auden, who became an American) is the Scot Hugh MacDiarmid. Seen in the same frame as soldiers running through snow, his head touches lofty mountains. The title *Revolt on the Clyde (Hugh MacDiarmid)* suggests the poet's campaigns, both literary and political, to regenerate Scots poetry and found the Scottish National Party; he felt Kitaj caught his 'anguish at the modern world'.[78]

Making prints by post is not, on the face of it, a promising scenario, but some of the most striking and complex portraits of poets were achieved by Kitaj while he was living on the Pacific coast – a feat that would have been impossible without previous experience at Kelpra. Surviving letters and instructions show how paintings, photographs, sketches and proofs went back and forth across the Atlantic until Kitaj was satisfied with the results (Figure 22). For *fifties grand Swank: (Morton Feldman)* (Figure 23), Kitaj actually sent Prater a blob of orange paint to try on Feldman's nose, and it ended up in print on half the edition. The invocation of brilliance exceeding that of the sun expresses Kitaj's regard and affection for *Star Betelgeuse* (*Robert Duncan*) (Figure 24), whose portrait was one of the most intensely worked. Kitaj's first communication was a sketch to show Prater the disposition of the component images (Figure 25). These included an 'orthodox' portrayal of Duncan's head (which Kitaj asked to have proofed in MacDiarmid brown), and a second head derived from the same oil drawing, with a collage enlargement of the poet's eyes, (which he asked to see both in black and dark blue). Requesting an elegant white hand-made paper, the artist told Prater that he could crop or shave, as he felt fit, the three black-and-white photos enclosed – of a library, of Jess Collins, the poet's companion, and of a hand holding a rock. In a later airletter, Kitaj suggested the 'orthodox' head should be varnished, and the collage opposite flipped, so that Duncan's more complex image faced right. It is evident from Kitaj's 'thrilled'

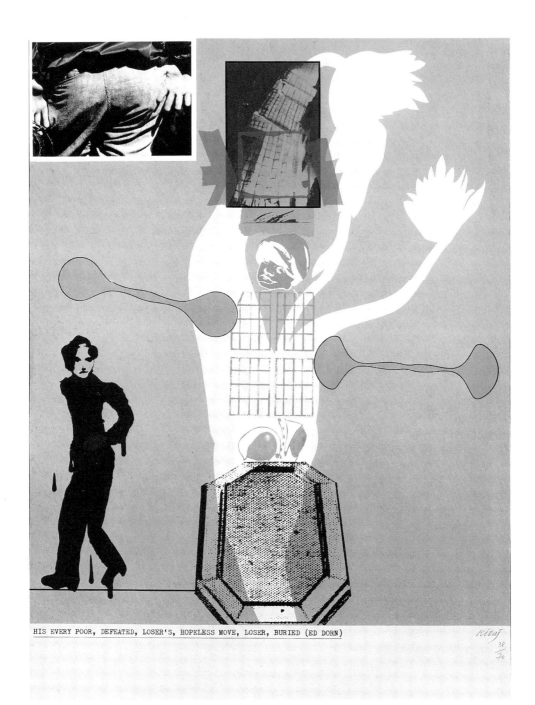

HIS EVERY POOR, DEFEATED, LOSER'S, HOPELESS MOVE, LOSER, BURIED (ED DORN)

20 *His Every Poor, Defeated, Loser's, Hopeless Move, Loser, Buried (Ed Dorn)*, 1966, from 'Mahler Becomes Politics, Beisbol', colour screenprint, photo screenprint, 76.6 x 50.4.

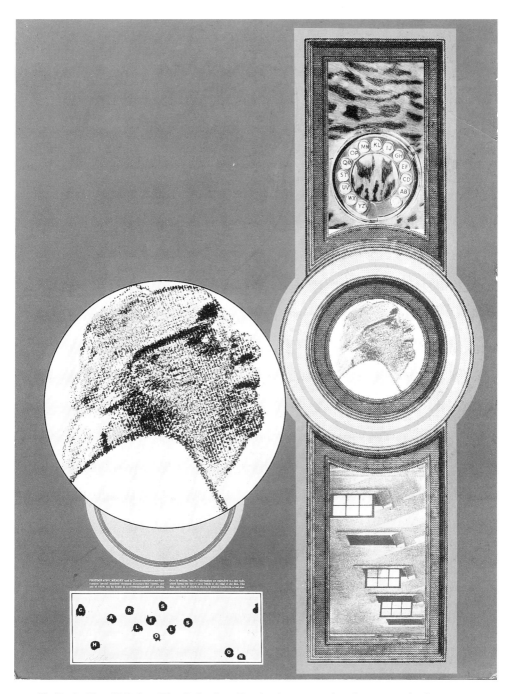

21 *Charles Olson*, 1969, from 'First Series: Some Poets', colour screenprint, photo screenprint, letterpress, collage, 76.2 x 57.2.

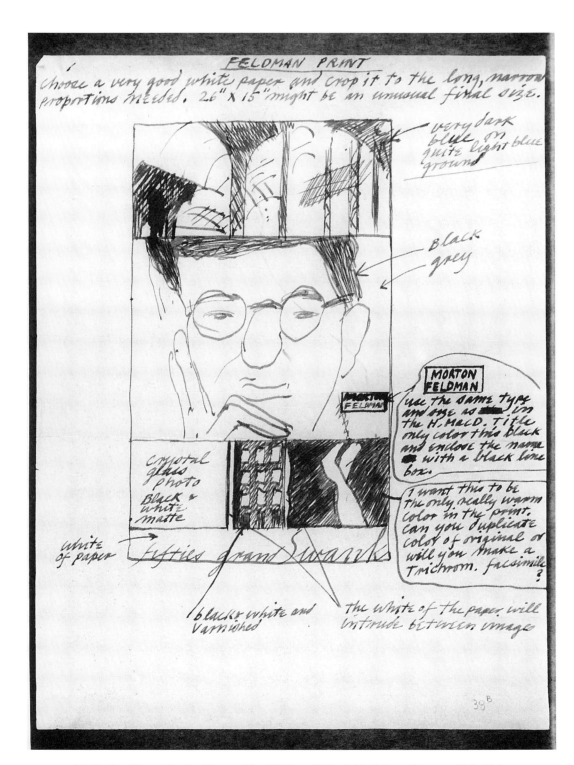

22 Sketch and instructions for *fifties grand Swank* (*Morton Feldman*), blue ink on yellow paper, 27.5 x 21.4.

Dear Chris

Two things; Please make
me a bromide of the enclosed
illustration of blindfolded couple.
and — on the FELDMAN portrait
— please do that print as soon
as you've finished the Duncan....
I want to try a _version_ of
the FELD man with a blob of
paint right on his nose
— say, bright orange and so I
also enclose a blob of paint for
you — send me proofs with
the paint on the nose and also
ones without.

I guess
you will
have to Enlarge
my enclosed
orange spot?

orange
paint spot

(print an
orange WHITE
first and then
the bright orange
on top of that??

←PTO

(15.)

23 Sketch and instructions for *fifties grand Swank* (*Morton Feldman*), blue ink on white paper, 20.3 x 12.3.

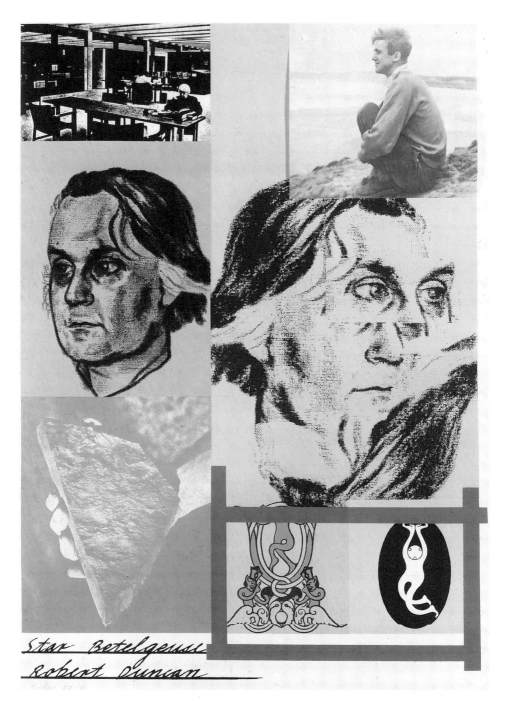

24 *Star Betelgeuse* (*Robert Duncan*) 1968, from 'First Series: Some Poets', colour screenprint, photo screenprint, 77.8 x 55.8.

25 Sketch and instructions for *Star Betelgeuse* (*Robert Duncan*), blue ink on white paper, 27.5 x 21.4, undated but c. Spring 1968.

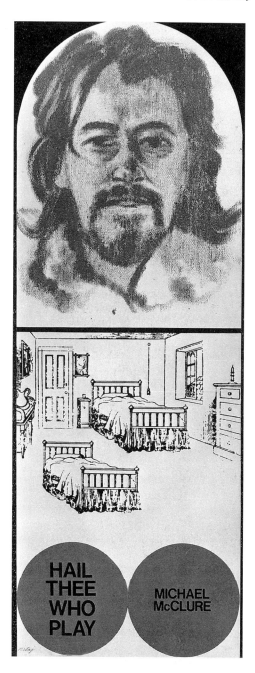

26 *Hail Thee Who Play* (*Michael McClure*), 1969, from 'First Series: Some Poets', colour screenprint, photo screenprint, collage, 83.8 x 35.4.

response to proofs, that Prater sent more alternatives than requested, for Kitaj suggests using all three variants of the collaged version, and approves the 'much *sharper*' printing of the other, interpreted by Prater in black on brown.

The artist asked for the snapshots to be less grainy, for that of Jess Collins to be changed to a 'good warm brown', and for the hand holding the rock, to be printed in 'pale, dull colours' – like the samples of green and yellow he enclosed. Around the ornaments at the print's base, described by Kitaj as 'goop cartoons', he asked for a 'bright blue frame', its placement indicated on an enclosed tracing.[79]

The portrait of Michael McClure, 1969 (Figure 26), was tackled by post a year later, and was made in a tall format, like that of Feldman. Kitaj asked for his oil drawing to be printed in grass-green on violet, above two red discs, one carrying the poet's name, the other the legend 'Hail thee who play', in a typeface suggesting McClure's declamatory manner. Later, Kitaj added the picture of a bedroom from a child's book, alluding to McClure's play *The Cherub*, which was staged in Berkeley in 1969, and featured a bed as an actor.[80] Although McClure's portrait is perhaps the least satisfying of the group, it gave birth to the sublime *Bedroom* in 1971. Printed in the close-toned shades of night-time, the composition's colours were modified by overlays suggesting stained glass.[81]

Concurrently with the poets, Kitaj worked on a number of single prints, including the masterpiece *Ctric News Topi*, 1968 (Figure 27),[82] about the dancer Josephine Baker. A brilliant conception, the subject is quintessential Kitaj,[83] for Baker – best known for appearing at the Folies-Bergères clad only in a suggestive girdle of

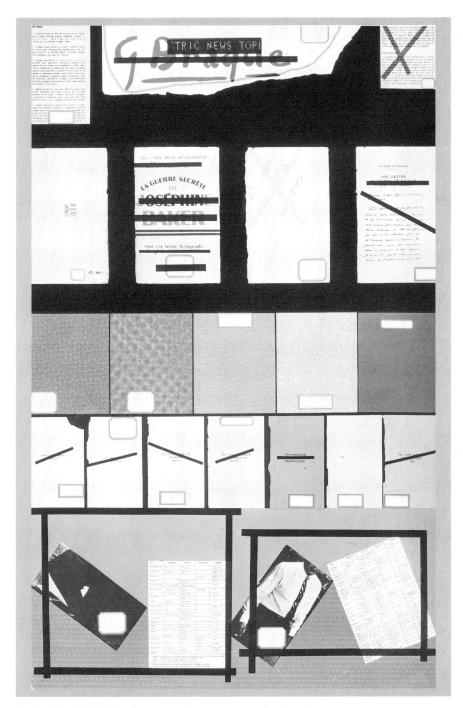

27 *Ctric News Topi*, 1968, colour screenprint, photo screenprint, 99 x 62.4.

bananas – was the daughter of a black American mother and a Jewish father. Kitaj alludes to Baker's scandalous reputation by tables detailing statutory penalties in each American state for offences from fornication to sodomy. The print's real subject, however, is Baker's 'secret war', referred to by the cover of a book. Kitaj enters into the spirit of its title, by blacking out with tape, blank labels and cancellation marks, Baker's other life as a heroine of the French Resistance.[84]

Kitaj worked on another suite while he was in California. It began life as 'Horizon/Blitz', but was later renamed 'Struggle in the West: The Bombing of London'. In an airletter of August 1967 (Figure 28), Kitaj told Prater the theme was 'London during the Blitz'. With an eye to the zany, Kitaj had already conceived the 'prologue', which was to feature the contribution to the war effort of four literary gentlemen – whose simulated photos were to be pasted, side by side, on a fancy paper called 'Burma Lizard'. One was of Cyril Connolly, 'leader of the literary avant-garde', who founded *Horizon* in 1939 to keep contemporary literature alive during the war. The others were the poets Louis MacNeice and Stephen Spender, captioned respectively as 'BBC script writer' and 'fireman', and the Rt. Hon. John Strachey, later an Under-Secretary of State, who was introduced as an 'Air Raid Warden'. Kitaj explained to Prater that the three prints planned for the set were intended to depend on each other, 'and be like *one* work'. The prologue, he said, 'would not really be a print, but a vehicle for the photos in association with

28 Sketch for *Horizon/Blitz*, prologue to 'Struggle in the West: The Bombing of London', flap of airletter, franked by Berkeley, CA, 18 August 1967.

two proper prints – with some complexity'. He wanted the '2nd Blitz sheet' to be 'real CRAZY in terms of all those slices of pasted down fancy paper [and] *the* most extraordinary colour job (complicated) that we've ever done'.[85] Kitaj enclosed a diagram, indicating a border of decorative papers, and the distribution of sixteen found images, which he asked to have posterised and printed. He wrote:

> Go for contrast – use a deep purple and a complementary yellow on one image, a flat orange and a khaki green on another etc. On the corners You might obliterate the sense of the tiger skin[86] pattern by using two strong contradictory colours … like bright red and green etc. I'll leave it to you to find strange mixtures and I can correct what I don't like.

'Blitz sheet three', at one time called 'An Exhortatory Letter to the English' (Figures 29 (a) and (b)), did not survive its early proofing. Kitaj's oil drawing in earth colours featured a dog like an evacuee with a label around its neck, sitting on a tilted plane suggesting a ship's deck, near a game of quoits and a bath full of water.[87] A painting called *Goodbye to Europe* closely resembles Kitaj's sketched instruction to the printer.[88] Having decided 'Blitz sheet three' was a non-starter, Kitaj based an alternative on pages from a book in his collection called *On the Safeguarding of Life in Theatres: Being a Study from the Standpoint of an Engineer.* The print brings together the title-page designs for fire escapes and smoke vents, and charred fragments showing the effects of fire on many different kinds of materials.[89] The title-page, however, defuses the subject's deadly seriousness with a bizarre and inappropriate cartoon, depicting a theatre-goer in evening dress, on fire, propelled into a pool of water by the powerful, jet of a fireman's hose. These antithetical contrasts – the very stuff of life in wartime – are also found in the '2nd Blitz sheet', whose title, *Die gute alte Zeit*, (*The Good Old Days*), 1969 (Figure 30) derives from the accidental juxtaposition of the legend beneath a poster of Hitler on a German street. The 'found' images, contrast the soft and vulnerable with the hard and destructive, but among them is the picture of a man whose entire house has been reduced by bombs to little more than a doorstep, on which the milkman has nevertheless remembered to leave the milk. Even the pre-history of the war is encapsulated in a double image – as profound as a metaphysical conceit – where the unemployed in the sepia dole queue become the employable, waiting to enlist. As Kitaj explained to Timothy Hyman: 'picturing people and aspects of their time on scorched earth … was what I always wanted to represent'.[90]

It is only recently that Kitaj has actively discouraged the showing of his early prints, and, by extension, inhibited their sale. Marlborough Fine Art, who published the greater part of his graphic output, were given a list in mid-1990 naming only 37 'preferred' pieces from some 140 images still in stock. A similar limitation was initially placed upon a book about the prints, written by a curator in the department I set up at the National Gallery of Australia. Australia purchased most of Kitaj's screenprints in 1980, but by 1985, when the artist made a gift of his more recent lithographs and etchings, the Gallery owned practically every print he

29 (a) and (b), Sketch for sheet 3 of the *Horizon/Blitz* portfolio, 'An Exhortatory Letter to the English', later abandoned. Biro on both sides of a sheet of torn blue airletter paper headed 'Berkeley: Department of Art', 27.5 x 21.4, n.d., c. early 1968.

on the white card dangling from the top of the pole –
print the enclosed illustration of the woman in the red dress.
~~~~ print a very dark brown or black brown and then the red
superimposed on the dress like in the picture ( maybe your registration
of the red will be better than the original!)
also – print the illustration perfectly vertical, parallel with the
sides of the sheet and not with the tilt of the card.

enlarge the illus. until
the whole space of the
card is filled cropping
the illust. where you must

leave this circular tab margin
white

on the card around the
dog's neck print a flat
tan and then print the
enclosed drawing of legs
in splints. leave the round
tab white.

this image will have
to be enlarged of course
from the original

white

tan

black

and
right here
supply a
black horizon line
about ⅛" thick
across & behind the
image. and perpendicular
to it and to the sides of
the sheet even though
the card tilts.

THE WHOLE
PRINT TO BE
REVERSED!

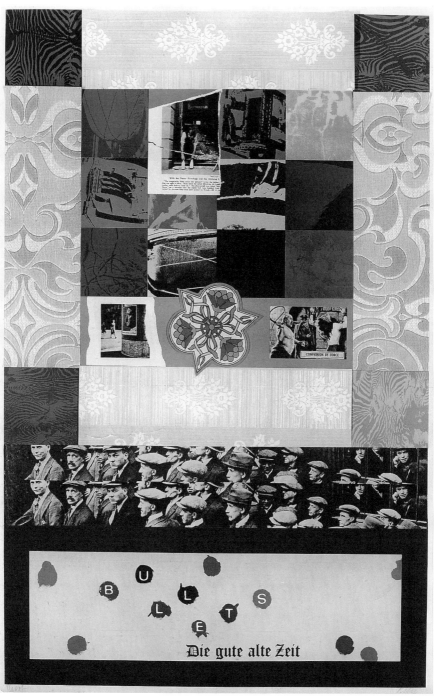

**30** *Die gute alte Zeit (The Good Old Days)*, 1969, from 'Struggle in the West: The Bombing of London', colour screenprint, photo screenprint, 98.4 x 63.4.

had ever made. Yet, even as he rounded out the national collection, Kitaj wrote diffi-
dently: 'Perhaps it is not a wonderful gift … I am not a great printmaker',[91]and he
added that he did not want a one-man print exhibition. The compromise was a two-
man show, mounted as a part of a 'British Season'.[92] It was while researching Kitaj
for the exhibition that Jane Kinsman developed her enthusiasm for the artist's work
and wrote a book about him including a complete checklist of his prints.[93]

A widespread tendency to accept the artist's negative evaluation of his graphic
art has undermined the published monographs about him.[94] In the Hirshhorn
catalogue of 1981 Shannon said that, although Kitaj's prints were felt to be 'a major
part of his oeuvre', the organisers had decided 'it would suffice to concentrate on
the paintings and drawings'.[95] To all intents and purposes, prints are also excluded
from Marco Livingstone's *Kitaj*, which mentions one or two titles, but makes little
attempt at analysis. Indeed, screenprinting is flatly described 'as a way of recycling
ready-made images by means of photomechanical reproduction', while the artist
is quoted as saying that his 'most extreme acts of ordinary modernity' were two
series of screenprints 'In Our Time' (1969) and 'A Day Book [for Robert Creeley]'
(1971).[96] Although Livingstone goes on to describe 'In Our Time' as 'a vivid record
of the artist's preoccupations, in the next breath it is damned as one of his 'most
blatant excursions into "Duchampism"'. The graphic work, graced by only two
marginal illustrations, is finally dismissed as 'much admired' but in the artist's eyes
'of only peripheral interest'.

The Tate Gallery, which owns most, if not all, of Kitaj's screenprints, failed to
convince the artist of their worth, and to include them in his 1994 retrospective.[97]
Yet, spelling out the Gallery's new policy to acquire modern prints in 1972,[98] the
author of the bi-annual report cogently argued that knowledge of the graphic art
was essential to understanding an artist's work. Citing Kitaj as an artist whose work
had been recently acquired,[99] the writer stated that 'in no case is it possible to make
a meaningful separation between the vision [artists] express in the print medium
and that embodied in their painting … The more recent the period … the more
absurd it becomes to isolate an artist's contribution in one medium from that in any
other'. And the report noted that the Tate would shortly receive, as a gift from the
Institution of Contemporary Prints, 'the most important work done in Britain in
this field since the war'.[100]

Happily, although the Tate did not exhibit Kitaj's prints in 1994, a show of them
was mounted to coincide with his retrospective by the Victoria and Albert
Museum.[101] The Victoria and Albert Museum's impressions of Kitaj's screen-
prints were purchased almost as soon as they were made, by Carol Hogben, who,
with his discriminating eye, collected for the Museum's still-lamented Regional
Services (or Circulation) Department.[102] He acquired not only 'In Our Time', and
the preparatory collages for *Errata* and *Acheson Go Home*, but 'Mahler Becomes
Politics, Beisbol', 'First Series: Some Poets' and 'Struggle in the West'. Despite
the artist's continuing reluctance to allow all fifty sheets of 'In Our Time' to be
exposed as she had hoped, the curator Rosemary Miles skilfully negotiated a show

with a fine balance between the early work and the more recent prints given by Kitaj to the museum.

It is 'In Our Time: Covers for A Small Library After the Life for the Most Part' that Kitaj seems mostly to have in mind when he talks of his 'post-Duchampian temptations' as if his inspired selection of fifty book-covers was somehow 'ready-made' (Figure 31).[103] Even 'assisted' ready-mades by Marcel Duchamp were essentially mass-produced manufactures, presented as found. In the case of Kitaj's eclectic library, the set – and it is only as a complete entity that it can really be judged – was critically re-presented through the screen, and it effectively constitutes a portrait of the artist, and a unique insight into his view of the twentieth century, reminding one of Benjamin's free-floating surreal collages of quotations, by means of which he hoped to capture 'the portrait of history in the most insignificant representation of reality'.[104] An analysis of the titles Kitaj chose reveals the same fascinations as his other works – the literary and poetical, the left-wing political, the sociological, as well as the farcical and allegorical. Why else would he present the City of Burbank's final annual budget – on the cover of which a typical American nuclear family rejoices in its firemen and police force? Or *Reklame durch das Schaufenster (Advertising Through the Shop Window)*, 1969 (Figure 32), which Kitaj says refers to the *Kristalnacht*, 'when Nazis shattered the shop windows (into crystals) of Jewish-owned stores'.

31  *O'Neill*, 1969, from 'In Our Time: Covers for a Small Library After the Life for the Most Part', colour screenprint, photo screenprint, 34.4 x 45.6.

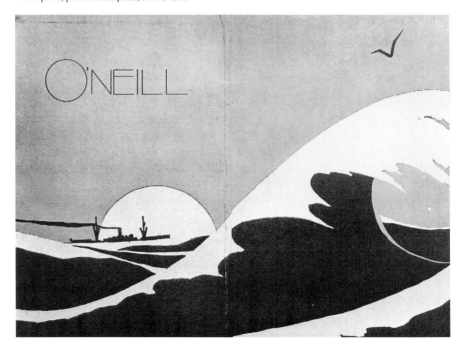

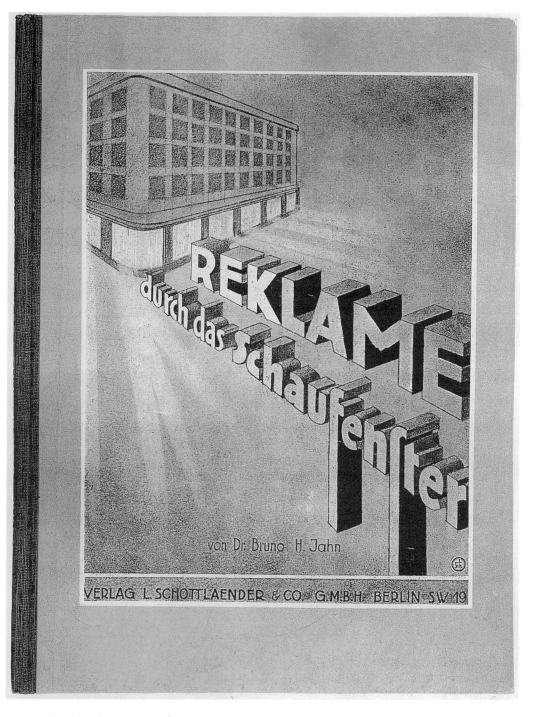

**32** *Reklame durch das Schaufenster (Advertising Through the Shop Window)*, 1969, from 'In Our Time: Covers for a Small Library After the Life for the Most Part', colour screenprint, photo screenprint, 57.4 x 43.2.

As to being 'ready-made', surviving letters show that while Kitaj was often delighted with Prater's first proofs[105] several of the covers were fastidiously edited, not only for formal and aesthetic reasons, but to imbue them with meaning. For example, Mark Rothko's name was reversed and reprinted over its first imposition on the cover of a Marlborough catalogue, signifying the artist's suicide by his name's cancellation of itself. *China of To-Day: The Yellow Peril*, 1969 (Figure 33), received its emblematic power by the suppression of all other typography, while the starkly minimal cover for *Edward Weston* was presented vertically instead of horizontally. The last three titles were abandoned because they lacked 'the *HEROIC* quality I want, which we got in the *Gorky*, The Kenneth *BURKE*, The *Songs of a Sourdough*, and the *transition*'.[106]

Shannon believes Kitaj's greatest strengths lie not in his naturalism or his realism, but in 'his modernism, his mannerism, his restless impurity, his eclecticism'. Other critics have noticed that even in recent paintings, it is collage that informs 'the disjunctures, the shifts of scale, the incongruity and sudden jumps and cuts'.[107] The fact is, however much he resists it, Kitaj's collaged screenprints delight the world that received them. Whatever he does in the future, he cannot unsay the past.[108]

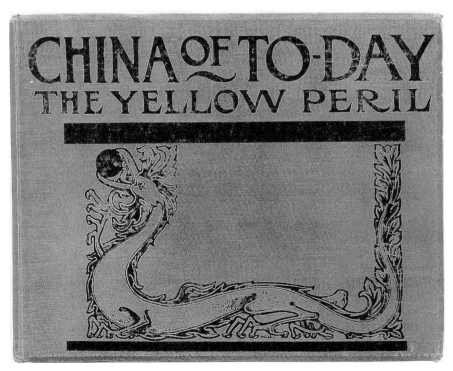

33  *China of To-Day: The Yellow Peril*, 1969, from 'In Our Time: Cover for a Small Library After the Life for the Most Part', colour screenprint, photo screenprint, 45.6 x 58.0.

# 6

# The history behind the surface: R. B. Kitaj and the Spanish Civil War

## Simon Faulkner

Sirs and Senoras, let me tell you a story.
A story neither of long ago nor faraway
But close enough now and to you unhappily.
We will call it Going-Into-History
And you all know History is a cruel country

Ewart Milne, 'Thinking of Artolas' (1940)[1]

A number of paintings produced by R. B. Kitaj during the early 1960s represent figures and events significant to the history of the European Left since the mid-nineteenth century. Amongst these works are *The Red Banquet* – which includes images of the Russian anarchists Michael Bakunin and Alexander Herzen – and *The Murder of Rosa Luxemburg* (Plate 8), both painted in 1960. Also part of this loose theme within Kitaj's early work is the painting *Kennst du das Land?*, 1962 (Figure 34), with which the current essay is concerned. Within these paintings Kitaj used the history of political radicalism as an archive from which motifs and references were selected as the basis for the composition of complex images. A significant aspect of some of these early works, and in particular of *Kennst du das Land?*, is the way in which they form equivalents for the formations of historical knowledge. In part *The Murder of Rosa Luxemburg* represents the histories central to German national identity, presented in the form of various public monuments.[2] The format of the painting as a montage of motifs constitutes a pictorial equivalent for the constructed nature of national consciousness and the dependence of national identity upon the retrospective production of a national lineage. *Kennst du das Land?* presents a less obvious representation of historical knowledge. Like the figure of Rosa Luxemburg, the German revolutionary murdered by the *Freikorps* in 1919, in *The Murder of Rosa Luxemburg* the central motif of *Kennst du das Land?* refers to an historical event, in this case the Spanish Civil War, but here the composition of the painting addresses the elusiveness of certain memories rather than the manifestation of memory in the form of national symbols.

In this essay *Kennst du das Land?* will be interpreted in relation to collective memories of the Spanish Civil War primarily in the United States and England. In this context 'collective memory' is taken to define those representations of the past which are part of the shared consciousness of a social group, involving popular discourses, monuments, festivals, media images, and even academic and official histories.[3] Thus my conception of collective memory does not involve the distinction between popular memory and history which has defined some of the debate in this area of academic study.[4] Here memory and history are taken to be intertwined. It should also be noted that collective memory is a process, memory is struggled over, produced, reaffirmed and in some cases erased. In these terms collective memory can often be factionalised. The essay proposes an understanding of *Kennst du das Land?* as a representation of the processes of remembering involved in certain historical articulations of the Spanish Civil War. The essay locates Kitaj's painting within history in two interrelated ways, in its specific historical context as a work of art in the early 1960s, and within history as a set of discourses on the Spanish Civil War. This complex positioning of *Kennst du das Land?* within history, as both context and historical discourse, enables the drawing out of those meanings established by the connections between the painting and wider historical formations. In making such a contextualisation there is a danger of giving the painting a historical load it was not meant to bear. But this is a risk worth taking if it allows for a better understanding of the relationship between *Kennst du das Land?* and wider sedimentations of historical knowledge, than that which is presented within the existing literature on Kitaj's oeuvre.[5]

### History painting

The lack of pictorial depth presented by the painted and collaged surface of *Kennst du das Land?* is characteristic of 'advanced' painting produced in London during the early 1960s. The painting is both literally flat in that its figurative elements tend to reinforce, rather than undermine, the pictorial flatness of the painting, and iconically flat in that its self-consciously flat configuration make reference to the currency of radical abstraction within the field of contemporary painting. Specifically, the painting can be located within the body of work produced by young painters at the Royal College of Art between 1958 and 1962. Along with Kitaj, these artists were, Pauline Boty, David Hockney, Peter Phillips, Patrick Caulfield, Allen Jones and Derek Boshier. In many of their works a general commitment to flatness, as the dominant sign of painterly radicalism at this time, was worked in relation to motifs taken from media and consumer culture, history and subcultural lifestyles. In particular, Kitaj's paintings during the early 1960s referred to concerns with political history, art history and literature. Thus Kitaj's early practice stood in a critical relationship to the anti-literariness of the forms of abstract art supported by art critics such as Clement Greenberg in the United States and Lawrence Alloway in England.[6] Alloway in particular championed a

range of abstract painting practices, from work influenced by Tachisme and Abstract Expressionism in the mid- and late 1950s to the work of the Situation artists in the early 1960s.[7] Such forms of radical abstraction gained a priority on the London art scene for artists interested in contemporary modernism during the mid-1950s and especially after the 'New American Painting' exhibition at the Tate Gallery in 1959.

In contrast to these forms of ostensibly Americanised modernism, Kitaj's paintings addressed some of the contradictions of modernist art practice which had existed in Europe prior to the Second World War. Kitaj's paintings from the early 1960s which deal with history of the European Left represented an attempt to engage with the loose European tradition of critical history painting defined by works such as Theodore Géricault's *Raft of the Medusa*, 1819, Gustav Courbet's *The Artist's Studio*, 1855, and Édouard Manet's *The Execution of the Emperor Maximilian*, 1867. This already etiolated tradition foundered in the mid-twentieth century with the ascendency of 'American type' modernism in Western art practice.[8] But the contradictions of representing a historical and political subject matter through a radical modernist technique were already apparent in Picasso's response to the Spanish Civil War, *Guernica*, produced in 1937. Kitaj's early historical works attempted to re-engage with the concerns present in Picasso's painting. But Kitaj's relationship to the practices of critical history painting was limited by his historical position after Abstract Expressionism. In order to understand the significance of this particular juncture in twentieth-century art, it is useful to contrast *Guernica* with the paintings produced in memory of the Spanish Republic by Robert Motherwell between the late 1940s and the 1980s under the generic title *Elegy to the Spanish Republic*. In these works the mediation of historical events through artistic practice reduced them to personal feelings. Such feelings may well have been generated through an engagement with political history. For example, Motherwell heard André Malraux speak on the subject of the Spanish Civil War during the conflict, but all explicit historical content is absent from the paintings themselves.[9] The drive towards personal expression and abstraction which defined the 'triumph' of American painting also resulted in a general marginalisation of explicit concerns with historical and political content within modernist painting.[10] Although working after the transformational moment of Abstract Expressionism, Kitaj attempted to reassert explicit forms of political and historical knowledge in his painting. The contradiction between Kitaj's interests in history and the formalist reading of modernism current in certain avant-gardist circles during the early 1960s was brought to the fore in his exhibition 'Pictures with Commentary, Pictures without Commentary', held at the Marlborough New London Gallery in February 1963, the catalogue to which included commentaries on paintings and a bibliography.

The figurative motifs used by the Royal College painters were often distributed across the surface of their paintings so that they were congruent with, or at the very least not contradictory to, the generic 'abstract' field which formed the base

of the composition. This emphasis on working flatness as a sign of modernist abstraction in relation to figurative motifs found its precedent in the flag, target and number paintings which Jasper Johns produced in the mid-1950s.[11] This precedent was continued in the work of the American painter Larry Rivers, who had visited the Royal College in autumn 1961,[12] and in the paintings of the English artist Richard Smith between 1960 and 1963. These practices established in the United States and England between the mid-1950s and early 1960s marked a moment in which the claimed autonomy of mainstream postwar modernism was contested in an attempt to reinvest modern art with some form of engagement with the vernacular world. Kitaj's attempts to produce history paintings were part of this moment.

*Kennst du das Land?* (Figure 34) bears a formal resemblance to Johns's painting *Target with Plaster Casts*, 1955. This work involves a target motif depicted on a

**34** *Kennst du das Land?*, 1962, oil on canvas, 122 x 122.

square canvas, above which a number of recessed boxes have been fixed. These boxes contain various plaster-cast body parts. Kitaj reproduced this format by dividing his canvas horizontally into two sections.[13] Similar formats were used by Peter Blake, David Hockney, Peter Phillips and Pauline Boty.[14] The lower area of *Kennst du das Land?*, covering approximately three-quarters of the work, presents a winter battle scene from the Spanish Civil War depicted in thick white paint over a darker ground. The white overpaint appears to have been smudged and smeared with a wet cloth.[15] This area also contains a number of motifs, painted in such a way that they are consonant with the emphatic surface of the work: two simple lemon symbols and a star-like badge, possibly a US marshal's badge. Depicted within the star is a marching leg and booted foot, around which have been painted red, blue-grey and brown horizontal bands of differing thickness, which could represent a road.

The upper section of the painting is differentiated from the lower area by a monochrome white ground, upon which four other motifs have been painted and collaged. The first and third motifs involve pieces of unevenly torn brown paper upon which have been painted or printed ambiguous shapes in black paint, the oil from which has soaked into the paper. These collaged elements were perhaps taken from a larger composition on paper. The use of these fragments of a former work is consistent with the general concern with memory which structures *Kennst du das Land?*. These motifs also function in a similar way to the repeated brushstrokes and drip-marks in some paintings by Jasper Johns and Robert Rauschenberg produced in the mid-1950s. In Rauschenberg's paintings *Factum I* and *Factum II*, 1957, brush strokes and drips are repeated between the two works as a means of problematising the notion of expressive spontaneity central to Abstract Expressionism. Johns's paintings present a parody of painterly spontaneity in the form of small repetitous brush strokes defined by the technical limitations of quickly cooling and hardening encaustic paint. In *Kennst du das Land?* the collaged fragments undermine the sense of spontaneity present in the white brush strokes and smears in the lower section of the painting, both through their apparent production by a form of block printing and by the fact that they are 'readymade' elements. This approach to 'expression' after Abstract Expressionism demanded a different kind of viewer than the works of Pollock or Rothko, a viewer not necessarily capable of resolving the contradictions within Kitaj's work, but capable of working within them. In Kitaj's early 'historical' works all content appears to be mediated through pre-existing representations. Everything is in some way second-hand. Thus the form of memory involved in works such as *Kennst du das Land?* was not the supposedly trans-historical memory represented in certain forms of Abstract Expressionism, rather it was the form of memory involved in the re-presentation of already existing images and ideas. The composition of *Kennst du das Land?* may have been unique and structured by an individualistic aesthetic, but it was also inscribed with a sense of social memory.

The second motif in the upper section of the painting is a line drawing of a woman pulling up her stocking depicted on a numbered piece of notepaper. This

image was derived from a drawing made by Goya between 1796 and 1797 in his so-called 'Small Sanlucar Sketchbook'.[16] The sketchbook was produced while Goya was visiting one of the Andalusian estates of the Duchess of Alba in Sanlucar. This intimate drawing was also transformed into an image of a prostitute in the seventeenth plate of the *Caprichos*, entitled 'It fits well'.[17] This appropriation of an image by Goya is fitting for the theme of a painting about the Spanish Civil War in that it refers back to a prior period of civil strife in Spain and to the practice of an artist associated with Spanish liberalism. The contrast between progress and reaction in Goya's time was analogous to the contrast between the liberal and socialist Republic and the conservative Nationalist insurgency during the Spanish Civil War.[18]

The motifs in the upper section of the painting, along with the lemons and the star, have been described by Kitaj in retrospect as 'various granadas (grenades/pomegranates)'.[19] This description links the significance of these images to the etymology of the word grenade used to describe a hand-thrown explosive device. In that this word derives from *granada*, the Spanish word for pomegranate, Kitaj's 'granadas' conjoin fruit and explosive. The import of this term could be that the motifs used in the painting are both potentially fecund and explosive in their meanings. Though perhaps the real significance of the term is its ambivalence, its function as a linguistic equivalent to Ludwig Wittgenstein's 'rabbit/duck' symbol, the meaning of which oscillates between the denotation of a fruit and the denotation of an explosive.[20] Thus Kitaj's description of the various motifs in *Kennst du das Land?* as 'granadas' refers to the ambivalence of the painting as a whole. This sense of ambivalence is not only the product of the obscurity of individual motifs, but more generally of Kitaj's attempt to articulate a historical theme in relation to a modernist mode of representation.

### Durruti on Old Bond Street

*Kennst du das Land?* represents Kitaj's sympathy for the former Spanish Republic and its leftist supporters during the Spanish Civil War. This affinity to the Spanish left between 1936 and 1939 was made plain by the inclusion of a photograph of the Spanish anarchist leader Buenaventura Durruti visiting the Aragon Front in August 1936, on the same page of the 1963 exhibition catalogue as the notes on *Kennst du das Land?* (Figure 35). This photograph was also displayed in the window of Marlborough's Old Bond Street gallery during the exhibition.[21] This use of an image of Durruti not only signified Kitaj's romantic attachment to the Spanish Republic, but also defined his sympathies for the extreme libertarian forces which were strongest in Catalonia during the war. These forces, comprised mainly of the anarcho-syndicalist trade union CNT (Confederacion Nacional de Trabajo) and the federation of militant anarchists FAI (Federacion Anarquista Iberica), pursued revolutionary libertarian policies during the early period of the war. Although it should be noted that Kitaj's nostalgic attachment to the Spanish

Durruti

6   **An untitled romance**  1961
    Oil on wood   29 × 9 inches

7   **Nietzsche's Moustache**  1962
    Oil on canvas   48 × 48 inches

    'In their reaction against Hitler's authoritarianism, German
    universities since the war are given to punctilious
    observation of democratic procedures; and during the
    past years the faculty of one great university after another
    had to reject by solemn vote an offer for the sale of –
    Nietzsche's moustache, allegedly severed from the corpse
    before burial.'
    —from *Nietzsche and the Seven Sirens* by Walter Kaufmann
    Partisan Review   May–June, 1952

8   **Kennst Du Das Land?**  1962
    Oil on canvas; with collage   48 × 48 inches

    'Know'st thou the land where lemon-trees do bloom,
    And oranges like gold in leafy gloom;
    A gentle wind from deep blue heaven blows,
    The myrtle thick, and high the laurel grows?
    Know'st thou it, then?
                        'Tis there! 'tis there,'
    —Goethe, from *Wilhelm Meister* in Carlyle's translation

    **In Memoriam**
    Jarama River
    Brunete
    Quinto
    Belchite
    Teruel
    The Aragon Retreats

**35**  Durruti, *R. B. Kitaj Pictures with Commentary Pictures without Commentary*, exhibition catalogue
(London: Marlborough Fine Art Ltd.), 1963, p. 6.

Civil War was in part structured around the history of the communist-organised International Brigades and other communist figures,[22] this concern was highly romanticised, with an emphasis on the International Brigader as adventurer and anti-fascist, rather than as member of the Comintern.

Kitaj's sympathy for the Spanish libertarians can be likened to the concerns of certain English writers during the war itself. George Orwell fought with the dissident communist party POUM (Partido Obrero de Unificacion Marxista) on the Aragon Front and had strong sympathies for the Catalan libertarians. Aldous Huxley expressed his solidarity with the Catalan anarchists in a questionnaire organised by the *Left Review* concerned with the political affinities of British writers in relation to the Spanish Civil War.[23] As Katherine Bail Hoskins observes, Huxley's liking for the anarchists was based on his attraction to their emphasis on individual liberty and political decentralisation,[24] as opposed to 'highly centralised [and] dictatorial Communism'.[25] Herbert Read also expressed solidarity with the Spanish libertarians, stating: 'In Spain, and almost only in Spain, there still lives a spirit to resist the bureaucratic tyranny of the state and the intellectual intolerance of all doctrinaires. For that reason all poets must follow the course of this struggle with open and passionate partisanship.'[26] In his book *Anarchy and Order*, first published in 1945, some of which was written during the Spanish Civil War, Read also defined the anarchist experiment in Catalonia as an exemplary model of libertarian social organisation in contrast to the 'instruments of oppression' established by the central Republican government as a means of fighting the war.[27]

Making a link between Kitaj and these writers highlights the anachronism of his historical concerns in contrast to the interests of other members of his artistic generation. In December 1956 the young abstract painters Robyn Denny and Richard Smith had published an open letter to the older artist John Minton in the Royal College of Art publication *Newsheet*, which stated: 'To your generation the thirties meant the Spanish Civil War; to us it means Astaire and Rogers.'[28] Here Smith and Denny were clearly referring to the activities of the former Artists' International Association (AIA) amongst the British supporters of the Republican government during the Spanish war.[29] It should also be emphasised that the Republican cause was an imaginative focal point for an artistic and literary generation on the Left in Britain during the 1930s.[30] In contrast to this generationally defined commitment to socialist politics and politically engaged art, Denny and Smith defined their concern with the 1930s in terms of popular media culture, reflecting their strong interest in contemporary urban culture during the mid- and late 1950s.[31] Kitaj's nostalgia for the Spanish Civil War and its libertarian moment stood in contrast to the concerns with contemporary culture presented by Denny and Smith in the 1950s, and other young painters at the Royal College in the early 1960s. It was this nostalgic optic, unique to Kitaj at the Royal College, which was central to his early self-formation as an artist.

Transcoded into Kitaj's discourse on art, anarchistic libertarianism, understood in terms of an emphasis upon radical individualism rather than collectivism,

especially during a period in which affiliations to anarchism had little political significance, could be mapped almost directly onto the persona of the Bohemian creative artist. 'Art', defined as exemplary of the human spirit in contrast to the spheres of industry, technology and commerce during the modern period, was established as an equivalent to the search for human freedom represented by the anarchist tradition. The kind of commitment to libertarianism articulated by Orwell, Huxley and Read was reconfigured by Kitaj as a form of romanticism which made a fetish of the figure of Durruti and used him as a historical reference point in relation to which a claim for cultural authenticity could be made. As James Aulich has observed, the 'Heroic Failures' of modern political history were conceived by Kitaj 'as the last bastions of liberal individualism' in the twentieth century,[32] a tradition of individualism which was experiencing rapid erosion in the postwar era of state corporatism, 'mass' culture and corporate capitalism. That anarchist libertarianism was important to Kitaj's thinking in the early 1960s was shown not only by such works as *The Red Banquet*, 1960, but also by his painting *Interior/Dan Chatterton's House*, produced in San Feliu de Guixals in Catalonia in the summer of 1962. Kitaj has observed that the painting established a link between Dan Chatterton and Catalonia defined by shared commitments to anarchism.[33]

Kitaj used Durruti and the Spanish Republic as a point of identification in the construction of his early artistic identity. This use of a distant historical moment as the basis of a form of self-othering from the dominant formations of one's own society was comparable to other geograpically orientated forms of identification between the late 1950s and early 1960s. Van Goose has described how young Americans used post-Batista Cuba as a point of reference for the construction of their radical identities.[34] In 1960 Kitaj produced a painting entitled *A Reconstitution*, which pictured a barbed Cuba at the centre of a map of the Americas. In the map South America is in the process of being sucked into a vacuum cleaner. This vacuum cleaner functions as a metaphor for the political reconstitution implied in the title of the painting, a continental reconfiguration heralded by the revolution in Cuba in 1959.[35] To the left of the painting another landmass is represented which includes the Czechoslovakian provinces of Moravia and Bohemia, the latter perhaps pointing to the importance of Cuba for radical identities in 1960. Kitaj also made reference to the former dictator of Cuba Fulgencio Batista in the painting *Reflections on Violence*, 1962. Similarly, John Berger used a geographic alterity to define the authenticity of the main character in his 1958 novel *A Painter of Our Time*. In the novel, set in the mid-1950s, an émigré Hungarian artist works in his London studio in preparation for a solo exhibition only to leave to join the revolution in Budapest in 1956 at the point of his commercial success.[36] The uprising against totalitarianism being enacted in Hungary was contrasted by Berger to the inauthenticity of the West, with its profit-driven culture industry.

Kitaj's re-presentation of Durruti on Old Bond Street in 1963 presented a contrast between the romantic mythologies of anarchism and the Spanish Civil

War, and Bond Street as the site of enhanced commercialism in the London art world.[37] Thus the opposition between art and commerce structural to the artistic field was transcoded into the opposition between Durruti, as a symbol of the aspirations of human freedom, and the commodification of culture. During the Spanish Civil War British left-wing intellectuals used the Republican cause as a form of self-authenticating alterity. As Anthony Hartley observed in the early 1960s, from the point of view of middle-class English writers 'Spain provided a much more satisfactory field of action, since a Catalan militiaman or an Asturian could far more easily be romanticised and admired than a Lancashire cotton-worker or a Northumbrian ship-builder'.[38] If geographic distance enabled romanticisation on the part of British intellectuals in the 1930s, then this was a fortiori the case for Kitaj's temporal distance from the Spanish Republic in 1963.

The foregrounding of individual liberty involved in the symbolic linkage of the anarchist and the artist enabled the intersection of the political and artistic fields in the construction of Kitaj's early artistic imaginary, though it should be added that this intersection took place at the cost of political engagement and understanding. Kitaj's concern with 'socialism' has been highly individualistic and without a commitment to a collective political programme, or to a materialist understanding of the world. For Kitaj socialism has been a matter of personal opinion and feeling. Thus he has stated: 'I feel like a socialist',[39] and that, 'Socialism for me is just another word for compassion.'[40] Within Kitaj's early identity notions of cultural and political authenticity merged at the level of individual sensibility.

Durruti had become famous in Spain for his early anarchist activism and for his part in the defence of Aragon in July 1936 and Madrid later that year, where he was mortally wounded on 19 November. His funeral in Barcelona was a huge spectacle, attended by 500,000 people.[41] By the end of 1936 Durruti had become a heroic and romantic figure within Republican Spain. In death the figure of Durruti experienced a form of apotheosis, not only through the funeral, but also through a number of posters which elevated him to the status of a revolutionary icon. For example one poster issued by the anarchist youth organisation the FIJL (Federacion Iberica de Juventudes Libertarias), presented a greatly enlarged portrait of Durruti above a revolutionary landscape constructed through photographic montage.[42] There was even a new cinema, Cine Durruti, built in Barcelona in 1937, named after the dead anarchist leader.[43] It was Durruti's romantic and iconic status that Kitaj appropriated in 1963, both in the use of the photograph and in his depiction of Durruti on the far right of the painting *Junta*, 1962, also included in the Marlborough exhibition. Like *Kennst du das Land?* and *Interior/Dan Chatterton's House*, *Junta* was painted partly in Catalonia in the summer of 1962 and grew out of an interest in the old anarchists Kitaj was introduced to by his friend Josep Vincente.[44]

Within Kitaj's artistic discourse the mythologisation of Durruti which occurred immediately after his death was taken to a higher level. The Durruti as icon which was produced within the political field in Catalonia during the Spanish Civil War

was relocated by Kitaj within the thoroughly alien context of the London art world of 1963. This relocation gave the image of the anarchist hero a new iconic function in which the historical content of this image continued to have significance but in a very different form. If in 1937, the image of Durruti was hypostatised as a symbol of a particular position within the complex and contradictory field of Republican politics, in 1963 it was established as an icon for Republican politics in general. On Old Bond Street in 1963 Durruti as icon functioned as a symbol of a revolutionary situation, but a situation bereft of its actual contradictions and internecine struggles. Thus in 1963 history was signified, but only through the elision of the concrete historical context within which Durruti was originally turned into myth.

The notes to *Kennst du das Land?* in the 1963 catalogue also listed principal battles of the Spanish Civil War in chronological order. These battles formed a kind of mnemonic incantation, the names acting as triggers for a structure of memory and feeling. This mnemonic function was emphasised by the heading 'In Memoriam' at the beginning of the list. The list read:

> Jarama River
> Brunete
> Quinto
> Belchite
> Teruel
> The Aragon Retreats[45]

The first battle on this list has had a particular function within a Left-liberal collective memory of the Spanish war especially for those associated with the British and American International Brigades, not only because it was the first battle in which foreign volunteers were used by the Republic, but also because the battle of Jarama near Madrid in spring 1937 has been one of the focal points of the rituals of remembrance made by the veterans. The Scottish volunteer Alec McDade, who died at Brunete, wrote a song after Jarama entitled 'There's a Valley in Spain', which begins:

> There's a valley in Spain called Jarama,
> That's a place that we all know so well,
> For 'tis there that we wasted our manhood
> And most of our old age as well.[46]

This song was modified for singing at International Brigade memorial meetings.[47] In addition to this use of McDade's song in Britain, the song was also sung by American International Brigaders.[48] Jarama also appears to have been central to Kitaj's nostalgia for the Spanish Civil War. In the late 1980s, Kitaj recalled having had fantasies of 'fighting at the Jarama' during the early 1950s.[49]

The sequence of battles presented in the list also defined a tragic narrative beginning with the Republican defence at Jarama, continuing with Republican offensives at Brunette in July 1937, in Aragon in the Quinto–Belchite campaign

of August 1937 and at Teruel in southern Aragon in December 1937, and ending with Republican defeat in Aragon after the Nationalist offensive between March and July 1938. Kitaj's use of the phrase 'The Aragon Retreats', forms a distinctive terminus to his narrative. The fighting in Aragon in mid-1938 defined the point at which the Republic was pushed almost wholly onto a defensive footing. Thus 'The Aragon Retreats' was a phrase heavily loaded with historical import, but it was also another motif of American memories of the Spanish war in particular. 'The Retreats' being a phrase used by American International Brigaders to describe the series of withdrawals made by the Republic in Aragon in mid-1938.[50] Kitaj later transforms this name for a significant historical event into the name for a geographic area of Spain, stating in 1994 that he had not returned to 'San Feliu or the Aragon Retreats for about fifteen years'.[51] Thus Kitaj inscribes the topography of Aragon with collective memory.

The basic narrative sequence from hope to tragedy presented by the list has been structural to collective memories of the Spanish Civil War amongst liberals and leftists,[52] constituting what Yael Zerubavel terms a 'master commemorative narrative'.[53] This leftist commemorative narrative inflects the dominant reading of European history between the early 1930s and the end of the Second World War, which defines this period in terms of a sequence from the rise to the overthrow of tyranny, with a sense of pessimism and loss over what might have been achieved if the Spanish Republic had won. For example here is the English writer Philip Toynbee, an undergraduate communist at Oxford University in 1936, looking back on the war from the vantage of 1954:

> It is easy to see now that the Spanish Civil War was, from the very beginning, the tragic, drawn-out death agony of a political epoch. Once the generals had made their revolt they would eventually win it: once they had won it, a world war would be fought against fascist aggression, but not for anything we hoped for in 1936.[54]

For Toynbee the Spanish war and the defeat of the Republic defined a dividing line between a moment of relative left-wing optimism and a drawn-out period of left-wing decline and occlusion marked by the ascendancy of fascism.

Kitaj has expressed his interest in the Spanish Civil War in terms which can be interpreted in a similar way to Toynbee's account, stating in relation to his visits to Spain from 1953 onwards, that 'Spain meant a lot to me ... It was the focus of a tremendous romance for me in its civil war against fascism ... I had been raised in a milieu for which Spain was a place of destiny ... I was very moved to be journeying through that defeated land.'[55] For Kitaj in the early 1950s Spain was a place of political and moral 'destiny',[56] but this place could only be imagined through a romantic and nostalgic relation to a past blotted out by fascism. Elsewhere, Kitaj presents the Spanish war, and in particular the revolution in Catalonia, as representative of a moment of hope – of a 'very brief historical success' for libertarian politics within European history in general, before 'oblivion came down' on the continent.[57] For Kitaj, Spain under Franco was a country whose cultural and social

topography was to be interpreted through leftist collective memory, for it was only through the historical narrative of hope to tragedy central to left-wing discourses on the Spanish Civil War and the rise of European fascism that Spain could be understood as a 'defeated land'. If Kitaj used Durruti as a symbol of utopian politics and cultural authenticity in 1963, then Durruti had to be understood as a figure of the past. Durruti's function as an iconic controller of identity for Kitaj was dependent on his secure location in a lost moment of history.

As I have noted, it was not incidental for Kitaj that the battles listed in the 1963 catalogue involved the International Brigades and in particular the American Abraham Lincoln Brigade (actually a battalion) and thus could be linked directly to the left-wing milieu of Kitaj's American upbringing. It is significant here that the place of the Abraham Lincoln Brigade in the collective memory of the American Left is defined by images of both heroism and personal tragedy. In all the battles listed by Kitaj, the brigade suffered heavy losses, but casualties were particularly high at Jarama and Brunete. In the first, out of the 400 American volunteers involved in the battle, 127 were killed and 200 were wounded.[58] At Brunete, where the American and British battalions spearheaded the Republican attack, losses were so heavy that the Abraham Lincoln Brigade had to merge with the other American unit, the George Washington Battalion. Kitaj observes that two of his mother's boyfriends were killed during the Spanish Civil War.[59] As with Kitaj's fantasies about the battle of Jarama, this anecdote defines a clear link between his own history and the wider collective memories established through the historicisation of the American International Brigades.

Also of relevance to the relationship between *Kennst du das Land?* and collective memories of the Spanish Civil War in 1963 was the inclusion of a number of texts in Kitaj's general bibliography on page 14 of the 1963 catalogue. These were George Orwell's *Homage to Catalonia*, published in 1938, Orwell's *Collected Essays*, published in 1961, which included the essay 'Looking Back on the Spanish War', Harold Cardozo's *The March of a Nation*, published in 1938, and a pamphlet entitled Durruti, produced by the CNT and FAI in 1937. If it is not already obvious, this list should give an indication that Kitaj had at least a selective knowledge of the Spanish Civil War and its subsequent historicisation. It should also be added that artists, and especially Kitaj, rarely reveal all their sources.[60] Kitaj's listing of battles during the Spanish Civil War alone indicates a greater knowledge of the conflict than that which could have been provided by either Orwell or Cardozo's personalised and limited accounts. Using these specific references and other sources possibly unacknowledged, Kitaj produced *Kennst du das Land?* by farming the collective memory of the Spanish Civil War, some of which was probably Spanish in origin, specifically oral history gained through Josep Vincente and his anarchist friends.

Kitaj's nostalgic optic appropriated memories of the Spanish Civil War presented in images, texts and oral accounts, but his optic was certainly not that of the historian. Kitaj's aim was not to map the complexities of a particular

historical event; rather his approach to history, represented by the relationships between *Kennst du das Land?*, the 1963 catalogue and the photograph in the gallery window, involved a conflation of those events and formations which would have been individuated through critical historical inquiry. Kitaj's construction of the anarchist and the International Brigader as hero conflated these quite distinct figures within a generalised conception of the Spanish Republic, based upon an appropriated structure of feeling, rather than upon the specificities of history.

### Nostalgia as utopia

The title *Kennst du das Land?* is derived from Goethe's poem of the same name included within the novel *Wilhelm Meister*, which Kitaj had read in Thomas Carlyle's translation, first published in 1824. In English the title reads: 'Know'st thou the land?'.[61] The notes which accompanied the painting in the 1963 catalogue, included the following section of the poem:

> Know'st thou the land where lemon-trees do bloom,
> And oranges like gold in leafy gloom;
> A gentle wind from deep blue heaven blows,
> The myrtle thick, and high the laurel grows?
> Know'st thou it then?
> > > > > Tis there! tis there [62]

The poem forms the epigraph to chapter 1 of Book III of the novel and is also sung to Wilhelm Meister by the child character Mignon.[63] In the Preface to *Kennst du das Land?* in the catalogue to his retrospective exhibition at the Tate Gallery in 1994, Kitaj notes his reference to Goethe, observing that he had transferred 'the land where lemon-trees do bloom' from Italy to Spain:

> Goethe meant Italy of course in his famous lines, but my picture is about Spain, because I had fallen in love with Catalonia since my first wife and I spent the winter of 1953 in the port of San Feliu de Guixols, where I would buy a house twenty years later. What I loved even more than Catalonia was my friendship with Josep,[64] just about the purest heart I've ever known, and this painting, begun in his house high over the sea is really about what he called 'our war' which tore Spain apart and burned its way into the souls of so many people I've known. This painting of mine is just another little altarpiece among those many journeyman shrines which mark the graveyards of fascism.[65]

Again this statement points to an intersection of personal and epochal political history. Kitaj's memories of Catalonia and his friendships with Spaniards are sedimented within wider memories of the Spanish Civil War and European fascism. Within Kitaj's imaginary Goethe's vision of Italy was mixed with personal and collective memories of Spain.

10 *From London (James Joll and John Golding)*, 1975–76, oil on canvas, 152.4 x 243.8.

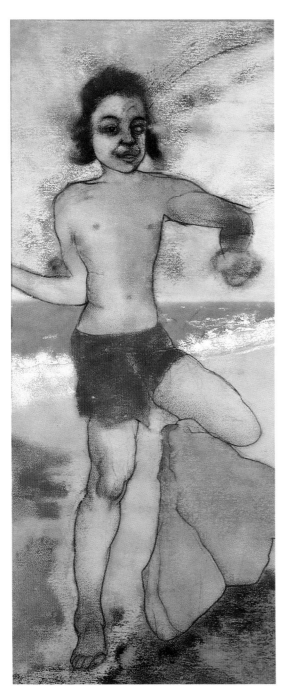

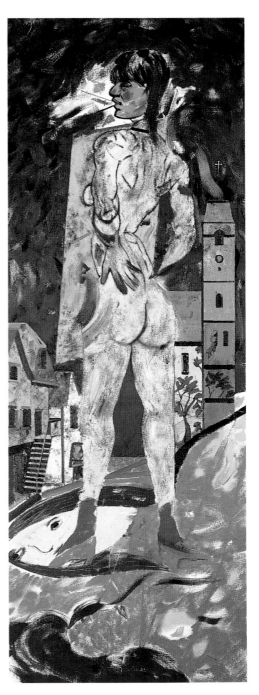

11  *Bather* (*Psychotic Boy*), 1980, pastel and charcoal on paper, 134 x 57.2.

12  *Self-Portrait as a Woman*, 1984, oil on canvas, 246.4 x 77.2.

In the 1994 Preface to *Kennst du das Land?* Kitaj also comments that the winter scene represented in the painting could be the battle of Teruel between December 1937 and February 1938. Temperatures during the fighting were very low and the battle was marked by a four-day blizzard in late December 1937, during which some six hundred vehicles from both sides became snowbound. This link is supported by the inclusion of this specific battle in the list printed in the 1963 catalogue, though it was made explicit only retrospectively.[66] But visual connections between the painting and the Spanish Civil War do not only involve the white paint signifying snow which covers the bottom section of the canvas. More direct references can be found in Kitaj's use of photographs from Harold Cardozo's account of time spent with Franco's forces during the war, *The March of the Nation: My Year of Spain's Civil War*.[67] Cardozo was a reporter for the pro-Franco British newspaper the *Daily Mail* and was personally very sympathetic towards the Nationalist cause. Cardozo's photographs were the source for the schematic figures manning the two machine guns at the bottom of the painting and for the two cars pictured at the centre right of the image. The two photographs from *The March of the Nation* used by Kitaj are titled 'Nationalists advancing in the Suburbs of Madrid' (Figure 36) and 'The Author's Car snowed up on the Road from Avila to Talavera La Reina, November 1936'.
[68] The former photograph is highly staged with the photographer positioned almost in the line of fire of the two machine guns. Other soldiers are standing in

**36** H. G. Cardozo, 'Nationalists advancing in the Suburbs of Madrid', *The March of A Nation. My Year of Spain's Civil War* (London, The 'Right' Book Club), 1937, Plate 11.

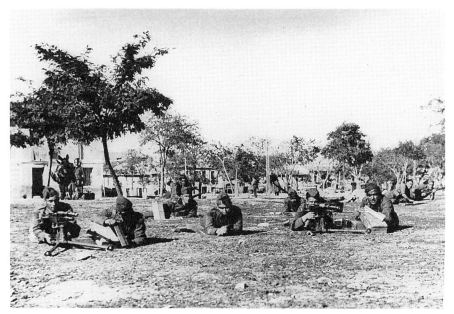

the background, two of whom are not even facing the apparent direction of the battle. One figure appears to be carrying a bucket. Such images, organised for propaganda purposes, were common on both sides during the war.[69] The single car in the latter image is repeated in Kitaj's painting, with the farthest vehicle appearing larger than the nearest car, a device which functions as a means to further flatten the painting. It is perhaps this image that provided the stimulus for the snow in the painting itself, enabling Kitaj to unite different images in a 'blizzard' of scumbled white paint.

It should be obvious that there is an incongruity involved in the use of images derived from a pro-Franco account of the early period of the Spanish Civil War in a painting which is supposed to be 'In Memoriam' to the Spanish Republic. On the subject of the visual sources for the painting Julián Ríos asked Kitaj in the late 1980s: 'Did you look up photos of that war in order to compose your battle painting?' To this Kitaj replied: 'Yes, of course I dipped into my archives for Spanish war stuff.'[70] What should we make of this rather vague comment uttered nearly thirty years after the painting was produced? The use of Cardozo's photographs in Kitaj's painting was very specific. Does Kitaj's subsumption of Cardozo's book within a wider Spanish Civil War 'archive' mean that he had forgotten the original source of his imagery, or that the source of the imagery was not of particular importance for the meanings of the painting? It is possible that Kitaj was not concerned with the specific contents of the painting three decades after its production and that his imprecise answer reflected a generic significance which the painting had gained for him over a thirty-year period. Hence Kitaj's general references to the 'graveyards of fascism' in 1994. Such ambivalence about the sources of the painting fits with Kitaj's assertion that his discourse on his own work has been structured by ambiguity and the concealment of meaning, and with his argument that the meaning of his paintings exist 'in history' and therefore change with time.[71] Further, this imprecision reflects Kitaj's tendency towards historical conflation noted above in relation to the use of Durruti during the 1963 exhibition. But a more precise reading of the imagery Kitaj used in *Kennst du das Land?* is possible, through which it is understood that Cardozo's photographs were explicitly referenced as a means of constructing a specific representation of the Spanish Civil War as a subject of collective memory.

George Orwell's book *Homage to Catalonia* provides us with a starting point for this interpretation. As I have already noted this book was included in the bibliography of the 1963 exhibition catalogue. It is also important to note that the edition which Kitaj listed was published in the same year as the painting was produced and thus was probably fresh in Kitaj's mind. The book may even have been read during Kitaj's stay in Catalonia in the summer of 1962, when *Kennst du das Land?* was begun. At the beginning of the book Orwell describes an encounter with an Italian militiaman at the Lenin Barracks in Barcelona in December 1936. The immediate affection and solidarity which was felt between Orwell and the Italian, despite language differences, were symptomatic of the particular atmosphere in

revolutionary Catalonia during this period of the war. But from the vantage of the summer of 1937, when Orwell's account was written, this atmosphere seemed to belong to a different age. As Orwell stated: 'This was in late December 1936, less than seven months ago as I write, and yet it is a period that has already receded into enormous distance. Later events have obliterated it much more completely than they have obliterated 1935, or 1905, for that matter.'[72] For Orwell, the Spanish Revolution of 1936 defined a form of rupture in 'normal' social existence. Thus he stated later in the book: 'It is so different from the rest of my life that already it has taken on the magic quality which, as a rule, belongs only to memories that are years old.'[73] This sense of radical difference in the experience of social practices was also expressed by other commentators on the events in Catalonia in 1936. For example, one participant Alejandro Vitoria, recalled that the revolutionary events were 'dreamlike [and] hallucinating'.[74] In particular such events were dreamlike in relation to the experience of social time. A POUM militant recalled that during the Revolution: 'Time is as different as when you've got a toothache; you don't eat, hardly sleep, you forget where you've been, what you've been doing. Days are like hours, and months like days.'[75] But it was not merely the pace of events which gave the Revolution its hallucinatory effect but the nature of the changes it wrought. The reconstruction of established forms of social practice and order meant that the entire experience of social time was transformed, and it was this sense of radical difference that Orwell was attempting to describe from the temporal and geographic distance of England in mid-1937. It is such a sense of temporal distance that I would argue Kitaj intended to convey in his painting – a sense of an unbridgable space between that which is remembered and the moment of remembering. This was the space which gave Kitaj's use of Durruti and the Spanish Civil War its romantic charge.

The main image of *Kennst du das Land?* is echoed in Orwell's text. Orwell foregrounded the sense of difficulty involved in invoking the experiences of the Aragon Front. His answer to this problem was a list which fits to a certain extent with the battle scene in Kitaj's painting. Quoting this passage from Orwell's account of his experiences of trench warfare in Spain is also compatible with Kitaj's practice during the early 1960s of linking the subject of a painting to a section from a historical text.[76] For example, *The Murder of Rosa Luxemburg*, 1960 (Plate 8), includes a section from Paul Fröhlich's account of Luxemburg's death[77] in Kitaj's own handwriting, collaged onto the top right-hand corner of the painting. A similar section of text is collaged in the lower left corner of *The Red Banquet*, 1960. *Homage to Catalonia* is not explicitly referenced in *Kennst du das Land?*. Indeed, the similarities between Orwell's description and Kitaj's painting are generalised and may well be coincidental. But despite the absense of direct references, I would argue that it remains possible to identify a relationship between the painting and a particular section of Orwell's book as a means to define the atmosphere which Kitaj was in part attempting to represent. Orwell's description is as follows:

It was beastly while it was happening, but it is a good patch of my mind to browse upon. I wish I could convey to you the atmosphere of the time. I hope I have done so, a little, in the earlier chapters of this book. It is all bound up in my mind with the winter cold, the ragged uniforms of the militiamen, the oval Spanish faces, the morse-like tapping of the machine-guns, the smells of urine and rotting bread, the tinny taste of bean-stews wolfed hurriedly out of unclean pannikins.[78]

Within this description are suggested the elements of the scene which occupies the lower area of the painting: the winter cold, the militiamen with their oval Spanish faces, the machine guns. But in Kitaj's painting the meaning of these elements is inverted. Rather than referring to Orwell's experiences fighting within one of the most revolutionary sections of the Republican army, the image, at least in terms of its pictorial referent, pictures Franco's forces. There is a sense in which Kitaj could be using Cardozo's photograph as the basis for a generic image of Spaniards at war, a generalisation which fits with Orwell's observation made in relation to the illustrations to R. Timmerman's book *Heroes of the Alcazar*, 1937: 'The photographs of groups of Nationalist defenders bring home one of the most pathetic aspects of the civil war. They are so like groups of Government militiamen that if they were changed around no one would know the difference.'[79] But given the implication made emphatic in 1963 through the use of the Durruti photograph, that Kitaj's painting is meant to commemorate the struggle against Franco, the ambiguity remains. In this sense *Kennst du das Land?* is radically different from Xavier Bueno's 1938 painting *The Spanish Soldier*, which bore the subtitle 'In Memory of My Friend who Died in Defence of Madrid'.[80] Bueno's painting, although symbolic of sacrifice and struggle, is manifestly about its claimed subject, in that it is a painting in memory of the Republican dead which presents an image of a wounded and almost Christ-like Republican soldier. Kitaj's painting in contrast is ambiguous in the extreme. It memorialises the Republic, but depicts those who took part in the suppression of the Republican cause. How should this ambiguity be addressed? In answer to this question I would suggest that *Kennst du das Land?* is structured by a tension between politically positive meanings related to the Spanish Republic and other negative meanings related to the Nationalist insurgency and fascism. It is the particular nature of that tension which needs to be elaborated here. What needs to be understood is how the memories presented by Orwell in his account, as a supporter of the Republic, and Kitaj's 'memories of memories',[81] as someone brought up in a pro-Republican milieu in the United States, have been worked in relation to imagery which represents the military power and victory of the Nationalists.

Let us continue this discussion in relation to Kitaj's use of Goethe in the title of *Kennst du das Land?* and the quotation from Goethe's poem in the 1963 catalogue. As noted, Goethe's poem refers to Italy. But the Italy of the poem was not only the subject of a yearning on the part of Goethe's character Mignon, but also the subject of a long-standing fantasy on the part of Goethe himself. Goethe had visited Italy between 1786 and 1788, but before this period, the imagined Italy of

antiquity had been a significant element of his literary imaginary. The poem
'Kennst du das Land?' was a product of this imaginative fixation. Kitaj transfers
this idealised 'land' to Spain and crucially he projects the retrospective relation-
ship between Goethe and antiquity onto a relationship between himself in the early
1960s and the lost revolutionary and utopian moment described by Orwell. Thus
the fantasy involved in Goethe's representation of Italy is transcoded by Kitaj into
a romantic understanding of the Spanish Republic.

In relation to this discussion of Kitaj's translocation of Goethe's Italian arcadia
to revolutionary Spain, it is useful to compare the quotation from 'Kennst du das
Land?' in the 1963 catalogue to Herbert Read's vision of a Spanish collective farm
in his poem 'A Song for the Spanish Anarchists', written in 1940, the first and last
stanza of which read:

> The golden lemon is not made
>     but grows on a green tree:
> A strong man and his crystal eyes
>     is a man born free
>
> And men are men who till the land
>     and women are women who weave:
> Fifty men own the lemon grove
>     and no man is a slave.[82]

Here is a model for Goethe's 'land where lemon-trees do bloom' reconstructed as
revolutionary Spain. Read's utopian vision of freedom presented in terms of an
idealised pastoral conception of Spanish peasant life, turns the lemon from a
symbol merely signifying the warmth of southern Europe into a symbol of a revo-
lutionary moment. Given Read's seniority on the London art scene in the early
1960s, it is inconceivable that Kitaj, as a well-read young artist was unaware of him,
but there is no evidence that Kitaj knew of Read's poem, let alone used it as a refer-
ence point for *Kennst du das Land?*. Nevertheless, I believe that it is the idealised
revolutionary Spain presented by Read's poem and described by Orwell which
forms a ghost image to the actual motifs of Kitaj's painting. This ghost image
existed both beyond the painting – located within wider collective memories – and
within the painting itself as an implicit positive binary of the image of the
Nationalist machine-gunners. It is the absence of the ideal of revolutionary Spain
in any overt form which defines the meaning of the painting, a significant absence
which was emphasised by the photograph of Durruti and the section of Goethe's
poem in the 1963 catalogue. The photograph, the lines of poetry and the lemons
in the painting itself served as metonymic traces of what was absent from *Kennst
du das Land?*. The utopian vision of anarchism and the Spanish Republic presented
by Read and Orwell was occluded by both the resistance of the painting – with its
modernist surface – to interpretation and by the wider historical erasure of the
Spanish Revolution by the Nationalist victory and by the culture of what Stuart
Hall has termed the 'political Ice Age'[83] during the Cold War.[84]

At this point it is necessary to explore the significance of the painted surface in the lower section of *Kennst du das Land?* which stands in place of the utopian past. As I have noted, the primary image of the painting is derived from Cardozo's heavily pro-Nationalist account of the early period of the Spanish Civil War. In places Cardozo's description of events can be considered as little more than propaganda. The Nationalists placed rigorously upheld restrictions upon the press, only allowing those journalists with sympathies for the army revolt to travel freely within the Nationalist zone.[85] Cardozo's text reflected this situation. For example, here is his description of the activities of the popular militia and the revolutionary fervour in Catalonia at the beginning of the war:

> So brutal and so systematic were the murders, so complete were the burnings of churches and convents, that it was perfectly evident that it could only be the result of a carefully thought-out policy, consistently imposed … part of a political plan imposed by Moscow.
>
> … soil the the hands of as many as possible of your adherents in blood. Madden them in any way you like – by alcohol, by incendiary speeches, by lust or envy – and force them to commit crimes which are indescribable in their horror. Once the tale of murder, rape, arson has been inscribed those men are Red revolutionaries for ever: they cannot desert; they cannot surrender, for they cannot plead for mercy. They have placed themselves outside the pale of humanity, and therefore they are fit tools for a Communist regime inspired from Moscow. That was the work of Madrid during the first weeks of the movement.[86]

But it was not only Cardozo's anti-communist rhetoric which placed *The March of a Nation* firmly in opposition to the Spanish Republic. For the book was published by the 'Right' Book Club established in 1937[87] to counter Victor Gollanz's anti-fascist and Popular Front orientated Left Book Club[88] (with its 40,000 members in mid-1936)[89] and in particular to oppose the considerable intellectual and popular support for the Republicans in Britain at that time.[90] Like the Left Book Club, the 'Right' Book Club sent special editions of selected books to its members. Two of the precepts of the 'Right' Book Club were: firstly, 'to uphold constitutional government' and 'to maintain individual freedom'; and secondly, 'to oppose and fight against communism and left propaganda'. In the context of its support for Franco, the book club's conceptions of 'constitutional government' and 'individual freedom' were highly partisan. But such conceptions of 'order' and 'liberty' were certainly consistent with general right-wing thinking at that time.[91] It was this linkage to political struggles within Britain over the Spanish Civil War and in particular to the political Right that Kitaj mobilised in his use of Cardozo's photographs. These links between *Kennst du das Land?* and the network of pro-Nationalist organisations and individuals in England between 1937 and 1938 form part of the historical texture of the painterly surface which Kitaj constructed as a means to represent the occlusion of the utopian idyll constructed within leftist collective memories of the Spanish Republic.

## The surface of history

Of particular importance for understanding the way in which Kitaj's painting can be read as a representation of leftist collective memories of the Spanish Civil War is George Orwell's essay 'Looking Back on the Spanish Civil War', written in 1943. As I have noted, this essay was included in the volume of Orwell's *Collected Essays* published in 1961, listed in the bibliography to the 1963 catalogue. To examine the significance of this text for *Kennst du das Land?*, the discussion of the discursive context for the painting needs to be taken beyond representations of the Spanish Civil War to discourses on the general formations of European politics during the late 1930s and early 1940s.

The crucial statement in Orwell's essay is his description of a conversation with the émigré Hungarian and ex-communist Arthur Koestler, whom Orwell had met in late 1940 after Koestler had sought asylum in England. Here Orwell declared, 'History stopped in 1936', a statement with which Koestler was in complete agreement. Orwell continued: 'We were both thinking of totalitarianism in general, but more particularly of the Spanish Civil War.'[92] In making this observation, Orwell was referring to the general degradation of journalistic discourse on all sides during the Spanish Civil War. For Orwell, the published record of the war was ridden with politically motivated representations which endangered the very idea of objectivity. Thus he stated: 'This kind of thing is frightening to me, because it often gives me the feeling that the very concept of objective truth is fading out of the world. After all, the chances are that lies, or at any rate similar lies, will pass into history.'[93] In these terms, it was not merely contemporary understandings of the war which were at stake, but also those accounts of the war which would endure to become the dominant formations of collective memory. In the age of modern totalitarianism the perversion of 'documentary' discourse in the service of state ideology and party lines had reached its apogee. Thus the politics of the present were leading to the 'death' of history as an intellectual practice premised upon a belief in the overriding value of veracity. In his words: 'The implied objective of this line of thought is a nightmare world in which the leaders, or some ruling clique, controls not only the future but the past.'[94]

Orwell's thinking had been moving in the direction of an overarching pessimism concerning the near future since at least 1937. In July that year, he wrote to Rayner Heppenstall expressing his concern that after his experiences in Spain the future would be 'pretty grim'.[95] Later, in May 1938, Orwell observed that in the era of Hitler and Stalin the time of novel writing was over and that he would probably have to finish his current project, *Coming Up for Air*, 'in the concentration camp'.[96] Orwell made similar references to the 'loom[ing]' concentration camp in other correspondence from 1938[97] and in his article 'Why I joined the Independent Labour Party', published in *New Leader* in June that same year.[98] Between the late 1930s and early 1940s the concept of the concentration camp in Europe appears to have functioned as a generic metaphor through which leftist intellectuals could

define an increasingly oppressive era. Thus in 1941 Koestler described Lisbon in relatively independent Portugal as 'the bottle-neck of Europe, the last open gate of the concentration camp extending over the greater part of the continent's surface'.[99] Orwell's observations point to a gradual loss of hope on his part for a future socialist or even liberal-democratic alternative in Europe. For him the European future appeared to be profoundly authoritarian. But what is significant about Orwell's 1943 essay for the current discussion is the emphasis he placed upon the political control of the past within this totalitarian future. In this context the manipulation of history was becoming a weapon of the ideologues. We can be sceptical of the innocence which Orwell implied was a characteristic of the representation of history prior to the late 1930s. Even Orwell himself had noted that: 'Early in life I have noticed that no event is ever correctly reported in a newspaper.'[100] But it was certainly reasonable in 1943 to ascribe a qualitative and quantitative difference to recent manipulations of information and historical knowledge.

Orwell's observations in 1943 can be related to a statement made by Walter Benjamin three years before in his 'Theses on the Philosophy of History', written before the fall of France on the eve of Benjamin's suicide in September 1940:[101]

> In every era the attempt must be made anew to wrest tradition away from a conformism that is about to overpower it. The Messiah comes not only as the redeemer, he comes as the subduer of Antichrist. Only that historian will have the gift of fanning the spark of hope in the past who is firmly convinced that even the dead will not be safe from the enemy if he wins. And this enemy has not ceased to be victorious.[102]

Here the 'Messiah' is the possibility of proletarian revolution and the utopian intervention into history that such a revolution would herald.[103] The liberatory intervention into the seemingly cyclical barbarisms of normal history which Benjamin called for was thus conceived in terms of a teleology structured by the politics of class warfare. Though, of course, Benjamin's hopes for such a utopian intervention were tainted by the defeats of the 1930s and by the darkness which appeared to lie ahead for both him and Europe. In relation to this construction of the proletarian 'Messiah', the 'Antichrist' was also something quite specific: being the hegemony of the bourgeoisie and the barbarities this domination represented. But it is possible to read the 'Antichrist' as something much more general; as a motif more fitting to a generic moral Manichaeism. In these terms the 'Antichrist' was the symbol of dominatory power, not merely in the capitalist present, but also in the pre-capitalist past – it was the name borrowed from the world of theology for the power which enabled the destruction of the hopes, lives and memories of the dominated.

I have found no record of Orwell's being acquainted with Benjamin, but a link between them can be found in Koestler. Koestler had known Benjamin in Paris in the late 1930s and had met him again in Marseilles when both of them, in fear of

the Gestapo, were attempting to escape France. In Koestler's book *Scum of the Earth*, published in London by the Left Book Club in 1941, there is a dedication which reads: 'To the memory of my colleagues, the exiled writers of Germany who took their lives when France fell.'[104] Amongst those listed under this statement is Walter Benjamin. In the book itself, Koestler describes his meeting with Benjamin in Marseilles when the latter described his plan to take his own life if escape became impossible.[105] This tenuous linkage of Orwell to Benjamin through Koestler is of significance because it points to a general sensibility articulated in Benjamin's essay on history and Orwell's essay on the Spanish Civil War: a despondent sense of a threat to freedom and hope which marked the imagination of many leftist European writers in the early 1940s. This often exilic structure of feeling was defined in terms of a sense of hope being in the past: of writing from a position on the other side of a chasm which separated oneself from hope.[106] For Orwell, Benjamin and Koestler the future lay in darkness, and hope was a dangerous commodity. As I have noted, such an opposition between hope and tragedy defined the leftist commemorative narrative of the Spanish Civil War after 1939 which in turn informed Kitaj's thinking about *Kennst du das Land?* Kitaj's elaboration of an identity which was after hope – albeit mediated through collective memory from the distance of twenty years – was articulated specifically in his listing of Spanish Civil War battles, but this appropriated subjectivity was also structural to the construction of meaning within the painting itself.

The sense of pessimism shared by leftist intellectuals of Orwell and Benjamin's generation was given strong expression for the latter in his concern that not only the living but also the dead were endangered by the politics of contemporary Europe. In Benjamin's terms the (nameless) dead are the subjects of historical knowledge; it is their lives, struggles, courage, aspirations and visions, that have to be represented and done justice to by history.[107] The past needs to be continually struggled over from generation to generation to save the dead from the oblivion brought on by the powerful suppression of historical consciousness which resides at the heart of the culture of capitalism. By saving the dead from such an oblivion a spark of hope could be fanned in the present and for the future. A similar sense of hope being stored up for an indefinite future was present in Orwell's essay on the Spanish Civil War.[108]

The endangerment of the dead discussed by Benjamin was brought to its appalling nadir during Orwell's era in the form of the Nazi Holocaust. As Arno Mayer observes, the out-and-out extermination sites of the Nazi concentration-camp system represented an attempt to cast the victims of the Nazi Holocaust into a state of absolute negation, denying them physical trace or historical memory.[109] In his book *The Drowned and the Saved*, Primo Levi states that, 'the entire history of the brief "millenial Reich" can be reread as a war against memory, an Orwellian falsification of memory, falsification of reality, negation of reality'.[110] It was precisely this kind of negation of memory that Orwell noted in relation to Spain and fascism in general. This sense of the destruction of memory was particularly

strong for Orwell in 1943, when the Franco regime was a *fait accompli* and the traces of the revolutionary moment in Spain between 1936 and 1939 were undergoing erasure. Thus he stated: 'But suppose Fascism is finally defeated and some kind of democratic government restored in Spain in the fairly near future; even then, how is the history of the war to be written. What kinds of records will Franco have left behind him?'[111]

The counter-revolutionary violence involved in the suppression of a revolutionary moment also involves the reinvention of history. As Benjamin famously argued in his history essay, the construction of 'civilisation' was necessarily based on domination, being a 'triumphal procession in which the present rulers step over those who are lying prostrate'.[112] The violence which creates the dominant order and enables the sanctification of certain cultural forms is obscured in much the same way that an assertion of French 'civilisation' was facilitated, as Marx observed in 1871, by the removal of the corpses after the suppression of the Paris Commune.[113] The victory of Franco over the Spanish Republic produced a similar counter-revolution. After the Nationalists entered Barcelona in January 1939, the streets were littered with paper, 'torn-up party and union membership cards, documents'.[114] This detritus was the product of a particular moment in the counter-revolution, a set of willful acts of forgetting, both on the part of Franco's army as they destroyed the documentary evidence of the revolutionary period and on the part of Republicans as they attempted to erase the official signifiers of their recent past as a means of escaping the more significant erasure of execution. 'Order' and 'civilisation' was cstablished in Barcelona over the prostrate body of the Republic and the Catalonian working class. In the words of General Alvarez Arenas, the new military commandant in Barcelona: 'This is a city that has sinned greatly, and it must now be sanctified.'[115] In this case sanctification involved extreme acts of violence and enforced forgetfulness.

In the context of Spain after the civil war, the political reconstruction of memory involved concurrent strategies of remembering and forgetting. In the former case, remembering involved the construction of official memories of 'the nation' as a mystical, organic and transhistorical formation around the institutions of the army, the church and the state under the figure of Franco. Within this construct Franco's 'anti-Red' crusade was presented as part of a national destiny which linked the Nationalist cause to the medieval *Reconquista*, which ended with the expulsion of 3 million Muslims and 300,000 Jews from Spain at the end of the fifteenth century.[116] Within this official structure of collective memory the Spanish nation was symbolised through the icons of the new totalitarian state, which militated for a dominant reading of the past, present and future. These icons were established through the fascist-style aestheticisation of politics involved in the ceremonies, memorials and histories established by the Franco regime: through torch-lit parades for fallen Nationalist heroes, and through monuments such as the victory arch constructed at the entrance to the University City in Madrid and the huge monument of the Valley of the Fallen, carved into the hillside north-east of

Madrid between 1940 and 1960.[117] The latter monument was a literal embodiment of Benjamin's conjunction of civilisation and domination, being a memorial to those who died for the restoration of 'civilised' and 'Christian' Spain, and having also been built by the slave labour of defeated Republican prisoners. In terms of practices of forgetting, the symbolic construction of Nationalist 'Spain' necessitated the erasure of the political alternatives to this now victorious totalitarian structure – practices of forgetting symbolised by the removal of the inscriptions on the tombs in the Barcelona cemetery of Montjuich commemorating Durruti, Durruti's friend and fellow anarchist Francisco Ascaso, killed resisting the military uprising in Barcelona in July 1936, and the anarchist schoolmaster and educationalist Francisco Ferrer, who had been executed by the Spanish state in 1909.[118]

In light of this discussion I think it is possible to argue that Kitaj's painting is in part about the confiscation of memory by political power described by Orwell in his 1943 essay. At one level the literally white surface of the lower section of the painting represents the whitewashing of history. Thus the painterly surface forms a pictorial equivalent for the 'surface' of official memory which buries alternative understandings of the past. The notion of white paint obscuring memories was later articulated by Kitaj in relation to his painting *My Cities (An Experimental Drama)*, 1990–93. Here Kitaj represented figures performing on a stage with a backdrop, upon which were depicted the capital letters of the cities in which he had lived. These letters were obscured by brushstrokes of white paint. In Kitaj's words, the letters 'have been sublimated by white paint for the most part because they got too emphatic, so now they're not too easy to read or even see, some of them representing faded (whitened) memories anyway'.[119] More directly relevant to the Spanish Civil War, Kitaj observed in a conversation with David Plante in 1983, that 'I remember jumping off a bus onto the Spanish earth, so deep with Hemingway and everything I'd heard in my youth, all of that pressed beneath the repressive surface of Franco's regime. That gave me the sense of a great secret.'[120] Is it possible to argue that the white surface of *Kennst du das Land?*, with its pictorial references to Cardozo's overtly pro-Franco account of the Spanish Civil War, represents this 'repressive surface'? Perhaps this is too simplistic. Nevertheless, Kitaj's comment from the early 1980s is highly suggestive of a reading of the painting based upon a structural relationship between the facades of official history and other repressed histories. In this context, the ghost image implicit within *Kennst du das Land?* is Kitaj's 'great secret': the ghost of a murdered utopian moment. The white surface of the painting embodies the condition of the artist as someone painting after hope. In this sense the surface of the painting is a representation of the leftist commemorative narrative of the Spanish Civil War which presents a transition from hope to tragedy.

The conjunction of the machine-gunners with the white modernist surface of the painting presents a modern version of Goya's picture *The Firing Squad, 3 May, 1808*, 1814,[121] though in Kitaj's image the victims are absent and all that remains are the executioners. The painterly surface which covers the canvas from edge to

edge and thus consumes our vision, blocking out other possible views of the past, is quite literally a 'repressive surface', which contains within itself an image of actual repression in the form of the machine-gunners. Repression is also represented by the boot pictured inside the star motif. This boot is reminiscent of both Republican posters concerned with fascist intervention in Spain during the war[122] and the galumphing boot of the monster in Max Ernst's painting *Angel of Hearth and Home*, 1937, a painting which Ernst falsely claimed was painted after the fall of the Spanish Republic and which was meant to represent a fascist 'juggernaut' consuming Europe.[123] Beneath the 'repressive surface' lie the Republican dead, whose presence is indicated by little more than the lemons and perhaps Goya's woman removing her stocking as a trace of some Spanish past before Franco. But perhaps the image of the machine-gunners also carries a sense of the absurdities of propaganda and manufactured history intimated through the use of Cardozo's contrived photograph of Nationalist soldiers supposedly advancing on Madrid in 1937.

### The modernist terminus

The all-over or monochrome canvas has functioned as a terminus point for formalist readings of modernism in the postwar period. A subset of the field of all-over or monochrome painting has been the all-white or almost all-white canvas, for example, Jackson Pollock's *The Deep*, 1953, Barnett Newman's *The Name II*, 1950, and *Shining Forth (To George)*, 1961, William Turnbull's *29-1958*, 1958, and Robert Ryman's white paintings from the early 1960s. Other 'white' works were produced between the early 1950s and early 1960s by artists who were unhappy with the codified expressionist cul-de-sac which was left in the wake of the first generation of Abstract Expressionists, or who were critical of the form of abstractionism vaunted by certain modernists during this period. These works included Robert Rauschenberg's 'White Paintings' from 1951, Jasper Johns's *White Flag*, 1955, and *Large White Numbers*, 1958, and Yves Klein's white monochromes from the late 1950s.

Not all these works would have been known to Kitaj; indeed, not all of them had been shown in London by the early 1960s, but he was aware that the dominant trajectory of advanced modernist painting in America and Europe was defined by a field of practices committed to some understanding that a primary characteristic of good painting was all-overness or flatness. As I noted at the beginning of the current essay, *Kennst du das Land?* displays this awareness. The painting was produced after the stylistic dominance of Abstract Expressionism had been established within avant-garde circles in London. But *Kennst du das Land?* was also produced after the early work of Robert Rauschenberg and Jasper Johns which addressed the increasingly codified nature of Abstract Expressionism in the mid-1950s. Kitaj's painting was thus defined by an awareness of modernist painting since Abstract Expressionism and of the limitations such practices placed upon critical thought

and potential content. As I have elaborated in the body of the essay, *Kennst du das Land?* articulates some of the tropes of advanced painting since Abstract Expressionism in relation to the traces and signs of a wider political history. The whiteness of the lower section of the painting, with its snowbound battle, both gives priority to and parodies the modernist all-over or monochrome white canvas. The lemons, the star motif, the cars and the machine-gunners are all fixed within the emphatic flatness of the white paint. They hover within painterly whiteness as if it were a medium preserving and freezing them within time, their historical significance suppressed by a whiteness which stands as a symbol of the late modernist discourse of autonomy. The historicity of these various images fights it out with the powerful associations all-over whiteness had with claims to artistic ahistoricity and disinterestedness within the context of postwar modernism.

Flatness has signified a range of things within the history of artistic modernism. In Britain between the late 1950s and early 1960s, aside from the formalist reading of flatness as a sign of modernist self-definition and progress, it could signify a number of different things: the literal flatness of the canvas could be understood as an arena for the enactment of an expressive event, as in the work influenced by French Tachisme and American Abstract Expressionism by William Green, Robyn Denny and Richard Smith; the flat canvas could be understood as a surface upon which abstract equivalents for the phenomenal experience of urban modernity could be designed, as in the work of the Situation artists; the flat canvas could be understood as a surface upon which references to the non-artistic world were distributed as a set of iconic fragments, as in the work of the Royal College painters in the early 1960s. As I have pointed out Kitaj's painting is close to the latter grouping, but I want to end this discussion by suggesting an additional inflection of the meaning of the signifying surface of modernist painting in London during the early 1960s in relation to *Kennst du das Land?*.

In certain quarters of the London art scene between the mid-1950s and mid-1960s, abstraction after Abstract Expressionism was seen to have an ethical aspect. For example in the catalogue for the Situation exhibition at the RBA Gallery in 1960, Roger Coleman asserted that the mode of production of the work displayed, involving 'direct execution' on the canvas, meant that the artist was committed to a 'much closer relationship with the work', while also commiting 'him ethically'.[124] The nature of this 'ethical' position was explained when he stated that the '"venturesomeness" which is involved in this approach to the act of painting is one of the ethical values represented by modern art'.[125] Thus the direct execution of the abstract painting enabled risks to be taken on the canvas, allowing for 'venturesomeness' and the breaking down of closures on artistic language, establishing the artist as an ethical agent rather than the subject of a codified artistic practice.[126] It can be observed immediately that this is a very limited conception of the potential ethics of art, given the history of social and political engagement which has marked European modernism. But let us work with this limited definition of ethics for a moment.

I have noted that *Kennst du das Land?* can be interpreted as a particular contestation of the limits set upon signifying content by certain abstractionist and formalist discourses influential on the London art scene after the mid-1950s. It is possible to read this contestation in relation to the discourse on the ethics of art practice articulated by Coleman. To do this I must assume that Kitaj had at least some understanding of the idea that the means of artistic production derived from French Tachisme and American Abstract Expressionism were conceived by their supporters as having an ethical aspect. In relation to this assumption, Kitaj's working of figurative elements against an abstract ground in *Kennst du das Land?* was not merely a knowing articulation of a pre-existing formula for making interesting paintings after Abstract Expressionism, presented by the likes of Johns and Rivers, but rather had an ethical inflection. This sense of ethical import was not merely about some notion of formal risk taking, however. It involved a limited attempt to retrieve the ethical priorities of modernism from the arena of formal concerns. If the utopianism of early twentieth-century European modernism had been sublimated into formalism in the postwar period, Kitaj's engagement with political history in the early 1960s represented a sense that the ethics of artistic practice had to be reinvigorated through a critical engagement with the world. The modernist surface of *Kennst du das Land?* is in this particular sense an ethical surface; a surface animated by an ethical struggle over what contemporary art could mean, over what a contemporary form of history painting could be and, in relation to the latter, over what relationship a painting about the Spanish Civil War could have with the 'repressive surface' of received history. Here the ethical struggle of the painter is not merely a formal one, nor merely one about the ethics of the construction of historical representation, but a historical one over the conditions of modern art practice in the early 1960s and over the limits these conditions placed upon the ability of modern art to engage with political history. The notion of abstract painting's being ethical may have given Kitaj one starting point for his painting. This is why I think his use of a flat late modernist surface is not merely a form of parody or deference to contemporary abstraction. But it should be emphasised that Kitaj's early project seems to have been aimed at taking the moral import of art well beyond this initial starting point.

# Secure objects and ancestor worship: Kitaj's practice versus transactions of an Art & Language history

## Terry Atkinson

> The history of art is conventionally told as a history of triumphs of the will. There is another history to be thought: a history of unredeemed incompetence, of unpainted and unpaintable pictures, a history of the wasted and unauthenticated, the abandoned and the destroyed.
>
> Charles Harrison, *Essays on Art & Language* (Oxford, Blackwell), 1991 p. 180

Of the practices of art, painting is one of its continuities, it seems to guarantee certain things. Sculpture is the other. But in the context of Kitaj it is painting with which we are concerned. In modernism the terms painting and sculpture have been ceaselessly wrangled over. Most painters do not concern themselves with such wrangles, they just get on and paint. Gary Hume is a current example. Kitaj is another from an older generation. Continuity of a practice may be a mark of our humanity, of our human culture and of our mental capacity, but it is no guarantee of our mental flexibility, or of our spirit of inquiry.

Since through our making of culture we have made large parts of our world, and we show every sign of increasing our influence in the making of our world, then we can change the world. As part of this we are increasingly likely to ask questions of those practices we accept as continuities. This is one of the ways we might, if we wish, change the world we have made. Culture then can have at least two characteristics: it can continue to repeat what we already have achieved, and/or it can extend what we know and do. The former may be a protection and maintenance of a tradition. Painting, it seems to me, is, nearly without exception, a practice of continuing to repeat the culture of what we have already achieved. Of course questions arise as to what we are to count as painting. But, the Johnsian tradition notwithstanding, I intend to put these questions aside in this essay, since Kitaj's practice seems unequivocally to rest at the centre of what we count as painting under any circumstances. He is pretty straightforwardly a painter – no ifs and buts.

And the practice of his painting is a practice of repeating what we have already achieved – it may be the maintenance of standards of excellence in painting according to the criteria of some such as the European Treasure House theory of art. All painters whose practice lies as securely at the centre of the identity 'painting' as does that of Kitaj seem to me to work with, and ask very little, of the functions of representation established long ago in the founding days of the Treasure House. In this sense the practice of painting is recapitulatory. The sort of recapitulatory function I have in mind here is not the theory of recapitulation which was so prevalent in biology at the turn of the century – good job too! That theory was highly disreputable, loaded with racism and imperialist supremacy, and by the early 1920s and the establishment of Mendelian genetics could be seen to have no scientific foundation whatsoever.[1] The theory of recapitulation which was applied in biology at the turn of the last century was one applied to human natural development. One of its most ardent protagonists was Ernst Haeckel, who was a vehement populariser of Darwin's theory. Thus what Haeckel imagined he was applying the theory to were the Darwinian mechanisms of evolution. Thus not only would it be morally repugnant to transpose this notion of recapitulation to painting, it would be cognitively absurd, since painting develops by cultural trans-mission and the mechanisms of cultural transmission are Lamarckian ones. Thus I am using recapitulation here in the Lamarckian context of cultural transmission. By recapitulation here I mean a practice the propensity of which is to repeat the achievements of ancestors.

Kitaj is an ancestor worshipper. As is Wollheim, a long-standing Kitaj enthu-siast, one of which ancestors he worships being Freud. Ancestor worship, it is argued, maintains the high value of the tradition. Thus Kitaj's practice presup-poses a continuity, the continuity not least being painting. This is a presupposi-tion made unexceptionally throughout, for example, the members of the so-called School of London. It is also a presupposition made throughout large sectors of the wider art milieu.[2] Kitaj's ancestor worship is erudite, it embraces many painters and artists, and literary and political figures, Hannah Arendt and Walter Benjamin for example. But it is, more abstractly, an ancestor worship of painting itself.

Something which Kitaj has consistently, and insistently, called painting, at least since he first emerged into a wider public view as a student at the Royal College in the early 1960s, has been imbedded in the centre of the vocabulary through which he has publicly pronounced upon his work during these last nearly forty years. And he has been a persistent public pronouncer upon his own practice throughout this period. But this something called 'painting' comes dangerously (I do not use the word lightly) close to being a fetish. So what is so dangerous about being a fetish? Before I try and write what I mean by fetish, and also what I do not mean, I pose the following questions. Does the fashioning and use of a fetish neces-sarily entail uncritical use of what the fetish is a fetish of? Is the use of a fetish necessarily affirmative? In this latter case turning the producer artist, and other

art spectators (whichever community uses the fetish), into fan and enthusiast? So I mean fetish in the sense of a commitment which becomes increasingly blind. Whilst it is the case that to maintain the canon 'great' there must be examples of bad and mediocre work against which the canonical works are held out and contrasted, I mean blind, in the case of Kitaj, and there are many other artists similarly blind, of his holding that 'painting' as a structural category is faultless. Whenever and wherever there is uninteresting painting, the fault always lies with the painters not with the category itself.[3] No criticism is directed at the structural category 'painting' per se. Thus I do not mean fetish in the widest, detailed Freudian sense.[4] I mean fetish in the sense of a devoted but blind commitment to some thing, although this may be included in the Freudian sense of fetish.

The logic of this kind of fetishisation is something like this. That, whilst the category painting may have continuously within it many examples of bad painting, that there may be produced within it a lot of bad painting, nevertheless, as a structural category, painting is not an impediment to producing significant art. Of course the word significant may offer up all sorts of trouble here; we could just as easily use the word 'great' (which is one Kitaj himself often uses), and have exactly the same problem. And an examination of the use of the word 'great', simply because of its contemporary currency, may be more indicative than one of the word 'significant' of the extent of the revision that would be required in order to contemplate any view other than the presently widely held one that the structural category 'painting' as capable of sustaining great work is eternally settled. In terms of the structure of the inquiry it hardly matters whether we inquire into the use of the word 'great', or some such word as 'significant', 'interesting' or 'good', they can all be made to act as synonyms, even though, in our familiar vocabulary in evaluating art works, 'great' is usually seen as being something over and above 'significant', and several grades above 'interesting' or 'good'. I am choosing the word 'great' here not only because, as I have noted it, it is a widely used word both in Kitaj's own rhetoric about his own work and painting and art in general, but because it is often used, and and even more often implied, by complimentary commentators upon Kitaj's work. Thus one of the complexities here of inquiring into our use of the word 'great' is that it is not simply directed at what may or may not be examples of 'great' work, 'great' painting, but of inquiring into the presumed status of the structural category itself. A further complexity is if there is a revision of the status of the category is this simply vis-à-vis future work or back to, say, 1960, or is it a more wholesale historical revision concerning the status assigned to the category throughout its entire history, whenever the beginning of that may be? A Thames and Hudson potted art historian may take some such point as the execution of the cave paintings at Lascaux as the initial point of the emergence of the structural category 'painting'. For purposes of this essay I am presuming that practices such as those of Jasper Johns and Frank Stella around 1960 began to suggest that the category 'painting' may have limits in sustaining future significant work.

To close the matter of the logic of what I am calling the fetishisation of painting. That the use of the particular resources of expression of the category painting do not necessarily except the user of these resources from producing great art (painting).[5] That the use of such resources is not necessarily a cognitive impediment. That painting can be great art and that painting is necessarily no impediment to greatness. (Perhaps now the use of the word 'great' can be seen to be susceptible to the danger of hyper-inflation, so let us dispense with 'great' and use instead something like the term 'good ideas'. Logically the opposite of 'good ideas' is 'bad ideas' – there may be many synonyms we can come up with, 'banal ideas' for example.) That painting, like art, necessarily cannot be caught in the bind of, say, science.[6] That painting, like art, necessarily must produce some good ideas. A particular argument of the likes of the Kitaj dialectical hinterland, and there are many hinterlands just like it, is that what goes for art goes for painting. It is not only that Giorgione, Matisse, etc., are ancestors to worship, it is also that we are back to the more abstract ancestor, the worship of painting itself. There is nothing contingent about Kitaj's embrace of painting; it is, if the modernist rhetoric is to be believed, a matter of compulsive necessity.

Kitaj's painting is modernist, not only in the sense that it is free from commercial drudgery, but also because it is a painting allegedly driven by inner compulsion. He is the paradigmatic modernist painter, the painter producing out of his own studio, which studio is a symbolic space for sanctified ongoing inner/private cognitive transactions, allegedly profound and allegedly a self-confirming centre of truth. This is a case of believing the modernist rhetoric – the artist's workplace is private, and fittingly so, according to the status in modernist ideology granted to artistic subjectivity as essentially individualistic. This ideology itself embraces a contradiction when such an artist is an addict of ancestor worship, and most modernist artists are ancestor worshippers. Ancestor worship entails some kind of intersubjective and public exchange, we have to agree what an ancestor is, who or what are the ancestors, and which ones are worth worshipping. The first two particularly are unlikely to be purely private judgements. Such contradictions, all in one way or another centred on public agreements about the notion of the private and inner, are standard dialectical glitches of modernist ideology, since this ideology is seemingly so addicted to the binary contrast of the inner and the outer.

There follows now a brief discussion contrasting Kitaj's practice with that of Art & Language in the last half of the 1960s. Art & Language at that time had built a practice in which at least two main areas (David Bainbridge's and Harold Hurrell's 'cybernetic sculptures' and Terry Atkinson's and Michael Baldwin's textual/conversation work) were in apparently uneasy (some at that time may have said eerie) relation to the by that time established model of artistic subjectivity as one of singular and solitary individual practice, a prominent part of the public profile of which rested on the site and icon of the artist's private studio space. The contrast of the setting of the Art & Language projects with the established ideological characterisation of artistic subjectivity was: (1) that Bainbridge and Hurrell

produced their works in something like a machine-shop milieu with its strong connotations of public scrutiny and trade-union supervision of working conditions; and (2) the Atkinson/Baldwin projects were produced irrespective of any special kind of space. Art & Language at this time sought out a noisy public space, a public form that in production could move from public space to public space.[7]

At the centre of Art & Language practice in the late 1960s was teaching. Teaching was the practice. And it was teaching, in the main, against the conventional pattern of art teaching then which embraced the notion of a hierarchy of spaces with the private space of the artist's studio as the top and most desirable space. In many exchanges we encouraged the idea of the art school, because it was such a public space, as the best space for production. We interrogated the model of the solitary private soliloquy as part of the production of our teaching, our work. In this sense we thought our model of teaching and our use of the art school to be more consistent and rational than the established model of teaching which treated the art school as a public space in which to transmit the model of the artist's production as essentially taking place in a space of isolated private reverie. Behind this established hierarchy of spaces was the model of the artist as self-confirming centre of truth, and thus our objections to the model were epistemological: not only under what kind of conditions could knowledge be best produced, but under what conditions it could best be tested as knowledge. Perish the thought we would ever sympathise with his politics, but in respect of seeing practice as producing knowledge which could be tested in public exchange Art & Language was Popperian.[8]

Thus, that panoply of practices which, by the turn of the 1960s into the 1970s, had come loosely together under the title of Art & Language represented various kinds of interrogation of, and assaults upon, the model of the artist's production space as an essentially private one in which allegedly profound truths emanating from the artist's inner life were expressed. And perhaps more importantly in the Art & Language view, we not only inquired how profound such alleged inner truths were, but entertained doubts as to the status of an inner life itself – we asked some questions about just how secure was the private/public binary opposition.[9]

The noisy concatenation of new members of Art & Language throughout the late 1960s/early 1970s was itself a sign of the commitment to upgrade public exchange and downgrade introspection as a kind of certitude of the model of the artist as self-confirming centre of truth.[10] The art school, as opposed to the private studio, seemed the logical space in which to undertake the project. Meanwhile throughout the 1970s, the reputation of artists such as Kitaj, whose production was based on the most traditional modernist model of artistic subjectivity, grew remorselessly and regardless of the Art & Language programme. The inscription of the traditional modernist model carries on today just as remorselessly, but the Art & Language tradition is not still or dead either, hence this essay. Throughout the 1970s and 1980s, with and all through the pluralist whiteout of the postmodernist deluge, the model of the artist as a private inner-centred individual and the

corresponding notion of the artist's production space as a private space was impen-itently reinscribed.[11]

Some of the most turbulent and convulsive reactions to Art & Language work in the late 1960s was to the Terry Atkinson/Michael Baldwin work 'in the head' (as TA later called it). This reaction was particularly to conversational work of which there was no recording – in other words for any audience to know of these projects we had to mention their having taken place. Conversational events ('objects') enjoyed the same ontological status as (what I am going to call here) 'objects' of the mental realm (viz. thoughts, judgements, beliefs, desires, inten-tions, intensions[12]) in the project and moves of our work. That is to say we (TA/MB) were working with a relatively expanded and complex notion of object compared to the perceivable, regular middle-sized ontology of art objecthood (paintings, sculptures, etc.). How such conversational events could be considered art, since there was no record of them, puzzled and irritated people, and in a few cases enraged them. They were sometimes even more enraged when we pronounced that whether or not the projects were art was not a question that much concerned us. But there was, at first look, anyway, a seeming paradox here. Events 'in the head', say a silent conversation with oneself, are by definition the most private of events. But the critical point here is to remember that the essential working condition of these projects was that it comprised conversation with someone else, by definition an intersubjective event. The main protagonists of such conversations were TA and MB, with DB and HH inevitably pulled in for good measure. But in many conversations we pulled in anyone who seemed interested, or sometimes, anyone in whom we were interested, presuming they were acces-sible and willing. Teaching (conversation) was, obviously, focused on the students who chose to work with us, but we didn't see these students as the limiting boundary of such conversational events. The art school had all sorts of potential target participants. The fact that many of them may have been uneasy or unwilling, or more commonly, uninterested, sometimes was the attraction of producing a conversational event – we wished to discuss issues with them. The milieu of the art school had various potential conversational targets, some sympathetic to us, some strongly opposed to us. But the crux of the Art & Language project in the last half of the 1960s was a determined TA/DB/MB/HH exchange *as* the work, with teaching as the central operation of the work.[13] This was a determined attempt to build some such entity as a collective intelligence.

Kitaj's affection for and addiction to painting is a fetish, and this is a widespread fetish, a defining condition of adherence to the modernist ideology of the solitary practitioner and the artist as a self-confirming centre of truth. To this day almost the entire profession subscribes to one form or another of this ideology. Kitaj's relations of production, typically, required a private studio. Art & Language's rela-tions of production required a public mileu, and if something like a machine shop or a studio, providing this latter was subject to, so to write, open social intercourse, was attached, then so much the better. The Art & Language producer's (artist's?)

relations of production, since they insisted on open access and exchange, as a matter of definition, not only put the notion of artist under interrogation, they also put the notion of self and individual under interrogation. Here was one of a number of points where Art & Language practice lapped into established philosophical problems. Descartes, with Hobbes, was probably one of the pioneer materialists, but caricatures of Descartes's notion of a mind/body split still find fecund ground in the protocols of modern notions of art practice. These caricatures, still so widespread and licentiously held to in art schools, were a main target of Art & Language work. Whilst Art & Language practice was a white boys' movie, this shortcoming notwithstanding, the practice acknowledged that the model of the solitary heroic individual artist, if it ever had been adequate, was not now an adequate model to handle the complex level of information that Art & Language held as constituting the practice. Not simply that the model of the artist may be inadequate but that the model of art may also be. Art & Language's 'work in the head' was part of a series of moves intended, as I have noted already, to construct something like a collective intelligence. Another set of moves in this project was the use of cybernetics (feedback loop) used by Bainbridge and Hurrell in their respective 'sculptures'. The notion of the feedback loop itself could be made to threaten notions of mysterious, immaterialist introspection. The work of the likes of Ross Ashby and Norbert Wiener, which Bainbridge and Hurrell closely studied, was tied in closely with a materialist theory of mental operations, a materialist theory of mind.[14] If the general art-school milieu had any theory of mind in mind, where it did have pretensions to be a materialist theory, it was frequently hopelessly inconsistent.

Authenticity is often equated with the notion of an inner life. In this context the inner life (whatever it may mean) is seen here as the most authentic zone of the experience of the individual. Since Freud the notion of the unconscious has come to be widely conceived as the more, sometimes the only, authentic zone of experience, where, so to write, what is repressed from the conscious is truly there. Certainly it is a widely accepted view in the art milieu that what is expressed in realising a lot of art works are records of events from/in the unconscious of the expresser. Freud aspired to a psychiatry as a practice resting on a psychology the status of which was that of a natural science. But though talk therapy, rather than, say, painting or drawing therapy, may be the primary therapy of psychiatry it does not involve talking to oneself, even if the analyst is there only to listen. Talk therapy, no matter how much it, in various cases, may value soliloquy, acknowledges the intersubjective character of conversation. Freud may turn out to have written more poetry than science in his work, but I am not going to argue this subject in this essay. What I am suggesting is that the notion of the unconscious, in the characteristic caricatured Cartesian guise in which it circulates widely in the art milieu, is often a refuge of epistemological scoundrels. Whilst Freud was no epistemological scoundrel, there are many uses to which the prioritising of some such as the inner life, the unconscious, whatever, is put by artists and their apologists which amount

to sophistry and epistemological scandal (the model of the artist as a self-confirming centre of truth).

It is obvious that the physical space required for conversation and writing may be less specialised (talk therapy sites may be one of the exceptions) than the physical space required for traditional professional art making. The character of the respective technologies, say paint/brush/canvas versus pen and paper/voice box is decisive here. Quite aside from any wishes on the part of the artist for quiet and solitariness, conditioned or not, the physical scale of large and middle-size painting, and the technical detritus of a technology like, say, oil painting (to say nothing of the relatively exotic technologies which have emerged as part of the conception of complex and expanded practice in, say, the last fifty years) is likely to be intrusive if it takes place in a non-specialised site. Attempting, on a small kitchen table, to make a large Pollock-like drip painting, or an asphalt pour, or to cut an animal in two (in a kitchen that is) might prove intrusive, not to mention difficult. In the last half of the 1960s, Art & Language with their insistent and incessant chatter and scrawling (with almost anyone who was interested to talk to them) were accused not so much of not labouring at their craft as of not having an appropriate craft/technology to labour over. With the introduction of the concept of labour we come to yet another site and space which are historically masculinized.[15] Talking/writing, technologies, such as they are, were seen as banal, too everyday, too domestic, not a dramatic enough presentation compared to the way the masculinized symbolic space of the studio was considered for what was, and is taken still, as the high-octane presence of the artist in the workaday world: the artist as ultra-presence. If his commentaries[16] are to be read at anything like face value then Kitaj envisages himself as the artist as ultra-presence; his commentators envisage him, if it is possible, as even more so.

If Art & Language as white boys' movie was to come home to haunt them in the early years of the 1970s, maybe contributing to the wreck of the founding formation, it wasn't out of any particular vision of, or empathy towards, the re-emergent feminist movement,[17] but perhaps rather through not being able to negotiate well enough the reflex of the trope of the masculinized studio. The machine shop itself, one of the alternatives to the studio space which Bainbridge's and Hurrell's 'cybernetic sculpture' canvassed, had something of the same masculinized trope as artist's studio (see note 16) – the site of what Carolyn Jones has called 'virile design and manufactures'.[18] Art & Language was hesitant but perhaps not resistant enough (for 'resistant' here perhaps read 'dialectical'), to textual production being pushed out onto an unreflexive male pantheon. The fact is that the Art & Language conversation, certainly Art & Language in the United Kingdom, hardly ever sustained a female voice. I guess this Art & Language 'virility' was one of the things that more or less guaranteed, at some point in the near future, the emergence of a corporate managerial structure. The artist in the grand modernist position is invariably a one-man boss; if we keep in mind the emergence, after the Second World War, of increasing numbers of artist one-woman bosses, then their

practices are, just as invariably, made in the same trope of the studio and the estab-
lished masculinized art technologies.

Whilst perhaps Art & Language was more successful in reducing the contrast
between studio and machine shop, a move launched in the search for ways of
producing that would sustain and develop the new conceptions of practice, then it
is perhaps worth noting that part of this was resistance to the resistance in the art
world to forming a social collective practice. In some respects Art & Language
practice was also successful in reducing the contrast between the studio and the
domestic space.[19] Many TA/MB works were conceived and executed in their
entirety on the kitchen table, in a parked Morris Minor, on a train seat, or some
such equivalent. But it is perhaps a moot point still whether this was dominantly
a sympathy for the domestic or an intrusion into it. What is not contentious is that
working in the head and with the mouth never required anything like a Rowney
technology. On the matter of writing, a Bic pen was sufficient, and writing produc-
tion in a more formal mode was never much more than a Corona typewriter until
1972. In front of the graphical and presentational wizardry that the current
computers can deliver, Michael Baldwin today still expounds the virtue of the likes
of Thomas Hobbes's quill pen, one serious point of his quip being that substan-
tial presentation is not the same as substance being present.

So far in this essay I have written nothing much about the differences between
Kitaj's subjects and Art & Language's subjects. It perhaps should be noted that I
am writing here only of Art & Language's concerns up to the close of the 1960s.
Were I to restrict my view of Kitaj's practice only as far as then, I would be stop-
ping at works such the small portrait of Unity Mitford of 1968.[20] But Kitaj has
remained steadfastly a painter, and I am arguing here that this steadfastness
towards the medium may itself be a sign of a too uncritical ancestor worship, both
of individual painters and of their work, but more particularly, of painting itself.
The metaphysical issues raised by the treating of an abstract entity such as the
practice of painting as an ancestor, these I have tended to pass over here. It would
require a more substantial essay than the space allotted to me can offer. I am
arguing that there is a sense in which steadfastness to the medium such as Kitaj's
is a symptom of a condition of practice, let us call it the 'not being able to get over
painting' symptom. Kitaj, through the technical and methodological continuity of
his practice, has a secure practical home; Art & Language, or the transactions of
the Art & Language tradition, not least because various practitioners who are in
this tradition have for intermittent, and sometimes prolonged, periods since the
1970s made extenuating, problematic, distended and sometimes anomalous uses of
something that might be called an amplified and augmented practice of painting,
seems not to have much of a home anywhere. This latter may turn out to be either
a virtue or a weakness, but I am suggesting Kitaj sees himself much more definitely
as an artist, much more securely anchored in a respectable trade, than do the prac-
titioners in the Art & Language tradition. It is my argument here that Kitaj's
methodological and epistemological steadfastness will turn out to be a weakness,

because it embraces the entire rhetoric and mythology of the modernist model of the artistic subject – and this at a point of sufficiently imbedded establishment becomes both methodological timidity and epistemological smugness. The weakness is not particular to Kitaj, it is not just generational, but through-generational. Measured against its radical rhetoric an epistemologically respectable defence of painting is a hard thing to make.[21]

Both Kitaj and three of the founder members of Art & Language (Atkinson, Bainbridge, Hurrell) were processed through the same kind of modernist-ideology transmitting stations (the art schools, mediating mechanisms, etc.) at roughly the same time (1950s/1960s), and for the middle years of the 1960s in exactly the same art milieu (London). Up to about 1963 three of the future Art & Language founders and Kitaj shared the same modernist ideology and rhetoric. From 1963 these three future Art & Language founders would become increasingly critical of the presuppositional framework and the alleged certainties of modernist ideology. Kitaj remained steadfast to modernist ideology.[22] Thus one might argue that up to 1963 three of the future Art & Language founders and Kitaj shared near enough the same methodological and epistemological principles. By the end of 1966, these three Art & Language founders, now with the detonatory and equally critical contribution of the fourth, younger founder and soulmate, Michael Baldwin, helping to ratchet up the anti-modernist models of artistic subjectivity, had worked through a series of shifts in/from these principles.[23] By this time, late 1966, the shifts were such that they were not so much a modification of modernist ideology, not so much very different ways of making arts works, products, etc., but in terms of these settled methodological and epistemological principles of modernism might not count as art at all. If Art & Language had any soulmates at all in the art milieu in, say, 1967, it would be someone like Robert Smithson.[24] By this time Art & Language were a world away from Kitaj and the modernist pantheon.

Kitaj's work was, and has remained, steadfastly modernist.[25] Kitaj, I think, sees the artist as the man with the first vision, the vision particular and subjectively specific, the subjective space sacred and incorrigible. A vision, so to write, locked into the rhetoric of the artist as fundamentalist, original and authentic because able to reconstitute the 'dawn of creation'. The artist as spirit, the essence being immaterialist, modernism, as always, hanging on the coat tails of Judaeo-Christian religion.[26] Kitaj's particular dance with the writings of Walter Benjamin is a good index of the confused mix of materialism and religion in the modernist construction of the subject of the artist. I will argue more of this below. Locked into this immaterialist subterfuge, supporting it and providing a climate in which it thrives, is the modernist rhetoric of democratic diversity. The postmodernist whiteout of the 1980s held out pluralist sameness (more not less of it) as a virtue against what it held to be the authoritarian instructions of what it called the Enlightenment grand narratives. There never was a much more epistemologically feckless notion than Foucault's 'truth is only the will to power' – or at least there never was a notion more amenable to epistemologically feckless devotees. But the postmodernist

model was the modernist model, the old modernist priests writ large in postmodernist cassock. Foucault's notion of the artist as herald, for example, was an especially addicted version of the modernist notion of the artist as high-octane presence. Kitaj, as ever, remained steadfast to the modernist model throughout all the years of postmodernist misconjecture. I don't know whether he knew, or cared, that the postmodernist gurus were out to reinforce the vapid rhetorical figures of the modernist model of artist; that, on the subject of the construction of artistic subjectivity, the modernists and the postmodernists were all of one piece. A postmodernist watchphrase might be something like 'be true to your diverse self' (this was one of the paradoxical ironies of Barthes's notion of the 'death of the author' – it seems the twist of the logic might produce a condition where we were all similar diverse selves). The title of Richard Morphet's opening essay in the catalogue of the Kitaj retrospective exhibition at the Tate Gallery in London in 1994 is 'The Art of R. B. Kitaj: "To thine own self be true"' – the subtitle a quote from Hamlet.[27] Using such a quote seems to suggest that neither Kitaj nor Morphet have much trouble constructing and identifying what they take to be selves – par for the modernist course. Art & Language, in the 1960s, always harboured a suspicion that constructing selves might be a little more complicated and this bore to a considerable extent on their idealistic aspiration to construct a collective intelligence. In the matter of trying to achieve this aspiration, teaching seemed much more promising than, for example, painting. Such an aspiration may not seem so outlandish to anyone who suspects that the notion of the self may be a result of a long-range historical, collective project – and not a natural kind based on to each their own.

So, to end, I want to try and say a little more about the problems of painting. They seem the same today as they were in the mid-1960s. Kitaj's painting resources of expression are pre-Cubist. That is to say, Kitaj deploys a set of resources which in terms of raising the critical painting issues of (1) picturing and painting, and (2) showing and representing[28] could have been in position before Cubism, and, I dare say, if it had been the case, acted, at that time, as a staging post on the way to Cubism. But Braque and Picasso seized Cézanne with such resolution that such staging posts were never required. The founding Cubists jumped a whole set of stages that might have taken place between, say, 1906 and 1910, had the move to Cubism been a more gradualist one. There is a sense in which any painter using – what shall we call it – various gradations of the figuration/abstraction mix is using resources of expression which are pre-Cubist. Picasso's and Braque's work after Cubism would be paradigmatic cases of the malaise, if that is what it is.[29] What came after Cubism which was not 'could have been pre-Cubist' were the likes of Léger, Pollock, Johns and Stella. The introduction of the names of the last two brings us into the 1960s, and back into the 1960s London art milieu in which Kitaj and three of the future members of Art & Language were protagonists. A setting to start with might be a list of the *dramatis personae*, such as they are, of this essay. Kitaj (b. 1932), Atkinson (b. 1939), Bainbridge (b. 1941), Baldwin

(b. 1945), Hurrell (b. 1940). Of the Art & Language personnel, at the time of writing, Baldwin, the youngest, is approaching 54, Atkinson, the oldest, is approaching 60. Kitaj is approaching 67. Atkinson (1960–67), Bainbridge (1963–68), Hurrell (1963–68) were all living in London when Kitaj had his first exhibition there, at Marlborough Fine Art. Baldwin was just starting at art school in Banbury.

I saw the show at Marlborough with John Bowstead, Jacqui McClennan, Roger Jeffs and Bernard Jennings. The three males were, with myself, to form in late 1963, at the Slade, where we were all final-year students, a group called Fine-Artz.[30] This was my first group. Through the cognitive soup I was stewing in at that time the forming of the group was a realisation of my first inklings that a collective effort might be required to sort out the complexity and rapid expansion of practice. By 1964 Bainbridge and Hurrell, both in the sculpture area at St Martin's, were working in proximity to Fine-Artz. In the Kitaj chronology in the Tate catalogue the following appears in the section 1962-65: 'First met Howard Hodgkin, Peter Blake, Richard Hamilton and Tony Caro, often at the house of Joe and Jos Tilson in Argyll Road, Kensington'. John Bowstead and Jacqui McClennan lived at the Tilson house in Argyll Road in 1963, generously loaned to them by the Tilsons whilst they were away for several months in America. I don't recall meeting Kitaj, but I spent a fair amount of time at the Tilson house when John Bowstead and Jacqui McClennan were in residence there, and frequently visited the Tilsons with Fine-Artz when they returned. Apparently I met the same London art milieu at the Tilsons as Kitaj did. As I recall Fine-Artz was formed whilst Bowstead was in residence in Argyll Road. I think my dates are pretty sound. It was on a visit to Argyll Road that, as she opened the door, Jacqui McClennan informed me Kennedy had been assassinated. I went to Argyll Road that night to attend a meeting concerning what kind of project Fine-Artz would enter for the forthcoming Young Contemporaries exhibition in early 1964. Bainbridge and Hurrell came to meetings and parties we held at Argyll Road.

Evidently Kitaj and three-quarters of the future Art & Language were in close proximity, although, so far as I recall, we never met. By this time the future Art & Language contingent were all aware of the painting, and the gains and difficulties it bequeathed us, of Johns, Stella and the ubiquitously emergent Warhol. By this time too Fine-Artz took painting to be problematic – their own practice presupposed this. By the time Fine-Artz saw Kitaj's exhibition in 1963, we had figured that the problems posed by American painting of the now established grandees – named above – were beyond the strategies of the modernist models of the artist. Their painting had bequeathed art practice a set of problems, such that straight-up modernist practice could not animate, but only deaden. This threatened a whole edifice of modernist painting. Anyone settling within that edifice necessarily makes the act of painting an act of recapitulation – that amounts to a hell of a lot of painters then in 1963, and even more now. The market dictates the settled edifice – it is rapacious not least in its desire for secure objects. It is worth noting that the

notion of a complex and expanded practice had, by the early 1980s, come to realise a complex and expanded range of secure objects. Not so much the modernist models regaining control, since they never lost it – the proclaimed and acclaimed radical break of postmodernist practices was a distracted and distracting storm in the modernist teacup. Kitaj's practice is amongst those most comfortably situated and seriously authenticated as a modernist model.

There are many Kitaj pictures I might cite, but briefly looking at just one might fill out some of the detail of the above claim, such as *The Autumn of Central Paris (after Walter Benjamin)*, 1972–73 (Plate 9). I choose this one because it has some typical Kitaj concerns. The use of a figure from Western modern radical culture theory (Benjamin) imbedded in a pre-Cubist pictorial space. There is nothing radical about Kitaj's resources of expression here, they are standard Kitaj pictorial vocabulary. By the time Kitaj painted this picture I had very little interest in his work, for pretty much the reasons I have outlined above, vis-à-vis the achievements of Johns, Stella, Warhol et al. Just for the record the picture was painted around the time Art & Language were making the Indexes, which projects shattered the founding formation of the group, so I guess I was concerned with other things than the erudition and alleged radical credentials of Kitaj's work. Benjamin's work, however, has been a compelling study for me for twenty years. My first Benjamin mentor was Cliff Slaughter, during exchanges in the Coburg pub in Leeds during the first few years I started teaching at the university there. Slaughter was a Benjamin mentor not to be taken lightly. In Slaughter's view Benjamin belonged in the cultural heavy brigade. Thus I guess representations of Benjamin's work, both conscious and unwitting, have permeated my work for these past two decades. But the representations, so far as I know, are not pictorial ones. Presumably, a pictorial representation of Benjamin would be, in no matter how attenuated a figure, a portrait of him. When I first came across a reproduction of Kitaj's picture I puzzled over it. Since the title provides, by convention, something of a key – I half looked for Benjamin and found Gramsci. I found too, as I have said, pre-Cubist pictorial space, flattened form, pieces of the composition poised on the figuration/abstraction border, a red worker (proletarian? miner?) in the bottom of the picture, set amongst other red shapes (table tops, chairbacks, presumably), various figures, presumably recognisable, figuratively or symbolically, to those in the Kitaj know. Whilst I may not have recognised the figures, I think I recognised the status of the resources of expression of the picture. Whenever this first view of the Kitaj reproduction was (around, I think, 1977 – before I had met Cliff Slaughter), I took it to be one more Kitaj, with the standard Kitaj devices. I took it that the use of the name of Walter Benjamin in the title was to provide an infusion of radicalism into what are skilfully rendered traditional and conservative resources of expression. Then, at the end of 1994, I saw the Tate Gallery catalogue, where a good number of reproductions of Kitaj's pictures are accompanied by what Kitaj calls Prefaces. *The Autumn of Central Paris (after Walter Benjamin)* is one of these. Kitaj writes there the following: 'I feel I ought to apologise for this type of painting because its

such a rouged and puerile reflection upon such a vivid personality, but maybe I won't (apologise); maybe a painter who snips off a length of picture from the flawed scroll which is ever depicting the train of his interest, as Benjamin did, may put a (daemon) spirit like Benjamin in the picture.' So Benjamin is in the picture if only in (daemon) spirit. And there's me thinking all the time it was Gramsci. Cheers, Cliff! Come to think of it maybe modernism has become a rouged and puerile reflection.

# Kitaj, history and tradition

## James Aulich

This essay addresses R. B. Kitaj's work within the context of figurative painting in Britain in the decade 1975–85. The analysis concentrates primarily on the relationships between Kitaj's output and the work of Francis Bacon, Frank Auerbach, Lucian Freud, Leon Kossoff and other members of what became known as the School of London. It attempts to examine and to test the nature of the dominant middle-class and liberal-humanist art-historical discourse within which the School of London is constructed. The discourse eloquently and convincingly describes the work as emerging from an expressive struggle to realise an existential imagery of human relationships through the facility of the imagination and sheer hard work. But it fails to take account of the historical position of the humanist tradition in the contemporary world, and speaks too easily of untroubled relationships to the European tradition of painting in the grand manner.

Kitaj's paintings are complex and refuse single interpretations, or even a single glance. The depictive is rammed up against the abstract in pictures where the observer recognises a likeness, only to discover that it slips away into something else. Cognition is ruptured and painting reveals itself as artifice in a reflection of historical discontinuity. Conventional interpretation of Kitaj's work tends to place it within the traditional boundaries of the aesthetic where it is defined as the history of the promise of the reconciliation between nature and man. Traditional aesthetics proposes itself as a radical form of value and theoretical principle where the appearance of the human and the concrete in natural, unmediated, authentic expressions is nevertheless inseparable from the dominant ideological forms of late twentieth-century liberal democratic society. But this author argues that it is precisely in the work's conditions of repetition rather than imitation, of obsession, neurosis and self-reflectiveness, that, paradoxically, it finds its real power as a late modern gesture of hope in the recollection of a tradition irreparably junked in the history of the twentieth century.

During the summer of 1976 a rather naive and inexperienced postgraduate student went to Kitaj's studio in Chelsea where later that same day they were joined by David Hockney and his entourage. Open on the library desk was the carefully hand-written text for *The Human Clay* where references to Hannah

Arendt and Walter Benjamin were laid bare. In front of the large double-portrait painting of his friends James Joll[1] and John Golding,[2] Kitaj and Hockney conversed about the state of contemporary art. For them the picture was the end of the large canvases, 'the last of the big buggers'. In conversation and in practice, the artists were making an interrogation of the tradition of high and late modernism as it had come to rest in mainstream art history. The grammar and syntax of abstraction and its claims for purity and value were subjected to radical deconstruction. On the surface of the painting veils of dense and layered pigment compete with drawing and painterly description to create a pictorial allegory consisting of portraiture, biography and symbolic attributes. These are so densely interwoven into the fabric of the picture that they justify, in reference to the art of John Golding, the abstracted construction of the painting itself.[3]

For Kitaj's notion of the School of London, *From London* (*James Joll and John Golding*), 1975–76 (Plate 10), is a key picture. As a double portrait of figures from a generation of artists and intellectuals who have lived and worked in London since the 1950s, the painting maps part of the artist's conceptual geography of the cultural and intellectual life of the city. When the picture was exhibited in Edinburgh in the autumn of 1977 a typed note was pinned to the wall beside it: 'This painting is very unfinished but I thought I would show it in Edinburgh anyway. I enjoy seeing paintings in early states and maybe other people would like that too. Also it seems possible to keep a picture alive over some years, like a novel, so I will come back to it before long.' In its subject matter and in the approach the artist takes to the picture as something to be absorbed over time, and returned to in time, it is not so much supported by written texts as it is *like* literature.

Originally, the School of London had emerged as a descriptive phrase from the writing of the introduction to the exhibition of artists' drawings, *The Human Clay*, which Kitaj had been invited to select for the Arts Council of Great Britain.[4] In the essay he establishes the culture of London in a nostalgic and partly literary frame-work stretching from Charles Dickens to T. S. Eliot. The choice of writers is a revealing one, and situates Kitaj's thinking within the paradigms of an urban moder-nity without direct political agendas or avant-gardist pretension. Crucially, Kitaj assigns the human figure a role as the basic building block for art, and he attributes great importance to facilities such as skill, imagination and an allegorical sense of narrative. He writes of 'ambition', 'complexity, difficulty, mystery' to compound the human image 'in great compositions, enigmas, confessions, prophecies, sacraments, fragments, questions which have been and will be peculiar to the art of painting'.[5]

Confession or rallying call, the polemic spoke for the kind of art analysed by historians such as Edgar Wind who had been an important inspiration for Kitaj since his stay at the Ruskin School of Drawing in Oxford. Wind had delivered the Reith lectures in 1960 in what might be considered a *riposte* to Clement Greenberg who had lectured in Oxford in 1959. For Wind: 'The effect of leaving the artist too much to himself is clearly shown in paintings by the abstract expressionists. These artists have carried introspection to an extreme … Theirs is an art searching

desperately for substance ... Nothing leads more certainly to perfect barbarity ... than an exclusive attachment to pure spirit.'[6] Published in 1963 as *Art and Anarchy*, the lectures argued for the efficacy of historical models and the grand manner. Wind's conception of art as a public process of recollection was a denial of modernist and reductionist avant-gardism and involved the searching out of pre-existing forms in order to keep alive the experience of the past in the present. As a view on art it was highly appealing for Kitaj. It implicitly questioned the radical avant-garde strategies of the Abstract Expressionists and subsequent minimal-, conceptual- and perfor-mance-related forms where the work was apparently emptied of narrative and history in a denial of the centrality of the traditional art object.

The publication of *The Human Clay* marked Kitaj's more or less final aban-donment of the screenprint and the collage-like structures of much of his painted work in the 1960s, inspired as it was by Surrealist, neo-Dadaist and, arguably, McLuhanite precedent.[7] In 1967 he had written:

> My own hope is that when modernist lessons become *alien* to our living *concerns* they will be absorbed in ways which will be *seen* to become free from the elitest demands of the fag-ends of Western city life and *seen* to become available, if not since such and such a time – then for the first *good* time – available to much experience, intercourse with which is widely denied our art – our art which prides itself on freedom and on what has become the sham of renewal.[8]

Kitaj had had his own encounters with more conceptual and object-based art in the screenprints and especially the series 'In Our Time', 1969. There are also the less well-known experiments for the Art and Technology Program at the Los Angeles County Museum from 1968–70,[9] which like the prints he had found ulti-mately unsatisfactory. Revealingly, the installation bore more than a passing rela-tionship to notions of heroic materialism and to the memories of the great engineers and philanthropists of the industrial revolution. Tellingly, Kenneth Clark had offered these self-same people as a palliative to the modern condition in his popular television series *Civilisation*, first broadcast in spring 1969.

In England *The Human Clay* was launched into a complex field of artistic and cultural debate characterised, at least in part, by the lines drawn between two popular and contrasting television series. The first was the already mentioned *Civilisation* with its traditional views on genius, beauty and intrinsic value. Written under the shadow of the Bomb and the threat of disillusion, (emanating it is safe to assume from Clark's reaction to the radical turn among the young and the wide-spread urban and unrest characteristic of the last years of the 1960s):

> I said at the beginning that it is lack of confidence, more than anything else, that kills a civilisation. We can destroy ourselves by cynicism and disillusion, just as effectively as by bombs ... The trouble is that there is still no centre. The moral and intellectual failure of Marxism has left us with no alternative to heroic mat-erialism, and that isn't enough. One may be optimistic, but one can't be exactly joyful at the prospect before us.[10]

The other was John Berger's *Ways of Seeing*, first broadcast in 1972, which shifted the emphasis in the interpretation of art away from aesthetic to ideological value. Berger made the claim that traditional aesthetics had been undermined by commodity exchange and the new material means of producing and reproducing imagery, although he soon realised he had negotiated an art-shaped hole incapable of making meaningful distinctions between art as commodity in the pursuit of profit, and the value found in the exchange of ideas for the purposes of critique. Under these conditions art could only be a sign of something else.

Kitaj like Berger like had discovered Walter Benjamin, but where Berger had found in 'The Work of Art in the Age of Mechanical Reproduction' a progressive modernity tempered with a relativist pluralism suitable for the media age, Kitaj had found justification for his own working practices and attitudes to history. These had come through Hannah Arendt's reading of the 'Theses on the Philosophy of History' which, incidentally, were to provide a basis for his increasing attraction to Judaism.[11] Benjamin's philosophy of history, later to prove highly influential for critical theory, provided two buttresses of support for Kitaj's approach to subject matter with its emphases on histories denied and themes left largely untouched by contemporary art. As an approach to history it is contrary to progressive modernism and is figured in Benjamin's writings by the angel of history as it is driven backwards into the future by the catastrophe of the present.

As a humanistic perspective on art, and a construction of history as partial as Clement Greenberg's history of modernism in art, Kitaj's *The Human Clay* found a ready audience in England in the second half of the 1970s. His position was not as idiosyncratic as is often suggested, and found its most eloquent parallels in the critical writings of Peter Fuller who had discovered in a quotation from Benjamin's essay on Surrealism, 'the true, creative overcoming of religious illumination, a materialistic, anthropological inspiration'.[12] As an echo from the 1930s it could provide intellectual legitimacy for figurative art in an answer to the challenge from the early 1960s of how to paint figuratively and yet remain modern. For Fuller, the 1970s was a decade when modernism had breathed its last. The Postimpressionist exhibition at the Royal College of Art in the winter of 1979, much visited by Kitaj, was described by Fuller in terms of avalanches of 'mysterious purple suffusions' from 'that moment when modernism first discovered itself', where he found an antidote to the 'destruction of imaginative expression' in mainstream contemporary art.[13] In the essay, 'Where was the Art of the Seventies', from which these quotations are taken, he reasserts the essentialism and universalism of the early Karl Marx. The origins of this position are found in some of the Marxist thinking which had come to Fuller through Christopher Caudwell and Max Raphael, as well as the more contemporary neo-Marxism of Herbert Marcuse and the Frankfurt School. Like Kitaj's, the arguments are not political except in the widest of senses. Fuller's neo-Marxism is superficial, the quotations from Marx serving as little more than a legitimating text in the light of his former political radicalism and dalliance with John Berger. Ultimately, his defence of traditional means in painting

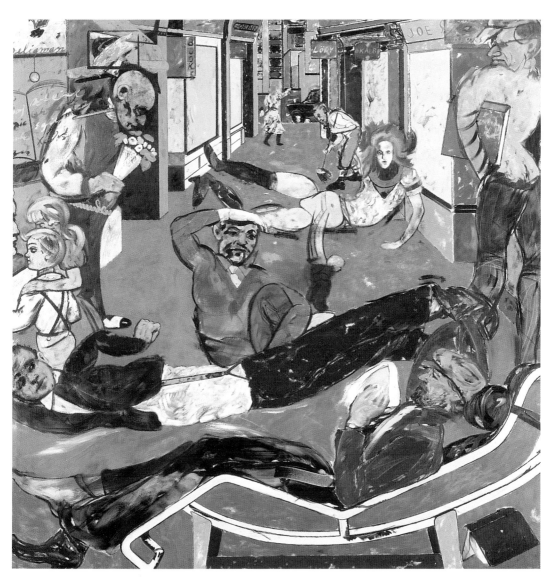

13  *Cecil Court, London WC2* (*The Refugees*), 1983–4, oil on canvas, 182.9 x 182.9.

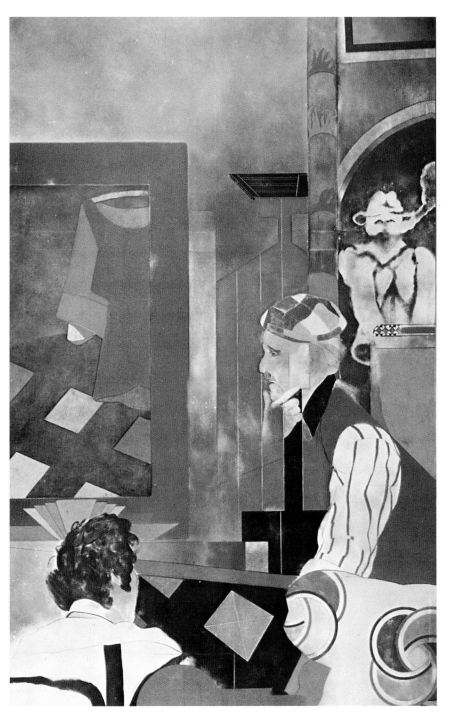

14 *Kenneth Anger and Michael Powell*, 1973, oil on canvas, 243.8 x 152.4.

and sculpture rests on an admittedly socialist, but nevertheless liberal-humanist aesthetic. In a vein derived from William Morris the imagination is central for 'Man's expression of his joy in labour'.[14] Like Kitaj, Fuller does not abandon the achievements of modernism, but rather seeks to incorporate them within an aesthetic capable of overcoming the more alienating aspects of contemporary art through an application to the body and its gestures. According to Fuller, in an echo of the central thesis of *The Human Clay*, 'from the Renaissance until the late 19th century, the "language" of paintings was based primarily on the artist's grasp of perceived, or objective, anatomy: the bodies of others'.[15]

The position reveals itself in the statement: 'Authentic expression then, by its very nature, *protests against ideology*', and contrary to much contemporary critical theory 'refutes the view that the human subject is constituted wholly within ideology'.[16] A crucial element of the argument hinges on the concept of the imagination as a shared facility integral to the human condition, and marks a return to a biologically determinist view of the individual. It parallels a wider, if parochial, disenchantment with forms of urban rationalism displayed in minimal and conceptual aesthetics and their radical engagements with traditional art forms and institutions. Its revisionism can as easily be found in the Joe Tilson of *Alchera 1970-1976* who abandoned the glitz of London and the *engagé* political radicalism of his print series 'Pages', 1969-70, (when he had quoted from James Joyce, 'History, Stephen said, is a nightmare from which I am trying to awake'), for an art submersed in elemental symbolism and erudite references to classical and Renaissance philosophers and poets. Similarly, Peter Blake relinquished his urban cast of characters for a rather anodyne and saccharine view of Englishness embodied in the Brotherhood of Ruralists. Born of the disillusion in the wake of the aftermath of 1968, it was part of an idealist attempt to wrest the individualist agendas of late modernism away from corporatist and state ideologies associated with the urban institutions of art. As a cultural phenomenon it must be seen against the background of the revisionist histories of contemporary art and late modernism which began to appear in the van of the American defeat in Vietnam.[17]

To return to Fuller's essay, he gives full acknowledgement to Kitaj and further supports his argument with reference to Timothy Hyman's 'Narrative Paintings: Figurative Art of Two Generations' which was held at the Arnolfini in Bristol in 1979. Like Fuller, Hyman was openly inspired by Kitaj's humanist perspectives.[18] Fuller had found in England no firm base for modernism, and the pursuit of an historical pedigree for what remained was on. Hyman found a longer history in Cézanne, Léger, Beckmann, Hopper and Balthus abroad, and in England, William Blake, Fuseli, the Pre-Raphaelites, William Roberts, Stanley Spencer and Francis Bacon. It was a history of what he called the 'disguised' narrative painters of Pop among whom he included Kitaj, Eduardo Paolozzi, David Hockney and Howard Hodgkin. Simultaneously, he looked to literary parallels in Doris Lessing, Edward Bond and Geoffrey Hill and the music of Benjamin Britten. It was as if the history of modernism in England was being unwritten.[19]

Hyman as a painter and a writer had established himself among the *culturati* in London, writing for the *London Magazine* and *Artscribe*, but few even among the *culturati* were prepared for the wholesale adoption by the cultural establishment of this approach to history. In 1981 the exhibition 'A New Spirit in Painting' took the art world by storm. It was organised by Christos M. Joachimedes; Norman Rosenthal, the exhibitions secretary at the Royal Academy; and Nicholas Serota, the director of the Whitechapel Art Gallery. In the 'Preface' to the catalogue they had written:

> We are in a period when it seems to many people that painting has lost its relevance as one of the highest and most eloquent forms of artistic expression …
>
> We hope that this disregard for convention, this sense of risk allied with a deep reflection on the traditions of painting will also be evident … Our aim has been to stimulate a new reading and thereby encourage a serious and exciting debate which will once again draw attention to the art of painting.[20]

Its revisionism and defiance of what Lucy Lippard had broadly characterised as the 'dematerialization of the art-object' was so complete that at its core lay a call for the return of the art of painting. Joachimedes polemicised for the conspicuous assertion of traditional values, falling back on such stalwarts of the vocabularies of art-historical writing as 'individual creativity', 'subjective experience' and 'quality'. The notion of 'accountability', derived from Marxist aesthetics, was introduced to make the mere expression of subjectivity insufficient, and to stake a claim for the kind of art which 'throw[s] light on the condition of contemporary art and, by association, on the society in which it is produced'.[21] Close to what Fuller had called 'a form of materially realized social dreaming', the high-modernist agendas of the impossibility of meaning were replaced by a concern for its possibility. As such, the art on show, which included several major works by Kitaj,[22] was considered progressive:

> The new spirit in painting is one which has swept aside unnecessary convention to establish a new connection between image and reality through a painting of inten-sive poetic force and piercing imagination. It is also the spirit of creative obsessions in painting, a broad realm that includes such antitheses as the vibrant, erotic visions of a Balthus, or a Lucian Freud, and the Beckett-like loneliness of Alan Charlton's canvases; where the haunting monuments of a Markus Lupertz correspond strangely with the volcanic form and colour of a recent Stella and where unbending formal self-control of a Robert Ryman may meet on common ground with Penck's dark, anarchic, archetypal configurations.[23]

As a liberal humanist agenda it offered a broad church inclusive of almost any artist using traditional materials and art forms, and who through hard work and imagi-nation could be perceived to be involved in a struggle for realisation. Specifically, for English art, the issue settled around two overlapping groupings of figurative artists. The one was based on Kitaj's School of London and broadly came to focus on the work of Michael Andrews, Frank Auerbach, Francis Bacon, Lucian Freud,

Leon Kossoff and Kitaj himself. The other took as its point of departure questions surrounding realism and materiality. In addition to the artists already mentioned it included artists as diverse as David Hockney, John Wonnacott, John and Helen Lessore, Peter Blake and Euan Uglow, for example. As an art-historical category, ill-defined as it was, it continued to find legitimacy in the 1980s with Lawrence Gowing's exhibition 'Eight Figurative Painters'[24] at the Yale Center for British Art in New Haven in 1981, and Richard Morphet's 'The Hard Won Image: Traditional Method and Subject in Recent British Art' at the Tate Gallery in 1984. In 1987 the School of London, with its attendant values of 'injury, distraction, contraction', attained canonical status in the history of British art with Dawn Ades's essay, 'Figure and Place: A Context for Five Post-War Artists', written for the catalogue to the exhibition, 'British Art in the 20th Century', held at the Royal Academy of Arts.[25] In the same year an *Art International* Special Issue, partly written and edited by Michael Peppiatt, was published to coincide with the European touring exhibition 'The School of London'. The process continued in 1990 with Tim Wilcox's 'The Pursuit of the Real: British Figurative Painting from Sickert to Bacon', held at the Barbican Art Gallery and Manchester City Art Galleries in 1990. In 1986 Lucian Freud represented Britain at the Venice Biennale and in the spring of 1988 Peter Fuller launched the magazine *Modern Painters* as a contribution to the 'revaluation of British art which Kitaj's comments implied'. The editorial opened with the following words:

> The first issue of *Modern Painters* appears more than twelve years after Ron Kitaj wrote in the catalogue to his exhibition 'The Human Clay', 'The bottom line is that there are artistic personalities in this small island more unique and strong and I think numerous than anywhere in the world outside America's jolting vigour.' Today, we may safely delete Kitaj's qualification: as the exhibition of recent American art at the Saatchi Gallery so clearly demonstrated, American art, today, is aesthetically bankrupt.[26]

The School of London is surrounded by, and produced in, a liberal-humanist critical orthodoxy which, above all, speaks of an easy relationship to a tradition often defined by the collection of the National Gallery in London. Aside from Kitaj's pictorial references to the history of European art, Francis Bacon, Frank Auerbach, Leon Kossoff and Lucian Freud consistently treat traditional themes. They have all made painted encounters with some of the major paintings in the European tradition. The reclining nude, the portrait, the bather and the landscape inform Kitaj's encounters with Titian (*If Not, Not*, 1975–76) (Plate 3), Bacon's with Velásquez (*Pope*, 1954), Auerbach's with Titian (*Bacchus and Ariadne*, 1971), Kossoff's with Rembrandt (*From a Rembrandt Etching*, 1983) and Freud's with Watteau (*Large Interior W.11 (after Watteau)*, 1981-83), for example. One could go on. These encounters, in turn, have informed the critical discourse where tradition is defined by what actually exists in the museum, gallery and the library.

The critical reception and the ethos of the School of London depends on a discourse which defines the work of art as a carrier of expressive meaning universally accessible to all observers who are sufficiently responsive, and who share with the artist 'visual sensitivity'. By way of an example I would like to take Colin Wiggins's 'Frank Auerbach and the Old Masters', published in *Modern Painters*.[27] Wiggins and Auerbach set up a number of tensions or paradoxes between instinct and improvisation (nature) and artifice or imitation (culture). Wiggins finds the old masters' still alive, still a long, long way from becoming cultural fossils', and quotes Auerbach's stated need to learn the grammar: 'I use reproductions of the Old Masters to help me with my work, but in order to arrive at a direct, rather than pictorial experience, I am forced to dispense with some superficial resemblances to pictures already in existence.' Direct, unmediated experience engendered through the innocent eye of the unreconstructed modernist, positions the picture within a discourse which dispenses with 'superficial resemblances'. Wiggins then proceeds to reduce Auerbach's work to an art-historical cliché with the words, 'his conscious struggle is to paint form and mass … these forms are organic wholes, not simply existing but also feeling and reacting'. Revealingly, Auerbach declares a nostalgia for the possibility of wholeness, a resolved unalienated unrepressed existence: 'Titian for involvement, subtlety, completeness, humanity'. The pictures and the artist are constructed within the modern and avant-gardist myth where the expressionist code of the existential subject and modern primitive defines the artist as capable of direct and authentic expression. Auerbach claims, 'my conscious struggle and involvement has always been to inhabit the form (or let it inhabit me) and to make a formal image that stands up for itself. The rest I leave to my instincts, responsive or limited as they might be.' He speaks for the possibility of unmediated experience through his instincts, while simultaneously admitting, 'Painting is a cultured activity – it's not like spitting, one can't kid oneself.'[28]

Furthermore, tradition is granted an unquestioning authority. Auerbach refers to Reynolds's *Fourth Discourse*: 'Study therefore, the great works of the great masters, for ever … consider them as models which you are to imitate, and at the same time as rivals with whom you are to contend.' Little account is taken of the character of the tradition, the nature of its authority or its position in a postmodern culture. If the tradition is institutionally ratified, whose power does it legitimate? Is it capable of maintaining a critical and emancipatory role for the individual? Or, is its historical function exhausted in the face of market capitalism and the information-technology explosion? Or might the whole question of the humanist tradition have been bankrupted in history itself?

Since the late 1960s artists and intellectuals have begun to understand their relations to the public and society as a whole. One of the consequences of this self-consciouness is the conclusion that art is perhaps incapable of transforming either society or life. In contrast to Kitaj's engagements with history, for example, stand Terry Atkinson's interventions in the gallery system. He understands his art as a

product of the gallery system and the institution of art. He defines his audience not as some abstract universal entity, but in terms of the art schools and those who have an active and professional interest in the arts. The painting, *Happy Snap 4*, 1984, places the nuclear family, the domesticity of the holiday snapshot, and the familiarity of the style of the postcard into the context of the high seriousness of the gallery and the discourse of art. Like Kitaj, he often attaches autobiographical narratives to the pictures. In this case he anchors the meaning of the painting in an ironic relation to history and the politics of the cold war with a text which contains the words: 'Part of a nuclear family; Sue, Ruby, and Amber above the Dordogne River near Souillac on Hiroshima Day, August 7, 1983.'

Atkinson, an artist once associated with Art & Language, demonstrates an unusual institutional self-awareness, and explicitly, rather than implicitly, engages the material history of visual culture rather than an *a priori* tradition. Art & Language, in the 1981 essay, 'Art History, Art Criticism and Explanation', by Michael Baldwin, Charles Harrison and Mel Ramsden, launched an assault on 'A New Spirit in Painting' and its humanistic ideological values, which for them concealed the interests of the market and the careerism of the curators. It was a discourse of art which found its authority in an ideology free zone framed by a 'love of art' and a 'visual sensibility':

> just look at the pictures and feel a reawakened humanism. No vulgar consideration can have any bearing – any causal significance in relation to what these pictures mean and express. To claim such considerations must have causal and explanatory signif-icance would be to commit a social solecism, to risk being accused of lacking 'love for art' and lacking 'objectivity' (which are taken as synonymous), and thus to invite ostracism from the Islands of the Sensitive.
>
> ... there is much talk of the liberating effects of art. The possibility of true liber-ation, we would assert, entails the ability to distinguish between the real from the ideological. To see a system of beliefs as ideological is to see it grounded in the exis-tence of a particular contingent form of class society, and as serving the interests of a system of false consciousness intrinsic to it. It is to see these beliefs as part of culture, part of history, and therefore themselves open to causal explanation.[29]

Art & Language would wish to limit 'A New Spirit in Painting' to the reproduc-tion of class interest, curatorial careerism and the machinations of the international art market.[30] The approach, while it has a certain historical acuity, does an injus-tice to the art as certain as that done by those who would wish to reduce painting to an art-historical cliché. The view is close to that described by Art & Language as 'the quivering romantic humanist art critic ... the self-appointed guardian and explainer of the transcendental tear-jerking communicativeness of Great Art'.[31]

While the painters of the School of London do not position themselves self-consciously in relation to the institutions of art, their relationships to history and the tradition are much more problematic than the critical discourse would gener-ally allow.[32] Take, by way of contrast, the example of Stephen McKenna's *O Ilium*, 1982. On the face of it, the picture speaks for a return to narrative, iconography

and iconology. There appears to be an application to signification in the search for meaning. References to Homer, the Iliad and the epic story of the Trojan wars are thick on the ground in an age when the classical tradition has lost its authority. In this context, consumer-friendly neo-classicism is related to status, like a neo-Georgian housing or office development. The picture is designed within the codes of the consumer of high-status cultural objects, as much as the films of Quentin Tarrantino are constructed within the terms of a cult audience: their legitimating discourse is market value, not the classical humanist tradition. Its relation to the market, its self-consciousness, its middle-class taste and its lack of socially trans-formative pretension, are as unproblematic for the artist as for the filmmaker. McKenna is representative of high or classical postmodernism (Quinlan Terry in architecture), which shares with the School of London a self-aware repetition of the past and a self-conscious artificiality.

But as Kitaj expressed it: 'Cézanne said he wanted to do Poussin again after nature. I like to dwell on the idea that one might try to do Cézanne and Degas over again after Auschwitz.'[33] Kitaj takes one of the legitmating cornerstones of modernist art-historical writing and applies it to the one single event in history that speaks for the failure and collapse of the project of modernity. The painting *If Not, Not*, 1975-76 (Plate 3), for example, addresses the question of the Holocaust directly, and in one of the commentaries to the picture Kitaj quotes from Winston Churchill, calling it 'the greatest and most horrible crime ever committed in the whole history of the world'.[34]

Kitaj paints elaborate allegories rich in historical, literary and art-historical allusion. *If Not, Not* alludes to a wide cross-section of cultural reference and includes, among other things, Lorenzetti's fresco's of *Good and Bad Government* in Siena, Giorgione's *Tempesta*, Ezra Pound's editorial contributions to T. S. Eliot's *Waste Land* and Joseph Conrad's *Heart of Darkness*, to present modern history as a corruption of liberal humanism.[35] The painting takes its title from the ancient coronation oath of medieval Aragon as Kitaj's friend the poet Robert Creeley points out in a note to his essay 'Ecce Homo':

> As instance of Kitaj's own social and political context, and the complexity of its reso-lution here, consider the following from a book found in his library: 'We who are as good as you swear to you who are no better than we, to accept you as our king, providing you observe all our liberties and laws, but if not, not – this formula of the ancient coronation oath of Aragon defines the revelations of the sovereigns to their noble subjects in all the kingdoms of medieval Spain.' F.D. Klingender, *Goya in the Democratic Tradition*, London, 1968 (2nd edition), p.18. All these elements, e.g. Klingender, Goya, etc., can be present, albeit transformed by Kitaj's use of them in the painting itself.[36]

The pictures are the wish fulfilment of our dreams and our nightmares, and Cézannist aesthetics and modernist formalism are refigured within an historical narrative of catastrophe, neurosis and anxiety where there is no definitive closure, and nothing is complete. The self-evident disjuncture between the concept and

the representation, what Slavoj Žižek called in his book *The Sublime Object of Ideology* (1989) the rupture that lies at the heart of the real, paradoxically, in its refusal of closure offers the hope of some kind of resolution.

Inspired by the example of Cézanne's *The Bathers*, c. 1905-6, Kitaj embarked on a series of pictures in pastel on hand made paper which, at first, as in *The Rise of Fascism*, 1979–80 (Figure 7), seemed to deal with the theme of the Holocaust in an effective, if rather literal-minded and illustrational way.[37] Others, such as, *Bather (Psychotic Boy)*, 1980 (Plate 11), are rather more complex and can be read as a critique of the kind of modernist histories which begin with Courbet and Cézanne and end with Pollock. Kitaj had written in 1980:

> It seems interesting to me that the period that separates us from 1900, surely one of the most terrible histories of bad faith ever, should somehow conceive and nourish a life of forms increasingly divorced from the illustration of human life … It seems fated to me that the art should have turned away (in horror) to a great introspective romance, but I am also beset with a feeling of *lost paradise*, that all is not well enough.[38]

*Bather (Psychotic Boy)* has the same acidic palette derived from Post-impressionism as *If Not, Not*, but the boy is put through a series of impossible contortions as he is forced to comply with an aesthetic which would make him conform to a shallow picture space. So severe is the pressure to which the boy has been subjected that his left forearm is amputated with a smudge of red pastel before its *di sotto in su* perspective can threaten the integrity of the decorative surface of the picture plane. Simultaneously, his right hand is cut off by the edge of the paper to further assert the subjection of the humane to the aesthetic. As Wind had written, 'nothing leads us more certainly to perfect barbarity … than an exclusive attention to pure spirit'. It offers an interrogative challenge to material images of humanity which have attained such a level of self-alienation that in their scale and difficulty humanity is capable of experiencing its own destruction as an aesthetic pleasure. The pictures also serve as a warning to those who would present the sensual pleasure of the body as an unqualified affirmation of human freedom in the face of a dominant rationalism which would seek to control physical pleasure for its own purposes.

The bather theme is generally presented as an allegorical depiction of man in harmony with nature. Kitaj seizes not on the idyllic in Cézanne, or its formal equivalences, but on what Picasso had discovered in *The Bathers*, when he wrote of their anxiety, violation and pain:

> … late, late Cézanne? What was going on in that wondrous man's mind? Those clumped, hurt, awkward, stilted bathers with webbed feet, no ankles, moronic heads, slipping features … were invented in our century. It seems to me to be a fix we are in now, on recently scorched and revisionist earth, when so many good painters have to urge their depictions, as if through a fog towards an unknown shore, toward a common ease, a manifest social destiny, a better life. So it was for the Post Impressionists, even Degas.[39]

The bather has been renegotiated in pictures as diverse as Leon Kossoff's *Children's Swimming Pool, Autumn Afternoon*, 1971, and Kitaj's *London, England (Bathers)*,1982, to domesticate and localise a 'universal' theme of early modernism. As part of that process they plot a geographical and human landscape which speaks for the search for long-term stable relationships shown, for example, in other ways by Frank Auerbach's *The Camden Theatre, Winter*, 1975-76, and Kitaj's *The Garden*, 1981, and *Fulham Rd. S.W.10 (After Breughel)*, 1988.

There is, however, an awareness of history in Kitaj's work, which in spite of itself would seem to problematise its own origins in the projects of the Enlightenment and modernity. To put it in mock-heroic terms and to risk trivialising an historical truth, the utopian and progressive imperatives of history since the French Revolution have produced equally, if not more powerful, dystopian reactions. These have severely undermined the efficacy of the liberal-humanist tradition of reason, edification, education and individual freedom, for which the School of London is perceived to speak so eloquently. Kitaj draws on memories of a liberal Enlightenment tradition which had been effectively preserved in Europe amongst secular Jews whose energies had been directed towards assimilation in the years leading up to the Second World War.[40] Overtaken by historical events the tradition was effectively annihilated by nationalist, pseudo-mystical and totalitarian ideologies. But it might be argued that the tradition found a resting place in Kitaj's School of London among the memories of scholarly figures such as Aby Warburg. It is also found in the community of Warburg's successors such as Irwin Panofsky, Fritz Saxl, Edgar Wind, Michael Podro and John Golding. The community is augmented by many others, from the historian of anarchism, James Joll, to Mr Seligmann, the bookseller whose portrait is included in *Cecil Court, London WC2 (The Refugees)*, 1983–84 (Plate 13). Significantly, Kitaj wrote a Preface for this picture and headed it with the quotation from Sigmund Freud, 'I consider myself no longer a German. I prefer to call myself a Jew.'[41]

The intellectual tradition of secular Jewishness can be seen in Kitaj's art. It holds the possibility for secular redemption in the materiality of the pictures themselves, but as I argue, it is only the *possibility* of redemption, made available by means of an imaginative reconnection with the Enlightenment project of individual emancipation. As we have already seen this tradition relies on a materialism which gives it a physical existence in the institutions of the museum, art gallery, library, university and literary magazine. Strongly individualist, it is concerned with freedom of expression and the relations of the individual to the forces of the state and the market. To pursue the hints Kitaj first laid down in the catalogues to his one-man exhibitions in London and New York in 1963 and 1965, as well as the pictures themselves, it is also deeply and persistently aware of the limitations of the individual. To paraphrase Erwin Panofsky quoted by Kitaj in the second one-man exhibition catalogue, it is possessed of the notion that the senses have their own kind of intellect, and the intellect its own kind of joys.[42] As such, it betrays an unqualified humanism. Conservative rather than

progressive, the tradition nevertheless exists as a challenge to contemporary cultural values rooted in the market. As one would expect of a humanist art it is further characterised by a concentration on the human figure, the head, and small groups of figures often in domestic, recreational or intimate situations.

A key picture for the painters of the School of London, and Kitaj in particular, is Titian's *The Flaying of Marsyas*, from about 1570.[43] It was exhibited in London at the Royal Academy of Art in the winter of 1984, when it stimulated artistic and cultural debate – not least because, as Lawrence Gowing pointed out, it had not been shown in the West since 1673 when a Bishop in Bohemia won it in a raffle. Three years after the end of the exhibition, for example, the painting appeared in the background to Tom Phillip's portrait of Iris Murdoch. At the time of its showing in London Gowing wrote:

> All these months London has been half under the spell of this masterpiece, in which the tragic sense that overtook Titian's poesie in his seventies reached its cruel and solemn extreme.
>
> In the autumnal woods a satyr is tied head down to a tree, from which pipes are hanging, to suffer punishment for challenging Apollo to a musical competition, which he could not by definition win against an antagonist who was none other than the inventor of music. With a rustic assistant (wearing Phrygian cap) Apollo, identi-fied by golden hair and a wreath of laurels from Parnassus, with almost loving atten-tion is skinning him. A puppy laps up the blood that is shed and a hound is restrained by a child of the woodland people; another satyr comes with a bucket of water, and Midas, the judge, broods sadly on his failure to defend the mortal from the god. Behind, as god-like as anyone, a musician in crimson plays with feeling.[44]

Gowing asks the question as to how such a horribly painful subject could become the occasion of beauty and greatness in art. One answer might lie in the fact that the picture, while it is about pain and failure, is also about the nature of the modern romantic construction of the artist and the ways in which he is defined and revealed in relation to the world. Gowing quotes from Ovid: 'his nerves were exposed unprotected, his veins pulsed with no skin to protect them. It was possible to count his throbbing organs and the chambers of the lungs clearly visible within his breast.' The painting is the archetype for what Kitaj had called 'Romantic Failure', and what Gowing called the 'inherently vulnerable' in a form of words which brings to mind the work of Francis Bacon. The story of Marsyas is a parable for the punishment of arrogance, but Marsyas like Apollo was a kind of artist, he was deceived, and illusion is the artist's *forte*. The picture cuts two ways. Marsyas' skin (surface appearance) is peeled away to get to the bone of the matter, but whose bones? It is at this point the artist becomes his own subject and as Terry Eagleton would have it, 'Meaning is ripped from the ruins of the body, from flayed flesh rather than the harmonious figure.'[45]

In a recent text published in association with his retrospective at the Tate Gallery in 1994 Kitaj describes the painting *Self-Portrait as a Woman*, 1984 (Plate 12), in a parallel fiction. Narrated as if by his former landlady part of the text reads:

I slept with a Jew and got caught, so these thugs stripped me and I had to march
naked through the streets of the suburb of Wahring, wearing this placard and yelling
out that I'd slept with a Jew ... When I saw this painting of his in a book forty years
later, I wrote to him in London saying I had no idea he felt close enough to my humil-
iation to have put himself in my place as it were, to have put himself in the picture.[46]

The artist places himself in relation to the romantic and avant-garde construction
of the artist as outsider, and depicts himself as woman, Jew, victim. The artist has
become his own subject in the line which runs from late Michelangelo, Titian and
Rembrandt, to Géricault and Delacroix, and then to Van Gogh and Pollock. Here
it is literally depicted as a repetition, not an imitation. The artist's subject and self-
image are as one, defined at once in relation to history, and within the framework
of the institution of art and all of what that implies in relation to the imaginary,
constructed conditions of the tradition to which it refers.

The relationship to the tradition in the work is both repetitive and problematic.
The constant recurrence of the reclining nude, the re-engagements with art-
historical example, the references to what Kitaj called 'a lineage in Western art'.
For those versed in psychoanalysis there is a kind of transference going on here,
where the artist continually and repetitively returns to the source of a conflict in
order to work it through, to reach some kind of resolution, or not. The self-
constructions of the artist and the subjects of the pictures are symptomatic of a
cultural neurosis produced, at worst, by the collapse in history of liberal humanism
on the road running through the Second World War between the twin peaks of the
Holocaust and Hiroshima. Or at best, the coexistence of barbarism and high
cultural achievement in Europe, so eloquently described by George Steiner in his
book *Bluebeard's Castle*. Kitaj, for example, has spoken of his search for an iconog-
raphy of the Holocaust in a demonstration of what he unconsciously sees as the
inadequacy of the tradition in the face of history.

Kitaj's engagements with the Holocaust reached a particular intensity in 1985,
but the point is that the historical disjuncture of the Holocaust has produced a
cultural neurosis for these deeply conservative and traditional intellectuals and
artists. For many, their biographies speak for an intimate knowledge of the collapse
of the tradition to which they consciously or unconsciously, persistently and obses-
sively, refer. Frank Auerbach was born in Berlin in 1931; Leon Kossoff was born
in the East end of Russian Jewish parents in 1926; Lucian Freud was born in Berlin
in 1922;[47] Kitaj was born in Cleveland, Ohio in 1932 of a mother of Russian Jewish
extraction; his stepfather was a Hungarian Jew. Edgar Wind and Erwin Panofsky
were also Jewish émigrés from Hitler's Germany, and even Peter Fuller, who was
not Jewish, had been born in Damascus.

Persistent reference to this constructed tradition would speak much less for an
unmediated experience of the world, than one which is conventional, and defined
within the limits of the history of art, despite contemporary claims to the contrary.
Robert Hughes, for example, wrote that, 'What counts most in Auerbach's work
is the sense it projects of the immediacy of experience ... Auerbach's struggle is

not to express himself, but to stabilize and to define the terms of his relations to the real, resistant and experienced world.'[48] This is Kitaj's 'earthed human image', incapable of perfection, and vulnerable to disease but replete with the impossibility of representation without the mediation of a tradition whose legitimacy and currency has been compromised in history. For all their claimed authenticity the images participate in a simulacrum divorced from the real world, they are not a response to life so much as they are a material response to other images. Reality is transformed into an image legible within a framework of other images. Fragmentary and incomplete they reinterpret and reinflect the tradition through which they are coerced into meaning. The gap between the image and its actual referent seals the pictures in a discrete and separate world wholly accessible only to the expert, in the area Herbert Marcuse has called the 'humane marginality' of art.

The materiality and stickiness of the paint would speak for the creation of an image in its own right, an image that is not just the picture of something. It responds to what Lawrence Gowing called, 'the actual physical material that comes to life in Western art ... the stuff of imaginative embodiment'.[49] There is a special relationship to the subject. Auerbach paints the same subject for twenty years with continuous and constant obsessive application. Or, as Bacon once said, 'I'm not sure I would do them such violence ... if they weren't my friends.' This is not the revelation of character through faithful depiction of the model. The gestural involvement is such that it probably tells us little about the model. The real subject of these pictures is the artist himself. They are all Phillip Roth's Zuckerman. The gesture speaks for an immediacy and authenticity of experience that can as easily be interpreted as a register of the artist's absence. But in the gesture is the nostalgia for a resolved existence, a longing for the lost innocence now made impossible by the history of the twentieth century. The pictures refer to a tradition based in the Enlightenment ideal of modernity, but look for their reconstitution in the imaginary.

Since 1980–81 Kitaj's paint has become more substantial and has taken on the appearance of the expressive gesture. As a result the use of the brush and the line find their *metaphor* in a model which would have been familiar to Kitaj from the thought and writings of Aby Warburg:

> There is no poem that is not accompanied by gesticulations, an appropriate posture of the body, and a musical treatment of the language; no solemn act that does not assume a poetical shape; no creation of the visual arts in which motifs of language, music and bodily expression do not reverberate ... For that age ... the world was not a matter of ideas and thoughts, but of immediate impressions ... Whatever the problems of life which had to be solved psychologically, they were not pinned down in concepts and hemmed in by propositions. Rather they were reproduced in their immediacy and their significance was taken up by those psychological faculties which reflected their appearance in symbolic form ... Thus immediate intuition and thought still coincided and the whole of mental life and of culture had a symbolic character.[50]

Throughout the work, interviews and writings great stress is placed on individuality, independence, sensibility and difficulty to construct the artist as working in a 'humane depictive lineage' – a liberal ideology expressed by Kossoff when he spoke of draughtmanship and freedom. According to this ideology, hard work, skill and labour will bring freedom in an era, defined by Fredric Jameson, as an age of corporate capitalism, bureaucracy and the state, where that older bourgeois individual no longer exists. The understanding of art as spontaneous and free stands in living opposition to a bureaucratic and technological world, but it is nothing more or less than a humane and nostalgic gesture. The artist looks to the history of culture to speak through the voices of the past, and this art is as much about art as classical modernism had been, but it is an attempt to reconcile deep, repressed cultural traumas and the need to experience them on a cultural level. Namely, the search for the Europe of Ezra Pound, of modernist American exile now consigned not only to the past which cannot be revisited, but obscured by the recent history of Europe.

Kitaj, Bacon, Auerbach, Freud and Kossoff all reveal their insecurities in the face of a bankrupt tradition and unstable human relationships. There are no heroes, only the fractured, localised, isolated and unsure, characterised by anxiety and loss. To quote Susan Sontag on Hans Jürgen Syberberg:

> What is central now is the relation between memory and the past; the clash between the possibility of remembering, of going on, and the lure of oblivion ... To understand the past, and thereby exorcise it, is his largest moral ambition ... Benjamin suggests that melancholy is the origin of true – that is, just – historical understanding. The true understanding of history ... is a process of empathy whose origin is indolence of the heart, acedia.[51]

For all of his expressive surfaces, Kitaj works in an impersonal style. He has never taken up the intensely subjective self of romantic modernism associated with an expressionist aesthetic. At the same time, he makes use of the distinctive tools of the melancholic, the allegorical props, the talismans, the secret self-references – to create a *Trauerspiel*. As for Walter Benjamin, it is less a tragedy than a work of mourning for a modernist utopia cut short and then decimated by the Holocaust. Kitaj's is a restless, obsessive returning to the past at a time when the official narratives were being exposed as tools of propaganda in the cold war, and the heroic dispositions of individual artists were being appropriated for a particular kind of American freedom. His many pictures of, and references to, baseball speak of his distance from, and longing for, an America of the imagination, his shame at being absent from that, and the no longer available continuity of the European tradition is accommodated by a mythologising of what has been lost.[52] His art is a denial of the late modernist continuum Greenberg had proposed. It prefers, instead, to reconfigure fragments of the past and to save from the official narratives that which has been forgotten in a ritual of repetition which refuses consolation, and in so doing holds onto a hope for future happiness.

# Shootism, or, whitehair movie maniac Kitaj and Hollywood kulchur

## Alan Woods

A spectre is haunting Europe – the spectre of eroticism.[1]

We were shown around cheap dream manufactories and shops full of obscure dramas. It was a splendid cinema in which the roles were played by our old friends. We lost sight of them and we went to find them again always in this same place.[2]

He recognizes in all these dislocations, of course, his lonely quest for the impossible mating, the crazy embrace of polarities, as though the distance between the terror and the comedy of the void were somehow erotic – it's a kind of pornography. No wonder the sailor asked that his eyes be plucked out! He overlays frenzy with freeze frames, the flight of rockets with the stakings of the vampire's heart, Death's face with thrusting buttocks, cheesecake with chaingangs, and all just to prove to himself over and over again that nothing and everything is true. Slapstick is romance, heroism a dance number. Kisses kill. Back projections are the last adequate measure of freedom and great stars are clocks: no time like the presence. Nothing, like a nun with a switchblade, is happening faster and faster, and cause (that indefinable something) is a happy ending. Or maybe not.[3]

Let me now explain how flimsy is the texture of these films.[4]

Cinema isn't there.

Cinema is the flow of a perfect present tense, a liquid now, time that moves within a shape, like a fountain – and then it is memory.

In the grand tradition, buckled by modernism(s), the tradition within which Kitaj has always worked, painting flows from (and, characteristically, mingles) two sources: language, which the painter translates from linear abstraction to static embodiment in pictorial space; and life, defined, within the particularities of each individual practice, by selection and isolation, by the action of painting: life is what is taken out of life and into art when the painter draws from life. There is, of course, a third source for any new work: the tradition itself, the history and ubiquity of images.

These are the three bases that earth Kitaj's practice, which engages with the great dialectic of Western painting: imagining and imaging the unseen – the written – from the basic discipline and experience of the visual world; moving between vision and visions.

But this is an essay on Kitaj and cinema, the twentieth century's art form, which adds at the very least a new element to the old dialogues between text and world and text and image. Cinema[5] is neither unvisualised text, nor life, whether the life that goes on outside all around us or the life that breathes within the static pose of the life class. It contributes, massively, to the spectacle, to the visual buzz of representation which drifts, like the hum of refrigeration in our homes, above and below conscious attention, but it does so through publicity, through posters, through stills, through advertisers' parodies of all these, through the image lives of stars and 'personalities', through the sad decline into broadcast movies; cinema itself is seen in the dark, by an audience, elusive, unfixed and unfixable. (A painter can draw on cinema, but not *from it*; what would cinema sketches look like?)[6] Were it not for genre, repeating situations with the inevitability of crucifixion or annunciation scenes in the history of painting, memory would have difficulty retaining it – though the *aide-memoire* of genre, in the same action, eradicates nuance: what we ultimately grasp of the cowboy film, the film noir, the romance is archetypal. And that is always with us, lived out, parodied in our conversations, inflecting, corrupting, inspiring our sense of who we are and where we are. Mafia people, one gathers, are anxious to behave as Mafia people behave in movies. Alasdair Gray's theory in *Lanark* that the greatness of cities – and the actual quality of life within them – depends largely on their parallel existence (or lack of it) through imaginative recreations in art is as true of cinematic as of literary reworkings. One arrives in America as if into a film set, with everything familiar save such unfilmable physicalities as the unexpected thickness of a coffee mug in a New York diner, but this works both ways.

> I brought myself up on the Lost Generation, especially Hemingway and Fitzgerald, and in high school I was damn well going to Europe to do what they had done, only this time in painting. I had discovered Joyce, Pound, Eliot and Surrealism as a teenager, just before I came to Europe, and movies like The *Red Shoes* gave me exactly the unreal melodrama of the artistic life in Europe I wanted it to be (and still do). Michael Powell, who made it, was to become a dear friend and I told him he was the pusher who addicted me when I was about fifteen in a movie theater just off Times Square. When 1 arrived in Paris at eighteen, on my way to Vienna to study art, I didn't spend much time at the Louvre. I just got on the Orient Express with *The Third Man* twanging away in my mind. Maybe I would meet a Valli or a Moira Shearer. Art and adventure are always confused in my life and I can't get them sorted out, thank God.[7]

The point is reinforced in correspondence: 'Movie images of Europe had a great impact on me in a youth filled with H'wd movies. When I landed in NY aged 17, it was the real thing in the form of Michael Powell (*Red Shoes*), Carol Reed (*3rd*

*Man*) and the great Italians (*Open City, Bicycle Thieves* etc) that helped, urged me toward 'abroad' … So I *went* there!'[8] Once in Europe, of course, American movie images of America were themselves inevitably transformed – a suspicion which the same letter confirmed:

> Cinema (in) exile all those European years, Yes, Right on! Curiously, H'wd movies brought out a heartfelt *patriotism* in me during my European Exile. Ford drove me nuts! Not exactly Nationalism – certainly not in any rightist sense but in an Absence-Makes-The-Heart-Grow-Fonder sense. Just today, seeing *She Wore A Yellow Ribbon* in *Color* for the *1st* time, like it had *changed* after all those European years in b&w!'[9]

Movies are everywhere as well as nowhere, the century's erotic, part image, part tone of voice: synaesthetic dream perfume, *Gesamtkunstwerk* unfolding as a climate. Movies mediate relationships between people and people as well as people and places, above all, inevitably, between Americans and the rest of us. There is something cinematic – or rather, mediated by cinema's afterlife within the lives of its audience – in the particular mix of self-portraiture and identification in the 'Kitaj' within Kitaj's work. There is a likeness of himself that runs throughout the oeuvre – even as signature.[10] This role playing is most startling in *Self-Portrait as a Woman*, 1984 (Plate 12), but is always present in his self-portraiture, as complex as, and comparable to, an author's 'I'. The self-portraiture, rather like that of the Renaissance masters – most unnervingly Michelangelo's self-likeness in a flayed skin in Kitaj's favourite large painting, *The Last Judgement* – is generally within some kind of vortex/event – he appears, for example, as the referee in *Whistler v. Ruskin*, 1992.[11] One might compare this fluid character with the chain of acting and identification and parody and wish-fulfilment present as the filmgoer empathises and identifies not merely with Bogart, or with Bogart's characters, but with Bogart-as-Rick (or whoever). In the work, Kitaj can be Kitaj-as-Manet, Kitaj-as-Van Gogh, Kitaj-as-Cézanne. (Compare, also, the depiction of Michael Podro as the Jewish Rider (Plate 1); or even Quentin Crisp as a life model recognisable as himself.)

What do people remember in the cinema? According to Peter Greenaway, 'They remember ambience, they remember event, they remember incidents, performance, atmosphere, a line of dialogue, a sense of genius loci.'[12] (Anything but *narrative*, in fact.)

Greenaway is a filmmaker whose debts to Kitaj might partly be teased out in a close examination of Greenaway's paintings and drawings, but they are always expressed by Greenaway himself in relation to filmmaking. His early engagement with Kitaj's first show (in 1963, at the Marlborough), with its 'heady mix of sex and politics', opened up possibilities for a painter moving into film, although Kitaj could hardly be quoted within cinema as Greenaway quoted Vermeer in *A Zed and Two Noughts* (1985), or Deville quoted Balthus in *Death in a French Garden*. However 'cinematic' Kitaj might be thought to be (in the way he is defined as a 'poetic' or 'literary' painter), there are few of his works that could be recreated

within the strange subgenre, theatrical before its incorporation into cinema, of the *tableau vivant*, with its move from the 'collapsed time,[13] of the stillness of pictures to the trebling stillness of the life class reinvented as amateur dramatics, the strange though familiar balance of art and model reversed. Kitaj's influence on Greenaway is comparable to Benjamin's or Kafka's influence on Kitaj; a sponsoring figure whose direct and massive inspiration does not lead to easily identifiable or (critically) detachable details within individual works.

Greenaway's list of what we retain from cinema might serve also as a suggestion both of what we retain from viewing a Kitaj, and, beyond that, of what Kitaj retains from his life, his reading, his flings with visual tradition and popular imagery, his studio days, his pursuit of painting 'itself', mixing all of these to leave behind his marks on a surface, magically impure, half meal, half recipe, dragging behind them old and new allusions and illusions. Such an appropriation of Greenaway's remarks, combined with the mixture of cinema and literature (and real life) in Kitaj's own account of his anticipatory vision of and first visit to Europe, suggest that any account of Kitaj and cinema must itself be oblique, tangential, alert to foldings of absence within presence, presence within absence, in both life and art. Some difficult shapes can be more easily drawn, as Sickert recommended, by concentrating not on objects or parts of objects, but on the spaces between them.

Cinema is everything that painting is not. It presents and disappears before the familiar can become strange; it lacks substance and surface (and *line*), it controls and manipulates, while paint remains constant before the gaze, explicit and vulnerable, available for interrogation. Drawing is *drawing*; one might relate Kitaj's paintings, as systems or machines or atmospheres, to sister arts (or to arts less closely related to painting), but not, surely, his drawing, or his use of paint. And in using 'poetic' to describe a quality of his paintings, one should remember that this remains a quality of *paintings*. Kitaj's commitment to the tradition and activity of drawing and painting has been almost absolute, during a period (from the 1960s on) when it has been commonplace for artists (not least Kitaj's close friend Hockney) to work across media. Even his screenprints of the 1960s, collage-based or reproducing book-covers, have come to seem to him a betrayal of the real business of his art. And the periods when he has ceased to paint have clearly been periods when life itself has been of such intensity to forbid art – although eventually, inevitably, the painting receives everything back into itself.

A film may contain a picture, though always destructively so; the painting is lost as it is shown. (What it loses above all is what, in almost any version of modernism, is most essential to it: it is no longer a physical object. Instead, in and as film, the picture is reduced to a single dimension, time – the only dimension it lacks.) A painting can never contain a film, but only refer to it, suggest it, *represent* it. Nor does Kitaj usually incorporate cinema in isolation, setting image up against (or after) film, as Richard Hamilton has done, for example in *I'm Dreaming of a White*

*Christmas,* 1967–68. Cinema simply joins the mix, a mix that includes other art forms. For all Kitaj's love of cinema, he makes at least as many references to theatre, for example.[14] His hero, Kafka, is a novelist, and he has incorporated the novelistic notion of character into his work with his repeated use of the figure of Joe Singer. Another hero, Benjamin, is an essayist (the literary form of the collagist/collector); one of the more 'cinematic' paintings is named for a columnist, Walter Lippmann. But still, we do not call Kitaj a 'novelistic' painter, or even an essayist in paint, any more than we call him cinematic; we call him a 'poetic' artist, and there are technical reasons for this, for the early and constant influence of Eliot and Pound (and the love of Creeley and Ashbery) proving decisive (rather than merely present), entering into the very heart of the work. 'Eliot inspired me, first in a tentative way in this painting [*Tarot Variations,* 1958 (Figure 11)] and then more plainly and awkwardly in a few others, to place images abreast (and later annotated), as if they were poetic lines on a page. Some few early modernist poets had arranged words to resemble pictures or designs and I began to think I could do the reverse for art: to lay down pictures as if they were poems to look at.'[15] The poem, on the other hand, and to a unique extent in writing practices, aspires (to a greater or lesser extent) to something of the simultaneity of painting; in Lavinia Greenlaw's phrase, 'you can be everywhere in a poem at once: it is intended for scrutiny not just as words, but parts of words, even patterns of letters'.[16]

One could fill a volume with the differences between paintings and poems. Relations between the arts, like metaphors, are ultimately based on difference, not identity. Resemblance is a species of difference. But still, there can be an affinity between painting and poetry translatable into technical and formal decisions and ambitions; though one should also simultaneously consider the relationship as one of subject matter, of aboutness. Degas's paintings about dance are not dance-like. Kitaj is fond of comparing the importance of books to his pictures to the importance of trees to a landscape painter. And books are his subject in the widest possible sense; they are not invisible in the work, mere texts evaporating into the image. Text is visible, and the book itself, in that particular edition, is visible,[17] and the bookshops where the books are purchased, and the places of reading them, are all part of what is included. *Cecil Court, London WC2 (The Refugees),* 1983–84 (Plate 13), for example, is set in 'the book alley I'd prowled all my life in England, which fed so much into my dubious pictures from its shops and their refugee booksellers'.[18] Perhaps the dealer Seligmann, holding flowers in the painting, was too organised to fit this generalisation, but there is something Kitaj-like about second-hand bookshops generally – shops where the organisation (looser than that in new shops, either more intuitive and personal to the bookseller and his regular clients, or simply shambolic) allows, within the unifying patina of dust and the smell of yellowing paper, a mysterious haptic conversation between the lost and found, the classic (perhaps translated for a long since dead 'contemporary' readership) and a momentary which has long since outlived its moment, expressed in ancient titles including the words 'today', or 'modern', or 'contemporary'. And this space of the

bookshop is an antechamber to the spaces of reading itself, reading with its open-ended reveries and collisions and associations, which is Kitaj's central subject.

The ways in which cinema dances in and out of text must be considered; some motion pictures have books, and some books have motion pictures. It is not just that some books are filmed, and more books want to be; so many books, from popular fiction through to Coover's cinema texts in *A Night at the Movies*, depend on the reader's familiarity with cinema in their appeal to the mind's eye, and indeed in their narrative structure. One might call *The Street (A Life)* (also reproduced as *Femme de Peuple 11*) cinematic; Kitaj's own Preface, having moved – on its way to Daumier – from Baudelaire to Benjamin to Picasso to Degas, describes it as 'styled after the jacket of a pulp thriller'. But the jackets of pulp thrillers, when they are not literally carrying images from films, are themselves styled after cinema. More generally, the integration of high and low sources or references in Kitaj's Preface[19] expands upon a movement in Kitaj's work usefully compressed in his phrase 'Hollywood Kulchur', which borrows Pound's whimsical spelling of 'culture' to yoke the associative technique of the *Cantos* to popular cinema.[20]

One can, having heavily qualified the task, assemble a few existing notes towards the definition of Kitaj and cinema from the literature. But even there, one begins with an absence: a missing picture, abandoned in 1970.

From the Tate retrospective chronology: '1970 – Rented a house in Hollywood overlooking Sunset Boulevard … Kitaj painted very little that year, 'because my heart just wasn't in it, but preparing a large Hollywood painting (destroyed), he visited some of the great old directors, drawing them in their homes.'[21] (Kitaj is now back in Los Angeles, 'this Movie Town', with '30s Deco Movie Palaces on my corner'; back 'in the womb of movies … and loving it'; the Los Angeles period has begun.) In 1989, Ríos asked Kitaj what the 'plot' was of this 'epic Hollywood picture': 'It looked like a movie poster – a pile of montage, like the pilot for *The Autumn of Central Paris*, but worse. The "plot" was being worked out in the doing, like *Casablanca*, like a Hollywood movie where they don't know what they're doing. I put my foot through it at a beach house on the Pacific Ocean.'[22] The Tate chronology includes Kitaj's photograph of John Ford; photographs of Kitaj drawing Rouben Mamoulian and posing with Jean Renoir, taken that same year (1970) by his son Lem; and also a photograph taken by Kitaj in 1973 of 'Michael Powell directing Lem Kitaj in a film' (presumably *The Boy Who Turned Yellow*). The primary purpose of the visits to directors was, in 'a crazy year during which I began to devote myself to raising the children',[23] to enable Lem to meet them. This may have partly accounted for the perceived failure of the Hollywood 'epic', although a cinema painting of sorts, *Kenneth Anger and Michael Powell*, did emerge in 1973 (Plate 14).

> Michael Powell was a close friend and taught Lem a good deal; he even gave Lem a good part in his film *The Boy Who Turned Yellow* … he was a legend to me and I loved his films long before I met him. … Anger, I only knew casually when he was camping

out here in a derelict house near me, here in London. I've only seen a few of his films. Yes, his life as a renegade is amazing. He's a Satanist, a follower of Aleister Crowley. ... No-one ever knows where he is. He's always revising his strange book – *Hollywood Babylon*. Once in a blue moon he writes me from a blue moon. I brought Anger and Powell together because they admired each other. They're both quite mysterious and since I introduced them, I painted them together in their disjunction.[24]

A London painting, in effect; Hollywood present as an implied book title. It was not until 1983, the year he began *Amerika (John Ford on his Deathbed)*, 1983–84 (Figure 37), that Kitaj turned again to the Hollywood material gathered in 1970. As this is the most straightforward 'cinema picture' by Kitaj, it is worth including the entire Preface:[25]

37 *Amerika (John Ford on his Deathbed)*, 1983–84, oil on canvas, 152.4 x 152.4.

Ford has always been my favourite director. Even as a boy, he brought tears to my eyes and resolution to my heart. An old mutual friend phoned him for me and asked him if I could sketch him for a Hollywood painting I wanted to make (in Hollywood where we were living) in 1970. Ford said OK and so I took my eldest son Lem, who even then, aged about eleven, wanted to direct, in the path of the master. Ford lived near UCLA, where I was teaching, in an old-fashioned house full of mementos – Academy awards, Will Rogers' lasso, signed photos everywhere 'to Jack' from Ike, from Bull Halsey, from Mark Clark etc. We nearly died because we were told John Wayne had just left. Ford was in bed, like my painting shows, wearing what I thought at first was a baseball cap, but turned out to be an admiral's bridge cap. I think he was made an admiral for filming the battle of Midway. He looked like a dying man as I sketched him. He had a bowl to spit into. I've painted a picture above his head that wasn't there, near where the rosary beads were hanging. It's a still from his favourite among his own films – *The Sun Shines Bright*, a marvellous post-war tear-jerker about Judge Priest. At the foot of the bed sit Charlie Grapewin and Elisabeth Patterson, as if on their front porch in *Tobacco Road*, being directed by Ford in his prime at the lower left. There's a kind of dance going on, as in so many Ford movies, and Victor McLaglan looms as Quincannon of the Cavalry Trilogy at the top left. I got the idea for all these corny ghosts from that wonderful last scene in Huston's *Moulin Rouge*, when all his past characters reappear at Lautrec's deathbed. Ford's Irish rebel, anti-British chat was memorable, but I noticed he kept *Burke's Peerage* on his bookshelf. He told Lem not to go to film school because it's a waste of time, advice which Lem took because if John Ford tells you not to go to film school, you don't go. That year, I also sketched Renoir, Cukor, Milestone, Mamoulian, Hathaway and Wilder out there, but in the end I lost heart for a Hollywood *Gesmantkunstwerk*. It took me fifteen years to get around to my Ford painting.[26]

Even without a literary overlay, there is a dancing complexity of source, reference and representation. (Complexity is not the same as *difficulty*, a word overused in relation to visual art in general as well as Kitaj in particular. It suggests that Kitaj's works are cryptic, in the sense that one might discover a key to them that would make everything explicable; that there is an *answer*, wilfully withheld; whereas there can be no final explanations, only expositions, notations, exegesis, as the paintings live their lives. It is striking how often Kitaj's notes present them almost as premonitions, strange intuitions or prophecies confirmed by later events or readings.) Fifteen years or so after Kitaj's visit, he has his memory, his sketches, his photograph(s). It seems the photograph (also reproduced in Ríos) was used rather than the sketches: 'They're no good', he told Ríos. 'No one has ever seen them, but I can't bring myself to destroy them yet.'[27] Kitaj was also able to 'plunder' Lem's 'vast Ford archive', which was then kept at Kitaj's London home (and studio) in Elm Park Road;[28] the strictly technical problem of the intangibility – unavailability – of most cinematic sources was therefore solved in this picture.

It is tempting, writing on painting and cinema, to play with the notion of 'the frame'. In painting, it is the frame which allows the painting to be viewed as a painting, as a distinct fictional world. Cinema needs no such boundary or

transitional marker between real and painted space; cinema, rather, obliterates our real space through blackout; the theatricality of the sweeping curtains is anachronistic and redundant. The film becomes all we can see, and, as Greenaway has pointed out, there is no proper frame in cinema; a director composing, as a painter would, in relation to a precise edge is doomed to disappointment. The cinematic frame, in fact, is not what borders the image, but what constitutes it, at least for one-twenty-fourth of a second; it is the frame of film, the origin of performance but invisible within it.

There are a number of examples of and plays on frames in *John Ford on his Deathbed*. On the far wall there are three frames; one, skew-whiff, is mentioned in Kitaj's notes – it contains a version of a still from *The Sun Shines Bright*.[29] Black-and-white in its colourful wooden frame, it joins up with the use of white elsewhere in the picture; the sheets and pillows directly beneath it, Quincannon's white glove and the white accents in the directing scene across the bottom of the picture. Another – a frame cut off by the picture's own frame – contains a text, THE END. (Perhaps the true frame in cinema is temporal, and consists of the opening and closing credits).

'The end' – a shameless Hollywood sentimentality, linking life itself not to a journey but to cinematic narrative – though within a picture which, as all of Kitaj's works, denies any possibility of closure. No painting has an ending, but this one includes two happy endings – the traditional ending of a traditional film, itself endlessly repeatable – and the suggestion of an afterlife – Ford is holding the rosary that was hanging on his wall when Kitaj visited him. There is also, of course, the implied notion of immortality through art as well as faith. The dying Ford looks across at a dance he has directed; these ghosts, these flickering images, will survive him, and he will survive through them. The composition is based on a simple but conceptually neat and intricate cross: the young Ford, bottom left, the dying Ford, top right, each looking across the picture, the young Ford at his actors. Before and after cinema. The dying Ford's glasses are clear beneath his cap, his mouth closed around a cigar; the young Ford is blind, as it were, behind his sun glasses; there is no camera; he directs through a megaphone, creating through the word, like a Jewish God – his left hand reaches out, faintly Michelangelesque, across a solid blue void – which may be simply a large cushion.

The third frame on the wall is not mentioned in Kitaj's commentary; nor is it self- explanatory. Its position, and its ambiguity (is it a mirror – are those figures, a man and a boy?) suggests, again faintly, *Las Meninas*, which, even if Kitaj had not been quoting Velásquez at the time in his baseball painting, would be appropriate enough for a picture about picture-making.

The major frame in the painting, however, conjures up (even if easel-like in certain respects) a cinema screen – although, as it floats in perspective in the picture space (cutting across two of the frames on the wall), the dancing figures are not quite contained by it; the male figure is both before and behind it, as in Murillo's self-portrait in the National Gallery, and both figures escape the perspective of the

screen's surface. McLaglan as Quincannon escapes it altogether. For the director, of course, to remember a film is to remember the filming, the actors rather than the characters; there is an extreme physicality to filmmaking which cinema lacks. It is not inappropriate, therefore, that the relation of the young Ford to the actors is oddly reminiscent of that more familiar relation of artist and model; and indeed, while we might image Ford to be shouting 'action', Grapewin in particular seems as fixed as a life-class model.

There is something about the figure of Grapewin that also suggests Cézanne. *Western Bathers*, 1993–94 (Plate 15), is, rather than a picture about a director of Westerns, a Western itself, albeit a Western unexpectedly inspired by Cézanne:

> This is my first real Western. After sixty years of fumbling, I've become a fast gun, a regular shootist, and I did the damn thing within a one month shooting schedule. Western movies are among the happiest things in my life. In fact I owe quite a few narrow escapes from boredom and desperation to their familiar intimacies, graces and subtexts, so I thought I'd better direct a Western picture or two before I ride into the sunset. My favourite painting in London is Cézanne's very late, absurd *Bathers* in the National Gallery. Sitting in front of it one day, the crazy figures looked like they were grouped around a campfire and so I got the idea for my first Western. Cézanne's *Bathers* are works of imagination, the opposite (in a sense) of his mode of observation, but I had to start somewhere, so I began to look at film-frames of Budd Boetticher's *Ride Lonesome*, 1959, starring Randolph Scott and the heavenly Karen Steele. That got me going and then I adopted the techniques I love in Ford and Peckinpah of using a dependable stock-company to act the character roles. My own regulars are drawn mostly from figures and images in past art which tend to stay with me always – not unlike a habitual method of Cézanne and many painters from Michelangelo to Picasso. You want loyal friends round your campfire as a man grows older.[30]

The painting has a neo-Cubist, even neo-Vorticist, balance between figure and ground – ultimately, Cézanne's legacy – that makes it a difficult painting to read either at first glance or, consistently, through time spent in front of it. Details are grasped, swim into focus, but they then swim out of focus again. Hair, flesh, sand and rock are given the same or similar colours; smoke, cloud and sky are solid as any other element. (Something Picasso learnt from El Greco as well as Cézanne.) The nudity of Cézanne's bathers is comically married to the cowboy gear, so several figures are naked from the waist down; it becomes quite a camp campfire. Elements that in early Kitaj would have been set beside each other are merged together, neither one thing nor the other, or perhaps both at once; the energy of the collaged surface (or the painted surface organised by the principles of collage), pushing forward, retreating from area to area, but essentially structured around flatness, is replaced by a sense of perspectival recession. This is not entirely new – there are works of the 1970s where one could debate whether one was looking at a perspective space rethought after modernism (comparable in some ways to Balthus's rethinking of the interior after Matisse and Picasso) or a modernist space with

fragments of foreshortening, hints of perspective, organised on the picture surface (more akin, say, to Hamilton's photo-collaged interiors). But it is misleading to discuss perspective as if it was a simple or a single system; the best models within perspective for the intricacies of Kitaj's machinery of reference and allusion are the Renaissance works – from Donatello to Mannerism – where the spaces are organised to create distinct pockets of narrative action, either classically, as in Donatello, or hysterically, as in Uccello's rushing *Flood*, both acknowledged sources. Neither of the major sources in *Western Bathers* – the Cézanne or the film frame – encourages this, however, and the *thought* of the painting is comparatively simple: bathers (for the purposes of this picture) = cowboys.

There is a shift in the two prefaces quoted at length above, barely noticeable but of great significance, from 'still' to 'film-frame'. The still – keepsake cinema, a photograph taken by a stills photographer on set – is cinema's reduction of itself, for the purposes of promotion and enticement, to a single image, from which, armed with our knowledge of genre, we intuit the entire film. Book-cover illustration, particularly in the area of pulp fiction, plays the same game of archetype and legibility, often with the same lazy distortions and inaccuracies. Cindy Sherman, of course, pounced on the still as a way of directing films that consist only of a single image, films in which she can also star, in a blend of fantasy, identification with other actors in other films, self-disguise and self-revelation. The still, like the traditional narrative painting, condenses narrative into a static image.

The film frame, on the other hand, is closer to a frame from the sequences of human and animal locomotion shot by Muybridge, himself a cinema pioneer. The film frame, its qualities only visible at all viewed in isolation, returns cinema to still photography. (The frame is not how one remembers cinema, but then the photograph is not how one remembers the world.) Muybridge assumed that artists would not slavishly copy individual frames from his sequences, but would rather, Rodin-like, synthesise them into graceful solutions to the problem of movement informed by photographic accuracy. Of course, artists were immediately fascinated by the strangeness of the individual frames, less an *aide-mémoire* than a revelation, with their suggestive and otherwise invisible awkwardness.

'Movies, and particularly frame-enlargements, have been in my work what engravings and such were for artists in the distant past, what printed illustrations were for painters like Manet and Van Gogh, what photographs were for Degas and Cézanne and later for Sickert and Bacon … no more and no less.'[31] Fifteen years on, the frame enlargements are still invaluable:

> One of the by-products of my Bibliomania is a collection of movie books illustrated, not *by stills*, but by *frame-enlargements* – whole books, quite rare, where each page is a frame-enlargement from *one* movie (Dreyer's *Joan* for instance). Yes, my precious frame-enlargements suggest things countlessly. The most recent: A H'wd painting called SECOND DIASPORIST MANIFESTO (My 1st LA painting) depicts the (3) Marx Bros besieging their central and *dominant* hostess – Margaret Dumont –

i.e. Diaspora Jews in their amused & tolerant & suspicious host country par excel-
lence. Most of the imagery has its source in frame-enlargements as opposed to stills
which are almost always less interesting to me. Another painting just begun based
on a clip of a (1899) Melies about the Dreyfuss affair … and so on.

Europe pictured in America, America pictured in Europe; the dialogue continues,
with Kitaj now 'right smack in H'wd! My screenwriter son and his milieu of movie
people here, with grandpa Whitehair Movie Maniac beaming approvingly!'

Finally, a painting of 1966, *Walter Lippmann* (Plate 16): a premonition or early
flowering of Diasporism, in which the subject is represented, in a variety of styles,
in the margin of the painting, with his subject – complex and serious events –
reworked 'in terms of romance, intrigue, spies and alpine idyll, like movies did in
those days, often made by refugees, themselves escaping from serious events'.[32]
Robert Donat from *The Thirty-Nine Steps* is spliced with Victoria Hopper in *The
Constant Nymph*.[33]

Another cinematic pairing, the division of the sexes shown as black and white,
stands at the top of the stairs (themselves black and white) in the middle distance.
(Eliot, in both *The Love Song of J. Alfred Prufrock* and *The Waste Land*, associates
sexual encounters with flights of stairs; and so, often, does Kitaj.) If Kitaj is
unhappy at the way that 'late modern art' seems to have abandoned the eternal
subject of woman and man,[34] he can be sure that Hollywood Kulchur never will.

The *Walter Lippmann* Preface ends with a kind of non-sequitor. Kitaj has been
talking of the talkies, but then he reminds us that 'when movies were first shown,
the form was so new and unusual that most people found it difficult to understand
what was happening, so they were helped by a narrator who stood beside the
piano'. A sly suggestion that modernism's, and Kitaj's own, supposed illegibility
is overrated, may pass. But Kitaj also clearly loves the idea of the narrator beside
the piano. Perhaps his ideal would be the legendary Persian cinema narrator
described by Patrick Hughes:[35]

> his non-stop verbal explications, declaimed as he strode up and down the crowded
> aisles, described the gods and mythology and history of the people of Persia, and his
> improvisation fitted what was happening in the film as the hair fits the head. In this
> way were seen *Gone With the Wind* and *All Quiet on the Western Front*: as events in
> the nation's history, peopled by characters from the Persian pantheon. At the same
> time, our poet's impromptu verses – often he hadn't seen the film before – were in
> the complex scheme of Persian poetry, rhyming, scanning, and so on … at the height
> of his powers our man sometimes accompanied a two hour programme of film trailers
> spliced together. The popular poet's imagination, skill and learning could concoct,
> at that instant, a sustained story with a cast of hundreds that linked all those wars,
> love affairs, catastrophes, comedies and come-what-may into a coherent whole.

As the pictures, so with pictures; Kitaj's pictures, at last (though perhaps inco-
herent, or non-narrative, wholes are even better). The exegesis continues. 'Good
deconstruction, no? Good Midrash.'[36]

# The trace of the Other
# in the work of R. B. Kitaj

Folding/Crossing, self-limitation, difference and deconstruction
in the context of image aesthetics and Talmud reading

## Martin Roman Deppner

*English adaptation by David Dickinson and Andrea Rehberg*

Since the 1970s R. B. Kitaj has introduced a form of Jewish identity into the discourse of contemporary art which seeks to emphasise both commemoration and renewal. He has done so through numerous drawings and paintings as well as through accompanying commentaries, interviews, articles, and the book, the *First Diasporist Manifesto*.[1] Significantly, the fact that numerous artists of Jewish origin have helped to shape art since 1945 moved the American Kitaj[2] (who lived in London until July 1997) to work through Jewish identity in culture and history in an art which grapples with the results of modernism. As with Barnett Newman, the focus is on traces of thought with specifically Jewish connotations, but they lead to a different result without yet wholly giving up the correspondence to Newman's message.

In the process of self-discovery as a Jewish artist, Kitaj's reflections are not motivated chiefly by the question of a projected art which commemorates Auschwitz by means of permanence, the immanent ambition of art, even though keeping alive the trace of a memory unites artists of such different orientations as Richard Serra, George Segal, Marie Jo Lafontaine, Frank Auerbach, Christian Boltanski, Sol LeWitt, to name but a few.[3] What chiefly motivates Kitaj in his striving for Jewish identity in his art, as with other Jewish artists, are three factors; firstly, his art has developed in its essential aspects in an occidental, or non-Jewish context; secondly, his art nonetheless diverges from the usual occidental paradigms in individual, sometimes decisive, sometimes hardly noticeable aspects; and thirdly, his art derives its innovative strength precisely from this tension. In short, he is concerned with an identity which develops in dialogue with the Other, here initially to be understood as the other culture of Jewish Talmudic tradition.

Furthermore, all this is to be seen as a reflection of the *Renouveau Juif*, a dimension of thought which originated in Paris under the influence of the Talmud

scholar and phenomenologist Emmanuel Lévinas, and which, among others things, led to Jean-Paul Sartre's conception of 'the Jew as an anti-Semitic projection' being abandoned in France.[4]

The discovery and thematisation of one's own Jewish identity in thought and action becomes, in the context of this and other impulses (such as the re-reading of Walter Benjamin), also an inspiration in art, which feeds off different sources. The theory of deconstruction developed by Jacques Derrida, partly in dialogue with Emmanuel Lévinas, is as much a part of this as the emerging consciousness of a Diaspora existence characterised by sedimentation, or the layering of meaning.[5]

Kitaj's *If Not, Not*, 1975–76 (Plate 3), is a reflection of Jewish identity in the context of European art and the international reception of modernism. As this chapter will also demonstrate, the discourse of postmodernity is also involved without being subsumed in the former. Painted between 1975 and 1977, the 152.4 cm x 152.4 cm painting in the National Gallery in Edinburgh, originated simultaneously with the *Renouveau Juiv* in France and comparable processes of and reflections on renewal elsewhere, such as in London.

At first glance, *If Not, Not* is a landscape painting which confronts us with the high horizon of a panoramic view from past conceptions of art. The effect of the colours, by contrast, mimics the artificiality of current glossy magazine reproductions. In some places, the application of colour seems like imitation velvet, comparable to a modern design aesthetic. Dark and light colours alternate; contourless flakes of colour and contoured details of imagery 'encounter' each other.

In addition, *If Not, Not* offers the horrifically 'beautiful' film scenario of an inferno in which, through colour, the montage of horror mutates into the call of an adventure. 'Crowned' by a watchtower, the painting finishes off with stranded people at the bottom. The watchtower is the quoted depiction of the main gate of Auschwitz. Like a gate to hell, it seems to have spewed out what once testified to human culture. But, in a commentary to *If Not, Not*, Kitaj writes, 'The general look of the picture was inspired by my first impressions of Giorgione's *Tempesta* on a visit to Venice, of which the little pool at the heart of my canvas is a reminder.'[6]

With Giorgione's *Tempesta* (1506–8) Kitaj follows the model of an intimate relationship with nature, in which the ambivalence of security and anxiety already resonates. According to one interpretation, Giorgione is said to have painted the ideal of a landscape in which he inserted himself and his family. According to another interpretation, he is said to have mysteriously confronted 'a soldier and a gypsy'.[7] Kitaj does not show one or the other, but indicates a certain discord between them in full knowledge of Giorgione's utopia. It includes an openness of reading which aims at ambivalence.

According to Edgar Wind's interpretation, known to Kitaj, there is also the dimension of 'pastoral allegory'. Giorgione captures Fortuna accompanied by the approaching storm so as to include both strength (the soldier) and mercy (the

nursing mother). Wind argues that the approaching storm shows itself capable of stirring the soul, because of the connection of differing elements within one form which have been influenced by this reading of Giorgione.[8]

Giorgione had carefully unified composed nature with original nature. With Kitaj this becomes – and this is to be differentiated – a careful composition of instances and acts against nature. The point of reference to be emphasised for Kitaj is the break in the clouds in which Giorgione hints at lightning. Accordingly, Kitaj's glimmers of colour and plays of shadow simultaneously point to calm and storm, to light and darkness. This is accompanied on the level of the image by the ambivalences between static figures and moving tree silhouettes. *If Not, Not* affords a glance at the consequences of a development alienated from nature: zones of artificially coloured remnants of nature overlap like torn-off tree-patterned wallpaper. In the sewer drift rubble, books, heads. Beneath palm trees a murder is taking place. The presence of a wanderer equipped with expedition bag indicates that a voyage of discovery has turned into a nightmare. He looks on, passive and bandaged.

In *If Not, Not* the Jewish passion (the gate at Auschwitz, Figure 38) and apocalyptic vision intersect in a conception of nature which emerged at the beginning of modern civilisation. Nature was the measure of the individual. From nature, he derived his definition as a self-reflective being, in relation to nature he orientated

38  Auschwitz Gatehouse.

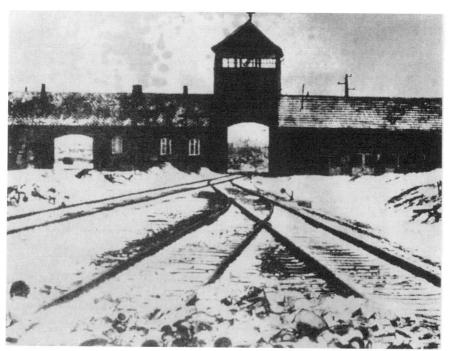

his actions.⁹ Kitaj allows this positive determination to show itself by reminding us of the continuum of a Renaissance landscape without, in the end, allowing it validity. A contiguity of ideal and actuality meet like calm and storm at a change in the weather. Transformed into traces of differing projections of art is the apprehension of another time, another aesthetic; it becomes harmony accompanied by conflict.

The ambiguities of the painting begin with the title. At first this sounds like an absurd formula, intended to underline the vision of the end of time as the absurdity of being. The title can be identified as a quote from the description of Ezra Pound by Gertrud Stein: 'Ezra Pound is a village explainer, excellent if you are a village, if you are not, not.' And Robert Creeley points out that Kitaj took into account the royal oath of the Aragons, cited in F. D. Klingender's *Goya* book: 'We, who are your equals, swear to you, who are not our superiors, to recognise you as our king, as long as you respect all our liberties and laws, but if not, not.'¹⁰

This ambiguity reminds us of Jacques Derrida's 'differance' in the field of writing and interpretation. By writing 'differance' with an 'a', which sounds like a spoken 'e' in French, Derrida seeks to evoke a bundle of meanings and a constant change of perspective. First of all, the 'a' alludes to the soundless aleph of the Hebrew alphabet, which, as an intonation produced in the larynx, stands at the beginning of a word. Breathed it becomes an ambiguous sign and concentrates an abundance of promises. Furthermore, Derrida views the 'a' as a graphic intervention into other traditional contexts. For him it is a 'silent monument' which, printed as a capital letter (A) displays the shape of a pyramid. 'Differance', spelt with an 'a', is also meant to restore, at least symbolically, the polysemy and ambiguity of *différer* – meaning to defer, to temporise, as well as not being identical, being other – and *différend* – meaning war, conflict. Derrida sees in these webs and sedimentations a loosely woven net, not a word or concept, but a preliminary graphic trace which will have to display its effects in time. Viewed thus, the philosophy of difference wants to stay in multiplicity and at the same time think the originary trace, which is no longer a discernible origin.¹¹

The title *If Not, Not* is comparable to Derrida's 'differance', and is intended to break up one-dimensional references. Similarly, Kitaj's painting, as already hinted, is multidimensional in its aesthetic structure. The relationship to the originary trace also requires investigating. There are the ambiguities of the pictorial fragment of the watchtower, which can be interpreted as the main gate of Auschwitz, as the gate of hell, or as the castle of terror, as in paintings since the seventeenth century. These ambivalences are accompanied by the ambiguity displayed by the male figure cut into by the lower edge of the picture: everyman of the twentieth century and the archetype of the person stranded by waters. In addition are what can be adduced from other Kitaj paintings, such as the hearing aid, which accompanies the spy in his painting of Benjamin, *The Autumn of Central Paris (after Walter Benjamin)*, 1972–73 (Plate 9), as well as the traveller in a train compartment, whom Kitaj calls *The Jew Etc.*, 1976 (Figure 5).¹²

A further aesthetic device in *If Not, Not* is the 'peculiar tumult of dreams', noted by Robert Creeley, 'the feeling of things' co-ordinated and led by colour, which lends objects an expressive character in contrast to the physical order.[13] What appears as 'discontinuity' and what exists as 'soft tumult' is nothing other than the intermediary realm which crystalises out of the overlapping fragments unified by a pictorial aesthetic, whose originary trace is lost in the abundance of references. Slotted into Giorgione's Renaissance landscape, for example, are land-scape images such as the large composition *Joie de Vivre* by Matisse. One is also reminded of El Greco's *View of Toledo* of the year 1600. Toledo was a spiritual centre for the Spanish Jews and by association we are reminded of the expulsion of Spanish Jews in 1547, intensified in 1609-14 under Philipp III.[14] On a trivial level it is a quotation of a living-room wallpaper, even though the Japanese tree pattern – together with artificial lighting – is reminiscent of Hiroshima. In this context the 'gate of Auschwitz' takes on the function of a disruptive motif. It breaks open completely the image of harmony traditionally associated with the reception of nature and the landscape tradition. The same goes for the combination of images of the dead and crouched figure on the right of the picture, where the composi-tion is based on the still of a firing squad from Pudovkin's film, *The Mother* (Figure 39). All in all, Kitaj operates here against logocentric discourse, and in doing so he harmonises with Derrida's intentions. In the abundance of reflections, no stable referent can be made out.

The conflicts between the painting's various semantic and form-related levels identify Kitaj first of all as an artist representative of a virulent strain of modern art in England which surprisingly coincides with some aspects of Kitaj's 'self-education in Jewish identity'. The strain is that of the 'image-aesthetic' which above all else can be identified in the work of the expatriates Ezra Pound and T. S. Eliot.[15] In 1980, Kitaj acknowledged that he still liked 'Pound's differentiation between sign and symbol', where the sign does not exhaust its meaning as quickly as a symbol.[16] Kitaj often alludes to his concept of the 'image', which for Pound is synonymous with a sign: 'The symbols of the symbolists are fixed quantities like the numbers in arithmetic like 1, 2, or 7. The images of the imagists are variable quantities like the numbers a, b, and x in algebra.'[17]

In his poems Pound understood these variable quantities as coincidences of pictorial impressions, as the combination of a complex network of meaning in an image. 'The image is the material of the poet', said Pound, and an image is 'an intellectual and emotional complex in a moment of time', a still centre which keeps open the last logical step for the imaginative work of the reader, superim-positions of layers of sense-provoking thought to constitute, according to Pound, the aesthetic of the image.[18] This approach also found expression in T. S. Eliot's *The Waste Land*, a classic of the twentieth century, which was decisively influ-enced by Ezra Pound, and from which Kitaj derived several paintings, including *If Not, Not.*

**39** Still from Pudovkin's *The Mother*.

In Eliot's poem as in Kitaj's paintings, a comparable perspective is active, according to John Ashbery, in which 'things come into focus for a moment and then fade away again, in which contiguous phenomena are compromised to a mysterious unity and the distinct contour suddenly becomes unrecognisable'.[19] According to Kitaj, the *The Waste Land* is exemplary for *If Not, Not* as a 'family of loose assemblage'. What Eliot assembles kaleidoscopically into 'linguistic images' from facets of metropolitan civilisation and traditional culture has served Kitaj in terms of content, beyond a formal stimulus. The river destroyed by oil, the singing river goddess, Tiresias – hermaphrodite and seer in the dosshouse – the 'watery death', sexual alienation, the *liebestod*; grey trees, the 'purple hour' of the metropolis, oriental nirvana, the 'streaming masses' on London Bridge, land without water, the stranded Odysseus – all these are stations in Eliot's poem. Not all are reflected in *If Not, Not*.[20]

Besides the symbolism of water, identical in terms of image, in the river polluted by oil and tar, the watching wanderer and the seer 'Tiresias', the stranded man in a suit, the shipwrecked Odysseus, the oriental nature imagery in Kitaj and the philosophic message 'Shantih, shantih, shantih' in Eliot's *The Waste Land* are also related. Both poem and painting depict a culture randomly thrown together but capable of being endlessly combined into new fragmentary patterns of sense and ambiguity. The metaphor of failure by the river goes back to Joseph Conrad's *Heart of Darkness*. In Conrad's novel the adventurers and conquerors are not equal to the river as a force of nature. Kitaj writes: 'the dying figures among the trees to the right of my canvas make similar use of Conrad's bodies strewn along the river-bank'.[21] Kitaj also took from *The Waste Land* the method of projecting disturbing factors into the image of nature in order to release the imagination.

Decisive for Kitaj's cross-over aesthetic, which includes the different, the other, and what is separated in time, is the influence of Edgar Wind. After his move from the United States to England (via Vienna), Kitaj began studying at the Ruskin School of Drawing in Oxford in 1957. He was taught art history there by Edgar Wind, who had been an assistant to Aby Warburg, and who had emigrated to London in 1933 with Warburg's legendary Hamburg library of cultural-studies texts. Wind not only encouraged Kitaj to follow in the steps of Warburg, which was reflected in Kitaj's research into Warburg's sources and texts, but he also pointed out the 'dissociations of sensibility' which had come to the fore in Eliot's aesthetic.[22]

Signs are detached from their original carriers, the emotions associated with them are robbed of their native anchors, while at the same time they are kept ready for new expressive constructions and combinations. In this way different associations, connected with things and events such as birth and death, beauty and disgust, blood and colour, film and painting can be seen and felt together. The consequences are, on the one hand, a loss of reality and, on the other, anxiety. At the same time there is an affinity with the semiotics of postmodernity, connected especially with the plurality that belongs to the displacement of signs.[23] Finally,

the *cours de linguistique générale*, developed contemporaneously with Pound's imag-
istic ideas, which in linguistics establishes the split of signs into sounds and
meaning, into *signifiant* and *signifié*, into signifier and signified, into husk and core
of the sign, has to be seen as a parallel development.[24] Connected with this is the
insight that the communicator knows how to transfer the husk of one thing to
another. As Ludwig Wittgenstein interpreted the use of colours, in his
*Philosophische Untersuchungen* (*Philosophical Investigations*): 'It is as if we detached
the colour-impression from the object, like a membrane.'[25] Nowadays, the disso-
ciation of signs has become the basic tool of poststructuralism. Among other things
this enables a theoretical transfer between Saussure's linguistics and Derridas's
deconstruction, and hence opens a path to the *Renouveau Juif* inspired by
Emmanuel Lévinas: for Derrida is as much influenced by Saussure as he is close
to Lévinas.[26]

A structurally similar association is to be found in Kitaj's aesthetic thinking and
practice in fine art, if one compares the image theory of Eliot's 'dissociations' with
those Talmudic networks on which Lévinas bases himself and which Kitaj begins
to discover for himself and his art, at the time of the painting *If Not, Not*. The
aesthetic is first of all an indication of the discovery of the same in the other. It too
operates with heterogeneous materials of signs. In both cases, it is language which
is capable of producing images in the imagination and which clears the way for the
image as text by means of the text as image.

According to Ezra Pound, *The Waste Land* is an 'emotional unity' which
prevents the poem from becoming a 'consistent, logical thought construct'.[27]
Such a 'consistent, logical thought construct' is also absent from the Talmud,
that collection kept alive in Jewish thought of sedimentary explanations, discus-
sions and doctrines on the Scriptures. In the repetition, in the re-collection of
preserved commentaries and in documented (and still outstanding) connections,
a memory trace becomes retrievable and, fed by oral tradition, keeps awake the
memory, and documents it as history. Besides sublime religious pronouncements,
the Talmud contains everyday jurisdiction. A core point is emphasised,
supported by commentaries from different times. The commentaries contain
answers and replies, 'responses', which reveal a dialogical principle, producing
ever new possibilities of explanation,[28] so that their dispersion becomes
connnectable via the interpretation.

The Jewish Cabbala, which aims at the remythologising of the Torah and which
is a commentary on the five books of Moses, helped Jewish mysticism to expand
as a spiritual movement in the thirteenth century. In relation to the Cabbala
permutations and combinations of letters are cited which, in deepest contempla-
tion, lead to a 'jumping', which in turn, via the imagination, leads to a 'mystical
experience'. In an historical source to the Cabbala found in Gershom Scholem one
reads: 'In the use of *jumping* one has to let the combinations of letters unravel in a
quick movement.'[29] In the context of Eliot's *The Waste Land*, Wolfgang Iser also
speaks of unravelling images, interrupted by sudden fade-ins, jerky scene changes,

15 *Western Bathers*, 1993–94, oil on canvas, 135.3 x 190.2.

**16** *Walter Lippmann,* 1966, oil on canvas, 183 x 213.4.

as well as of imagining and of a reality hanging in the balance.[30] Furthermore, Jewish thought and 'image-aesthetic' find a *dépendance* in the goal of sending the imagination on an endless path.

It seems as though Kitaj, on the basis of these surprising similarities, has been able to draw Jewish mysticism into the image method through the common factor of the pictorial, or rather to integrate it into Jewish thought. Scholem writes: 'The original point, which lights up from the nothing is the mystical centre around which are concentrated the processes of theogony as of cosmogony'.[31] The doctrine of the orientation to a concealed, infinite God, En-Sof, should also be named as a further point of reference, but without conforming to the image. Thus, in *If Not, Not*, Kitaj, like a Cabbalist, might have integrated available motifs and signs from his own sources into an ambiguous network but without a 'fixed cabinet of thought with main and sub-divisions'.[32] This explains why the system of relations within the painting expands in such a way that referent, signified and pictorial denominator lose their contours, at which point the paradigm of the image-aesthetic is abandoned. Correspondingly, the religious symbols in the picture – lamb, tree of life and black raven – have the effect of supplying an additional layer to the iconography and semantics of the painting which are already so ambiguous. Furthermore, the complex of images – into which these symbols are put – extends their meanings to further nuances, references and codings. To this there belongs the fact that *If Not, Not* is the companion piece to the contemporaneous *Land of Lakes*, 1975–77, which derives its original idea from Ambrogio Lorenzetti's fresco *Good and Bad Government* painted in 1338/39 in the Palazzo Publico of the city of Siena.[33] The ideal of an early bourgeois relationship to nature, fundamentally based on trust in a rule led by reason, changes here into an arcadia in which death, according to two paintings by Poussin, is also at home. In contrast to Lorenzetti's model landscape, *Land of Lakes* is devoid of people but does not completely exclude life-giving water from the desert.

The work of Franz Kafka is exemplary for Kitaj in its use of Jewish mysticism, which combines a modern aesthetic with occidental pictorial patterns. 'Kafka appeals to me', says Kitaj, 'as a Jew of nearly my own time who achieved an art I can cherish indiscriminately, as I love the art of Cézanne for instance. But above all, Kafka encourages me to know myself and puzzle out my own Jewishness and try to make that over into an art of picture-making.'[34] Kitaj agrees with Gerschom Scholem who characterised Kafka's 'ambiguity' and obscurity as a secularised form of the Cabbala.[35]

In this vein, Kitaj utilised the traditional conception of the landscape as world stage for a theatre of signs. Shorthand images which immediately refer to the Jewish passion, such as the watchtower of Auschwitz, symbols, which concern Jewish faith, such as the tree of life, become part of western culture and its historical development. Supported by the design-like interlacing of zones of colour and image, signs are integrated into the picture's continuum but are alienated from their traditional places. A proper sense, the result of an effective inner

dispersion, emerges from the convergence of the different others and from the potential references which grow out of this convergence. In this way new images lose their fragmentary character. But their montage only conceals the core conflict between bourgeois utopia and a reality from which Auschwitz can no longer be excluded. Most conspicuous are the results of an understanding of human beings and nature which moves from appropriation to annihilation. But the traces which lead to the root of evil get blurred and, as if seen through filters which diminish contrast, seem to peter out towards the centre of the picture where glimmering pigments symbolically allude to the continuing smouldering of the conflict. Consequently, difference remains written into the complexity of the interlacing of the one in the other and any orientation towards a redeeming signified is denied.

Kitaj himself says that in his art he is concerned with staging the forty-nine layers of meaning of the Talmud (in coded and yet appealing ways). This corresponds to the appeal 'interpret us', through which, according to Emmanuel Lévinas, the rabbinical texts and commentaries speak to those who incline towards them.[36] This is taken as the call of the Other, who reveals himself in the Talmudic texts which are without a speaking subject. Every speaker, in speaking, refers to another, as happens for instance, in the collection Nedarim 40a: 'Rawin said, Raw had said: How is it, that the saint nurses the sick?' etc. The 'self' only comes to be in the encounter with collected textual traces, by forming means of communication for others. For this reason, Arnold Goldberg speaks of *communicative* citation instead of a mere citation, and commentary which includes the others instead of one that would merely confirm the commentator in his role.[37]

   A further difference could be noted here which distinguishes image-aesthetic from Talmudic thought constructions. The partial zones of Pound's and Eliot's sign chains were not intentionally read as traces of the Other nor were they formed for reception as such. The dismantling of the 'I' – where Pound imagined himself as Odysseus, who cunningly made himself known to Polypheme as 'nobody' – is not the aim from which responsibility for the Other could arise.[38] Nor is it the omnipotent individual whom Pound on the other hand took himself to be. In order to master incoherences, in poems and chants, accompanied by theoretically omni-form principles, heterogeneity was meant to be combinable according to a common denominator.[39] By contrast, to turn oneself into a sign for the Other, to open oneself, is for Lévinas, the basic condition for becoming a subject. For the event of subjectivity is twofold: my significance as a sign ('ma signifiance de signe') for the Other is also my exposure ('*exposition*') to them. And, in being addressed by the Other, I am called forth as a subject.[40]

   Lévinas avers that in the the appeal 'interpret us', which can be derived from the traces of the tradition, the paths of the Talmud intersect. Jewish philosophy has to begin with the Talmud and with what the trace of the Other, both present and yet concealed, turned into the focus of its reflections and meditations. For

Lévinas, the Talmud is the source of Judaism and it opens up access to the Bible as well. Thus the tradition belongs to the diverse, sometimes contradictory, always pluralistic study of revelation, to become original revelation. This unfolds by means of a mutual disclosure of texts and reader, in an infinite process of interpretation rich in perspectives. Hence the tradition is no dead letter, but a living, creative process of the acquisition of textual sources.[41] As Stéphane Mosès has shown, this conception is based on revelation itself, as in Exodus 3, which always demands fulfilment by means of the actor in the double future of 'I will be who I will be' (instead of: 'I am who I am').[42]

Apart from the active connecting of interpretations of the Talmud and Torah, Lévinas also pursues a connection between Athens and Jerusalem, or, as has been said 'a translation of Jewish sources into Greek'. That is to say, a translation into the general language of enlightenment and the enlightened in which the Talmud embodies the antithesis of an open-ended, pluralistic thinking.[43] But this translation does not aim at the abolition of the otherness of Judaism in the universality of Greek thinking. The wisdom of Israel is here the irreducible Other of Greek wisdom and in this lies its great significance. Correspondingly, the confrontation of a Talmudically inspired aesthetic structure of argument, in the image of an enlightenment metaphoric landscape such as Kitaj's *If Not, Not*, is to be viewed as the sign of an irreducible Otherness. This evokes a being dependent on the Other, which always at the same time includes a distance. Derrida would say: 'differance'. It also evokes Ezra Pound's structurally involved discourse of modernity, whose symbolic heterogeneity, which occasionally leads to a postmodern acsthetic, at times renders the difference unnoticeable.

This thinking, as a dialogical interlacing of different othernesses, dates back to a mitnaggdic understanding of Judaism. This developed in Lithuania and strove for a connection between modernity and Judaism, between Western Haskala, which sought involvement in the Enlightenment and could appear anti-religious, and the Eastern Chassidic movement of religious awakening and devotion. Hence this thinking is a kind of crisis theology, which attempts to overcome the opposition of culture and belief.

The dialogical philosophy which foregrounds the Other and the trace arises from the first accounts of the creation of the human being (Genesis 1 and 2). In the first accounts of creation a triumphant Homo Faber is described as he who conquers the world through his activity. In the second chapter Adam is described as made of dust and brought to life by God. The sociability of the first Adam is pragmatically orientated to the conquest of the world, that of the second, essentially to an encounter and partnership as given by God. The point is that both oppositional types are supposed to be aspects of the one Adam. But in fact, creation and the human being as creature are imperfect. They have been deliberately broken by the creator so that human being would re-create, perfect and deify itself and the world (Tikkum Haolam). The dual nature of the human being, which is at once creator and creature, corresponds in Cabbalistic understanding to the dual

nature of God, at once revealed and concealed. The self-restriction of God (Zimzum) first of all opens up the space for human freedom. Following this parallel between God and human being, the latter's burden is a universal responsibility, from which Lévinas infers an unlimited moral duty towards the Other. It is also clear that there is inscribed in this dialogical relationship to God and to creation the awareness of a constant 'differance', as the sign of an infinite process and continuous conflict.[44]

Beyond the responsibility for the Other and beyond the priority of 'for-the-Other' over 'being-in-and-for-itself', the trace of the revealed God who nonetheless doesn't show himself becomes effective as the trace of the absent Other in a thinking based on the Talmud. At the same time, it is a key to an imagery, as that of Kitaj, which circumvents the Old Testament prohibition of images with the help of Jewish interpretation. 'The God who passed', Lévinas writes, 'is not the original whose face would be a copy.' To be according to the image of God does not mean to be an icon of God, but to be in his trace. The revealed God of our Judea-Christian spirituality contains the entire infinity of his absence, which is the personal order itself. He only shows himself in his trace, as in Exodus 33. To go towards him does not mean following this trace, which is not a sign, but to go towards the others who are held in the trace.[45]

The trace, which is not a sign, can do without the compulsion of a concrete reference. It has enough meaning, in that the infinity of the Other remains present in it. And especially within modernity this creates the effect of substance, when in modernity there are only sign and letter, reference and trace, and the representation generates constructs without being or beyond. What remains are signs of commemoration – everything that human being encounters in its unity of body and soul is at the same time the trace of something Other. Viewed thus, the return of writing as a trace can also be pictographic, ambiguous, imageless sign. In this process Kitaj's art is positioned, and combines the signs of this world, instead of its imagery, into a web of references that requires re-creation in reinterpretation. It was this that informed the combination of image-aesthetic and Talmudic thought, which prove to be compatible in all essential structural aspects, particularly with regard to referents of signifiers detached from their carriers. But what is to be distinguished is a compatibility into which is inscribed the difference regarding the conception of the Other.

The textuality of both, Talmud reading and image-aesthetic, which is turned into imagery, remains in conflict, since inconicity also retains its intrinsic value in Kitaj's works. But it improves its image in the dialogue with the structural Other. The simultaneous event of perception manifests itself in the image – bearing in mind, in Kitaj's case, the intertextuality of linguistic operations elevated, as it were, to an image. Thus, on the one hand, the suggestive force of the image is transformed into reflection, and on the other the rule-based system of language is interrupted: in the form of criss-crossing glances, intersecting resonances, and traces, relationships and differentiations.[46]

In Kitaj's painting *From London (James Joll and John Golding)*, 1975–76 (Plate 10), the aesthetic Other is a picture by Mondrian. Or is it merely a variation? In terms of imagery, the geometric reduction of coloured planes appears as a poster on the wall: the reproduction of a reproduction. It is placed between the people depicted. It is like a glimpse of order in a background characterised by diffuse colour marks and blurs reminiscent of the effects of soft-focus photography and cinematography. Does Mondrian's art function as an intermediary in an encounter equally marked by a turning towards and a turning away? Does it suggest a window in order to signal a vista offered by the veiled light in the mist? The ambiguity of the strange aesthetic disturbs the suggested nearness in the picture, which is further distracted by white empty space, reminiscent of the fresco paintings of the Renaissance, which fragments the head of one of the figures (John Golding).

Facing the fragment of the portrait is the abstraction, whose colour tone corresponds to the colourfulness of the objects and their tactility. An intermediary state has been reached which concerns the theoretician of anarchy (James Joll) and the theoretician of Cubism (John Golding) and which hints at an attempted mediation between the two opposing poles of figuration and abstraction. The signs which are visible on the table may contain hints in this regard. Thus, for example, a book which produces geometrical order and which corresponds in terms of colour to the figure that leans into it, as well as to the picture's dividing line and the Mondrian poster, is a book by Richard Wollheim which questions the constitution of works of art: 'Are they spiritual or material? Are they constructs of the mind?'[47] How could different conceptions of art still be distinguished?

George Segal's 1967 installation of *Sidney Janis with Mondrian's 1933 Composition on an Easel*, which combines concrete object, artistic figure and painting, also demonstrates antithetical conceptions of art in suspension. The white, life-sized figure is a paradox: in the title it is identified as a portrait of the influential New York gallery owner and art collector, but in appearance it is a ghostly monument of a living model cast in plaster. It confronts us with a concrete figure and its withdrawal, with a blank space in which poses a plastic figure.

The presence and absence of the real person simultaneously plays with that blank space, left behind by the monochrome abstraction without simply setting an image-realism against it. It now becomes noticeable that Segal – the son of a kosher butcher from the Bronx – owes to the New York School (schooled in the Talmud) the lesson which helped him to develop further the superceded subject–object split of his forbears Newman and Rothko by way of an opening to the Other.[48] The encounter with realism and abstraction expanded into the sculptural ensemble of a frozen stage play becomes an encounter between sculpture and painting, of artificiality and ready-made, concretely in the inclusion of a painting by Mondrian and an easel. Furthermore, it is the objectification of human being together with its environment which preserves the trace of a former life. In other works, Segal took compositions by Edward Hopper as a focus in which the concrete and abstract polarisation of modernity is refracted.[49]

In a comparison with Kitaj's painting of encounters an analogy appears in the question of difference between the conceptions of art that are built into the works. What is doubtful is merely the missed intersections of the traces of the different polarities between American and European art in whose oscillations Kitaj and Segal are able to develop.[50]

In the context of the Talmudic doctrine of the trace of the Other, the concealed creator, and of an apparently and actively infinite complex of references, the secularisation of the Scriptures becomes a motive for an art in which background texts, as it were, shine through to offer orientation. In this case, it does so as a structure mindful of the trace of the Other yet without liberating it from the responsibility of self-interpretation.[51] In that the self (here understood as one's own work) emerges out of the trace of the Other in interpretation – as is the case with Kitaj and Segal, who mirror one another in the different art of a Mondrian – the refraction of the self-projection and the trace of the Other in one's own representation become an opening onto a very old and wholly new view of the world. This view, deconstructively mindful of difference, explodes all the self-reflection and all artistic self-destructive thinking. It does so by manifesting in the face of the Other (which is in turn artistically mediated), and even deriving from it, its existence which is focused in the work of art.[52]

The task is the discovery, in the processes of art, of that dimension of the face which is for Lévinas the most complex trace of the absent Other and which he described as the event of the infinite. The face as a trace continually detaches itself from all forms and rests in none. Just because the face is not static it can enter into a relationship with the subject and yet remain separate, significant in itself, naked.[53] The face has this quality in common with the autonomous work of art, which only retains its independence when it withdraws from the instrumentalisation of a goal-orientated discourse. In this way, work of art and face embody simultaneously a concrete trace and a withdrawing aura.

The comparison between Kitaj's *The Sensualist*, completed in 1984 (Figure 40), (on which he worked for many years), and a neo-Expressionist work of art by the German Georg Baselitz, *Painter with Sailing Ship – Munch*, 1982, furthermore evokes the trace of the Other as part of an artistic dialogue. Both paintings are oversized male nudes and are of approximately the same, more than life-size, height. At first glance, the forceful style of painting and the coarse design of the figures appear to be similar. Whilst Baselitz's nude unaccountably is upside down and shows an inverted upright figure, Kitaj's standing 'sensualist' – with his over-stretched body – displays the formal quality of an overhead figure. Kitaj derived it from Titian's *Flaying of Marsyas*, which depicts the satyr who, according to legend, was hung upside down to be skinned. Having lost the contest with Apollo, the flute player is a symbol of sensuality's fate as an outsider. Kitaj likens the muted gesture of the sensualist to the gesture of a bather by Cézanne (in which the gesture of Michelangelo's slaves or the gestures of Picasso's *Demoiselles d'Avignon* become focused as in a videoclip). In doing so he stakes a cosmopolitan claim which can

be called omniformis (Pound) but is not necessarily inclined towards the 'Other'. But by means of the Cézanne adaptation the picture responds concretely to the expansive gesture of the Baselitz figure, which inaugurates a semantic change of direction.

Kitaj takes up his characteristic style of wild brush strokes, to convey them into a controlled web of colours – as can be seen from close up. In contrast to the expressive painting of Georg Baselitz, Kitaj poses a carefully considered colour structure. The irregular roughed-up surface rests on a foundation made of thick, plastery white – in which the traces of the brush have been left, as on a roughly whitewashed wall. The colours are applied on this background. They 'bracket' the foundation's traces of the brush which are suggestive of movement. Every paint stroke is applied purposefully. Daubs, strokes, sweeps – all stylistic means of forceful painting – are applied in a controlled manner and without haste. It is as if in this dialogue Max Beckmann's aesthetic, the aesthetic of an exiled art, were present as a corrective.[54] By means of Prussian blue, Kitaj attempts to produce the traces of a deep darkness which, in alternation with instances of lightening up, lend the body an inwardly directed plasticity. It is a darkness that seeks to surpass the light impermeability of the partner's blackness which is separated from the body. Thereby it goes beyond the deceptive light of a rose-tinted past which still echoes in the background, in the form of the template of a female portrait. Baselitz positioned his figure in terms of areas; its red detaches it from the black background and so becomes other than concrete. With Kitaj *The Sensualist* becomes a figure of pathos on whom the traces of colour are inflicted like stigmata. As regards the dialogical function of Jewish responses Kitaj's reply could signify the

40 *The Sensualist*, 1973–84, oil on canvas, 246.4 x 79.2.

wish to complement and calm Baselitz's effusions. But how far can this pacification be consistent with the presence of a sensualist, as proclaimed in the title? In question is an expanding potential of differences and dialogues in the space between Jewish and German art after the Shoah.[55]

With *The Sensualist*, Kitaj stage-managed himself in disguise, as an autonomous, sorely afflicted individual, entirely in the style of the great individualist artists of the nineteenth century. But, since the entire figuration of *The Sensualist* is at the same time a combination of formal solutions taken over from elsewhere, a surprising picture emerges. Without the existence of other art, the picture of his own dispositions and hardships could not be. Via self-reflection the reflection of other art leads into dialogue. The comparison with Georg Baselitz's painting shows that Kitaj looks through his own mirror image! The application of extraneous values – in this case symbolically to one's own body – appear both as burden and solution.

## Epilogue

Aby Warburg had an elliptical ceiling window installed in the reading room of the cultural-studies library in Hamburg. A regular ellipse can only be constructed by means of two focal points which correspond to that duality and polarity Warburg recognised as an effective motive in the art of the occident. The oscillations between the Apollonian and the Dionysian, between the reflective and the passionate, were seen by him – following but also correcting Nietzsche – to achieve a balance in a successful work of art. He extended our insight into this with his journey to the Pueblo Indians of New Mexico. He took this foreign culture as the opposite pole in a Hamburg–America axis – nowadays one would say in the oscillations between Europe and America. But what made him take the oscillations between the poles of an ellipse as the emblem of his researches was the commemoration of an identity formed between the mountain of the Torah and the Talmud of the Diaspora. A Jewish identity in Greek garb in which he let the plurality of his atlas of images become effective as the experience of difference and the refraction of Apollonian light projected as linear.[56]

Furthermore, an as yet to be traced Jewish impulse is conceivable as the trigger for the symbol of an oscillation between the poles of an ellipse. This impulse is equally significant for Kitaj and Lévinas, and Warburg gave expression to it, for instance in his reflections, located between the Enlightenment and magic, entitled 'Pagan-antique prophecies at the time of Luther in word and image'. Even today rabbinical commentaries refer to a comparable potential which has entered thought especially in the context of the Jewish enlightenment and which is the result of the intersection of faith and knowledge: 'Judaism has ever existed in the tension between mysticism and rationality.'[57]

# Notes

## Notes to Introduction

1  See John Lynch, chapter 3 in this volume.
2  See Pat Gilmour, chapter 5 in this volume.
3  See Alan Woods, chapter 9 in this volume.
4  For details of Kitaj's biography, see 'Chronology', compiled by Janet Northey, in Richard Morphet (ed.), *R. B. Kitaj A Retrospective* (London, Tate Gallery), 1994, pp. 57–64.
5  Lawrence Alloway called this group the third generation of Pop artists in England, and included among their number Kitaj, Derek Boshier, Partick Caulfield, David Hockney, Allen Jones and Peter Phillips. The second generation were Peter Blake and Jo Tilson; and the first, Richard Hamilton and Eduardo Paolozzi. Robert Melville was the art critic for *Architectural Review*, the one magazine at the time which consistently reviewed contemporary art: the notion of 'Pop art' was very much in the air and these artists seemed to fit the bill, although the category does not bear close examination.
6  See Afterwords by R. B. Kitaj, in Jane Kinsman, *The Prints of R. B. Kitaj* (Aldershot, Scolar Press), 1994, p. 10.
7  Historically, the Holocaust or Shoah did not emerge as a fundamental part of Jewish identity until after the Eichmann trial in 1963, and did not develop into a social phenomenon of significance until the later 1960s and early 1970s. See Annette Wievorka, 'From Survivor to Witness', in Jay Winter and Emmanuel Sivan (eds), *War and Remembrance in the Twentieth Century* (Cambridge and New York, Cambridge University Press), 1999, pp. 133–7.
8  Marco Livingstone, *R. B. Kitaj* (Oxford, Phaidon Press), 1985, p. 34.
9  See Kitaj, in Morphet, *Kitaj* (ed.), p. 84.
10 'Creeley, forlorn, alone, staring sideways at the wall, mopping at his eye with a handkerchief (Creeley had lost the eye in an accident and usually covered it with a patch; but since the patch made him self-conscious, he'd left it off ... only to have the eye – as always, when he got emotionally upset – run buckets). 'Martin Duberman, *Black Mountain: An Exploration in Community* (London, Wildwood House), 1974, pp. 393–4.
11 The figure apes Alphonse Legros's *Wandering Jew* as a version of Moritz von Schwind's *Rubezahl* (Spirit of the Sudeten Mountains): a source found pasted into the top right-hand corner of another painting titled *Dismantling the Red Tent*, 1964. Kitaj quotes from Edward Dahlberg's description of Bourne's meeting with Theodore Dreiser: 'In 1918 on a snow-flurried evening in front of the Night Court at Tenth

Street a large brooding man met a hapless little dwarf wrapped in a black witch's cape and hat, and sidled up against the brick wall to let it pass. Ashamed of his fright he walked and meditated with darksome remorse upon man's pitiless reactions to a hurt and pitiable lameness in another man. Then he forgot about it and dismissed if from his mind until the same little figure came to his door and announced himself as Randolph Bourne.' Edward Dahlberg, *Sing O'Barren* (London), 1947, p. 18: see R. B. Kitaj, exhibition catalogue (New York, Marlborough-Gerson), 1965, cat. no. 22. The quotation tells the spectator what the picture is 'about', but an asiduous spectator might return to Dreiser's original account as an inspiration for the picture:

> as badly deformed and, at the moment, as I accept it, as frightening a dwarf as I have ever seen. His body was so misshapen, the legs thin, the chest large, the arms long, the head deep sunk between the bony shoulders ... three pairs of stockings round his calves ... the head was praeternaturally large ... the skull and even the mouth appeared to be a little askew ... with eyes the character of which I could not grasp at the moment ... large and impressive blue eyes.

Kitaj informs us in the notes to the picture published in the 1965 catalogue that the collaged photographic eyes are taken from a book of physiognomy by E. Kretschmer titled *Physique and Character* (London), 1925, to signal Bourne's inner stength.

12  John Dos Passos, *U.S.A* (Harmondsworth, Penguin), 1966 (first published 1938), p. 424, quoted from Randolph Bourne, *The State* (New York, The Resistance Press), 1947, opposite title page.

13  The link with John Dos Passos has also been pointed out by Julian Ríos in *Kitaj: Pictures and Conversations* (Harmondsworth, Hamish Hamilton), 1994, p. 39. Interestingly, Kitaj does not explicitly deny the connection.

14  See letter dated July 1968 in 'Letters from 31 Artists to the Albright-Knox Gallery', *Gallery Notes* (New York, Praeger; Buffalo, Albright-Knox Art Gallery), Vol. 31–2 (Spring 1970), p. 18.

15  In J. Faure Walker, 'Interview with R. B. Kitaj', *Artscribe*, February 1977.

16  Kitaj will write texts for paintings after they have been completed such as he did with *Walter Lippmann*, 1966, and more recently with *The Murder of Rosa Luxemburg*, 1960. In other cases he will re-title details of pictures reproduced in books and catalogues: see *St Theresa* as detail of *Juan de la Cruz*, 1967, in Livingstone, *Kitaj*, Plates 58 and 61.

17  Ezra Pound, 'Introduction', *Selected Poems* (London, Faber and Faber), 1968, p. 10.

18  Kitaj has collaborated with both poets. Originally titled *Mahler: A Celebration and a Crutch,* the print series *Mahler becomes Politics, Beisbol*, 1964–67, was published in summer 1967 by Marlborough Fine Art, London, as a suite of fifteen screenprints with a book of forty poems by Jonathan Williams. The poems later appeared independently as *Mahler* (London, Cape Goliard, 1969), with a portrait of the poet by the artist. The first collaboration with Robert Creeley was *A Site*, 1967: 'hoping to help Barry Hall and Tom Pickard's Goliard Press (previous to its being bought by Cape). I contributed a poem, 'A Site' – Kitaj uses it in holograph as a basis for three prints, a triptych, which I very much like. It's a fantastically subtle take on my preoccupations, as well as materials, literally of the poem.' Letter to James Aulich, 6 July 1978. Subsequently, the artist and the poet collaborated on *A Day Book* between 1968 and 1972. It was published as a portfolio of screenprints and lithographs by Graphics in Berlin: 'Concerning *A Day Book* specifically, Kitaj was in Los Angeles, fall 1968, when I wrote that text for him – in this house as it happens, Placitas, New Mexico. He had asked me

to give him something with which he might work ... he showed me various prints as he worked through them, and also discussed typography, etc., but in this instance, he worked with a text I supplied independent of any significant discussion or suggestion after that' (ibid.)

19  Robert Rauschenberg had spent time at Black Mountain College while Charles Olson was also there, see Martin Duberman, *Black Mountain: An Exploration in Community* (London, Wildwood House), 1975. Through Jonathan Williams Kitaj became friends with many of the other Black Mountain poets including Robert Creeley and Robert Duncan; others like Olson, Ed Dorn, Kenneth Rexroth, Michael McLure and John Wieners he included in the print series *First Series Some Poets*, 1966–69. Kitaj had also been acquainted with *The Black Mountain Review* in the mid-1950s. Robert Rauschenberg's first one-man in England was held at the Whitechapel Gallery in 1964. Many of Kitaj's pictures from the early 1960s such as *Reflections on Violence*, 1962, bear comparison with Rauschenberg's *Factum I & II*, 1957, and the *Dante Drawings*, 1959–61. Significantly, Rauschenberg's work was just beginning to become known in England in the early 1960s.

20  Books I–IV, published between 1946 and 1958.

21  See 'The American Action Painter', *The Tradition of the New* (London, Thames and Hudson), 1962, pp. 35–47.

22  R. B. Kitaj and Maurice Tuchman, 'Written replies to questions sent to R. B. Kitaj', *R. B. Kitaj: Paintings and Prints*, exhibition catalogue (Los Angeles, Los Angeles County Museum of Art), August–September 1965.

23  Robert Duncan, the poet and friend of the artist, wrote in consideration of the American artist, Jess Collins: 'In composition by field, a colour does not glow in itself or grow dim, but has its glow by rhyme – a resonance that arises in the total field of the painting as it comes into the totality. The "completion" of the painting is the realisation of its elements as puns or rhymes. The painter works not to conclude the elements of the painting but to set them into motion, not to bind colours but to free them, to release the force of their inter-relationships.' 'Introduction', *Jess* (Los Angeles, Black Sparrow Press), 1971, p. iv.

24  The work of Max Ernst, and in particular his collage novel *Une Semaine de Bonté*, owned by the artist, as well as the kind of late Surrealism exemplified by the magazines *Minotaure* and *VVV*. For American surrealism he specifically mentions the magazine *View*, edited by Parker Tyler and Charles Henri Ford.

25  Guy Davenport, 'Ronald Johnson', *The Geography of the Imagination* (London, Picador), 1984, p. 102.

26  Charles Olson, 'European Literature and the Latin Middle Ages by Ernst Robert Curtius', *Black Mountain Review*, 1:2 (1954), 57.

27  Robert Hughes, *American Visions: The Epic History of Art in America* (London, The Harvill Press), 1997, p. 318.

28  *R. B. Kitaj* (New York, Marlborough-Gerson), 1965, unpaginated.

29  R. B. Kitaj, 'Untitled', in Robert J. Bertholf and Ian W. Reid (eds.), *Robert Duncan: Scales of the Marvellous* (New York, A New Directions Book), 1979, p. 206.

30  R. B. Kitaj, in James Scott (director), *R. B. Kitaj*, 1967, unpublished transcript of a film.

31  R. B. Kitaj, in Timothy Hyman, 'A Return to London', *London Magazine*, February 1980), 24.

32  R. B. Kitaj, in Scott (director), *Kitaj*. For a further discussion of this picture, see James Aulich, 'Vietnam, Fine Art and the Culture Industry', in Jeffrey Walsh and James Aulich (eds.), *Vietnam Images: War and Representation* (London, Macmillan), 1989, pp. 78–80.

33  Roy Campbell, 'Introduction', *St. John of the Cross Poems* (Harmondsworth, Penguin), 1960, p. 10.

34  'The title is taken from something a Communist is supposed to have said to Stephen Spender'. Harry Pollitt, the leader of the British Communist Party made the jibe at the expense of Spender's plan to go and fight with the Republicans in Spain. Campbell was entrusted with the papers of St John of the Cross by the monks of a Carmelite monastery for fear of Repulican anti-clericism. Soon after the monks were executed and the monastery burned.

35  Kinsman, *Prints*, pp. 32–3.

36  R. B. Kitaj, in Scott (director), *Kitaj*.

37  The 'Introduction' had first appeared in one of Kitaj's regular magazines, *The New Yorker*.

38  Benjamin had approached the Institute in the figures of Fritz Saxl and Irwin Panofsky for comments on his book *The Origins of German Tragic Drama*, 1928. It was one of his great regrets that they did not reply.

39  Quoted in Ernst Gombrich, *Aby Warburg: An Intellectual Biography* (Oxford, Phaidon), 1986, p. 245. (First published by the Warburg Institute, University of London, 1970).

40  Walter Benjamin, *Illuminations*, p. 257.

41  Terry Eagleton, *The Ideology of the Aesthetic* (Oxford, Basil Blackwell), 1990, p. 332.

42  Published in English translation by New Left Books in 1973. Two of its three parts had previously appeared in *Illuminations* and in *New Left Review* in 1968.

43  R. B. Kitaj, *The Human Clay*, exhibition catalogue (London, Arts Council of Great Britain), 1976, unpaginated.

44  R. B. Kitaj, 'Some Historical Notes Apropos', *Jim Dine: Works on Paper 1975–76*, exhibition catalogue (London, Waddington and Tooth Galleries), 1977, unpaginated.

45  See *R.B. Kitaj. Fifty Drawings and Pastels. Six Oil Paintings*, exhibition catalogue (New York, Marlborough Gallery), 1979; *R.B. Kitaj. Pastels and Drawings*, exhibition catalogue (London, Marlborough Fine Art), 1980; and *Jim Dine: Figure Drawings 1975–1979*, exhibition catalogue (New York, Icon Editions, Harper and Row, Publishers), 1979. Dine lived in London from 1967 to 1971.

46  The essay coined the term 'The School of London' and launched Kitaj into an aesthetic debate in which he and others elaborated a traditional and figurative aesthetic, as discussed by James Aulich.

47  See the correspondence from Janet Daley following Paul Overy's hostile review, 'Edinburgh picks the wrong artists', *The Times*, 2 September 1975, p. 7; 'Reply', *The Times*, 10 September, 1975, p. 15, and Janet Daley, 'Letter', *The Times*, 6 September 1975, p. 13. The controversy was further fuelled by the publication of a full-frontal photograph of Kitaj and David Hockney in the nude on the front of the January 1977 issue of *New Review*: see Anthony Holden, *Sunday Times*, 20 February 1977.

48  R. B. Kitaj, *Arte inglesi oggi 1960–76*, Part 1, exhibition catalogue (Milan, Electra Editrice), 1976, p. 128.

49  Susan Bucks-Morss, *The Dialectics of Seeing: Walter Benjamin and the Arcades Project* (Cambridge, Mass., and London, The MIT Press), 1989, pp. 184–5.

50  See the notes to *The Autumn of Central Paris (Walter Benjamin)*, 1972–73, in *Art International*, 22:10 (1979), pp. 19–20; and the pictures *La Femme du Peuple I*, 1975; *La Femme du Peuple II*, 1975, alternatively titled *The Street (A Life)*, 1975; *Frankfurt Brothel*, 1976; *Smyrna Greek (Nikos)*, 1976–77; *Barcelonetta*, 1979; *Sighs of Hell*, 1979; *Germania (Vienna)*, 1987; *Germania (To the Brothel)*, 1987.

51  Also quoted by Aulich in 'The Difficulty of Living in an Age of Cultural Decline and Spiritual Corruption: R. B. Kitaj 1965–70', *Oxford Art Journal*, 10:2 (1987), 43–57.

52  R. B. Kitaj in Timothy Hyman, 'A Return to London', *London Magazine*, 19 February 1980, 26.

53  Ibid., 27.

54  R. B. Kitaj, *First Diasporist Manifesto* (London, Thames & Hudson), 1989, p. 115.

55  'Memoir into Myth', *Times Literary Supplement*, 8–14 September, 1989, 970.

56  The train had appeared in *Synchromy with F. B. – General of Hot Desire*, 1968–69, as a metaphor for the insecurities and anxieties generated by modern life, featuring portraits of Francis Bacon and Sandra Fisher as naked female model in a railway compartment. The journey is not one of public history but personal biography.

57  See Peter Fuller, 'Kitaj at Christmas', *Art Monthly*, 92 (December/January 1986), 11–14; and Katy Deepwell and Juliet Steyn, 'Readings of the Jewish Artist', *Art Monthly*, 113 (February 1988), 6–9. The image carries a trace of Paul Celan's poem 'Deathfugue – A Fugue after Auschwitz' and Anselm Kiefer's paintings:

   Your ashen hair Shulamith we shovel a grave in the air there you won't
   lie too cramped

   Trans. John Felsteiner, in J. Felsteiner, *Paul Celan: Poet, Survivor, Jew* (New Haven and London, Yale University Press), 1995, p. 31.

58  Morphet (ed.), *Kitaj*, p. 220.

59  See Juliet Steyn in Deepwell and Steyn, 'Readings of the Jewish Artist', 8–9.

60  See James Hall, 'After the fall, the prize', *The Guardian*, 13 June 1995.

61  See R. B. Kitaj, Morphet (ed.), *Kitaj*, p. 168.

62  Ibid., p. 170. Kitaj reveals the compositional source of the painting: 'For thirty years I'd kept a reproduction of a small relief by Donatello which became the main source for my composition. ... Pope-Henessey['s] ... vivid description of it seemed weirdly in accord with my own intention. He writes of the complex, difficult and varied patterning of the anxiety, confusion and disorientation expressed by the figures in an emotional event taking place in an atmosphere of charged excitement ... just what I wanted.' The picture bears a clear compositional relationship to *The Ohio Gang*, 1964, and it is tempting to read back into that elusive picture something of this interpretation.

63  Lucinda Bredin, 'To Hell with the Lot of Them', *Sunday Telegraph Review*, 25 May 1997, p. 7.

64  It is interesting to speculate on the relationships between Kitaj's work and contemporary socialist realist practice of which he may have had some knowledge. In the German Democratic Republic pictures were regularly dedicated to Alexander Blok, Bertolt Brecht, Pablo Neruda, Rosa Luxemburg and Isaac Babel, for example. It was certainly a practice which German painters such as Anselm Kiefer and Karl Immendorf exploited, even before the explosion of interest in neo-expressionism at the end of the 1970s.

65  For example, Tom Wolfe in *The Painted Word* (New York, Farrar, Strauss & Giroux), 1975. The fact that art, contrary to modernist art for art's sake doctrine, found its meaning determined by a number of forces other than the purely optical came as something of a revelation.

66  Mikhail Bakhtin, *The Dialogic Imagination: Four Essays*, ed. Michael Holquist, trans. Caryl Emerson and Michael Holquist (Austin, University of Texas Press), 1981.

67  Dominick LaCapra, *Rethinking Intellectual History: Texts, Contexts, Language* (Ithaca, N.Y., and London, Cornell University Press), 1983, p. 38.

68  For a compilation of essays on this theme, see A. L. Rees and Frances Borzello (eds.) *The New Art History* (London, Camden Press), 1986, which, although a bit dated now, best summarises some of the critiques not just of the discipline of art history but more significantly, perhaps, its objects of knowledge.

69  Marco Livingstone, *R. B. Kitaj* (London, Phaidon Press), 1992 (rev. edn); Morphet (ed.), *Kitaj*.

70  See John Roberts, 'Introduction', *Art Has No History: The Making and Unmaking of Modern Art* (London and New York, Verso), 1994, pp. 20–33, for a discussion of the implications of various positions on the subject of intention and meaning in art.

71  The privileged position of the author, which is the subject of biography, has been continuously under siege since Roland Barthes's essay 'The Death of the Author' (1968), translated in R. Barthes, *Image Music Text*, ed. S. Heath (London, Fontana), 1977. Foucault's subsequent response 'What is an Author?' (1969), published in Colin Gordon (ed.), *Language, Counter-Memory and Practice* (Oxford, Basil Blackwell), 1977, challenges what he sees as Barthes's residue of transcendental thinking which displaced the authority of the author onto the 'text'.

72  This is further exemplified by Kitaj's practice of generally only conversing with interviewers via written correspondence.

73  For instance, Griselda Pollock, 'Artists, Media, Mythologies: Genius, Madness and Art History', *Screen*, 21:3 (1980), 55–96.

74  Morphet (ed.), *Kitaj*, pp. 9–34.

75  'Chronology', compiled by Joanne Northey, ibid., pp. 57–64.

76  Ibid., p. 57

77  J. R. R. Christie and Fred Orton argue that it must be recognised that the individuals are 'ontologically prior' to the processes of production and reading and that this must be addressed via some form of biography, but a biography that is self-consciously plural as opposed to presenting itself as singular, 'Writing on a Text of the Life', in F. Orton and G. Pollock, *Avant-Gardes and Partisans Reviewed* (Manchester and New York, Manchester University Press), 1996, p. 311.

78  Morphet (ed.), *Kitaj*, p. 223.

79  Orton and Christie, *Avant-Gardes*, p. 303.

80  Paul de Man, 'Autobiography as De-Facement', in *The Rhetoric of Romanticism* (New York, Columbia University Press), 1984, p. 70.

81  We would disagree, therefore, with the argument of an art historian such as Keith Moxey who contends that a critical theory informed by Lacanian psychoanalysis and semiotics can escape from the demands of historical narrative centred, as it is, on a humanist notion of subjectivity. Critical of attempts such as that by Orton and Christie to problematise, yet hold on to concepts of authorship and biographical or historical narratives, Moxey argues that rather than conceiving of interpretation as

one predicated on a model of 'depth' we are now free to engage in interpretation pictured as perpetually 'broadening'. See *The Practice of Theory: Poststructuralism, Cultural Politics and Art History* (Ithaca, N.Y., and London, Cornell University Press), 1994, pp. 58–61.

## Notes to Chapter 1

Thanks to Roy Merrens, Cyril Reade, and Howard Singerman for conversations about these issues and comments on an earlier draft; to Devora Neumark for inviting me to write an essay which later served as a shorter version of this paper; to Margie Searl for showing me Kitaj prints at the Memorial Art Gallery, Rochester; and to Lisa Finn, Stephanie Frontz and Marc Léger for research assistance.

1 Richard Morphet (ed.), *R. B. Kitaj* (New York, Rizzoli), 1994, p. 219.

2 He returned to the United States, to live in Los Angeles, in 1997.

3 R. B. Kitaj, *First Diasporist Manifesto* (New York, Thames and Hudson), 1989, pp. 95–6.

4 Kitaj, *First Diasporist Manifesto*, pp. 73, 63.

5 R. B. Kitaj, 'Jewish Art – Indictment and Defence', *Jewish Chronicle Colour Magazine*, 30 November 1984, p. 46.

6 For Kitaj's own description of this work, see Marco Livingstone, *R. B. Kitaj* (New York, Rizzoli), 1985, p. 150. Amongst others, the references in the work are to Eliot's *The Waste Land*, Conrad's *Heart of Darkness*, Giorgione's *Tempesta*, and a report by someone who retraced the train journey from Budapest to Auschwitz after the war, noticing the beautiful countryside visible en route.

7 Kitaj, 'Jewish Art', p. 46.

8 Avram Kampf, *Chagall to Kitaj: Jewish Experience in 20th Century Art* (London, Lund Humphries/Barbican Art Gallery), 1990, p. 108, quoting Kitaj's conversation with Timothy Hyman, 'A Return to London', in *Kitaj* (New York, Thames and Hudson), 1983.

9 Andrew Benjamin, 'Kitaj and the Question of Jewish Identity', in *Art, Mimesis and the Avant-Garde* (London and New York, Routledge), 1991.

10 Benjamin, 'Kitaj and the Question of Jewish Identity', pp. 89–90.

11 Livingstone, *Kitaj*, p. 34.

12 See, for example, Arthur Lubow, 'The Painter's Life is Cracking', *New York Times*, 13 November 1994; Nina Darnton, 'An American Artist displeases the English Cousins', *New York Times*, 24 October 1994; Hunter Drohojowska-Philp, 'Master of the Arcane', *Los Angeles Times*, 23 October 1994; John Ash, 'R. B. Kitaj, Metropolitan Museum of Art', *Artforum* 33: 9 (May 1995), 94–5.

13 Richard Dorment, 'It's Time to Learn that Less is More', *Daily Telegraph*, 22 June 1994.

14 Tim Hilton, 'Draw Draw is Better than Jaw Jaw', *The Independent*, 19 June 1994.

15 Brian Sewell, 'Tales half-told in the Name of Vanity', *Evening Standard*, 16 June 1994.

16 Andrew Graham-Dixon, 'The Kitaj Myth: The Man who would leapfrog His Way into History on the Backs of Giants stands Exposed', *The Independent*, 28 June 1994.

17 Morphet (ed.), *Kitaj*, p. 64.

18 For example, Richard Nilsen, 'LA Retrospective paints Profound Picture of R. B. Kitaj's Epic Vision', *Arizona Republic*, 18 December 1994; Kenneth Baker, 'The Inner

Life of R. B. Kitaj', *San Francisco Chronicle*, 11 December 1994; Robert L. Pincus, 'Symbolism tinges Kitaj's Radiant Art', *San Diego Union-Tribune*, 27 November 1994; Drohojowska-Philp, 'Master of the Arcane'; Michael Kimmelman, 'The Kitaj Show crosses the Atlantic', *New York Times*, 17 February 1995.

19  Darnton, 'An American Artist displeases the English Cousins'.

20  Quoted by Arthur Lubow, 'Rolling with the Punches', *The Independent*, 10 December 1994. (This is more or less the same article which appeared under the headline 'The Painter's life is Cracking' in the *New York Times*.)

21  On this last, see Tony Kushner, *The Persistence of Prejudice: Anti-Semitism in British Society during the Second World War* (Manchester and New York, Manchester University Press), 1989.

22  Morphet (ed.), *Kitaj*, pp. 58–64.

23  Jane Kinsman, *The Prints of R. B. Kitaj* (Aldershot, Scolar Press), 1994, p. 117.

24  See Kinsman, *Prints*, for detailed information on these series.

25  John Ashbery, 'Hunger and love in their variations', in *R.B. Kitaj* (Washington, D.C., Smithsonian Institution Press), 1981, exhibition catalogue, pp. 14–15. See also John Ashbery, 'Poetry in Motion', *New York*, 12:16 (16 April 1979).

26  David Lee, 'R. B. Kitaj', *Art Review*, June 1994, 7.

27  He says, for example, 'Why should everyone (critics, historians, poets, biographers, curators, etc.) be allowed to talk about a painting revealingly except the guy who made it?' Morphet (ed.), *Kitaj*, p. 47. In an interview in *Modern Painters*, 7 (Summer 1994), conducted just before the show opened, Kitaj also predicted hostility to his Prefaces: 'In the Tate catalogue there are going to be a lot of pictures with a preface, and they're going to make people roll their eyes to heaven. "Here's Kitaj, the literary artist, doing it again. He doesn't even know yet that a picture is supposed to speak for itself"'(24).

28  *Los Angeles Times*, 25 June 1995; *San Francisco Chronicle*, 28 May 1995; *The Guardian*, 2 June 1997.

29  *The Times*, 7 March 1996; *New York Times*, 18 February 1995, and *ARTNews*, May 1995; *The Independent*, 27 May 1997; *The Observer*, 1 June 1997.

30  *The Times*, 12 June 1997.

31  *The Times*, 23 June 1996.

32  *Sandra/Two* (New York and London, Marlborough Gallery Inc./Marlborough Fine Art (London), 1996), pp. 5, 8, 9.

33  *New York Times*, 7 June 1997; *The Guardian*, 28 May 1997.

34  More recent interviews show something of a reprieve from the obsession with his critics, and an ability to talk, again, about his work and his plans. See Joseph Giovannini, 'At Home with R. B. Kitaj: A Second Exile, His Rage Intact', *New York Times*, 19 March 1998.

35  *Kitaj* (Smithsonian Institution Press), p. 45.

36  See, for example, *Sandra/Two*, p. 12, where he discusses his 'Dreyfus-Complex', and states that '[t]here are many, many versions and degrees of anti-Semitism, all the way from sort of harmless pub talk in London (about Jewish influence in the art world) to the gas ovens in Poland'.

37  *The Times*, 8 June 1997; *The Times*, 3 June 1997; *Financial Times*, 31 May 1997.

38  *The Times*, 9 June 1996.

39  Dalya Alberge, *The Times*, 28 May 1997.

40 *Daily Telegraph*, 28 May 1997.

41 Richard Ingleby, *The Independent*, 3 June 1997.

42 Adrian Searle, *The Guardian*, 28 May 1997. (The *Jewish Telegraph* merely states, in a short report, that Kitaj has accused his critics of being anti-Semitic, without taking a position on this claim: 30 May 1997.)

43 Discussion of the 1912 exhibition of Italian Futurist painters at the Sackville Gallery, London, 1912: Anna Gruetzner Robins, *Modern Art in Britain 1910–1914* (London, Merrell Holberton/Barbican Art Gallery), 1997.

44 See Anne Massey, *The Independent Group: Modernism and Mass Culture in Britain 1945–59* (Manchester, Manchester University Press), 1995, for an account of these movements.

45 Sewell, 'Tales half-told in the Name of Vanity'.

46 Cited in Kinsman, *Prints*, p. 58.

47 See Morphet (ed.), *Kitaj*, p. 120.

48 Giovannini, 'At Home with R. B. Kitaj'. See also his comment, in *Sandra/Two*, that 'my great problem in London is that I come from a different culture': p. 9.

49 Patricia Utermohlen, quoted by Nina Darnton, *New York Times*, 24 October 1994. Alan O'Shea has looked at the origins of twentieth-century English xenophobia and anti-Americanism in relation to imperialism and its demise: 'English subjects of modernity', in Mica Nava and Alan O'Shea (eds.), *Modern Times: Reflections on a Century of English Modernity* (London, Routledge), 1996. British anti-Americanism is still much in evidence – for example in the popular response in October 1997 to the guilty verdict against Louise Woodward, the British au pair convicted of the murder of her American 8-month-old charge. See *New York Times*, 1 November 1997.

50 'Editorial: A Renaissance in British Art?', *Modern Painters*, 1:1 (Spring 1988). Ironically Fuller begins by citing approvingly Kitaj's words in the catalogue for *The Human Clay* exhibition of 1976.

51 An interesting and suggestive discussion of literary critics' out-of-proportion hostility to the writer, Martin Amis, suggested that its viciousness is partly the displaced (and disallowed) antagonism towards and fear of the success of writers from the ex-colonies: Jonathan Wilson, 'A very English story', *The New Yorker*, 6 March 1995.

52 The Prefaces are all reproduced in Morphet (ed.), *Kitaj*.

53 'A Day in the Life of R. B. Kitaj', *Art Newspaper*, 39 (June 1994).

54 See, for example, Colin Holmes, *Anti-Semitism in British Society 1918–1939* (London, Edward Arnold), 1979; Gisela C. Lebzelter, *Political Anti-Semitism in England 1918–1939* (New York, Holmes and Meier Inc.), 1978; David Feldman, *Englishmen and Jews: Social Relations and Political Culture 1840–1914* (New Haven and London, Yale University Press), 1994; Tony Kushner, *The Persistence of Prejudice*; Anne Karpf, *The War After: Living with the Holocaust* (London, Heinemann), 1996, Part II.

55 George Orwell, 'Anti-Semitism in Britain', *Collected Essays* (London, Secker and Warburg), 1961, p. 297.

56 See David Feldman, 'The Importance of Being English: Jewish Immigration and the Decay of Liberal England', in David Feldman and Gareth Stedman Jones (eds.), *Metropolis-London: Histories and Representations since 1800* (London and New York, Routledge), 1989; also Juliet Steyn, 'The complexities of assimilation in the 1906 Whitechapel Art Gallery Exhibition "Jewish Art and Antiquities"', *Oxford Art Journal*, 13:2 (1990).

57  See Charles Spencer, 'Anglo-Jewish Artists: The Migrant Generations', in *The Immigrant Generations: Jewish Artists in Britain 1900–1945* (New York, The Jewish Museum), 1983; also my article 'The Failure of a Hard Sponge: Class, Ethnicity and the Art of Mark Gertler', *New Formations*, 28 (Spring 1996).

58  Richard Bolchover, *British Jewry and the Holocaust* (Cambridge, Cambridge University Press), 1993, p. 107. However, Tony Kushner has pointed out that even anglicised Jewry 'could not escape the alien tag': *The Persistence of Prejudice*, p. 9.

59  Quoted by Lesley Hazelton, *England, Bloody England: An Expatriate's Return* (New York, The Atlantic Monthly Press), 1990, p. 48.

60  Calvin Trill in 'Drawing the line', *The New Yorker*, 12 December 1994.

61  Philip Roth, *The Counterlife* (New York, Farrar Straus Giroux), 1986, p. 279.

62  'Is Kitaj a Modern Dreyfus?', *Forward*, 29 July 1994. Also quoted in *ARTNews*, 93:7 (September 1994), 60.

63  *England, Bloody England*, pp. 47–8.

64  *England Bloody England*, p. 52. There are a few contemporary English-Jewish writers whose subject-matter has been Jewish life (Howard Jacobson, Clive Sinclair, Jack Rosenthal, for example).

65  For example, Murray Baumgarten and Barbara Gottfried, in their study of Philip Roth, argue that his male protagonists' struggle for masculinity in a gentile culture which feminises them is inevitably at the expense of women, particularly non-Jewish women. *Understanding Philip Roth* (Columbia, University of South Carolina Press), 1990, p. 143. Thanks to Bryan Cheyette for this reference.

66  Marco Livingstone, *Kitaj*, p. 39.

67  Morphet (ed.), *Kitaj*, p. 84.

68  Kinsman, *Prints*, p. 35.

69  See, for example, Ritchie Robertson, 'Historcising Weininger: The Nineteenth-Century German Image of the Feminised Jew', in Bryan Cheyette and Laura Marcus (eds.), *Modernity, Culture and 'the Jew'* (Cambridge, Polity Press), 1998.

70  Or, as in the case of black American males, in their hypermasculinisation. See Thelma Golden (ed.), *Black Male: Representations of Masculinity in Contemporary American Art* (New York, Whitney Museum of American Art), 1994. On white English masculinity, see Jonathan Rutherford, *Forever England: Reflections on Masculinity and Empire* (London, Lawrence and Wishart), 1997.

71  Daniel Boyarin, *Unheroic Conduct: The Rise of Heterosexuality and the Invention of the Jewish Man* (Berkeley, University of California Press), 1997. His argument, in fact, is that traditional Jewish culture itself produces a 'feminine' male identity, which becomes problematic when in contact with European gender ideals.

72  Boyarin, *Unheroic Conduct*, pp. 17–18.

73  Ken Johnson, 'R. B. Kitaj: Views of a Fractured Century', *Art in America*, 83:3 (March 1995), 80, 81. Johnson adds, in a footnote, that the negative reviews in 1994 had 'little analytical substance': p. 126.

74  Norbert Lynton, 'Kitaj's Fork', *Modern Painters*, 7 (Autumn 1994). References on pp. 96 and 95.

75  See, for example, Michael Podro, 'Kitaj in Retrospect', *The Burlington Magazine* (April 1995); Juliet Steyn, 'Painting Another: Other-than-Painting', in Juliet Steyn (ed.), *Other than Identity: The Subject, Politics and Art* (Manchester, Manchester University Press), 1997.

76  Kitaj, *First Diasporist Manifesto*, p. 37.

77  On this point, see Harold Rosenberg, 'Is There a Jewish art?', *Commentary*, 42:1 (July 1966), and my essay, 'The "Jewish Mark" in English Painting: Cultural Identity and Modern Art', in David Peters Corbett and Lara Perry (eds.), *English Art 1860–1914: Modern Artists and Identity* (Manchester, Manchester University Press), 2000.

78  Juliet Steyn has discussed this painting in detail, with regard to its relationship to Jewish identity: 'Painting Another'.

79  Drancy was an internment camp in France from which Jews were sent to the camps in the East.

## Notes to Chapter 2

1  R. B. Kitaj, in *R. B. Kitaj*, ed. Richard Morphet, exhib. cat., Tate Gallery (New York, Rizzoli), 1994, p. 120 All ellipses except the second and third are in the original.

2  Kitaj, cited in Julián Ríos, *Kitaj: Pictures and Conversations* (Harmondsworth, Hamish Hamilton), 1994, p. 97.

3  My pictures had and have secret lives', says Kitaj. Cited in Marco Livingstone, *Kitaj*, revised and expanded edition (London, Phaidon), 1992, p. 7.

4  Norman Bryson, 'Representing the Real: Gros's Paintings of Napoleon', *History of the Human Sciences*, 1: 1 (1988), 75–104, p. 78. All further references are given in parentheses after the quoted text.

5  On the historiographical aspects of this argument, see Keith Jenkins (ed.), *The Postmodern History Reader* (London, Routledge), 1997.

6  See on this the details of Kitaj's early life and upbringing in an intellectual Europeanized milieu in the mid-West as given most accessibly in Livingstone, *Kitaj*, pp. 8–18.

7  Kitaj, cited in Livingstone, *Kitaj*, p. 7. Unless otherwise noted, all quotations from Kitaj cited from Livingstone's book derive from correspondence and interviews Livingstone had with Kitaj between 1976 and 1984, and in 1991.

8  It is clear from the essay 'On Associating Texts with Paintings', subtitled 'a fragment of an unfinished paper', that Kitaj's relationship to the word at this stage was anything but fluent and easy. See note 19 for full bibliographical details of this important essay.

9  James Aulich, 'The Difficulty of Living in an Age of Cultural Decline and Spiritual Corruption: R. B. Kitaj 1965–1970', *Oxford Art Journal*, 10: 2 (1987), 43–57, p. 43. On the influence of both literary and visual collage, see Jane Kinsman, *The Prints of R. B. Kitaj*, Afterwords by R. B. Kitaj (Aldershot, Scolar Press in association with the National Gallery of Australia), 1994, p. 17.

10  Ríos, *Kitaj*, p. 107.

11  Kitaj, cited in Ríos, *Kitaj*, p. 107.

12  Virginia Woolf, *Walter Sickert: A Conversation*, introduction by Richard Shone (London, Bloomsbury Workshop), 1992, p. 17.

13  See Marco Livingstone, 'Iconology as a Theme in the Early Work of R. B. Kitaj', *Burlington Magazine*, 122: 928 (July 1980), 488–497, and Livingstone, *Kitaj*, pp. 12–13.

14  See Livingstone, 'Iconology as a Theme', p. 491.

15  Kitaj, cited in Livingstone, *Kitaj*, p. 12

16  Livingstone, *Kitaj*, p. 13.

17  See Livingstone, *Kitaj*, p. 13, for such a reading. Kitaj's own commentary on *Yamhill* can be found in *R. B. Kitaj*, exhib. cat., Marlborough-Gerson Gallery (New York, February 1965), unpaginated. There he refers the reader to G. Calmann, 'The Picture of a Nobody', *Journal of the Warburg and Courtauld Institutes*, 23:1–2 (1960), 60–100.

18  Cited as epigraphs in *R. B. Kitaj*, exhibition catalogue, Marlborough-Gerson Gallery, 1965, unpaginated.

19  R. B. Kitaj, 'On Associating Texts with Paintings', *Cambridge Opinion*, 37, 'Modern Art in Britain' issue (1964), pp. 52–3.

20  'On Associating Texts with Paintings', p. 53, emphasis in the original.

21  Morphet (ed.), *Kitaj*, p. 126. Kitaj attributes this formulation to Pound.

22  Kitaj describes bestowing 'the final title' on *Desk Murder* (1970–84) as 'the last stroke' of work on the painting: Morphet (ed.), *Kitaj*, p. 106.

23  On the confessional impulse in Kitaj, see Ríos, *Kitaj*, p. 97.

24  Kitaj, in Morphet (ed.), *Kitaj*, p. 70. James Aulich tells me that there is a painting called *Cracks and Reforms and Bursts in the Violet Air* (1962) which mimics the look of poetry. The phrase is a quotation from *The Wasteland*.

25  Morphet (ed.), *Kitaj*, p. 70.

26  *The Complete Poems and Plays of T. S. Eliot* (London, Faber & Faber, 1969), p. 76.

27  Morphet (ed.), *Kitaj*, p. 84.

28  Livingstone, *Kitaj*, p. 15, where Kitaj's 'plural energies' are also cited.

29  Kitaj, cited in Livingstone, 'Iconology as a Theme', p. 496.

30  See R. B. Kitaj, *First Diasporist Manifesto* (London, Thames and Hudson), 1989.

31  Morphet (ed.), *Kitaj*, p. 144.

32  Avram Kampf, *Chagall to Kitaj* (London, Lund Humphreys), 1990, p. 108.

33  Morphet (ed.), *Kitaj*, p. 120. It is perhaps significant that Kitaj comments of the sea of mud that the 'sense of strewn and abandoned things and people was suggested by a Bassano painting … showing a ground after a battle' (p. 120). The impulse here is visual rather than textual.

34  See, for instance, George Steiner in *Language and Silence: Essays 1958–1966* (Harmondsworth, Penguin), 1979.

35  On Joe Singer, see Ríos, *Kitaj*, pp. 101–7.

36  As he is in *Self-Portrait as a Woman* where the elongated shape and full-length figure recall Whistler's portraits.

37  Morphet (ed.), *Kitaj*, p. 186.

38  Kitaj's interest in explicitly sexual images in the 1970s and after may also have to do with these technical attempts to clear a space for the visual meaning of a work to emerge from under the regressive textual meanings that his earlier productions had solicited and attached so strongly to the visual. Thus in the pastel and charcoal drawing *His Hour*, 1975, the fantasist has spurned any textual stimulation in order to attend to a sexual dream which is graphically visual. And in the pastel *Communist and Socialist*, 1975, the implied debate about varieties of political conviction, which may in fact be taking place at the moment of the picture, is offset by the presence of the man's erection as an unmistakable and strongly visual marker of different and essentially non-verbal currents of meaning and event.

39  Morphet (ed.), *Kitaj*, p. 65.

## Notes to Chapter 3

This chapter was based on work originally done as part of the M.A. in the Social History of Art at Leeds University. I would like to thank all those who over the course of the year provided such an interesting and challenging discussion of these issues, especially my tutor Fred Orton. Thanks too to Dominic Rahtz for comments on an earlier draft of the work.

1 John Russell, *Sunday Times*, 10 February 1963, wrote: 'Only once or twice since the war has a first one-man show made anything like the impact of R. B. Kitaj's at the New London Gallery', p. 33; and John Richardson, *Evening Standard*, 8 February 1963, described Kitaj as: 'One of the most original and influential artists in England today', p. 11.

2 See Chris Harman, *The Lost Revolutionary: Germany 1918 to 1923* (London, Bookmarks), 1982, for a fuller account of these events and their wider context.

3 See Alex Callinicos, *Theories and Narratives: Reflections on the Philosophy of History* (Cambridge, Polity Press), 1995, for discussion of this from a Marxist perspective.

4 Klaus Theweleit, *Male Fantasies: Volume 2* (Cambridge, Polity Press), 1989, provides a psychoanalytical analysis of the representations of masculinity and the issues of gender, representation and violence in the popular literature of the *Freikorps*.

5 See Marina Warner, *Monuments and Maidens: The Allegory of the Female Form* (London, Weidenfeld and Nicholson), 1985, for discussion of this.

6 Alfred Neumeyer, 'Monuments to "Genius" in German Classicism', in *Journal of the Warburg Institute*, 11:2 (1938), 159–62.

7 Nigel Gosling, 'The Shape of the Sixties', *The Observer*, 10 February 1963, p. 21.

8 Paul de Man, *Blindness and Insight: Essays in the Rhetoric of Contemporary Criticism* (London and New York, Routledge), 1983, p. 189.

9 John A. Walker, *Rosa Luxemburg and Karl Liebknecht: Revolution, Remembrance, Representation*, exhibition catalogue (London, Pentonville Gallery), 11 October – 22 November 1986.

10 Irit Rogoff, 'The Aesthetics of Post-history', in Stephen Melville, and Bill Readings (eds), *Vision and Textuality* (London, Macmillan), 1995, p. 130. Rogoff writes: 'What is it that the work of historical commemoration wishes to achieve? I would say that above all else it wishes to render the invisible visible, to effect a form of historical reconciliation and to attempt the satisfaction of a desire for a concrete material presence as a tangible manifestation of some process of redemption which is taking place' (pp. 130–1).

11 I am thinking here of Ernst Bloch's formulation described in *The Principle of Hope*, trans. Stephen Plaice, Neville Plaice and Paul Knight (Cambridge, Mass., MIT Press; Oxford: Basil Blackwell), 1986, 3 vols. Bloch's apologia for Stalinism aside, Marxist cultural theorists such as Fredric Jameson and Douglas Kellner have found his conception of the utopian content of ideological configurations extremely useful; for a brief discussion of the relationship between his position and that of Walter Benjamin, see Susan Buck-Morss, *The Dialectics of Seeing: Walter Benjamin and the Arcades Project* (Cambridge, Mass., MIT Press), 1991, pp. 114–15.

12 Warburg and his legacy is familiar to Kitaj through his time at the Ruskin School of Drawing and Fine Art and his attendance at lectures given by Edgar Wind, a professor of fine art at Oxford. For comparison of Warburg's and Benjamin's projects, see Sigrid Weigel, *Body-and Image-Space: Re-reading Walter Benjamin* (London and New York, Routledge), 1996, pp. 150–7.

13  Richard Wolin, *Walter Benjamin: An Aesthetic of Redemption* (Berkeley, University of California Press), 1994, pp. 48–50.

14  Walter Benjamin, *Illuminations* (New York, Schocken Books), 1968, pp. 262–3.

15  Buck-Morss, *Dialectics of Seeing*, p. 78.

16  Roland Barthes, 'Myth Today', in *Mythologies* (London, Jonathan Cape), 1972.

17  Shannon does not discuss the Luxemburg painting although it does appear in the catalogue: John Ashbery, Joe Shannon, Jane Livingstone, Timothy Hyman, *Kitaj: Paintings, Drawings, Pastels* (London and New York, Thames and Hudson), 1983.

18  Craig Owens, 'The Allegorical Impulse: Towards a Theory of Postmodernism', in *October* (Spring 1980), pp. 67–86, and reprinted in *Beyond Recognition: Representation, Power, and Culture* (Berkeley, University of California Press), 1992, pp. 52–69.

19  In relation to this point it is interesting to consider David's painting of *The Death of Marat*, 1793, another commemoration of a revolutionary martyr that includes three different forms of writing within the picture space alongside the figure of Marat. See Dorothy Johnson, *J. L. David: Art in Metamorphosis* (Princeton, N.J., Princeton University Press), 1994, for discussion of how the relationship between the idealised body and various forms of writing calls into question the ambiguous nature of David's and all systems of representation, especially at times of revolution, pp. 108–9.

20  In the 1972 translation published by Pluto Press, as a footnote to the quoted excerpt, Frölich details the sources of the accounts: p. 317, n.154.

21  Richard Morphet (ed.), *R. B. Kitaj: A Retrospective* (London, Tate Gallery), 1994, p. 82.

22  John Griffiths in a special issue of *Art & Design* exploring 'deconstructionist tendencies in art' lists Kitaj ('Disparate images exploit simultaneity to evoke quizzical philosophic stances, cultural frissons and moral uncertainties. The painting as a partner in dialogue with the artist') among many other twentieth-century artists who exhibit such characteristics. Jacques Derrida, Geoff Bennington, John Russell Taylor, John Griffiths, *The New Modernism: Decontructionist Tendencies in Art* (London, Academy), 1988, p. 57.

23  Christopher Norris, 'Deconstruction, Post-Modernism and the Visual Arts', in Christopher Norris and Andrew Benjamin, *What is Deconstruction?* (London, Academy Editions), 1988, p. 8. Norris presents the most effective interpretation of the possibilities offered by deconstruction in an approach that does not become preoccupied with an idealism offered by the infinitely self-generating seduction of textuality; as he writes elsewhere: 'this is not to say that Derrida is some kind of transcendental solipsist, or that deconstruction is a discourse that celebrates the infinitized "freeplay" of writing cut off from all the irksome constraints of truth, reference or valid demonstrative argument'. *Uncritical Theory: Postmodernism, Intellectuals and the Gulf War* (London, Lawrence and Wishart), 1992, p. 32.

24  Michael Podro, 'Some Notes on Ron Kitaj', *Art International* 22:10 (March 1979), pp. 18–19.

25  See Kitaj: 'On Associating Texts with Paintings', *Cambridge Opinion*, 37 [January 1964]. He writes: 'If a title may be given to a work, a sub-title or a sequence of titles may be given; a set of notes may be given; an index and/or bibliography may be given; complex varieties of textual material may be introduced into the work (onto the painting) or otherwise "given" – ultimately or occasionally coalescing with the painted elements to the extent that they (the textual elements) can in no way be called peripheral. Some books have pictures and some pictures have books.'

26  Roland Barthes, 'Death of the Author', *Image–Music–Text* (London, Fontana), 1977, p. 148.

27  Marco Livingstone refers to this in an essay exploring some of the key influences on Kitaj during the early stages of his artistic career and his familiarity with Surrealist theory: 'Kitaj was aware of the persistence of this interpretation of handwriting as an agent capable of revealing personality in the Abstract Expressionist concept of "gesture," and makes the historical connection explicit by quoting the style and technique from De Kooning. Style and image thus reinforce each other in relaying the theme of picture-making as communication.' 'Iconology as Theme in the Early Work of R. B. Kitaj', *Burlington Magazine*, 5:72 (July 1980), 495.

28  There is a distinction between writing and signature, where the power of the signature lies in it being a condensation of the traces of authorial presence. My point is that what can be seen in the account, title and signature is a series of strategies that seeks to fill the space that the picture actually opens up. Peter Brunette and David Wills in the introduction to the collection of essays *Deconstruction and the Visual Arts: Art, Media, Architecture* (Cambridge, Cambridge University Press), 1994, describe this: 'Yet the signature is also foreign to what it defines, a piece of writing within figural space that disturbs the homogeneity of the medium; what seals the work is therefore also what breaks it open to reveal the otherness that resides within it' (p. 5).

29  See David Mellor, *The Sixties Art Scene in London* (London, Phaidon), 1993.

30  *The Tate Gallery: Illustrated Catalogue of Acquisitions 1980–82 (*London, The Tate Gallery), 1984, p. 156.

31  Morphet, *Kitaj*, p. 82.

32  Andrew Benjamin, *Art, Mimesis and the Avant-Garde: Aspects of a Philosophy of Difference* (London, Routledge), 1991. Also Juliet Steyn, 'Painting Another: Other-than-Painting', in Juliet Steyn (ed.), *Other than Identity: The Subject, Politics and Art* (Manchester and New York, Manchester University Press), 1997, pp. 211–20.

33  See V. N. Vološinov, *Marxism and the Philosophy of Language* (Cambridge, Mass.: Harvard University Press), 1986.

34  Carol Salus, 'R.B. Kitaj's The Murder of Rosa Luxemburg : A Personal Metaphor', *Jewish Art*, 16/17 (1990–91), 130–8.

35  Ibid., p. 135.

36  Isaac Deutscher in *The Non-Jewish Jew and Other Essays* (Oxford, Oxford University Press), 1968, refers to Luxemburg as part of this tradition: 'Spinoza, Heine, Marx, Rosa Luxemburg, Trotsky, and Freud all found Jewry too narrow, too archaic, and too constricting … As Jews they dwelt on the borderlines of various civilizations, religions, and national cultures … Their minds matured where the most diverse cultural influences crossed and fertilized each other … Each of them was in a society and yet not in it, of it and yet not of it. It was this that enabled them to rise in thought above their societies, above their nations, above their times and generations, and to strike out mentally into wide new horizons and far into the future' (pp. 26–7), quoted in Paul N. Siegel *The Meek and the Militant* (London, Zed Books), p. 63.

37  It doesn't seem unwarranted to quote Hannah Arendt who observed of those whose enthusiasm for Luxemburg's politics wanes that: 'Every New Left movement, when its moment came to change into the Old Left – usually when its members reached the age of forty – promptly buried its early enthusiasm for Rosa Luxemburg together with the dreams of youth.' Hannah Arendt, 'Rosa Luxemburg: 1871–1919', a review of

J. P. Nettl, *Rosa Luxemburg*, reprinted in *Men in Dark Times* (Harmondsworth, Penguin), 1973, p. 43.

38  Of his time in New York as an 18-year-old student Kitaj writes: 'Every day I'd walk the eight blocks to school along 4th Ave, which was then the greatest book street in America; where I'd pick up these *Partisan Reviews*, that is, I picked up some of my peculiar education.' Quoted in Jane Kinsman, *The Prints of R.B. Kitaj* (Aldershot, Scolar Press), 1994, p. 59. For a discussion of *Partisan Review* and its relationships with Trotskyism, Clement Greenberg and the cultural milieu of 1940s America, see Fred Orton and Griselda Pollock, 'Avant-Gardes and Partisans Reviewed', *in Avant-Gardes and Partisans Reviewed* (Manchester, Manchester University Press), 1996, pp. 141–64.

39  See Pat Gilmour's essay in this collection for discussion of Kitaj's output of screen-prints

40  Georg Lukács, *History and Class Consciousness* (London, Merlin Press), 1971, p. 155. See also Theodor Adorno, *Aesthetic Theory* (London, Athlone Press), 1997.

41  Umberto Eco, *The Name of the Rose* (London, Secker and Warburg), 1983, p. 500.

## Notes to Chapter 4

1  On the relation of a concept of postmodernism and allegory, see Craig Owens, 'The Allegorical Impulse'. *October*, 12 (Spring 1980): 67–86; 13 (Summer 1980): 59–80. For an important discussion of allegory and contemporary art theory, see Gail Day, 'Allegory: Between Deconstruction and Dialectics', *Oxford Art Journal*, 22–1 (1999).

2  Walter Benjamin, 'The Work of Art in the Age of Mechanical Reproduction', in *Illuminations* (New York, Schocken Books), 1969, p. 226.

3  Paul de Man, 'The Rhetoric of Temporality', in *Blindness and Insight* (London, Routledge), 1989, p. 207.

4  Ibid.

5  Walter Benjamin, *The Origin of German Tragic Drama* (London, Verso), 1985, p. 207.

6  Ibid., p. 192.

7  Ibid., p. 197.

8  Ibid., p. 188.

9  Richard Wollheim has suggested that in certain paintings of the early to mid-1970s, Kitaj combined a configurational and representational role in 'the cubicles into which the surface was divided'. It could be argued that these could also be read as allegorical transitions.

10  R. B. Kitaj, in R. Morphet (ed.), *R.B. Kitaj* (New York, Rizzoli), 1994, p. 106.

11  Benjamin, *Origin*, p. 184.

12  De Man, 'Rhetoric', p. 208.

13  Ibid., p. 209.

14  Benjamin often uses the word *Schein* in a manner which involves its meaning as 'appearance', but also as 'glimmer' and as 'illusion'. It is most frequently applied to beauty.

15  Benjamin, *Origin*, p. 184.

16  Kitaj refers to the painting's 'metaphysical desuetude', which seems accurate: Morphet (ed.), *Kitaj*, p. 106.

17  Benjamin, *Origin*, p. 185.

18  Ibid., p. 181.

19  Ibid., p. 169.

20  Ibid., p. 175.

21  Ibid., p. 166.

22  A slumber did my spirit seal;
    I had no human fears:
    She seemed a thing that could not feel
    The touch of earthly years.

    No motion has she now, no force;
    She neither hears nor sees;
    Rolled round in earth's diurnal course,
    With rocks, and stones, and trees.

23  De Man, 'Rhetoric', p. 224.

24  Ibid., p. 225.

25  Benjamin, *Origin*, p. 232.

26  Ibid., p. 232–3.

27  Ibid., p. 234.

28  See Marco Livingstone, 'Iconology as Theme in the Early Work of R. B. Kitaj', *Burlington Magazine*, 122:928 (July 1980), 488–96.

29  Juliet Steyn, 'The Loneliness of the Long Distance Rider', *Art Monthly*, 113 (February 1988), p. 9.

30  Ibid., p. 9.

31  Andrew Benjamin, *Art, Mimesis and the Avant-Garde* (London, Routledge), 1991, p. 88.

32  Ibid., p. 96.

33  Could the figuring of 'progress' be just such an allegory, a sign for the future which cannot coincide with its 'anterior', the sign from which it draws its meaning?

34  A. Benjamin, *Art*, p. 88.

35  Ibid., p. 89.

36  Ibid., p. 95.

37  A similar question is posed by Simon Critchley in a discussion of Levinas. 'How can one conclude from the "evidence" (given that there can be no evidence) for radical alterity that such alterity is goodness.' *Very Little … Almost Nothing: Death, Philosophy, Literature* (London, Routledge), 1997, p. 80.

38  It is worth noting in passing that Andrew Benjamin regards the Jewish identity given by anti-semitism as in some ways fixed, 'self-enclosed'. The emblems of the Holocaust in Kitaj's work therefore tend to appear to him as symbols against which he places the 'futural'. I would argue that they are allegorical emblems, perhaps despite Kitaj's aims, and as such equally non-self-present. Andrew Benjamin does touch on this when he notes that 'the smoke [is] the presence of an absence. It is an absence that checks the power of the image', A. Benjamin, *Art*, p. 92.

39  In Morphet (ed.), *Kitaj*, p. 106.

40  De Man, 'Rhetoric', p. 207.

41  Steyn, 'Loneliness', p. 9.

42  Ibid., p. 9.

43  De Man considers this in terms of irony rather than allegory, describing a simultaneously split self.

44  Walter Benjamin, *Charles Baudelaire: A Lyric Poet in the Era of High Capitalism* (London, NLB), 1973, p. 53.

45  As Terry Eagleton has argued in *Walter Benjamin* (London, Verso), 1981, in this Benjamin suspends but does not get beyond a persistent problem of western Marxism, the theorisation of the relation of the 'base' and 'superstructure'. This remains a central dilemma for the social history of art.

46  In Morphet (ed), *Kitaj*, p. 94.

47  There may well be other such figures elsewhere in Kitaj's work, Raymond Lull springs to mind as a possibility.

48  In Morphet (ed.), *Kitaj*, p. 94.

49  Although this is perhaps a qualified claim on Kitaj's part, it is nonetheless a claim. Kitaj writes: 'I feel I ought to apologise for this type of painting because it's such a rouged and puerile reflection upon such a vivid personeity, but maybe I won't (apologise); maybe a painter who snips off a length of picture from the flawed scroll which is ever depicting the train of his interest, as Benjamin did, may put a daemon spirit like Benjamin in the picture.' Morphet (ed.), *Kitaj*, p. 95.

50  W. Benjamin, *Origin*, p. 175.

## Notes to Chapter 5

1  Only a handful of the artists were familiar with screenprinting. Richard Hamilton had used the technique at the University of Newcastle-upon-Tyne, where he then taught. William Turnbull worked on film posters in Scotland in 1939 and at a studio John Coplans set up in London in 1956. Eduardo Paolozzi had transferred drawings onto screens of photo-sensitised gelatine at the London College of Printing; he also made several prints privately with Prater before the ICA project.

2  See the brochure *ICA Screen-print Project* published by the Institute of Contemporary Arts to advertise the sale and exhibition of the prints in Dover Street, London, 10–24 November 1964. The artists involved were Gillian Ayres, Peter Blake, Derek Boshier, Patrick Caulfield, Bernard Cohen, Harold Cohen, Robyn Denny, Richard Hamilton, Adrian Heath, David Hockney, Howard Hodgkin, Gordon House, Patrick Hughes, Gwyther Irwin, Allen Jones, Ron Kitaj, Henry Mundy, Eduardo Paolozzi, Victor Pasmore, William Turnbull. Hailing screenprinting as 'essentially a painter's vehicle', the ICA sold single images for 10 guineas, the complete set for £240.

3  An earlier London screenprint exhibition was held in the Library of the ICA from 17 December 1956. The Preface to the slim brochure *Serigraphs: British Silk Screen Prints*, by Robert Erskine of the St George's Gallery London, said it had been mounted to introduce the medium both to the public and to artists. There were eleven works by seven artists who used the tusche washout method. All but one had been printed by Philip Goodman at John Coplans's workshop. Coplans, who acquired his knowledge of screenprinting from a book, said he opened the workshop because the only other way to make a fine print in London then was in the etching or lithography department of an art school. Letter from Coplans to Gilmour, 8 July 1976.

4  Foreword, *Kelpra Prints: Arts Council 1970*, exhibition catalogue (London, Hayward Gallery), 17 June–7 July 1970, unpaginated. This catalogue lists every print made at Kelpra up to that time.

5 For example, the Tate Gallery purchased *Isaac Babel Riding with Buddyonny* in 1963, The Museum of Modern Art, New York, purchased *The Ohio Gang* in 1964, and the Nationalgalerie, Berlin, bought *Erie Shore* in 1966.

6 M. Vaizey, 'Kelpra Studio and Continuum', *Financial Times*, 2 July 1970.

7 G. Brett, 'Artists and Printers', *The Times*, 23 June 1970.

8 See *British International Print Biennale*, exhibition catalogue (Bradford, City Art Gallery and Museum), 23 November 1968–19 January 1969, no. 354 (K.29).

9 R. Thomas, 'Graphics', *Art and Artists*, 5 (June 1970), 46–7.

10 *R. B. Kitaj: Complete Graphics, 1963–1969*, exhibition catalogue (Berlin, Galerie Mikro), 1969.

11 The show was in the Philadelphia Museum of Art from 17 December 1971 to 27 February 1972. The section 'Contemporary Screenprints 1960–1971' lists 34 images printed at Kelpra. Of American print shops, 18 came from Sirocco, New Haven; 10 from Chiron Press, New York; 9 from KMF, New York; 8 from Styria Studio, New York; 7 from Aetna Silk Screen Products, New York; and 4 from Gemini GEL, Los Angeles. A further 13 were divided between Domberger and Hans Peter Haas in Stuttgart.

12 See R. S. Field, *The Prints of Richard Hamilton*, exhibition catalogue (Middletown, Connecticut, Wesleyan University, Davison Art Center), 29 September–4 November 1973, p. 7. To imply that the pioneers of screenprinting before 1960 were not making fine art was rather unjust. Quite apart from the Americans, the Australians also preceded the British. Francis Carr, who taught Paolozzi (in a graphic design/textile context) at the London College of Printing, claims that his *After the Storm* of 1949 was the first fine art screenprint in Britain, although Prater, then interested primarily in etching, remembers examples at the Working Men's College in 1948. Presumably, for Field, the crucial difference between the early serigraphers and the phenomenon post-1960 was that many artists already had international reputations in painting.

13 *Kelpra Studio, The Rose and Chris Prater Gift: Artists' Prints 1961–1980*, introd. P. Gilmour, exhibition catalogue (London, Tate Gallery), 1980. This catalogue includes essays by Gordon House, by the German artist Gerd Winner and by Kelpra's studio manager, Douglas Corker. Silvie Turner added a technical note.

14 The ICP was founded by Alistair McAlpine with the help of Stewart Mason. The archive they set up became the basis of the Tate's modern print collection. Except for the Petersburg Press, British publishers and workshops gave generously to it.

15 Prater received the OBE (Order of the British Empire) from the Queen in 1980 for 'Services to Art'.

16 Apart from a poster, the last screenprint Kitaj made at Kelpra was Prater's portrait for the Tate portfolio (K.103). His last intensively produced group of screenprints dates from 1975, although one or two others were produced in 1978. Kitaj did try serigraphy (i.e. drawing direct on the screen) with Prater in 1977, but he did not apply enough grease and the image washed out. See R. B. Kitaj, 'Chris … A Note Apropos', *Arts Review*, 29:16, 5 August 1977, 506.

17 Field wrote: Prater's genius was with the knife, as a stencil-cutter …' in *The Prints of Richard Hamilton*, p.7 (see n.12).

18 Odilon Redon said that the problem with the Impressionists was that their ceiling was too low, see 'Introduction to a Catalogue', *A soi-même, Journal (1867–1915)* (Paris, J. Corti), 1922/61.

19  Rose Prater died in 1982, having been ill for over a decade. After her death, Prater, who looked after her with great devotion, gradually ran down his business, working only with long-standing clients such as John Piper and Victor Pasmore – an activity he described as 'Pipering and Pasmoreing'. His first workshop opened at 31 Healey St, London NW1, in 1958. He moved to 330 St. John St, EC1, in January 1964, and then to 80/81 Britannia Walk, N1, in January 1967. Kelpra's final move was to 23–28 Penn St, N1, in November 1984; Prater retired in 1991 and died in 1996. See obituaries in *The Independent* and *Daily Telegraph* on 8 November, and in *The Guardian* on 16 November and *The Times* on 30 November.

20  Important aspects of the debate are to be found in Kitaj's apologia introducing *The Human Clay*, and in his debate with David Hockney, 'The Case for a Return to the Figurative'. The former was an exhibition selected by Kitaj in 1976 for the Arts Council of Great Britain, which focused on depictions of the single human figure; the latter, published in the *New Review*, February 1977, pp. 75–9, concerned the shortcomings of modernism, and a return to figure drawing; Hockney and Kitaj appeared nude on the cover.

21  Interview with Mark Glazebrook, 'Why do Artists make Prints?', *Studio International*, 173 (June 1967), 1–3.

22  *Kitaj: Complete Graphics*, unpaginated. Haftmann's essay, 'Kitaj's Graphics 1963–1969', also appeared in *Art and Artists*, 4 (November 1969), 24–9.

23  After giving up screenprinting, Kitaj chiefly made etchings and lithographs of people, working with the printers Ernie Donagh, Aldo Crommelynck, Mourlot Frères and Stanley Jones at Curwen Chilford.

24  On 18 December 1964 *La Chambre Syndicale de l'Estampe et du Dessin* directed print dealers to a definition formulated by the National Committee on Engraving, which required a print to be 'conceived and executed entirely by hand by the same artist … with the exclusion of any and all mechanical or photomechanical processes' (strictly speaking, this ruled out presses).

25  *Frontiers of Printmaking: New Aspects of Relief Printing* (London and New York), 1966, pp. 21–3.

26  The article appeared in *Art and Artists* in March 1967, and in America in the Fall issue of *New University Thought*.

27  Formica for Michael.

28  This was the title of chapter 2 in Hayter's book *About Prints* (London), 1962. A fresh attempt to define a print has recently been made. See the leaflet 'What is a Print?' produced in the United States by the International Fine Art Dealers' Association, and the discussion document from the British Standards Institute (BSI PAM/45, Project 91 6838). Both organisations define six non-judgemental categories, ranging from those where there is a total and singular involvement of the artist, to those where there is no involvement, either practical or sympathetic.

29  M. G. McNay, 'Minting Prints', *The Guardian*, 15 February 1967. Letters from Paolozzi and Allen Jones, stoutly defending their methods, were published in the same newspaper on 27 February.

30  Benjamin believed art's 'aura', by which he meant the authenticity dependent upon uniqueness, had been destroyed by photography, which in mechanising the means of production (particularly through film), had rendered the practice of art political. Not only has photography since acquired 'aura' (i.e. the authentic print, the original

negative), but Benjamin's essay proved irrelevant to printmaking, since he did not differentiate between copies of original works of art, and artists' prints, which are intrinsically multiple. For a most interesting discussion, see Paul Mattick, 'Mechanical Reproduction in the Age of Art', *Arts Magazine* (September 1990), 62–9.

31 Part of the title-page, including the words: 'Principles recommended by the Print Council of America', was used on the right-hand side of *The Defects of Its Qualities* (K.29), while pages respectively headed 'The Dealer' and 'Screen Processes' were used in the top corners of *Ctric News Topi* (K.31).

32 The Americans waged an even more vigorous campaign. By 1965, Joshua Binyon Kahn's *What is an Original Print?*, first published in 1961, had sold 55,000 copies. The PCA definition of originality required that '[t]he artist alone has created the master image in or upon the plate, stone, woodblock, or other material for the purpose of creating the print'. The breakdown of the definition in the United States also centred on screenprinting; see P. Gilmour, '"Originality" *circa* 1960: A Time for Thinking Caps', *The Tamarind Papers*, 13 (1990), pp. 28–33.

33 None of the letters is dated, but an estimate is possible, based on Kelpra's job-books. These give a rough idea of when a job first came in and the precise date of its invoice. Six of Kelpra's record books, covering the period January 1958 to February 1973 are in the Archive of the Tale Gallery (ref: TC 862).

34 Kitaj to Gilmour, June 1992: 'I have no interest in any technology including the technology of printmaking.' And in reply to a follow-up he replied (*c.* mid-September 1992): 'You must forgive me if I don't explain here such things as my distaste for technology (unlike my comrade Hockney) … It's complex and bound up with a general malaise about the modern world (which malaise I don't expect or ask anyone to share with me).'

35 Raymond Williams has warned that the word 'mechanical' needs continual examination because of the social prejudice historically attaching to its use, and the sense of a 'routine, unthinking activity – thus action without consciousness'. See Williams, *Keywords* (London, Fontana), 1976, p. 168.

36 The meshes used were 120 t.p.i. (threads per inch) for detailed work, and 90 t.p.i. for flat areas of colour.

37 Other fine art screenprinters, such as Arcay in France, used automatic presses; these printed 1,200 sheets an hour, compared to 150 by hand. Prater once visited Arcay's workshop and was amazed to find that he employed twenty retouchers.

38 Betambeau was tall, with hands big enough to pull Kelpra's largest screen, measuring 60 x 40 in.

39 Betambeau worked with artists at his own firm, Advanced Graphics, until his death from cancer in 1993. See my obituary in *The Independent*, 16 September 1993, and Tim Hilton's in *The Guardian*, 18 September 1993.

40 C. Prater, 'Experiment in Screenprinting', from the supplement on 'Lithographs and Original Prints' in *Studio International* (December 1967), 293. Kelpra's job-books suggest the print was *Die Gute alte Zeit* (K. 35 ii) from the portfolio provisionally called 'Horizon/Blitz', later entitled, 'Struggle in the West: The Bombing of London'.

41 See J. Curtis, 'The Original Print: An Epitaph', *Penrose Annual*, 1972, pp. 9, 10. Curtis reproduced *Outlying London Districts I*, 1971 (K.48) under the caption: 'a particularly good example of an artist using the new medium of screenprinting with creative awareness of its potentialities'.

42  Kitaj owned this collage novel, which he bought for £2.10s while he was at the Royal College. See M. Livingstone, *Kitaj* (London, Phaidon), 1985, rev. edn, 1992, p. 172, n. 5.

43  In fact, Kitaj's strategies were very different from Ernst's. He made no attempt to conceal the use of diverse fragments – as opposed to integrating them seamlessly on a surface – and introduced the hand-drawn among other elements.

44  C. Jaffee McCabe, *Artistic Collaboration in the Twentieth Century* (Washington, D.C., Smithsonian Institution Press), 1984; see colour plate 84: Work in Progress, 1962, mixed media on wood, 82 x 86.4 cm. The catalogue suggests another reason for doubts about collaborative screenprinting, given Prater's high visibility. Its second sentence says that '[t]he perception of the artist as a loner confirms the generally accepted notion of solitary genius'.

45  Typical of Kitaj's political heroes and heroines, Rosa Luxemburg was a German left-wing revolutionary who was murdered in 1919 after an abortive uprising.

46  From Babel's entry in the *Sunday Times's 1000 makers of the Twentieth Century* (first version); Kitaj contributed illustrations to this project.

47  One sheet of the collage bore Kitaj's own rather beautiful Rorschach experiment on a page from the same painting book – a tall and subtle shape in blue and brown, suggesting Robert Rauschenberg in the theatre piece *Pelican*.

48  David Cohen interviewing R. B. Kitaj, ARA, 'The Viennese Inspiration: In Search of Self', *Royal Academy Magazine* (Winter 1990), 34–6.

49  Mentioned in the entry for the collage in the Victoria and Albert Museum's catalogue of drawings.

50  Although the number of colours later increased exponentially, the average at the time was four or five. Prater still charged only £80 for Kitaj's edition of forty prints, which was far from economically viable. When he later ran four benches, his policy was to try to make a profit on three of them, and write off the fourth as a loss. He preferred demanding, which usually meant unprofitable, work.

51  The work gave rise to more than fifteen images, but not all of them were selected for the suite. Prater wrote 'Marler 1' and 'Marler 2' as two new Kitaj prints in his job-book, under nos. 64/59 and 64/60. These were later titled *Boys and Girls!* (K.11) and *Old and New Tables* (K.12). Although the prints were not invoiced until October 1964, they were listed and/or illustrated in February 1964 in *R. B. Kitaj*, exhibition catalogue (New York, Marlborough Gerson Gallery), cat. nos. 65, 67. Kitaj described them as respectively inspired by the second movement of the second symphony, and the first movement of the first symphony. The imagery is consonant with other Mahler images – *Boys and Girls!*, for example, features nude teenagers from a German nature magazine, and a detail of the anti-semitic film *Jud Suess*.

52  See R. B. Kitaj. *First Diasporist Manifesto* (London, Thames and Hudson), 1989, p. 41.

53  The title *The Flood of Laymen* (K.23 x), associated with Mahler's Sixth (Tragic) symphony, comes from Ford Madox Ford's statement: 'The flood of Laymen will in the end submerge us all and dance on our graves … the layman regards the artist as a sort of Jew.'

54  The title comes from *Gai Saber*, the old Provençal name for the art of poetry, after a guild formed in Toulouse in 1323 to keep Provençal language and culture alive.

55 The picture of the hunter (in fact a photograph of Ernest Hemingway) was used on the cover of the 1965 catalogue for Kitaj's Marlborough-Gerson Gallery exhibition in New York. When he eventually used the image in *Hellebore for Georg Trakl* (K.23 iii), Kitaj asked Prater to reverse the head so that the hunter faced one way, while his gun pointed in the opposite direction.

56 See G. Trakl, *Das dichterische Werk* (Munich), 1988. The print contains extracts of his poetry, for example: 'Flash in the sky. Were it said / Among twigs / "And then the world went / And then –"'. Kitaj balanced texts from Trakl's poetry with an article about an American artist he had admired in Cleveland – Albert Pinkham Ryder. The article includes a stanza of Ryder's 'Voice of the Night Wind', described as 'a bit wild', and ending (with some justification), 'And my fantastic wanderings/Who can pursue, who comprehend?'

57 The punkah, in this print (K.23 viii) – an image of colonial expatriation – recurs repeatedly in Kitaj's pictures, including his painted *Self-Portrait* of 1965, and the prints *Civic Virtue* (K.25), *Home Truths* (K. 26) and *The Romance of the Civil Service* (K.27). The photo is of Gauguin in 1888. The caption reporting Tioka's reaction when he found the artist was dead is taken from an article by Bengt Danielsson in *The Observer Colour Supplement*, 14 November 1965.

58 This view of Mahler is always stressed in the programme notes to his music.

59 It has been suggested that the increased possibility of moving images from print to print through screenprinting gave Kitaj the idea of creating characters that move from painting to painting, as characters in fiction move from book to book.

60 A railway siding was pictured in two paintings of 1965 – *The Sorrows of Belgium* and *Trout for Factitious Bait*. Although not part of the 'Mahler' suite, it became a white-on-white screenprint ominously entitled *The Reduction of Anxiety in Terminal Patients* (K.17). Belgium finds its way into the suite in *Heart* (K.23 v), based on *Queen Mary's Book in Aid of the Belgians* – tributes to Belgium's plucky resistance to the German invasion in the Great War.

61 This is taken from a disused station at the end of the defunct line from Gerona to San Feliu de Guixols in Spain, where Kitaj once had a house.

62 See *R. B. Kitaj* (Washington, D.C., Hirshhorn Museum and Sculpture Garden), 1981. Republished in German by the Städtische Kunsthalle, Düsseldorf (1982), and slightly modified in English as *R. B. Kitaj: Paintings, Drawings, Pastels* (London), 1983. It includes texts by John Ashbery, Joe Shannon and Jane Kinsman, as well as Timothy Hyman's interview with Kitaj: 'A Return to London', reprinted from the *London Magazine* (February 1980), 15–27.

63 The print (K.23 vii) is one of three registered in Prater's job-book in late 1964 and invoiced in January 1965. It takes off from a question asked by I. A. Richards in *The Philosophy of Rhetoric* (Oxford, Oxford University Press), 1965; Richards had suggested a comparison may 'be putting two things to work together, comparing like-ness with unlikeness, or drawing attention to one thing through the presence of another. The diversity of Kitaj's reading is indicated by a *Dictionary of Unusual Words* (graded according to difficulty!), the Right Book Club's *March of a Nation*, and a volume on the heroes of the Spanish Civil War. Beneath the books, Kitaj juxta-poses feathers with a grid, burnt matchsticks with a race of ballbearings, soldiers with computer perforations and bees swarming over the back of Canova's sculpture *The Three Graces*.

64 I am reminded of a nauseating German propaganda film, shown at the Imperial War Museum, London, in which Jews, herded into Warsaw ghettos and deprived of all necessities, are then likened to sewer rats.

65 A note in Kitaj's 1965 New York catalogue announces this as a projected print, 'honouring the memory of Hans and Sophie Scholl among others; to be made to act in the Mahler sequence'. Possible titles indicated were *For the White Rose* or *Leaflets of the White Rose* – references to the name of the group to which the Scholls belonged.

66 The image in Kitaj's painting *Tedeum*, 1963, was in turn derived from a photo of a performance of Jean-Paul Sartre's play *No Exit*, 1946.

67 Hence 'Beisbol' – the Latin American pronunciation of baseball – in the suite's title.

68 'New Acquisitions', *Tate Gallery*, 1968–70 (London, Tate Gallery, 1970), pp. 90, 91.

69 Another of Kitaj's photos of baseball players appears in *I've Balled Every Waitress in This Club* (K.23 xii).

70 The Chaplinesque figure also made an appearance in the painting *Good News for Incunabulists* and the print *Boys and Girls!*.

71 See M. R. Deppner, *R. B. Kitaj: Mahler Becomes Politics, Beisbol*, exhibition catalogue (Hamburg Kunsthalle), 9 November 1990–3 February 1991.

72 Only two prints from the sequence are included in the list of pictures for Kinsman's book (see note 96 below), and none appears on Marlborough's 'preferred' list, although Kitaj told Livingstone, *Kitaj*, p. 174: 'They're kind of nutty but maybe not so bad as "citations" (in Benjamin's practice), aberrant quotations and pickings from the world.'

73 The series spanned three years, 1966–69 (K.34 i–x).

74 For the role of poets at Black Mountain College, see Alan Jones, 'The World before Grants', *Arts Magazine* (September 1990), 29–30.

75 In 1967 Kitaj told Glazebrook (who assumed he had done more prints than drawings): 'I've done more *drawings* than prints over the past few years … but unorthodox … thus no doubt misleading … mostly on small canvases with pigment and french stub. Many of these drawings have been autonomous, but some of them crop up in prints.' 'Why do Artists make Prints?', p. 2. Prater represented the nuances of the monochrome oil drawings by printing them in two to three tones of the same colour.

76 See Jones, 'The World before Grants', p. 30.

77 The same windows are used to very different effect in *Outlying London Districts I* (K.48).

78 Related by Kitaj in his discussion with Francis Wyndham at the time of his 'Artist's Eye' exhibition at the National Gallery, London. See 'The Dream Studio of R. B. Kitaj', *Sunday Times*, 25 May 1980, pp. 59–62 and 67.

79 The ink tracing has survived. Although other letters mention the Duncan print in passing, three deal substantively with the making of the print, and another provides the title to be reproduced from Kitaj's copybook handwriting. None of the communications is dated, but Prater booked the print c. February 1968, and invoiced it in April 1968 after Kitaj's March visit to London.

80 The account in *Contemporary Poets* (4th edn), ed. J. Vinson and D. L. Kirkpatrick (London, Macmillan), 1985, says: '[the bed] snores, wakes up, speaks, has a missile countdown while Jesus and Camus "are at it again upstairs". The explosive exuberance leads to a sweetly innocent and still moving conclusion: a naked man and woman repeat "good morning" to each other. A movie of clouds becomes a cluster of grapes.

They repeat "yes" to each other. The light flares up and dies out, a [nd] [sic] leaves a cluster of grapes.'

81  The entry in Prater's job-book indicates that at one stage *Bedroom* (K.44) was planned as no. 111 of the *Outlying London Districts* (K.48, 49). A fascinating and poetic letter survives (no date, but early 1971) in which Kitaj asks Prater to re-proof the second image. He systematically describes the existing colours, asking for each one to be 'taken way down to a dark version of the same colour'. A small note dealing with *Bedroom* similarly asks Prater to 'lower all tones to night darks' and requests a multi-paned window frame to be printed 'rather bright blue in tone between darks of bedroom and light of sky'. His query as to whether there were 'any transparent glazes we can use' inspired Prater's imaginative application of a variety of rubbed-down textures, known in the trade as 'zippertones'.

82  This suggests a truncated form of a message in lights, such as 'Electric News Topical'.

83  The print (K.31) was almost entirely made by post (eight letters dealing with it survive). It began in the second half of 1967 with a collage, but there were endless adjustments: Prater's job-book lists three proofings. A 'proofing' usually indicates radical changes to the screen, not just colour variants, which are legion. The invoice date, October 1968, reveals that the image took Kitaj over a year to resolve; one undated card tells Prater that 'the J. Baker proof will lie on the floor germinating for a while now.'

84  The cover of *La Guerre Secrète de Josephine Baker* appears in the print, together with an autograph letter from General de Gaulle. Baker won the *Croix de guerre* with Palm, the *Légion d'honneur* and the *Rosette* of the Resistance. A tireless civil-rights campaigner in the United States after the war, Baker returned to the stage between 1959 and 1975 to fund the multi-racial orphanage she had founded.

85  Kitaj got his wish; *Die gute alte Zeit (The Good Old Days)* (K.35 ii) was re-proofed five times. The printing of the edition involved 81 separate operations – with 57 printed colours, plus several applications of varnish and the collaging of ten additional pieces. The bill for the edition was £600 (invoiced 3 February 1969). In an undated note sent later that year, Kitaj mentioned that Gilbert Lloyd of Marlborough had phoned from New York to say 'he would have a hard time explaining the bill for that one extrava-gant print'.

86  In fact they are zebra skins. In a letter sent before his return to London in September 1968, Kitaj said that for the borders, he had decided to use 'certain kinds of wallpaper that may have been used during the Blitz period instead of fancy papers'. So Rose Prater unearthed old stock from the basements of wallpaper manufacturers to enable Kitaj to choose those he felt evoked the period.

87  The airletter with the sketch for 'Blitz sheet three' has been torn and stuck together with Sellotape, but its verso is iconographically of considerable interest. Although the labels in the related painting are blank, in the print the one around the dog's neck was intended to bear an image of legs in splints; that hanging from the pole or lamp was to receive Kitaj's recurring image of a man propositioning a woman, 1940s vintage, as seen in the lithograph (K.85) and the related painting *The Street (A Life)*, 1975. See Kitaj's note on the latter picture in Livingstone, *Kitaj*, p. 166.

88  This work is dated 1969, see *R. B. Kitaj* (Hanover, Kestner Gesellschaft), 1970, no. 167. 'Blitz 3' is shown in Prater's job-books as coming in during 1968, so the oil drawing for the print stems to have ante-dated (or even provided the basis for) the painting. When the print was abandoned, Prater crossed out 'Blitz 3' and wrote in

*Safeguarding of Life* – the image with which Kitaj replaced it. The latter was invoiced in February 1969.

89  These charred fragments find their way not only into Kitaj's *Self-Portrait* of 1965, but into several prints of 1967, among them *Civic Virtue* (K.25) and *Home Truths* (K.26). Three sheets of the charred fragments (including the single fragment in the works cited above) became part of the suite as three *Set Pieces* ('a picture in fireworks; an elaborately prepared performance').

90  This is a mischievous quotation. Kitaj was telling Hyman why he had given up collage, but this collage screenprint sequence seems to me to address both the horror and the humour of 'aspects of time on scorched earth'. See the Hirshhorn exhibition catalogue (1981), p. 41.

91  Kitaj to James Mollison, Director of the Australian National Gallery (now renamed National Gallery of Australia) franked 4 March, received 13 March 1985.

92  *Joe Tilson and R. B. Kitaj: A Change of He(art)*, exhibition catalogue (Canberra, Australian National Gallery), December 1987–March 1988. Catalogue essays by Pat Gilmour, Cathy Leahy and Jane Kinsman.

93  Jane Kinsman, *R. B. Kitaj's Prints* (Aldershot, Scolar Press), 1994. The K. nos. in this article derive from Kinsman's listing.

94  The periods artists themselves reject are often regarded in quite a different light by history – to give just two examples, Chaim Soutine's Céret landscapes and Giorgio de Chirico's early works.

95  See Joe Shannon in the Hirshhorn catalogue, p. 36, n. 3.

96  It is, in fact, a loose-leaf book of texts on different coloured papers, written by the American poet Robert Creeley, and accompanied by fourteen prints. Not all were screenprinted; several etchings were made at White Ink, and one lithograph at Mourlot in Paris. A complex production with several collaborators, the last invoices are dated January and March 1972, when Prater completed the profile of Creeley, added screenprinting to four etchings, and re-ran the end papers (K.51 i–xiv).

97  The Tate Gallery show ran from 15 June to 4 September 1994 and then travelled to Los Angeles and New York.

98  *The Tate Gallery, 1970–72* (London), 1972, pp. 27–9.

99  Kitaj's 'Mahler Becomes Politics, Beisbol' (K.23 i–xv) was catalogued in the bi-annual report for 1968–70. The Tate bought the set of fifteen prints before it realised that all Kelpra's production would come to it by gift though the ICP.

100  In passing its archives to the Tate Gallery in 1975, the ICP stressed that the collection 'should be as accessible as possible, not permanently locked away, the prints should be available to researchers and a changing selection on exhibition to the public'. See J. Howorth, 'The Institute of Contemporary Prints: A History', *Catalogue of the Print Collection* (London, Tate Gallery, Modern Collection), 1980. Only two Kitaj prints had been shown since 1980 – *French Subjects* (K.70) in 1986, and *Boys and Girls!* (K.11) in 1991.

101  The Kitaj exhibition at the Victoria and Albert Museum ran from 8 June to 9 October 1994.

102  The Department was axed by Sir Roy Strong, then Director, after cuts to the arts by the Callaghan government. The loss caused a furore throughout the country. See R. Cork, *Evening Standard*, 11 November 1976, reprinted in R. Cork, *The Social Role of Art* (London, Fraser), 1979, 24–7.

103 See Kitaj's essay 'School of London', in *The Human Clay*, unpaginated. Saying he had decided only to buy pictures representing people, Kitaj explained he was a poor judge of abstraction and 'an ever poorer judge of the host of art things in the non-picture line, even when I have given in to those post-Duchampian temptations myself.'

104 See H. Arendt's introduction to Walter Benjamin, *Illuminations* (London, Jonathan Cape), 1970, pp. 11, 45–51.

105 Although only 19 of the 50 titles are referred to in his letters to Prater, 18 of the published covers received such accolades from Kitaj as 'incredible!', 'great', or 'very beautiful'. Prater certainly managed to convey, with magical economy, the dog-eared corners, frayed spines and well-thumbed jackets of much loved books.

106 '*Gorky*' refers to the book *Articles and Pamphlets* (K.37 xxiv), while the 'Kenneth *BURKE*' book is *Towards a Better Life* (K.37 xviii).

107 W. Packer, *The Financial Times*, 21 October 1980.

108 Counting only the images made at Kelpra, I estimate that there are over 14,420 Kitaj screenprints circulating in the world.

## Notes to Chapter 6

1 In Valentine Cunningham (ed.), *The Penguin Book of Spanish Civil War Verse* (Harmondsworth, Middlesex, Penguin), 1980, p. 177.

2 See Carol Salus, 'R. B. Kitaj's *The Murder of Rosa Luxemburg*: A Personal Metaphor', *Jewish Art*, 16:17 (1990–91), 132–3, and John Lynch, chapter 3 in this volume.

3 See Jaques Le Goff, *History and Memory* (New York, Columbia University Press), 1992, pp. 81–99.

4 See Yael Zerubavel, *Recovered Roots: Collective Memory and the Making of the Israeli National Tradition* (Chicago, University of Chicago Press), 1995, pp. 4–5.

5 For example, Marco Livingstone, 'Iconography as Theme in the Early Work of R. B. Kitaj', *Burlington Magazine*, 122:928 (July 1980), 496; Marco Livingstone, *R. B. Kitaj* (London, Phaidon), 1985, pp. 15–16; Linda Nochlin, 'Art and the Conditions of Exile: Men/Women, Emigration/Expatriation', in Susan Rubin Suleiman (ed.), *Exile and Creativity: Signposts, Travelers, Outsiders, Backward Glances* (London, Duke University Press), 1998, p. 41.

6 See Clement Greenberg, 'Modernist Painting', first published in *Arts Yearbook*, 4 (1961), pp. 109–16, and Lawrence Alloway, 'Criticism', in Theo Crosby (ed.), 'International Union of Architects Congress Building, South Bank, London', *Architectural Design*, 31 (November 1961), 507–8.

7 The 'Situation' exhibitions were held in 1960 and 1961, at the RBA Gallery and the Marlborough New London Gallery respectively.

8 See Jeff Wall, *Dan Graham's Kammerspiel* (Toronto, Art Metropole), 1991, p. 18.

9 See Robert Saltonstall Mattison, *Robert Motherwell: The Formative Years* (Ann Arbor, UMI Research Press), 1987, p. 202.

10 The reception of *Guernica* in the United States reveals much about American artistic culture after Abstract Expressionism. Both Clement Greenberg and Michael Fried found fault with the painting on formal grounds. See Clement Greenberg, 'Picasso at Seventy-Five' (1957), and 'Abstract, Representational and So Forth' (1954), in Greenberg, *Art and Culture: Critical Essays* (Boston, Beacon Press), 1965, pp. 63–5 and 134; see also Michael Fried, 'Three American Painters: Noland, Olitski, Stella', in

Fried, *Art and Objecthood: Essays and Reviews* (Chicago, The University of Chicago Press), 1998, p. 215. Picasso's *Massacre in Korea* (1951) was received with even less enthusiasm amongst modernist critics. See Francis Frascina, 'The Politics of Representation', in Paul Wood, Francis Frascina, Jonathan Harris, Charles Harrison, *Modernism in Dispute: Art Since the Forties* (New Haven, Conn., Yale University Press), 1993, pp. 140–2. On the subject of *Guernica* and historical content, Kitaj has observed:

> 'When I was young, there was a plaque next to the picture with a text explaining about the German bombing of the little Basque town and what Picasso had on his mind. Well, that text changed the interest in a difficult modern picture in some way for many, many people. A few years ago, I was shocked to see that the text was no longer shown next to the picture. I can only suppose that the formalist regime there [at the Museum of Modern Art, New York] decided that it wasn't necessary to know anything more than what a person could decipher in the picture.' ('R. B. Kitaj and George MacBeth: A Dialogue', *Art Monthly*, 6 (April 1977) 8).

11  See Fred Orton, *Figuring Jasper Johns* (London, Reaktion Books), 1994, pp. 133–46.

12  See Marco Livingstone, *Pop Art: A Continuing History* (New York, Harry N. Abrams), 1990, p. 254, n. 8.

13  Kitaj claims to have seen the work of Jasper Johns in New York in the mid-1950s. See Livingstone, *Kitaj*, p. 73, n. 129. *Target with Plaster Casts* was also known at the RCA in the early 1960s in reproduction. See Marco Livingstone, 'Peter Phillips', in *Retrovision: Peter Phillips, Paintings, 1960–1982* (Liverpool, Walker Art Gallery), 1982, p. 86, n. 9.

14  In particular: Peter Blake, *Everly Wall*, 1959, *The Fine Art Bit*, 1959, *Got a Girl*, 1960–61; David Hockney, *The Cha-Cha that was danced in the Early Hours of the 24th March*, 1961, *Doll Boy*, 1960; Peter Phillips, *Purple Flag*, 1960, *Distributer*, 1962, *Spotlight*, 1962–63, *Gravy for the Navy*, 1963; Pauline Boty, *Scandal 63*, 1963.

15  See Livingstone,1985, *Kitaj*, p. 173, n. 24.

16  The drawing is entitled *The Garter* in *Goya: Drawings from the Prado*, introduction by André Malraux (trans. Edward Sackville-West (London, Horizon), 1947. See also Livingstone, *Kitaj*, p. 173, n. 24.

17  See F. D. Klingender, *Goya in the Democratic Tradition* (London, Sidgwick and Jackson), 1948, p. 89.

18  Marco Livingstone makes a similar observation about Kitaj's use of Goya. See, Livingstone, *Kitaj*, p. 16.

19  Preface to *Kennst du das Land?* in Richard Morphet (ed.), *R. B. Kitaj: A Retrospective* (London, Tate Gallery), 1994, p. 78

20  See Ludwig Wittgenstein, 'Seeing and Seeing As', in Charles Harrison and Fred Orton (eds.), *Modernism, Criticism, Realism: Alternative Contexts for Art* (London, Harper and Row), 1984, p. 59.

21  See Jim Aulich, 'The Difficulty of Living in an Age of Cultural Decline and Spiritual Corruption: R. B. Kitaj, 1965–1970', *Oxford Art Journal*, 10:2 (1987) 45.

22  In 1969 Kitaj produced a small painting of the Spanish communist leader and orator 'La Pasionaria' (Dolores Ibarruri). Reproduced in Livingstone, *Kitaj*, p. 77.

23  *Authors Take Sides on the Spanish War* (London, Left Review), 1937. Huxley's statement is reproduced in full in Valentine Cunningham (ed.), *Spanish Front: Writers on the Civil War* (Oxford, Oxford University Press), 1986, p. 54.

24  Katherine Bail Hoskins, *Today the Struggle: Literature and Politics in England during the Spanish Civil War* (Austin, University of Texas Press), 1969, pp. 108–9.

25  Cunningham (ed.), *Spanish Front*, p. 54.

26  Ibid., p. 55.

27  Herbert Read, *Anarchy and Order: Essays in Politics* (London, Faber and Faber), 1954, pp. 48 and 51–2.

28  Robyn Denny and Dick Smith, 'An Open Letter to John Minton', reprinted in David Mellor, *The Sixties Art Scene in London* (London, Phaidon), 1993, p. 28.

29  See Robert Radford, *Art for a Purpose: The Artists' International Association, 1933–1953* (Winchester, Winchester School of Art Press), 1987, pp. 49–53 and 109–11; Lynda Morris and Robert Radford, *AIA: The Story of the Artists' International Association, 1933–1953* (Oxford, The Museum of Modern Art), 1983, pp. 31–2 and 53–4. See also, Bruce Laughton, *The Euston Road School: A Study in Objective Painting* (Aldershot, Scolar Press), 1986, pp. 183 and 198–200.

30  See Tom Buchanan, *Britain and the Spanish Civil War* (Cambridge, Cambridge University Press), 1997, pp. 146–68.

31  See for example the statement that Denny and Smith made in issue 24 of the Royal College of Arts' magazine *Ark*, published in the autumn of 1959, which was part of a proposal for a film on urban experience, *Ev'ry Which Way*, written for the film maker John Schlesinger. Unpaginated. See also Alex Seago, *Burning the Box of Beautiful Things: The Development of a Postmodern Sensibility* (Oxford, Oxford University Press), 1995, p. 101, and Mellor, *Sixties*, p. 15.

32  Aulich, 1987, 'Difficulty of Living', p. 47.

33  Quoted in Livingstone, *Kitaj*, p. 16.

34  Van Goose, *Where the Boys Are: Cuba, Cold War America and the Making of the New Left* (London, Verso), 1993, pp. 1–10.

35  See Mellor, *Sixties*, pp. 34–8.

36  John Berger, *A Painter of Our Time* (London, Secker and Warburg), 1958.

37  See John Pearson, 'The Barons of Bond Street', *Sunday Times Colour Magazine*, 17 March 1963, p. 22.

38  Anthony Hartley, *A State of England* (London, Hutchinson), 1963, p. 41.

39  Quoted in Jane Kinsman, *The Prints of R. B. Kitaj* (Aldershot, Scolar Press), 1994, p. 60.

40  Quoted in Frederic Tuten, 'Neither Fool, Nor Naive, Nor Poseur-Saint: Fragments on R. B. Kitaj', *Artforum*, 20:5 (January 1982), 68.

41  See Abel Paz, *Durruti: The People Armed* (Montreal, Black Rose Books), 1976, pp. 306–11. Other estimates put the number of those attending Durruti's funeral lower, at 200,000. See James Joll, *The Anarchists* (London, Methuen), 1979, p. 242.

42  Reproduced in Cary Nelson, 'Art in Flames: The Spanish Civil War Poster', in C. Nelson, *Shouts from the Wall: Posters and Photographs brought Home from the Spanish Civil War by American Volunteers* (Urbana, University of Illinois Press), 1996, p. 64. See also the poster of Durruti reproduced in Georges Soria, *Guerra y Revolucion en Espana, 1936–1939* (Barcelona, Ediciones Grijalbo), 1978, p. 37.

43  See Ronald Fraser, *Blood of Spain: An Oral History of the Spanish Civil War* (New York, Pantheon Books), 1979, p. 223.

44  R. B. Kitaj, Preface to *Junta*, printed in Livingstone, *Kitaj*, p. 163.

45  *R. B. Kitaj: Pictures with Commentary, Pictures without Commentary* (London, Marlborough Fine Art Limited New London Gallery), 1963, p. 6.

46  Reprinted in Cunningham, *Spanish Front*, p. 43.

47  Ibid., p. 44.

48  See Don Lawson, *The Abraham Lincoln Brigade: Americans Fighting Fascism in the Spanish Civil War* (New York, Thomas Y. Crowell), 1989, p. 45.

49  Julián Ríos, *Kitaj: Pictures and Conversations* (London, Hamish Hamilton), 1994 (first published in Spain, 1989), p. 168.

50  See for example, Lawson, *Abraham Lincoln Brigade*, p. 101.

51  Kitaj, Preface to *Kennst du das Land?* in Morphet (ed.), *Kitaj*, p. 78.

52  See Robert Stradling, 'Orwell and the Spanish Civil War: A Historical Critique', in Christopher Norris (ed.), *Inside the Myth, Orwell: Views from the Left* (London, Lawrence and Wishart), 1984, p. 118.

53  Zerubavel, *Recovered Roots*, pp. 6–7.

54  Quoted in Bail Hoskins, *Today the Struggle*, p. 7.

55  Quoted in Livingstone, *Kitaj*, p. 15.

56  Spain is defined in these terms by Don Lawson writing about his time as a student in the mid-1930s. Lawson, 1989, *Abraham Lincoln Brigade*, p. vii.

57  Livingstone, 1985, *Kitaj*, p. 163.

58  See John Gerassi, *The Premature Antifascists: North American Volunteers in the Spanish Civil War, 1936–1939, An Oral History* (New York, Praeger), 1986, p. 15.

59  See David Plante, 'Paris, 1983', *Sulphur*, 9 (1984), 104.

60  See Aulich, 1987, 'Difficulty of Living', p. 50.

61  An alternative translation reads: 'Do you know the land?' See Nicholas Boyle, *Goethe: The Poet and the Age, Volume I, The Poetry of Desire* (Oxford, Clarenden Press), 1991, p. 355.

62  *Kitaj: Pictures with Commentary*, p. 6.

63  Goethe, *Wilhelm Meister's Apprenticeship and Travels*, trans. Thomas Carlyle (London, Chapman and Hall), 1888, pp. 124 and 125.

64  The statement 'For Jose Vicente' was added by Kitaj after the Goethe reference in the catalogue to Kitaj's solo exhibition at the Marlborough-Gerson Gallery in New York in February 1965 (unpaginated). This dedication recurred in the catalogue to Kitaj's 1994 retrospective at the Tate Gallery (Morphet (ed.), *Kitaj*, p. 78). Vicente was a Catalan socialist and writer who was Kitaj's friend from 1962 onwards and was represented in a number of works by him: *Jose Vicente (Study for To Live in Peace)*, 1972–74, *The Singers (To Live in Peace)*, 1973–74, *Communist and Socialist*, 1979.

65  Morphet (ed.), *Kitaj*, p. 78.

66  This connection was originally made by Julián Ríos in conversation with Kitaj in the late 1980s and reaffirmed in Kitaj's Preface to the painting in 1994. See Ríos, *Kitaj:* p. 160.

67  Harold Cardozo, *The March of the Nation: My Year of Spain's Civil War* (London, Eyre and Spottiswoode), 1937. The publishers also produced a special edition of the book for The 'Right' Book Club, also in 1937 (see below, p. 000). My thanks to James Aulich for making me aware of this source and providing me with a copy of the book.

68  These images are numbered 11 and 16 in the book.

69  See for example the covers of the Republican magazine *La Vanguardia*, published in Barcelona, reprinted in Abel Paz, *The Spanish Civil War* (Paris, Editions Hazan), 1997, pp. 168–9.

70  Ríos, 1994, *Kitaj*, p. 160.

71  See Livingstone, 1985, *Kitaj*, pp. 7 and 8.

72  George Orwell, *Homage to Catalonia* (Harmondsworth, Penguin Books), 1962, p. 8.

73  Ibid., p. 103.

74  Fraser, *Blood of Spain*, p. 137.

75  Ibid., p. 141.

76  See Kinsman, *Prints*, p. 58, and Livingstone, *Kitaj*, p. 13.

77  Paul Fröhlich, *Rosa Luxemburg: Her Life and Work* (London, Left Book Club, Victor Gollancz), 1940.

78  Orwell, *Homage to Catalonia*, p. 103.

79  'Review of *Red Spanish Notebook* …', in George Orwell, *The Collected Essays, Journalism and Letters, Volume 1, An Age Like This: 1920–1940*, ed. Sonia Orwell and Ian Angus (Harmondsworth, Penguin Books), 1970, p. 322.

80  Illustrated in *Images of the Spanish Civil War* (London, George Allen & Unwin), 1986, p. 175.

81  Julián Ríos uses this phrase in relation to Kitaj's interest in the Spanish Civil War, see Ríos, *Kitaj*, p. 157.

82  Herbert Read, *Thirty Five Poems* (London, Faber and Faber), 1940, p. 41.

83  Quoted in John Seed, 'Hegemony Postponed: The Unravelling of the Culture of Consensus in Britain in the 1960s', in Bart Moore-Gilbert and John Seed (eds.), *Cultural Revolution? The Challenge of the Arts in the 1960s* (London, Routledge), 1992, p. 26.

84  For an analysis of the deformations of liberal histories of the Spanish Civil War produced during the early Cold War, see Noam Chomsky, 'Objectivity and Liberal Scholarship', in Chomsky, *American Power and the New Mandarins* (Harmondsworth, Penguin), 1969, pp. 62–103.

85  See Bail Hoskins, 1969, *Today the Struggle*, p. 24.

86  Cardozo, *March of the Nation*, p. 35.

87  The 'Right' Book Club had some 25,000 members in 1938.

88  See Stuart Samuels, 'The Left Book Club', *Journal of Contemporary History*, 1:2 (1966), p. 68.

89  Ibid., p. 67.

90  See Buchanan, *Britain and the Spanish Civil War*, pp. 4–5 and 93.

91  The patrons of the book club included: Sir Charles Petrice, a political right-winger and member of the January Club, a blackshirt front organisation during the 1930s; members of the British Admiralty who were calling for 'belligerent rights' to be granted to the Nationalists so that they could 'legally' blockade Republican ports; Alex Lennox-Boyd M.P., who was closely associated with the Nationalist cause in Britain (see Buchanan, *Britain and the Spanish Civil War*, pp. 16, 53 and 88), and Brigadier-General Sir Henry Page Croft, a member of the anti-communist and anti-alien British Empire Union, which had flirted with the British Union of Fascists in the early 1930s. Croft also wrote articles for the fascist-aligned and anti-semitic journal the *Weekly Review* in 1938 (see Kenneth Lunn, 'Political Anti-Semitism before 1914: Fascism's Heritage?', in Kenneth Lunn and Richard C. Thurlow (eds.), *British Fascism: Essays on the Radical Right in Inter-War Britain* (London, Croom Helm), 1980, pp. 34–5).

92  George Orwell, 'Looking Back on the Spanish Civil War', in Orwell, *Collected Essays* (London, Mercury Books), 1961, p. 195.

93  Ibid., p. 196.

94  Ibid., p. 197.

95  George Orwell, Letter to Rayner Heppenstall, 31 July 1937, reprinted in Orwell, *The Collected Essays*, 1970, p. 313.

96  George Orwell, Letter to Jack Common, May 1938 (no day specified), ibid., p. 366.

97  See Bernard Crick, *George Orwell: A Life* (Harmondsworth, Penguin Books), 1992, pp. 353 and 374.

98  In Orwell, *The Collected Essays*, 1970, p. 373.

99  Arthur Koestler, *Scum of the Earth* (London, Victor Gollancz, Left Book Club) 1941, p. 244.

100  Orwell, *Collected Essays*, 1961, p. 195.

101  See Momme Brodersen, *Walter Benjamin: A Biography* (London, Verso), 1996, p. 248.

102  Walter Benjamin, 'Theses on the Philosophy of History', in Benjamin, *Illuminations*, ed. Hannah Arendt (London, Fontana Press), 1992, p. 247.

103  See Susan Buck-Morss, *The Dialectics of Seeing: Walter Benjamin and the Arcades Project* (Cambridge, Mass., The MIT Press), 1991, p. 337.

104  Koestler, *Scum of the Earth*, p. 7.

105  Ibid., p. 247.

106  See Brodersen, *Benjamin*, p. 202.

107  Benjamin states: 'It is more arduous to honour the memory of the nameless than that of the renowned. Historical construction is devoted to the memory of the nameless.' Quoted ibid., p. 262.

108  Orwell, *Collected Essays*, 1961, pp. 206–7.

109  Arno J. Mayer, *Why Did the Heavens Not Darken? The 'Final Solution' in History* (London, Verso), 1990, p. 376.

110  Primo Levi, *The Drowned and the Saved* (London, Abacus), 1992, p. 18. See also Isabel Wollaston, *A War Against Memory? The Future of Holocaust Remembrance* (London, Society for Promoting Christian Knowledge), 1996, pp. 13–17.

111  Orwell, *Collected Essays*, 1961, p. 196.

112  Benjamin, 'Theses', p. 248; see also Michael Löwy, '"Against the Grain": The Dialectical Conception of Culture in Walter Benjamin's Theses of 1940', in Michael P. Steinberg (ed.), *Walter Benjamin and the Demands of History* (Ithaca, N.Y., Cornell University Press), 1996, p. 210.

113  Karl Marx, 'Address of the General Council of the International Working Men's Association on the Civil War in France, 1871', in Karl Marx and Frederick Engels, *Selected Works in Two Volumes: Volume I* (London, Lawrence and Wishart), 1950, p. 485.

114  Fraser, *Blood of Spain*, p. 482.

115  Ibid., p. 484.

116  See Paul Preston, *The Politics of Revenge: Fascism and the Military in 20th Century Spain* (London, Routledge), 1995, p. 32.

117  Ibid., pp. 42 and 44.

118  See Hugh Thomas, *The Spanish Civil War* (London, Hamish Hamilton), 1978, p. 874.

119  Morphet (ed.), *Kitaj*, p. 221. My thanks to James Aulich for alerting me to this point.

120  Plante, 'Paris 1983', p. 104.

121  Such a relationship is suggested by Julián Ríos. Ríos, *Kitaj*, p. 160.

122  One poster depicts a huge boot marked by the symbol of Italian fascism, the fasces, and containing a body of Italian soldiers standing on a map of Spain which is dotted

with fires. The text of the poster reads: 'Rise Up Against the Italian Invasion of Spain'. Reproduced in David Mitchell, *The Spanish Civil War* (London, Granada), 1982.

123 See David Batchelor and Charles Harrison, *Surrealism* (Milton Keynes, The Open University Press), 1983, p. 47.

124 Roger Coleman text for the Situation catalogue (London, RBA Gallery), 1960; reprinted in Mellor, *Sixties* p. 90.

125 Ibid.

126 Coleman had made similar comments in an article on Robyn Denny and Richard Smith: 'Two Painters', *Ark*, 20 (Autumn 1957), 24. The painter Bernard Cohen articulated the same concerns in early 1964: 'The Allegorical Situation, Definitions of Pictures', *Living Arts*, 3 (April 1964), 60.

## Notes to Chapter 7

1 Stephen J. Gould, *Ever Since Darwin: Reflections in Natural History* (Harmondsworth, Penguin Books), 1978, pp. 214–21.

2 Tom Lubbock in 'Is the writing on the wall?', *The Independent*, 11 May 1999, p. 11, opens up his review by rehearsing how tedious the 'painting is dead' debate can be. The review is relatively kind to painting but not very kind to the painters shown. Lubbock presupposes the continuity of painting, but gives us no argument for it – space restriction, I guess! It would take a considerable document to sort out the complexities of the pro- and anti-painting positions.

3 Kitaj has made a curious painting entitled *Against Slander*, curious that is, in respect of the sentiment of the title (reproduced in Richard Morphet (ed.), *R. B. Kitaj: A Retrospective* (London, Tate Gallery), 1994, p. 171). The picture, in respect of its resources of expression, is not curious at all; it is made from the standard Kitaj pre-Cubist fare. It is accompanied by a Preface, which opens with a quote from Psalm 34. 'Who desires life and loves to see good days, keep your tongue from evil, keep your lips from deceit.' Is this a plea for the exercising of moral virtue, or a plea to have no criticism?

4 Freud wrote several essays concerned with fetishism. The earliest discussion is in *Three Essays* (1905) in the *Standard Edition*, vol. 7 (London, Hogarth Press), 1953–74, pp. 153–5. He argued here that 'choosing' a fetish is 'an after-effect of some sexual impression', more often than not received in childhood. Later he singled out pleasure of smell as a basis for fetishism. Later still, that the fetish stands for the missing penis of the woman. And later still he singled out foot fetishism.

5 One formulation of the logic of the fetishisation of painting might be formulated as follows: whilst there may be great art then painting (by someone) (but not everybody) can never not be it.

6 The art/science division permeates the popular imagination, not least in the organisation of academic curriculae. But as science seems to more and more break into what has previously been called science fiction the proximity of science to art, in one sense, increases. Cloning, artificial life, etc., all seem to increasingly impinge upon what, traditionally, we have called the realm of the imagination. As this happens our fear of science seems to increase proportionately to our adoration of art.

7 Bainbridge and Hurrell sought out something like the ambience of a machine shop because for both of them, the work they were doing, relative to a lot of sculpture then,

demanded fine-engineering tolerance. Bainbridge was also interested in the machine shop as one of the sites of organised labour – its access to union political organisation. Such political structures were seen by the art milieu at large as restrictions on individual expression. The arguments with the art milieu at large, then, began right there. The Atkinson/Baldwin projects could be made almost anywhere – professional or domestic sites. Much of their work was done in the 'domestic' areas of the professional space of the art school – coffee bars and rest areas within the school, cafés across the street, along with the studios. Since teaching was the centre of the practice, work could be made anywhere teaching could take place, in or out of the art school.

8  Karl Popper, *Conjectures and Refutations: The Growth of Scientific Knowledge* (London, Routledge and Kegan Paul), 1972; and *The Logic of Scientific Discovery* (London, Hutchinson), 1959.

9  It was at points such as this that Art & Language practices crossed into other disciplines. This apparently confused large sections of the art milieu, since they then saw our practices as not art, but some such as philosophy. In the longer historical run there is a sense in which they might yet be right.

10  In Art & Language in the United Kingdom, most new members were students on the Art Theory course at Coventry. An exception is Charles Harrison, who became friends with Art & Language whilst he was editor at *Studio International* in London. I hardly need to add that he has been one of the most resolute participants and defenders of the entire Art & Language programme, to say nothing of its definitive historian thus far. Since this is an essay on Kitaj, it seems appropriate to add that, in my view, Harrison is perhaps the best commentator and judge of the complexities and predicaments of painting.

    In Art & Language in New York membership expanded rapidly, meetings and agendas proliferated. If it was possible, there may have been more hubris in ALNY than in ALUK. Joseph Kosuth, now living in Rome, Mel Ramsden, still an Art & Language stalwart at the centre of the present Art & Language production in England, Michael Corris now working in England, Ian Burn, who tragically drowned in Australia a few years ago, Terry Smith, now working in Australia, were, at one time or another, amongst many others, all members in New York.

11  For a very interesting and telling commentary on the relation and symbolic position of the studio in American art practice from Stella to Smithson, see Caroline A. Jones, *Machine in the Studio: Constructing the Postwar American Artist* (Chicago, University of Chicago Press), 1996. David Bainbridge directed my attention to this book.

12  In 1967–68 Michael Baldwin and I studied hard to work into our project a concern with intension. See Terry Atkinson, *Tarrying Art after Philosophy: Wittgenstein is smarter than Duchamp*, in *Joseph Kosuth and American Conceptual Art*, forthcoming.

13  Three of the Art & Language founding members were teaching at Coventry: Atkinson, Bainbridge and Baldwin. The other member, Harold Hurrell, was teaching at Hull. He was no less resolute, pernickety or precise for being alone in his teaching. To the contrary, the other three members were invited to teach at Hull on a regular basis during 1968–69. As far as one could see, Hurrell enjoyed good relations with many of the staff there, and the discussions seemed open and friendly.

14  Two prominent texts in Bainbridge/Hurrell studies at that time were W. Ross Ashby, *Design for a Brain* (New York, Wiley), 1960, and Norbert Wiener, *The Human Use of Human Beings: Cybernetics and Society* (London, Eyre and Spottiswoode), 1954.

15 David Bainbridge was particularly familiar with the masculinised sites and space of organised labour. He came to St Martin's School of Art in London from the shop floor at Newton Chambers, a large steelworks in Sheffield, where he was a trade union shop steward. But we should not be too hasty here. The steelmaking shop had six bays, each bay had a crane, all the crane drivers were women. Most of the core-makers were women (about twenty). All were organised, the crane drivers being in the National Union of Foundry Workers of Great Britain and Northern Ireland. Whilst far from models of sexual industrial democracy, Bainbridge observed, the kind of shop floor he helped organise was in such matters some way in front of any of the art schools we all later worked in.

16 By 'commentary' here I am referring to Kitaj's Prefaces in Morphet (ed.), *Kitaj*. Kitaj introduces the Prefaces with a text titled 'About the Prefaces' – a kind of preface to the Prefaces. He opens with a quote from Matisse: 'I only offer some remarks, notes made in the course of my lifetime as a painter. I ask that one read them in the indulgent spirit generally accorded the writings of a painter.' Special pleading on behalf of the painter before the work of the likes of Pollock, Johns, Stella et al. had made its mark upon the world of painting, is bad enough, special pleading after its input is incredible.

17 In using the word 're-emergent' here to characterise the feminist movement of the 1960s and 1970s, I attempt to index the earlier feminist struggles.

18 See Jones, *Machine in the Studio*.

19 Sue Atkinson and Terry Atkinson made a work for the exhibition 'A New Necessity' (First Tyne International) which Declan McGonagle curated at Gateshead in 1990. The work was titled *Gateshead Border Control* and attempted to deal with the border between domestic and professional spaces. This project had some personal resonance for us since we both then had studios in the house we live in. But it attempted to articulate the more general problem of professional versus domestic, and how far such matters, if they do at all, follow the contours of imbedded sexual division and identity.

20 This is one of the most glaring portents of a Kitaj strategy that was to stick throughout his work to the present. Choose a contentious social/political subject – what Kitaj calls 'Hitler's English Rose' – and draw it with nineteenth-century resources and a chic aplomb. In relation to the predicament of the practice of painting post-1960, who cares whether Cyril Connolly told Kitaj it didn't much look like her! It's a very authentic modernist drawing and neither here nor there in dealing with the methodological and epistemological shifts which have rendered modernist practice so irredeemable. I think I know something of the problem here. In 1976 I did a drawing of the the the *Freikorps* (the murderers of Rosa Luxemburg, to stick with a Kitaj theme) with Herman Goering at the centre. The drawing was cumbersome to make – its resources are nineteenth-century too. I did a lot of first-order/second-order ontological dancing trying to get the resources (say lines and shading) in a second-order perspective (forgive the pun!) – to no avail. The predicament of modernist practice is just the same. We are back with Charles Harrison's 'a history of the wasted and unauthenticated'.

21 Charles Harrison's essay 6, '"Seeing" and "Describing": the Artists' Studio' (pp. 150–74), and essay 7, 'On the Surface of Painting' (pp. 175–205), in *Essays on Art & Language* (Oxford, Blackwell), 1990 are, in my view, among the best commentaries on the predicament of painting.

22 I first saw Kitaj's work in the studios at the Royal College of Art in London whilst he was a student there, and whilst I was a student at the Slade. I had been at the Slade a

year in 1961 and had figured out that the RCA painting school was lot livelier than the Slade, hence I used to (sort of) sneak into the RCA to see what the likes of Hockney, Kitaj, Phillips and Boshier were at. I was interested in Kitaj's strategy with texts and textual motifs and was especially enthusiastic about his and Hockney's work. By the time I came to see Kitaj's show at the Marlborough in 1963, I thought the likes of Stella had eclipsed this kind of work, in fact I was beginning to get a glimmering that Stella may have eclipsed himself and a lot of painting too.

23  I met Michael Baldwin in Coventry, when he was a second-year student there, in June 1966. I went for an interview for a teaching job there since I had lost my job teaching in Birmingham. I was introduced to him by Ivor Abrahams, a sculpture teacher at Coventry. I was interested in Baldwin more or less immediately, not least because he had a copy of Wittgenstein's *Tractatus* on his bench – and he could talk about it. I took news back to Bainbridge and Hurrell in London. All three of us were sharing a flat in Shepherd's Bush. From this meeting the Coventry forum which in 1968 became Art & Language developed rapidly.

24  In 1967 I made my first visit to New York. As an emissary for the work Bainbridge, Baldwin, Hurrell and I had been making during the past couple of years. I went with a hit list of American artists I was to try and visit: Andre, LeWitt, Smithson, Morris, Judd, Graham. They all saw me except Judd, who wouldn't, and Morris, who wasn't in town. LeWitt and Smithson proved especially supportive. I was there for two months and spent quite a lot of time with Smithson. For a fuller account of this, see Terry Atkinson, *Cultural Instrument* (New York, Real Gallery), 1999.

25  The modernist–postmodernist boundary seems to me to be a border marked on the equivalent of Lewis Carroll's Bellman's Map. The differences 'postmodernism' is supposed to mark are chimeras; the model of artistic subjectivity is perhaps a bit more hysterically proclaimed by the alleged postmodernist gurus, but it is exactly the same model as the modernist one.

26  The structure of art discourse and belief is set upon religious notions of soul, spirit, etc. Both the notions of inspiration and creativity are heavily invested in this religious substratum. Otherwise respectable and self- proclaimed materialists frequently lose their materialist bearings when talking about art. This, I guess, must indicate something, perhaps something both pervasive and profound.

27  Morphet (ed.), *Kitaj*, p. 9.

28  Charles Harrison's commentary in the TV programme 'On Pictures and Painting' covers these issues in a thorough way: Open University programme, BBC, first shown on 18 May 1999.

29  I have argued that the figuration/abstraction border is problematic. The achievement of abstraction in the second decade of this century seems to have been posited upon some notion that the events broke into virgin representational territory. Even if this is true, after a number of years of 'abstract' practice – I'm not sure how many years, say thirty – there starts to emerge a public recognition of abstraction. This entails public figuration of abstraction – abstraction becomes recognised and recalled as a set of figurative references. There is then a sense in which abstraction is figurative. It is part of the historical burden which a practice like painting carries today. It is hard for any abstract painter today to make a claim that her practice is in virgin representational territory.

30  Jacqui McClennan was at this time married to John Bowstead. She was a fashion student at the Royal College, and a general confidante of Fine-Artz. She was friends

at this time with Zandra Rhodes, who Fine-Artz used to meet from time to time. Thus Fine-Artz had a cachet in the Pop/fashion world of that time. One of the big differences between Fine-Artz and Art & Language was that the latter explicitly distanced itself from this London milieu. Art & Language preferred, in a manner of writing, Bertrand Russell's philosophy to his one-time Bloomsbury aesthetics. Another strand in the story of Kitaj versus Art & Language might be cast in this vein – Kitaj at the heart of the London aesthetic hubris, Art & Language indulging themselves in the provincial ('provincial' is a much more eloquent and vicious word than the now pc 'regional') bathos of the industrial cities of the English Midlands. Kitaj is a self-proclaimed cosmopolitan and traveller to the extent, he says himself, of being homeless. It may be for sentimental reasons, since Art & Language got their first break there, but I've always preferred New York to London, but I like Paris and Berlin too. I guess, like the rest of the Art & Language 'good old boys', I also like living in provincial England.

## Notes to Chapter 8

1  Professor of International History at the London School of Economics.

2  Painter and Lecturer at the Courtauld Institute and the Royal College of Art, London. Appointed Professor of Fine Art at Cambridge University in 1976.

3  'There is a reference to a living room overlooking Battersea Park both in the view from the window and in the lamp and the Mondrian print which were in the room in real life. The books – Léger in the case of Dr. Golding and Gramsci for me – represent current academic interests of each of us at the time. All the rest is imaginary, with much symbolism I am unable to elucidate!' Letter from James Joll to the author, 21 November 1979.

4  'Hockney likes to quote the line from Auden's long poem Letter to Lord Byron which reads, "To me Art's subject is the human clay".' R. B. Kitaj, *The Human Clay* (London, Arts Council of Great Britain), 1976, unpaginated.

5  Ibid.

6  Edgar Wind, *Art And Anarchy* (New York, Vintage Books), 1969, p. 95. Broadcast by BBC Radio in 1960 as the Reith Lectures, they also appeared contemporaneously in *The Listener*.

7  Among the last screenprints was *The Red Dancer of Moscow*, 1975

8  R. B. Kitaj, 'This Museum shows all kinds Social Disease and Self Abuse Young Boys Need it Special', *R.B. Kitaj* (Berkeley, University of California), 1967, exhib. cat., unpaginated.

9  See Maurice Tuchman, *A Report on the Art and Technology Program of the Los Angeles County Museum of Art 1967–71* (Los Angeles, Los Angeles County Museum of Art), 1971, pp. 147–63. Direct inspiration for much of the imagery was derived from Samuel Smiles, *Lives of the Engineers*, 1861–62, and Francis D. Klingender, *Art and the Industrial Revolution* (London, Evelyn, Adams and Mackay), 1968 (first published 1947).

10  Kenneth Clark, *Civilisation: A Personal View* (British Broadcasting Company and London, John Murray), 1969, p. 347.

11  See Hannah Arendt, 'Introduction. Walter Benjamin: 1892–1940', in Walter Benjamin, *Illuminations* (Glasgow, Fontana/Collins), 1973.

12  Walter Benjamin, *One Way Street* (London, New Left Books), p. 227, quoted in Peter Fuller, *Seeing through Berger* (London and Lexington, The Claridge Press), 1988, p. 34.

13  Peter Fuller, *Beyond the Crisis in Art* (London, Writers and Readers Publishing Cooperative), 1980, p. 16.

14  Ibid., p 38.

15  Ibid., p. 35.

16  Ibid., pp. 32–3.

17  See Max Kozloff, 'American Painting during the Cold War', *Artforum*, 11:9 (May 1973), 43–54, and Eva Cockcroft, 'Abstract Expressionism, Weapon of the Cold War', *Artforum*, 12:10 (June 1974), 39–41. By 1979, Peter Fuller, for example, was championing Edward Hopper, Richard Diebenkorn, Mark Rothko, Robert Natkin, Leon Golub and Rudolf Baranik as an alternative postwar American canon: see 'American Painting since the Last War', *Art Monthly*, 27–8 (Summer 1979).

18  Hyman established a contemporary canon including Kitaj, Howard Hodgkin, Eduardo Paolozzi, David Hockney, Michael Andrews, Peter de Francia and Maggi Hambling, among others, with a younger generation of himself, Ken Kiff, Peter Darach, Andrzej Jackowski, Paul Butler, Gillian Barlow and Alexander Moffat, among others.

19  Charles Harrison's *English Art and Modernism 1900–1939* was published by Allen Lane (London) in 1981.

20  *A New Spirit in Painting*, exhib. cat. (London, Royal Academy of Arts), 1981, pp. 11, 13.

21  'A New Spirit in Painting', in Ibid., p. 15.

22  *If Not, Not*, 1975–76; *The Orientalist*, 1975–76; *Moresque*, 1975–76; *The Sailor (David Ward)*, 1979–80; *The Jewish School (Drawing a Golem)*, 1980.

23  'A New Spirit in Painting' p. 16.

24  The painters included in this exhibition were: Michael Andrews, Frank Auerbach, Francis Bacon, William Coldstream, Lucian Freud, Patrick George, Leon Kossoff and Euan Uglow.

25  Dawn Ades, in Susan Compton (ed.), *British Art in the 20th Century* (London, Royal Academy of Arts), pp. 73–81. The five artists were Francis Bacon, Lucian Freud, Frank Auerbach, Leon Kossoff and Michael Andrews. Kitaj would have been excluded by definition, as he was from 'The Pursuit of the Real', since he has always remained an American national, despite his domicile in England from 1957 to 1997.

26  Peter Fuller, 'Editorial. A Renaissance in British Art', *Modern Painters*, 1:1 (Spring 1988), 2.

27  Colin Wiggins, 'Frank Auerbach and the Old Masters', *Modern Painters*, 3:3 (Autumn 1990), 34–44. All the following quotations from Auerbach come from this article unless otherwise indicated.

28  Auerbach, quoted in Wiggins, 'Auerbach', from Catherine Lampert, 'A Conversation with Frank Auerbach', *Frank Auerbach*, exhib. cat. (London, Arts Council, Hayward Gallery), 1978, p. 22.

29  Originally published in *Art History*, 4:4 (December 1981); these quotations are taken from the edited version published in Francis Frascina (ed.), *Pollock and After: The Critical Debate* (London, Paul Chapman), 1983, p. 203.

30  Peter Fuller made much the same kind of observations for different reasons.

31  Frascina (ed.), *Pollock and After*, p. 201. The comment would seem to be aimed primarily at Peter Fuller.

32  The critic Michael Peppiatt is among the major exceptions.

33  R. B. Kitaj, in Frederic Tuten, 'Neither Fool, Nor Naive, Nor Poseur-Saint: Fragments on R. B. Kitaj', *Artforum* (January 1982), 47.

34  R. B. Kitaj, in Richard Morphet (ed.), *R. B. Kitaj: A Retrospective* (London, Tate Gallery), 1994, p. 120. Sources for this painting are well documented by the artist in notes published in *Skira Annual 4*, undated, p. 68; Marco Livingstone, *R.B. Kitaj* (Oxford, Phaidon Press), 1985, p. 150–1. Other sources for the painting might also include Uta Feldges-Henning, 'The Pictorial Programme of the Sala Della Pace: A New Interpretation', *Journal of the Warburg and Courtauld Institutes,* 35 (1972). Plate 23b, *Bad Government: The Country (detail)*, with its burnt-out smouldering village, ruined buildings and untended livestock shares many of the general chatacteristics of *If Not, Not*. The caption to the Plate reads: 'Because he seeks his own welfare in this world he subjects justice to Tyranny: thus no one treads his road without fear, for pillage is rife both within and without the city limits … the consequence is that where there is Tyranny, there is great suspicion; wars, rapine, treachery and deception gain the upper hand and use their wiles and ingenuity to keep away anyone who defends justice, rather than avoiding, by over-throwing Tyranny, such dark Injustice. Tyranny has anyone who tries to disturb it pursued and banished, together with his followers if he should have any, strengthening Tyranny for your Peace.' p. 148. Aside from the allusions to Matisse's *Joie de Vivre* another, much closer source for this painting and its companion piece *The Land of Lakes* (1977), might also be found in the Hungarian National Gallery and the work of Tivadar Kosztika Csontvary, namely *Ruins of the Greek Theatre at Taormina*, 1904, which shares a similar colour scheme, paint quality, scattered ruins and handling of architectural detail. Significantly, Csontvary specialised in historical and biblical scenes. In any case a fitting pictorial reference for Kitaj's own account of the picture: 'My journal for this painting reports a train journey someone took from Budapest to Auschwitz to get a sense of what the doomed could see through the slats of their cattle cars ('Beautiful, simply beautiful countryside') … I don't know who said it. Since then I've read that Buchenwald was constructed on the very hill where Goethe often walked with Eckermann.' Morphet (ed.), *Kitaj*, p. 120.

35  Interestingly enough Francis Ford Coppola's feature film *Apocalypse Now*, released in 1979, also partially inspired by Conrad's *The Heart of Darkness*, was begun at about the same time as this painting. It also sits in a well-established but little remarked tradition of neo-Romantic apocalyptic landscape which established itself in the United States in the years before and after the Second World War: see Peter Blume, *The Eternal City*, 1934–37, and *The Rock*, 1945–48; Pavel Tchelitchew, *Phenomena*, c.1937; George Grosz, *A Piece of My World I*, c. 1938, and *The Pit*, 1946; Edwin Dickinson, *Ruin at Daphne*, 1943–53; Kuniyoshi, *Headless Horse Who Wants to Jump*, 1945; and Charles Burchfield, *An April Mood*, 1955, for example.

36  *R. B. Kitaj: Pictures. Bilder*, exhib.cat. (London, Marlborough Fine Art), 1977, p. 5. The title for the painting was probably taken from a book by R. Giesey, in the artist's studio in the summer of 1977, titled *If Not, Not: The Oath of the Aragonese and the Legendary Laws of the Sobrabe* (Princeton, N.J., Princeton University Press), 1968.

37  See Livingstone, *Kitaj*, p. 152, and *The Tate Gallery: Illustrated Catalogue of Acquisitions 1978–80* (London, The Tate Gallery), 1981, pp. 107–8.

38  R. B. Kitaj, 'The Horror! The Horror', *Irving Petlin Rubbings … The Large Paintings and Small Pastels*, exhib. cat. (New York, Neuberger State University of New York), 1978, unpaginated.

39  Ibid.

40  See Isaac Deutscher, *The Non-Jewish Jew and other Essays* (Oxford, Oxford University Press), 1968.

41  Kitaj in Morphet (ed.), *Kitaj*, p. 158.

42  See *R. B. Kitaj: Pictures with Commentary. Pictures without Commentary*, exhib. cat. (London, Marlborough Fine Art), 1963, and *R. B. Kitaj*, exhib. cat. (New York, Marlborough-Gerson Gallery), 1965.

43  Kitaj sent the author a postcard of *The Flaying of Marsyas* in 1984.

44  Lawrence Gowing, 'The Genius of Venice 1500–1600', *London Review of Books* (1984), 13. Karl Miller, the then editor of the *London Review*, was a close neighbour of Kitaj, and Kitaj an avid reader.

45  *The Ideology of the Aesthetic* (London, Basil Blackwell), 1990, p. 338.

46  Kitaj, in Morphet (ed.), *Kitaj*, p. 144.

47  Described by his first wife, the writer, Caroline Blackwood, as 'temperamentally too dark,' for a man to have children by (John Ezard, 'Humour and Fragility', Obituary, *The Guardian*, 16 February 1996, p. 19). In July 1999 he reportedly withdrew paintings from an exhibition in Vienna. 'To deny, however, that the treatment of his grandfather [Sigmund Freud] has not had an effect on him – and indeed the murder of his great aunts – would also be wrong' – a quotation attributed to William Feaver in Fiachra Gibbons, 'Freud bans Show in Grandfather's City', *The Guardian*, 13 July 1999, p. 1.

48  Robert Hughes, *Frank Auerbach* (London, Thames and Hudson), 1990, p. 4.

49  Gowing, 'Genius of Venice', p. 14.

50  Aby Warburg, *Moderne Geschichtswissenschaft* (Freiburg i.B.), 1905, pp. 23 ff., quoted in E. H. Gombrich, *Aby Warburg: An Intellectual Biography* (Oxford, Phaidon), 1970, pp. 31–2.

51  Susan Sontag, 'Preface', Hans-Jürgen Syberberg, *Hitler: A Film from Germany*, trans. Joachim Neugroschel (Manchester, New Carcanet Press), 1982, p. xv.

52  Baseball is referenced in the print series '*Mahler Becomes Political, Beisbol*', 1967; the paintings *Sisler and Schoendienst*, 1967; *Tampa*, 1967; *The Williams Shift (For Lou Boudreau)*, 1967; *Tinkers to Evers*, 1967; *Stanky and Berra at St. Petersburg*, 1967; *Amerika (Baseball)*, 1983–84.

## Notes to Chapter 9

1  Nelly Kaplan, in Paul Hammond (ed.), *The Shadow and its Shadow: Surrealist Writing on the Cinema* (Edinburgh, Polygon), 1991, p. 216.

2  André Breton and Philippe Soupault, *The Magnetic Fields*, trans. David Gascoyne (London, Atlas), 1985, p. 26.

3  Robert Coover, *A Night at the Movies, or, You Must Remember This* (Illinois, Dalkey Archive Press), 1992, p. 25.

4  Lucretius, *On the Nature of the Universe, Book IV, Sensation and Sex* (Harmondsworth, Penguin), 1951, p. 133.

5  For present purposes, Hollywood cinema. Cinema began with the simple wonder of the trace in motion, the sufficient pleasure of the world-as-image. Such fascination and

delight survives, faintly, in commercial cinema through the sensibility of a handful of directors, most consistently Wenders (who trained as a painter), but was almost immediately overwhelmed by narrative, and, therefore, by text. Only in the art world, where real time can unfold in the context of exhibition rather than of an essentially theatrical notion of performance (there is a long and various tradition of boredom – and what can lie beyond it – as an avant-garde strategy), has there been a space for the development of a new art of looking through moving images. This is an art very different from drawing, and also from still photography. Video has made this new art easier, but is as different a medium from film as pastel is from oil paint.

6  Like the various forms of Fiona Banner's *The Nam*, perhaps, an heroic counter-example to this generalisation – a written description (writing as drawing) of what is seen on screen in the Vietnam movies, a pursuit of the impossible 'everything' which exists within the rush of the cinematic present. Banner's latest work is now, intriguingly, moving towards writing/drawing cinema from memory. Other contemporary art dealing with cinema often either concentrates on its tangible accessories, such as the film still, or, with modernist rigour, forces the physical process and apparatus of projection into the conditions of viewing. See *Transcript*, 3:3 (undated).

7  Richard Morphet (ed.), *R. B. Kitaj: A Retrospective* (London, The Tate Gallery),1994, p. 44.

8  Letter to the author, dated September 1998. All unattributed quotations below are from the same letter.

9  It was, then, a black-and-white yellow ribbon that inspired the yellow ribbon in *The Ohio Gang*, 1964: 'The yellow ribbon signifies that the young woman pledges herself, like in Ford's great movie, without divulging to which of two men.' Morphet (ed.), *Kitaj*, p. 84.

10  In one series of pictures he signs himself 'Ronald', a reference to Van Gogh's 'Vincent' signature all the more unexpected because – like many authors but few painters – he has been known, if not by his surname alone, then by his initials: R. B. Kitaj. This is also partly a trick of the memory, since it is the drawings and pastels that are signed rather than the oil paintings, the 'Bad' series of small oils signed 'Ronald' being an exception, more of an addition than a change. In correspondence he often contents himself with a Kafkaesque 'K'.

11  A strange painting of 1992 which turns the (in)famous trial (for libel, which makes the piece a companion for *Against Slander*, completed the previous year) into a boxing match, based on Bellows's Dempsey and Firpo at the Whitney, while also incorporating a Rembrandt torso of Christ, itself borrowed from Rubens. Julio Cortazar's short story 'Circe', published in 1951, mentions the fight: 'The Firpo–Dempsey fight took place and there were tears and indignation in every household, followed by a colonial and haunting melancholy.' If we think of Kitaj largely as an American in Europe, it is significant also (as later paintings looking back to his youth, such as *The Second Time (Vera Cruz)*, *A Tale of the Maritime Boulevard*, acknowledge) that his early travels as a merchant seaman were mostly to Cuba, Mexico, the Caribbean, South America, a succession of environments where being American was different again. Kitaj casts himself as the referee, neutral between the 'London American coxcomb', Whistler, and Ruskin – not only the founder of the art school Kitaj attended in Oxford but also the great nineteenth-century champion of meaning, breadth of knowledge and reference, and high seriousness in art. Both parties, of course, offer possible parallels to Kitaj's

position, possible self-identifications; his refusal to choose between them is comparable to Michelangelo's dodging of the question of whether he would be damned or saved.

12  Paul Melia and Alan Woods, *Peter Greenaway: Artworks, '63–'98* (Manchester, Manchester University Press), 1998, p. 134.

13  Morphet (ed.), *Kitaj*, p. 29.

14  Including theatre known from pictures, books and conversations. See ibid., pp. 150, 158, 194 – and also p. 84, the Preface to *The Ohio Gang*, which reminisces about Kitaj's performing in a scene from *Of Mice and Men* – itself a novel turned into a film – in acting class. There is a shadowy parallel history of painting and theatre, a history of sets and perspectives, of gestures, of the relation of figures to viewers; echoes of that history remain in Kitaj, most directly perhaps in or from his use of the history of painting rather than from particular theatrical references.

15  Ibid., p. 70. See also Marco Livingstone, *R .B. Kitaj* (London, Phaidon), 1985, p. 21, where Kitaj refers to collage as 'a free-verse game to play in art'. The preface to *The Ohio Gang* relates the streaming consciousness of the painting both to free verse and to 'early Buñuel' – whose freely associative technique itself derived from the theories of Surrealist poetry.

16  *New Statesman*, 19 March 1999, p. 48.

17  See *The Londonist*, 1987, or the Preface to *Rousseau*, 1990, in Morphet (ed.), *Kitaj*, p. 174. He has also drawn family portraits where his wife or son are reading.

18  Morphet (ed.), *Kitaj*, p. 158.

19  Integration, because we have long since gone way beyond opposition, or knowing juxtaposition, or in many cases, especially cinematic, distinction between 'high' and 'low'.

20  Morphet (ed.), *Kitaj*, p. 44.

21  Ibid., p. 61.

22  Julián Ríos, *Kitaj: Pictures and Conversations* (London, Hamish Hamilton), 1994, p. 253.

23  Livingstone, *Kitaj*, p. 25.

24  Ibid., p. 44.

25  This is, I think, the only commentary not to mention a writer (apart from the 'short stories' 'illustrating' *Self-Portrait as a Woman*, *Apotheosis of Groundlessness* and *Where the Railroad Leaves the Sea*) unless one counts Kenneth Burke; Kitaj remembered Ford's bookshelf well enough. However, Ríos's version of the title, like *Amerika (Baseball)* (painted at the same time, 1983–84, and also changed in the 1994 retrospective, to simply *Baseball*), uses the original spelling of Amerika from Kafka's unfinished novel of the same name. Kafka never visited America, of course; he imagined it. Hollywood films – especially Westerns, perhaps – might be seen as America's own invented America – although things are more complicated in the baseball painting, which combines Kitaj's childhood memories of baseball and his attention across distance to its continuing progress as both sport and national symbol (a democratic contrast to Velásquez's quoted *Boar Hunt*), with the Nature Theatre from the final (completed) chapters of *Amerika*. It is an intriguing coincidence that *The Kids of Survival* – who might well have felt excluded from most American versions of America – also (in this case literally) drew on Kafka's novel.

26  Morphet (ed.), *Kitaj*, p. 148. Kitaj had also represented Degas on his deathbed in a pastel of 1980.

27 'Yet' is 1989. As for possible affinities with Ford: 'I think there are affinities, elective and otherwise – Romance, America, slightly fake macho, playing the rebel, etc., but opposites too, yes.' Ríos, *Kitaj*, p. 252.

28 Ibid.,

29 A title which conjures up a fragment of doggerel, 'O the sun shines bright on Charlie Chaplin', a further cinematic reference, reworked, moreover, by Eliot in *The Waste Land* – where 'the moon shone bright on Mrs Porter / And on her daughter / They wash their feet in soda water'.

30 Morphet (ed.), *Kitaj*, p. 206. Any reading of Kitaj's oeuvre influenced by Bloom's notion of the anxiety of influence might well consider what it means for a painter to have writers (and filmmakers) for heroes alongside painters. Kitaj as a painter can never directly compete with Kafka, Benjamin, Ford, Eliot, Pound – there can be neither readings nor misreadings in the translation into another medium. When (in the very same 'literary' pictures, naturally) Kitaj takes on Cézanne, Titian, Michelangelo, Picasso, Matisse, Degas, or whoever, the (acknowledged) problem of rivalry returns.

31 Livingstone, *Kitaj*, p 22. The following quotations are from the letter to the author cited in note 8 above.

32 Morphet (ed.), *Kitaj*, p. 88.

33 See the discussion in Ríos, *Kitaj*, pp. 39–41. Livingstone, *Kitaj*, p. 23, offers no source for the 'archetypal romantic scene' in the centre. For other specific film details within paintings, see Livingstone, *Kitaj*, pp. 28, 37, 39, and Ríos, *Kitaj*, pp. 118, 128.

34 See the Preface to *Women and Men*, in Morphet (ed.), *Kitaj*, p. 180.

35 In Ian Breakwell and Paul Hammond's *Seeing in the Dark* (London, Serpent's Tail), 1990.

36 Ríos, *Kitaj*, p. 43.

## Notes to Chapter 10

1 See R. B. Kitaj, *Erstes Manifest des Diasporismus*, edited and arranged by Max Bartholl, Christoph Krämer and Ulrich Krempel (Zürich, Die Arche/Raabe und Vitali), 1988 (*First Diasporist Manifesto*, London, Thames and Hudson, 1989).

2 See Janet Wolff, chapter 1 in this volume.

3 See Martin Roman Deppner, 'Jüdische Identität in den bildenden Künsten nach 1945', in *An der Schwelle zum Neuen – Im Schatten der Vergangenheit. Jüdische Kultur in Deutschland heute* (Oldenburg, Isensee), 1997, pp. 53–79.

4 See Daniel Krochmalnik, 'Emmanuel Lévinas und der "*Renouveau Juif*", in Thomas Freyer und Richard Schenk (eds), *Emmanuel Lévinas: Fragen an die Moderne* (Wien, Passagen), 1996, pp. 95–136.

5 See Jacques Derrida, *Ein Portrait von Geoffrey Bennington und Jacques Derrida* (Frankfurt am Main, Suhrkamp), 1994; *Schibboleth. Für Paul Celan* (Graz, Böhlau), 1986; and *Gewalt und Metaphysik. Essay über das Denken Emmanuel Lévinas, also: Die Schrift und die Differenz* (Frankfurt am Main, Suhrkamp), 1972, pp. 121–235. See also Werner Stegmeier, 'Die Zeit und die Schrift. Berührungen zwischen Lévinas und Derrida', in Freyer und Schenk (eds), *Emmanuel Lévinas*, pp. 51–72 und Stéphane Mosès, *Der Engel der Geschichte, Franz Rosenzweig. Walter Benjamin. Gershom Scholem* (Frankfurt am Main, Suhrkamp) 1994.

  6  R. B. Kitaj, 'Preface' to *If Not, Not*, in Marco Livingstone, *R. B. Kitaj* (Oxford, Phaidon), 1985, p. 150.

  7  Compare Edgar Wind, *Giorgione's Tempesta with Comments on Giorgione's Poetic Allegories* (Oxford, Clarendon Press), 1969, pp. 1–15.

  8  Ibid., p. 4.

  9  See Matthias Eberle, *Individuum und Landschaft. Zur Entstehung und Entwicklung der Landschaftsmalerei* (Gießen, Anabas), 1980, pp. 8 ff and 111; and Joachim Ritter, 'Landschaft. Zur Funktion des Ästhetischen in der modernen Gesellschaft', in Joachim Ritter, *Subjektivität* (Frankfurt am Main, Suhrkampf), 1980, pp. 150 ff.

 10  See Martin Roman Deppner, *Zeichen und Bildwanderungen. Zum Ausdruck des Nicht-Seßhaften im Werk R.B. Kitajs* (Münster/Hamburg, Lit), 1992, pp. 109 and 25 n. and 26 n.

 11  Derrida, *Ein Portrait*, pp. 79–92; and Heinz Kimmerle, *Derrida zur Einführung* (Hamburg, Junius), 1988, pp. 81–8.

 12  See Paul Petzel, 'Marginalismus und Diasporismus', in Klaus-Peter Pfeiffer (ed.), *Vom Rande her? Zur Idee des Marginalismus* (Königshausen und Neumann), 1996, pp. 223–34.

 13  Robert Creeley, 'Ecce Homo', in: *R. B. Kitaj: Pictures/Bilder* (Zürich, Marlborough), 1977, p. 7.

 14  See Peter Dressendörfer, *Islam unter der Inquisition: The Morisco trials in Toledo 1575–1610* (Wiesbaden, F. Steiner), 1971, p. 20; Richard L. Kagen, 'The Toledo of El Greco', in *El Greco of Toledo*, exhibition catalogue (Boston, Little Brown), 1982, p. 54.

 15  See, regarding this complex, Deppner, *Zeichen und Bildwanderungen*.

 16  R. B. Kitaj, in 'Gespräch mit Timothy Hyman, Eine Rückkehr nach London', in *R.B. Kitaj*, exhibition catalogue (Düsseldorf, Düsseldorf Kunsthalle), 1982, p. 49.

 17  Ezra Pound, *Lesebuch, Dichtung und Prosa*, ed. Eva Hesse (Zürich, Die Arche), 1985, p. 104.

 18  See Wolfgang Iser, 'Image und Montage. Zur Bildkonzeption in der imaginistischen Lyrik', in Wolfgang Iser (ed.), *Poetik und Hermeneutik 2, Immanente Ästhetik, Ästhetische Reflektion. Lyric als Paradigma der Moderne* (München, Wilhem Fink), 1966, pp. 361–93.

 19  John Ashbery, 'Hunger und Liebe in Ihren Variations', in: *R.B. Kitaj* (Düsseldorf) p. 10.

 20  See Eva Hesse, *T. S. Eliot und 'Das wüste Land'. Eine Analyse* (Frankfurt am Main, Suhrkamp), 1973.

 21  Kitaj, in Livingstone, *Kitaj*, p. 150.

 22  See Edgar Wind, *Kunst und Anarchie* (Frankfurt am Main, Suhrkamp), 1979, pp. 25 and 43 n.

 23  See Martin Roman Deppner, 'Konstruktivismus und Dekonstruktivismus im kunst-wissenschaftlichen Diskurs', in Gottfried Jäger and Gudrun Wessing (eds), *Über Moholy-Nagy. Ergebnisse aus dem internationalen László Moholy-Nagy Symposium. Bielefeld 1995* (Bielefeld, Kerber), 1997, pp. 163–80.

 24  See Ferdinand de Saussure, *Grundfragen der allgemeinen Sprachwissenschaften* (Berlin, Walter de Gruyter), 1967.

 25  Ludwig Wittgenstein, 'Philosophische Untersuchungen', paragraph 276, in Ludwig Wittgenstein, *Tractatus-logico-philosophicus/philosophische Untersuchungen* (Leipzig, Reclam), 1990, p. 227.

26  See Derrida, *Ein Portrait,* and *Grammatologie* (Frankfurt am Main, Suhrkamp), 1974.

27  Ezra Pound, cited in Eva Hesse, *T. S. Eliot und 'Das wüste Land'*, p. 110.

28  See *The Talmud,* translated and explained by Reinhold Meyer (München, Wilhelm Goldmann), 1981, pp. 9–60.

29  See Gershom Scholem, *Die jüdische Mystik in ihren Hauptströmungen* (Frankfurt am Main, Suhrkamp), 1980, p. 169.

30  See Wolfgang Iser, *Image und Montage,* 1996, pp. 381 ff.

31  Scholem, *Die jüdische Mystik,* p. 238.

32  Erich Bischoff, *Die Kabbala. Einführung in die jüdische Mystik und Geheimwissenschaft* (Leipzig, Th. Grieben's Verlag), 1917, p. 4.

33  See R. B. Kitaj, 'Preface' to 'Land of Lakes', in Livingstone, *Kitaj,* p. 151.

34  R. B. Kitaj, quoted in Frederic Tuten, 'Neither Fool, Nor Naive, Nor Poseur-Saint', in 'Fragments on R.B. Kitaj', *Artforum,* January 1982, p. 67.

35  Ibid.

36  See 'Kitaj interviewed by Richard Morphet', in Richard Morphet (ed.), *R.B. Kitaj: A Retrospective* (London, Tate Gallery), 1994, p. 56. See also Emmanuel Lévinas, *Schwierige Freiheit: Versuche über das Judentum* (Frankfurt am Main, Suhrkamp), 1992, pp. 58–103; and Krochmalnik, *Emmanuel Lévinas,* p. 125.

37  See Arnold Goldberg, 'Der verschriftete Sprechakt als rabbinische Literatur', in Aleida und Jan Assmann/Christof Hardmeier (eds), *Schrift und Gedächtnis. Beiträge zur Archäologie der literarischen Kommunikation* (München, Wilhem Fink), 1983, pp. 126 ff.

38  See Eva Hesse, *Ezra Pound, Von Sinn und Wahnsinn* (München, Kindler), 1978, pp. 382 ff.

39  Ibid., pp. 50–92.

40  Emmanuel Lévinas, *Autrement qu'être ou-delà de l'essence* (Den Haag, Nijhoffje), 1978, pp. 6 and 17. See also Stegmaier, 'Die Zeit', pp. 64 ff.

41  See Emmanuel Lévinas, 'Von der Ethik zur Exegese', in M. Mayer and M. Hentschel (eds.), *Parabel. Schriftenreihe des Evangelischen Studentenwerks Villingst, Volume 12: Lévinas. Zur Möglichkeit einer prophetischen Philosophie* (Gießen, Focus), 1990, p. 15.

42  Stéphane Mosès in einem *Vortrag zum Thema:* 'Die Unübersetzbarkeit der göttlichen Namen. Überlegungen zur rabbinischen Interpretation der Offenbarung am brennenden Busch'. Universität Hamburg, received on the 1st November 1996.

43  See Krochmalnik, 'Emmanuel Lévinas', p. 120.

44  Ibid., pp. 99–111.

45  Emmanuel Lévinas, *Die Spur des Anderen, Untersuchungen zur Phänomenologie und Sozialphilosophie* (Freiburg/München, Karl Alber), p. 235.

46  See Gottfried Boehm, 'Die Wiederkehr der Bilder', in Gottfried Boehm (ed.*) Was ist ein Bild?* (München, Wilhelm Fink), 1994, pp. 11–38.

47  Richard Wollheim, *Objekte der Kunst* (Frankfurt am Main, Suhrkamp), 1982, p. 43.

48  See George Syamken, 'Mark Rothko und Barnett Newman. Ihr Verhältnis zu 2 Moses 20.4', in *Babylon,* 12 (1994), p. 28.

49  See Dirk Teuber, 'George Segal: Wege zur Körperüberformung' (Frankfurt am Main, Lang), 1987.

50  See Martin Roman Deppner and Karl Janke, *New York–London. Abstrakte und figurative Kunst im Vergleich. Raabits. Impulse und Materialien für eine kreative Unterrichtsgestaltung* (Heidelberg, Raabe), 1997.

51  See Albrecht Schöne, 'Können wir noch lesen?', *Die Zeit*, 18 August 1995.

52  See Deppner, *Zeichen und Bildwanderungen*, Kap. XV.4.

53  See Wolfgang N. Krewani, *Emmanuel Lévinas. Denker des Anderen* (Freiburg/München, Karl Alber), 1992, pp. 147–8.

54  See Martin Roman Deppner, 'Maske und Figur, Beckmann and Marées. Ein deutcher Künstler und sein jüdisches Vorbild', in *Kunstforum International*, 111 (Januar/Februar 1991), pp. 168–77.

55  See Deppner, *Zeichen und Bildwanderungen,* Kap. XV.5 und Kap. XVI.3.

56  See Tilmann von Stockhausen, *Die Kulturwissenschaftliche Bibliothek Warburg. Architektur, Einrichtung und Organisation* (Hamburg, Dölling und Galitz), 1992; Werner Hofmann, Georg Syamken and Martin Warnke, *Die Menschenrechte des Auges, Über Aby Warburg* (Frankfurt am Main, Europäische Verlagsanstalt), 1980; Georg Syamken, 'Warburgs Umwege als Hermeneutik *More Majorum*', in *Jahrbuch der Hamburger Kunstsammlungen*, 25 (Hamburg, Dr. Ernst Hausewedell), 1980, pp. 15–26; Hortst Bredekamp *et al.* (eds.), *Aby Warburg. Akten des Internationalen Symposiums Hamburg 1990* (Weinheim, VCH), 1991; Aby Warburg, 'Schlangenritual. Ein Reisebericht (1923)', ed. Ulrich Raulff (Berlin, Klaus Wagenbach), 1988; and Sigrid Weigel, 'Aby Warburgs Schlangenritual. Korrespondenzen zwischen Lektüre kultureller und geschriebener Texte', in Aleida Assmann (ed.), *Texte und Lektüren. Perspektiven der Literaturwissenschaft* (Frankfurt am Main, Fischer), 1966, pp. 269–88.

57  Rabbi David Polnauer, 'Zwischen Mystik und Rationalität. Gegen die Verweltlichung des Judentums', in *Allgemeine Jüdische Wochenzeitung*, 19/97 (18 September 1997), p. 14.

# Index

Note: Page numbers given in *italic* refer to illustrations; 'n' after a page reference indicates a note number on that page.